Ideal Commonwealths

Comprising:
More's Utopia
Bacon's New Atlantis
Campanella's City of the Sun
and
Harrington's Oceana

With introduction by
Henry Morley, LL.D.

DEDALUS/HIPPOCRENE

Published in the U.K. by Dedalus Ltd.
Langford Lodge, St. Judith's Lane, Sawtry, Cambridgeshire
PE17 5XE.

ISBN 0946626 26 X (Paperback)

Published in the U.S.A. by Hippocrene Books Inc.,
171 Madison Avenue, New York NY10016.

Dedalus edition 1988.

Printed by The City Printing Works (Chester-le-Street) Ltd.,
Broadwood View, Chester-le-Street, Co. Durham DH3 3NJ.

This book is sold subject to the condition that it shall not, by way of trade or otherwise be lent, re-sold or hired out or otherwise circulated without the publishers prior consent in any form of binding or cover other than that in which it is published and without a similar condition including this condition being imposed on the subsequent purchaser.

Cataloguing in Publication Data is available from the British Library on request.

INTRODUCTION

TO

UTOPIA, NEW ATLANTIS, AND CITY OF THE SUN

PLATO, in his "Republic," argues that it is the aim of individual man, as of the State, to be wise, brave, and temperate. In a State, he says, there are three orders—the Guardians, the Auxiliaries, the Producers. Wisdom should be the special virtue of the guardians; courage of the auxiliaries; and temperance of all. These three virtues belong respectively to the individual man—wisdom to his rational part, courage to his spirited, and temperance to his appetitive; while in the State, as in the man, it is injustice that disturbs their harmony.

Because the character of man appears in the State unchanged, but in a larger form, Plato represented Socrates as studying the ideal man himself through an ideal commonwealth.

In another of his dialogues, "Critias," of which we have only the beginning, Socrates wishes that he could see how such a commonwealth would work, if it were set moving. Critias undertakes to tell him; for he has received tradition of events that happened more than 9,000 years ago, when the Athenians themselves were such ideal citizens. Critias has received this tradition, he says, from a ninety-year-old grandfather, whose father, Dropides, was the friend of Solon. Solon, lawgiver and poet, had heard it from the priests of the goddess Neith, or Athene, at Sais, and had begun to shape it into a heroic poem.

This was the tradition: Nine thousand years before the time of Solon, the goddess Athene, who was worshipped also in Sais, had given to her Athenians a healthy climate, a fertile soil, and temperate people strong in wisdom and courage. Their republic was like that which Socrates imagined, and it had to bear the shock of a great invasion by the people of the

vast island Atlantis. This island, larger than all Libya and Asia put together, was once in the sea westward beyond the Atlantic waves; thus America was dreamed of long before it was discovered. Atlantis had ten kings, descended from ten sons of Poseidon (Neptune), who was the god magnificently worshipped by its people. Vast power and dominion, that extended through all Libya as far as Egypt, and over a part of Europe, caused the Atlantid kings to grow ambitious and unjust. Then they entered the Mediterranean and fell upon Athens with enormous force. But in the little band of citizens, temperate, brave, and wise, there were forces of reason able to resist and overcome brute strength. Now, however, gone are the Atlantids, gone are the old virtues of Athens. Earthquakes and deluges laid waste the world. The whole great island of Atlantis, with its people and its wealth, sank to the bottom of the ocean. The ideal warriors of Athens, in one day and night, were swallowed by an earthquake, and were to be seen no more.

Plato, a philosopher with the soul of a poet, died in the year 347 before Christ. Plutarch was writing at the close of the first century after Christ, and in his parallel "Lives of Greeks and Romans," the most famous of his many writings, he took occasion to paint an ideal commonwealth as the conception of Lycurgus, the half mythical or all mythical Solon of Sparta. To Plutarch's "Life of Lycurgus," as well as to Plato, Thomas More and others have been indebted for some part of the shaping of their philosophic dreams.

The discovery of the New World at the end of the fifteenth century followed hard upon the diffusion of the new invention of printing, and came at a time when the fall of Constantinople by scattering Greek scholars, who became teachers in Italy, France, and elsewhere, spread the study of Greek, and caused Plato to live again. Little had been heard of him through the Arabs, who cared little for his poetic method. But with the revival of learning he had become a force in Europe, a strong aid to the Reformers.

Sir Thomas More's "Utopia" was written in the years 1515 and 1516, when its author's age was about thirty-seven. He was a young man of twenty when Columbus first touched

the continent named after the Florentine Amerigo Vespucci, who made his voyages to it in the years 1499–1503. More wrote his "Utopia" when imaginations of men were stirred by the sudden enlargement of their conceptions of the world, and Amerigo Vespucci's account of his voyages, first printed in 1507, was fresh in every scholar's mind. He imagined a traveller, Raphael Hythloday—whose name is from ،Greek words that mean "knowing in trifles"—who had sailed with Vespucci on his three last voyages, but had not returned from the last voyage until, after separation from his comrades, he had wandered into some further discovery of his own. Thus he had found, somewhere in those parts, the island of Utopia. Its name is from Greek words meaning "nowhere." More had gone on an embassy to Brussels with Cuthbert Tunstal when he wrote his philosophical satire upon European, and more particularly English, statecraft, in the form of an ideal commonwealth described by Hythloday as he had found it in Utopia. It was printed at Louvain in the latter part of the year 1516, under the editorship of Erasmus and that enlightened young secretary to the municipality of Antwerp, Peter Giles, or Ægidius, who is introduced into the story. "Utopia" was not printed in England in the reign of Henry VIII, and could not be, for its satire was too direct to be misunderstood, even when it mocked English policy with ironical praise for doing exactly what it failed to do. More was a wit and a philosopher, but at the same time so practical and earnest that Erasmus tells of a burgomaster at Antwerp who fastened upon the parable of "Utopia" with such good-will that he learnt it by heart. And in 1517 Erasmus advised a correspondent to send for "Utopia," if he had not yet read it, and if he wished to see the true source of all political evils.

Francis Bacon's "New Atlantis," first written in Latin, was published in 1629, three years after its author's death. Bacon placed his ideal commonwealth in those seas where a great austral continent was even then supposed to be, but had not been discovered. As the old Atlantis implied a foreboding of the American continent, so the New Atlantis implied foreboding of the Australian. Bacon, in his philosophy, sought through experimental science the dominion of men over things,

"for nature is only governed by obeying her." In his ideal world of the New Atlantis, science is made the civilizer who binds man to man, and is his leader to the love of God.

Thomas Campanella was Bacon's contemporary, a man only seven years younger; and an Italian who suffered for his ardor in the cause of science. He was born in Calabria in 1568, and died in 1639. He entered the Dominican order when a boy, but had a free and eager appetite for knowledge. He urged, like Bacon, that nature should be studied through her own works, not through books; he attacked, like Bacon, the dead faith in Aristotle, that, instead of following his energetic spirit of research, lapsed into blind idolatry. Campanella strenuously urged that men should reform all sciences by following nature and the books of God. He had been stirring in this way for ten years, when there arose in Calabria a conspiracy against the Spanish rule. Campanella, who was an Italian patriot, was seized and sent to Naples. The Spanish Inquisition joined in attack on him. He was accused of books he had not written and of opinions he did not hold; he was seven times put to the question and suffered, with firmness of mind, the most cruel tortures. The Pope interceded in vain for him with the King of Spain. He suffered imprisonment for twenty-seven years, during which time he wrote much, and one piece of his prison work was his ideal of "The City of the Sun."

Released at last from his prison, Campanella went to Rome, where he was defended by Pope Urban VIII against continued violence of attack. But he was compelled at last to leave Rome, and made his escape as a servant in the livery of the French Ambassador. In Paris, Richelieu became Campanella's friend; the King of France gave him a pension of 3,000 livres; the Sorbonne vouched for the orthodoxy of his writings. He died in Paris, at the age of seventy-one, in the convent of the Dominicans.

Of Campanella's "*Civitas Solis*," which has not hitherto been translated into English, the translation here given, with one or two omissions of detail which can well be spared, has been made for me by my old pupil and friend, Mr. Thomas W. Halliday. H. M.

INTRODUCTION

TO

OCEANA

JAMES HARRINGTON, eldest son of Sir Sapcotes Harrington of Exton, in Rutlandshire, was born in the reign of James I, in January, 1611, five years before the death of Shakespeare. He was two or three years younger than John Milton. His great-grandfather was Sir James Harrington, who married Lucy, daughter of Sir William Sidney, lived with her to their golden wedding-day, and had eighteen children, through whom he counted himself, before his death, patriarch in a family that in his own time produced eight dukes, three marquises, seventy earls, twenty-seven viscounts, and thirty-six barons, sixteen of them all being Knights of the Garter. James Harrington's ideal of a commonwealth was the design, therefore, of a man in many ways connected with the chief nobility of England.

Sir Sapcotes Harrington married twice, and had by each of his wives two sons and two daughters. James Harrington was eldest son by the first marriage, which was to Jane, daughter of Sir William Samuel of Upton, in Northamptonshire. James Harrington's brother became a merchant; of his half-brothers, one went to sea, the other became a captain in the army.

As a child, James Harrington was studious, and so sedate that it was said playfully of him he rather kept his parents and teachers in awe than needed correction; but in after-life his quick wit made him full of playfulness in conversation. In 1629 he entered Trinity College, Oxford, as a gentleman commoner. There he had for tutor William Chillingworth, a Fellow of the college, who after conversion to the Church of Rome had reasoned his way back into Protestant opinions. Chillingworth became a famous champion of Protestantism in

the question between the Churches, although many Protestants attacked him as unsound because he would not accept the Athanasian Creed and had some other reservations.

Harrington prepared himself for foreign travel by study of modern languages, but before he went abroad, and while he was still under age, his father died and he succeeded to his patrimony. The socage tenure of his estate gave him free choice of his own guardian, and he chose his mother's mother, Lady Samuel.

He then began the season of travel which usually followed studies at the university, a part of his training to which he had looked forward with especial interest. He went first to Holland, which had been in Queen Elizabeth's time the battle-ground of civil and religious liberty. Before he left England he used to say he knew of monarchy, anarchy, aristocracy, democracy, oligarchy, only as hard words to be looked for in a dictionary. But his interest in problems of government began to be awakened while he was among the Dutch. He served in the regiment of Lord Craven, and afterward in that of Sir Robert Stone; was much at The Hague; became familiar with the Court of the Prince of Orange, and with King James's daughter, the Queen of Bohemia, who, with her husband the Prince Elector, was then a fugitive to Holland. Lord Harrington, who had once acted as governor to the princess, and won her affection, was James Harrington's uncle, and she now cordially welcomed the young student of life for his uncle's sake, and for his own pleasantness of outward wit and inward gravity of thought. Harrington was taken with him by the exiled and plundered Prince Elector, when he paid a visit to the Court of Denmark, and he was intrusted afterward with the chief care of the prince's affairs in England.

From Holland, James Harrington passed through Flanders into France, and thence to Italy. When he came back to England, some courtiers who were with him in Rome told Charles I that Harrington had been too squeamish at the Pope's consecration of wax lights, in refusing to obtain a light, as others did, by kissing his Holiness's toe. The King told Harrington that he might have complied with a custom which only signified respect to a temporal prince. But his Majesty was

satisfied with the reply, that having had the honor to kiss his Majesty's hand, he thought it beneath him to kiss any other prince's foot.

Of all places in Italy, Venice pleased Harrington best. He was deeply interested in the Venetian form of government, and his observations bore fruit in many suggestions for the administration of the Commonwealth of Oceana.

After his return to England, being of age, James Harrington cared actively for the interests of his younger brothers and sisters. It was he who made his brother William a merchant. William Harrington throve, and for his ingenuity in matters of construction he was afterward made one of the Fellows of the newly formed Royal Society. He took pains over the training of his sisters, making no difference between sisters and half-sisters, and treating his step-mother as a mother. He filled his home with loving-kindness, and was most liberal in giving help to friends. When he was told that he often threw away his bounty on ungrateful persons, he playfully told his advisers they were mercenary and that he saw they sold their gifts, since they expected so great a return as gratitude.

James Harrington's bent was for the study of life, and he made no active suit for court employment. But he went to court, where Charles I liked him, and admitted him as one of his privy chamber extraordinary, in which character he went with the King in his first expedition against the Scots.

Because Charles I knew him and liked him, and because he had shown himself no partisan of either side in the civil war, though he was known to be inclined, in the way of abstract opinion, toward a form of government that was not monarchy, the commissioners appointed in 1646 to bring Charles from Newcastle named Harrington as one of the King's attendants. The King was pleased, and Harrington was appointed a groom of the bedchamber at Holmby. He followed faithfully the fortunes of the fallen King, never saying even to the King himself a word in contradiction of his own principles of liberty, and finding nothing in his principles or in his temper that should prevent him from paying honor to his sovereign, and seeking to secure for him a happy issue out of his afflictions. Antony à Wood says that " His Majesty

loved Harrington's company, and, finding him to be an ingenious man, chose rather to converse with him than with others of his chamber: they had often discourses concerning government; but when they happened to talk of a commonwealth the King seemed not to endure it."

Harrington used all the influence he had with those in whose power the King was, to prevent the urging of avoidable questions that would stand in the way of such a treaty as they professed to seek during the King's imprisonment at Carisbrooke. Harrington's friendly interventions on the King's behalf before the Parliament commissioners at Newport caused him, indeed, to be suspected; and when the King was removed from Carisbrooke to Hurst Castle, Harrington was not allowed to remain in his service. But afterward, when King Charles was being taken to Windsor, Harrington got leave to bid him farewell at the door of his carriage. As he was about to kneel, the King took him by the hand and pulled him in. For a few days he was left with the King, but an oath was required of him that he would not assist in, or conceal knowledge of any attempt to procure, the King's escape. He would not take the oath; and was this time not only dismissed from the King's service but himself imprisoned, until Ireton obtained his release. Before the King's death, Harrington found his way to him again, and he was among those who were with Charles I upon the scaffold.

After the King's execution, Harrington was for some time secluded in his study. Monarchy was gone; some form of commonwealth was to be established; and he set to work upon the writing of "Oceana," calmly to show what form of government, since men were free to choose, to him seemed best.

He based his work on an opinion he had formed that the troubles of the time were not due wholly to the intemperance of faction, the misgovernment of a king, or the stubbornness of a people, but to change in the balance of property; and he laid the foundations of his commonwealth in the opinion that empire follows the balance of property. Then he showed the commonwealth of Oceana in action, with safeguards against future shiftings of that balance, and with a popular government in which all offices were filled by men chosen by ballot, who should hold office for a limited term. Thus there

was to be a constant flow of new blood through the political system, and the representative was to be kept true as a reflection of the public mind.

The Commonwealth of Oceana was England. Harrington called Scotland Marpesia; and Ireland, Panopea. London he called Emporium; the Thames, Halcionia; Westminster, Hiera; Westminster Hall, Pantheon. The Palace of St. James was Alma; Hampton Court, Convallium; Windsor, Mount Celia. By Hemisua, Harrington meant the river Trent. Past sovereigns of England he renamed for Oceana: William the Conqueror became Turbo; King John, Adoxus, Richard II, Dicotome; Henry VII, Panurgus; Henry VIII, Coraunus; Elizabeth, Parthenia; James I, Morpheus. He referred to Hobbes as Leviathan; and to Francis Bacon as Verulamius. Oliver Cromwell he renamed Olphaus Megaletor.

Harrington's book was seized while printing, and carried to Whitehall. Harrington went to Cromwell's daughter, Lady Claypole, played with her three-year-old child while waiting for her, and said to her, when she came and found him with her little girl upon his lap, "Madam, you have come in the nick of time, for I was just about to steal this pretty lady." "Why should you?" "Why shouldn't I, unless you cause your father to restore a child of mine that he has stolen?" It was only, he said, a kind of political romance; so far from any treason against her father that he hoped she would let him know it was to be dedicated to him. So the book was restored; and it was published in the time of Cromwell's Commonwealth, in the year 1656.

This treatise, which had its origin in the most direct pressure of the problem of government upon the minds of men continues the course of thought on which Machiavelli's "Prince" had formed one famous station, and Hobbe's "Leviathan," another.

"Oceana," when published, was widely read and actively attacked. One opponent of its doctrines was Dr. Henry Ferne, afterward Bishop of Chester. Another was Matthew Wren, eldest son to the Bishop of Ely. He was one of those who met for scientific research at the house of Dr. Wilkins and had, said Harrington, "an excellent faculty of magnifying a louse and diminishing a commonwealth."

In 1659, Harrington published an abridgment of his Oceana as "The Art of Lawgiving," in three books. Other pieces followed, in which he defended or developed his opinions. He again urged them when Cromwell's Commonwealth was in its death-throes. Then he fell back upon argument at nightly meetings of a Rota Club which met in the New Palace Yard, Westminster. Milton's old pupil, Cyriac Skinner, was one of its members; and its elections were by ballot, with rotation in the tenure of all offices. The club was put an end to at the Restoration, when Harrington retired to his study and amused himself by putting his "System of Politics" into the form of "Aphorisms."

On December 28, 1661, James Harrington, then fifty years old, was arrested and carried to the Tower as a traitor. His "Aphorisms" were on his desk, and as they also were to be carried off, he asked only that they might first be stitched together in their proper order. Why he was arrested, he was not told. One of his sisters pleaded in vain to the King. He was falsely accused of complicity in an imaginary plot, of which nothing could be made by its investigators. No heed was paid to the frank denials of a man of the sincerest nature, who never had concealed his thoughts or actions. "Why," he was asked, at his first examination by Lord Lauderdale, who was one of his kinsmen, "why did he, as a private man, meddle with politics? What had a private man to do with government?" His answer was: "My lord, there is not any public person, nor any magistrate, that has written on politics, worth a button. All they that have been excellent in this way have been private men, as private men, my lord, as myself. There is Plato, there is Aristotle, there is Livy, there is Machiavel. My lord, I can sum up Aristotle's 'Politics' in a very few words: he says, there is the Barbarous Monarchy—such a one where the people have no votes in making the laws; he says, there is the Heroic Monarchy—such a one where the people have their votes in making the laws; and then, he says, there is Democracy, and affirms that a man cannot be said to have liberty but in a democracy only." Lord Lauderdale here showing impatience, Harrington added: "I say Aristotle says so. I have not said so much. And under what prince was it? Was it not under Alexander, the greatest

prince then in the world? I beseech you, my lord, did Alexander hang up Aristotle? did he molest him? Livy, for a commonwealth, is one of the fullest authors; did not he write under Augustus Cæsar? Did Cæsar hang up Livy? did he molest him? Machiavel, what a commonwealthsman was he! but he wrote under the Medici when they were princes in Florence: did they hang up Machiavel, or did they molest him? I have done no otherwise than as the greatest politicians: the King will do no otherwise than as the greatest princes."

That was too much to hope, even in a dream, of the low-minded Charles II. Harrington could not obtain even the show of justice in a public trial. He was kept five months an untried prisoner in the Tower, only sheltered from daily brutalities by bribe to the lieutenant. When his *habeas corpus* had been moved for, it was at first flatly refused; and when it had been granted, Harrington was smuggled away from the Tower between one and two o'clock in the morning, and carried on board a ship that took him to closer imprisonment on St. Nicholas Island, opposite Plymouth. There his health suffered seriously, and his family obtained his removal to imprisonment in Plymouth by giving a bond of £5,000 as sureties against his escape. In Plymouth, Harrington suffered from scurvy, and at last he became insane.

When he had been made a complete wreck in body and in mind, his gracious Majesty restored Harrington to his family. He never recovered health, but still occupied himself much with his pen, writing, among other things, a serious argument to prove that they were themselves mad who thought him so.

In those last days of his shattered life James Harrington married an old friend of the family, a witty lady, daughter of Sir Marmaduke Dorrell, of Buckinghamshire. Gout was added to his troubles; then he was palsied; and he died at Westminster, at the age of sixty-six, on September 11, 1677. He was buried in St. Margaret's Church, by the grave of Sir Walter Raleigh, on the south side of the altar.

H. M.

CONTENTS

	PAGE
UTOPIA.	
Book I.	3
Book II.	34
NEW ATLANTIS.	103
THE CITY OF THE SUN.	141
OCEANA.	
Part I.	183
Part II.	234
Part III.	236
Part IV.	393
Description of Oceana	413

UTOPIA

—

BY

SIR THOMAS MORE

UTOPIA

BOOK I

HENRY VIII, the unconquered King of England, a prince adorned with all the virtues that become a great monarch, having some differences of no small consequence with Charles, the most serene Prince of Castile, sent me into Flanders, as his ambassador, for treating and composing matters between them. I was colleague and companion to that incomparable man Cuthbert Tonstal, whom the King with such universal applause lately made Master of the Rolls, but of whom I will say nothing; not because I fear that the testimony of a friend will be suspected, but rather because his learning and virtues are too great for me to do them justice, and so well known that they need not my commendations unless I would, according to the proverb, " Show the sun with a lanthorn." Those that were appointed by the Prince to treat with us, met us at Bruges, according to agreement; they were all worthy men. The Margrave of Bruges was their head, and the chief man among them; but he that was esteemed the wisest, and that spoke for the rest, was George Temse, the Provost of Casselsee; both art and nature had concurred to make him eloquent: he was very learned in the law; and as he had a great capacity, so by a long practice in affairs he was very dexterous at unravelling them.

After we had several times met without coming to an agreement, they went to Brussels for some days to know the Prince's pleasure. And since our business would admit it, I went to Antwerp. While I was there, among many that visited me, there was one that was more acceptable to me than any other, Peter Giles, born at Antwerp, who is a man of great honor, and of a good rank in his town, though less than he deserves;

for I do not know if there be anywhere to be found a more learned and a better bred young man: for as he is both a very worthy and a very knowing person, so he is so civil to all men, so particularly kind to his friends, and so full of candor and affection, that there is not perhaps above one or two anywhere to be found that are in all respects so perfect a friend. He is extraordinarily modest, there is no artifice in him; and yet no man has more of a prudent simplicity: his conversation was so pleasant and so innocently cheerful, that his company in a great measure lessened any longings to go back to my country, and to my wife and children, which an absence of four months had quickened very much. One day as I was returning home from mass at St. Mary's, which is the chief church, and the most frequented of any in Antwerp, I saw him by accident talking with a stranger, who seemed past the flower of his age; his face was tanned, he had a long beard, and his cloak was hanging carelessly about him, so that by his looks and habit I concluded he was a seaman.

As soon as Peter saw me, he came and saluted me; and as I was returning his civility, he took me aside, and pointing to him with whom he had been discoursing, he said: "Do you see that man? I was just thinking to bring him to you."

I answered, "He should have been very welcome on your account."

"And on his own too," replied he, "if you knew the man, for there is none alive that can give so copious an account of unknown nations and countries as he can do; which I know you very much desire."

Then said I, "I did not guess amiss, for at first sight I took him for a seaman."

"But you are much mistaken," said he, "for he has not sailed as a seaman, but as a traveller, or rather a philosopher. This Raphael, who from his family carries the name of Hythloday, is not ignorant of the Latin tongue, but is eminently learned in the Greek, having applied himself more particularly to that than to the former, because he had given himself much to philosophy, in which he knew that the Romans have left us nothing that is valuable, except what is to be found in Seneca and Cicero. He is a Portuguese by birth, and was so desirous of seeing the world that he divided his estate among his

brothers, ran the same hazard as Americus Vespucius, and bore a share in three of his four voyages, that are now published; only he did not return with him in his last, but obtained leave of him almost by force, that he might be one of those twenty-four who were left at the farthest place at which they touched, in their last voyage to New Castile. The leaving him thus did not a little gratify one that was more fond of travelling than of returning home to be buried in his own country; for he used often to say that the way to heaven was the same from all places; and he that had no grave had the heaven still over him. Yet this disposition of mind had cost him dear, if God had not been very gracious to him; for after he, with five Castilians, had travelled over many countries, at last, by strange good-fortune, he got to Ceylon, and from thence to Calicut, where he very happily found some Portuguese ships, and, beyond all men's expectations, returned to his native country."

When Peter had said this to me, I thanked him for his kindness, in intending to give me the acquaintance of a man whose conversation he knew would be so acceptable; and upon that Raphael and I embraced each other. After those civilities were passed which are usual with strangers upon their first meeting, we all went to my house, and entering into the garden, sat down on a green bank, and entertained one another in discourse. He told us that when Vespucius had sailed away, he and his companions that stayed behind in New Castile, by degrees insinuated themselves into the affections of the people of the country, meeting often with them, and treating them gently: and at last they not only lived among them without danger, but conversed familiarly with them; and got so far into the heart of a prince, whose name and country I have forgot, that he both furnished them plentifully with all things necessary, and also with the conveniences of travelling; both boats when they went by water, and wagons when they travelled over land: he sent with them a very faithful guide, who was to introduce and recommend them to such other princes as they had a mind to see: and after many days' journey, they came to towns and cities, and to commonwealths, that were both happily governed and well-peopled. Under the equator, and as far on both sides of it as the sun moves, there lay vast deserts that were parched with the perpetual heat of the sun; the soil was

withered, all things looked dismally, and all places were either quite uninhabited, or abounded with wild beasts and serpents, and some few men that were neither less wild nor less cruel than the beasts themselves.

But as they went farther, a new scene opened, all things grew milder, the air less burning, the soil more verdant, and even the beasts were less wild: and at last there were nations, towns, and cities, that had not only mutual commerce among themselves, and with their neighbors, but traded both by sea and land, to very remote countries. There they found the conveniences of seeing many countries on all hands, for no ship went any voyage into which he and his companions were not very welcome. The first vessels that they saw were flat-bottomed, their sails were made of reeds and wicker woven close together, only some were of leather; but afterward they found ships made with round keels and canvas sails, and in all respects like our ships; and the seamen understood both astronomy and navigation. He got wonderfully into their favor, by showing them the use of the needle, of which till then they were utterly ignorant. They sailed before with great caution, and only in summer-time, but now they count all seasons alike, trusting wholly to the loadstone, in which they are perhaps more secure than safe; so that there is reason to fear that this discovery, which was thought would prove so much to their advantage, may by their imprudence become an occasion of much mischief to them. But it were too long to dwell on all that he told us he had observed in every place; it would be too great a digression from our present purpose: whatever is necessary to be told, concerning those wise and prudent institutions which he observed among civilized nations, may perhaps be related by us on a more proper occasion. We asked him many questions concerning all these things, to which he answered very willingly; only we made no inquiries after monsters, than which nothing is more common; for everywhere one may hear of ravenous dogs and wolves, and cruel man-eaters; but it is not so easy to find States that are well and wisely governed.

As he told us of many things that were amiss in those new-discovered countries, so he reckoned up not a few things from which patterns might be taken for correcting the errors of these nations among whom we live; of which an account may be

given, as I have already promised, at some other time; for at present I intend only to relate those particulars that he told us of the manners and laws of the Utopians: but I will begin with the occasion that led us to speak of that commonwealth. After Raphael had discoursed with great judgment on the many errors that were both among us and these nations; had treated of the wise institutions both here and there, and had spoken as distinctly of the customs and government of every nation through which he had passed, as if he had spent his whole life in it, Peter, being struck with admiration, said: " I wonder, Raphael, how it comes that you enter into no king's service, for I am sure there are none to whom you would not be very acceptable: for your learning and knowledge both of men and things, are such that you would not only entertain them very pleasantly, but be of great use to them, by the examples you could set before them and the advices you could give them; and by this means you would both serve your own interest and be of great use to all your friends."

"As for my friends," answered he, " I need not be much concerned, having already done for them all that was incumbent on me; for when I was not only in good health, but fresh and young, I distributed that among my kindred and friends which other people do not part with till they are old and sick, when they then unwillingly give that which they can enjoy no longer themselves. I think my friends ought to rest contented with this, and not to expect that for their sake I should enslave myself to any king whatsoever."

" Soft and fair," said Peter, " I do not mean that you should be a slave to any king, but only that you should assist them, and be useful to them."

"The change of the word," said he, "does not alter the matter."

" But term it as you will," replied Peter, " I do not see any other way in which you can be so useful, both in private to your friends, and to the public, and by which you can make your own condition happier."

" Happier!" answered Raphael; " is that to be compassed in a way so abhorrent to my genius? Now I live as I will, to which I believe few courtiers can pretend. And there are so many that court the favor of great men, that there will be no

great loss if they are not troubled either with me or with others of my temper."

Upon this, said I: "I perceive, Raphael, that you neither desire wealth nor greatness; and indeed I value and admire such a man much more than I do any of the great men in the world. Yet I think you would do what would well become so generous and philosophical a soul as yours is, if you would apply your time and thoughts to public affairs, even though you may happen to find it a little uneasy to yourself: and this you can never do with so much advantage, as by being taken into the counsel of some great prince, and putting him on noble and worthy actions, which I know you would do if you were in such a post; for the springs both of good and evil flow from the prince, over a whole nation, as from a lasting fountain. So much learning as you have, even without practice in affairs, or so great a practice as you have had, without any other learning, would render you a very fit counsellor to any king whatsoever."

"You are doubly mistaken," said he, "Mr. More, both in your opinion of me, and in the judgment you make of things: for as I have not that capacity that you fancy I have, so, if I had it, the public would not be one jot the better, when I had sacrificed my quiet to it. For most princes apply themselves more to affairs of war than to the useful arts of peace; and in these I neither have any knowledge, nor do I much desire it: they are generally more set on acquiring new kingdoms, right or wrong, than on governing well those they possess. And among the ministers of princes, there are none that are not so wise as to need no assistance, or at least that do not think themselves so wise that they imagine they need none; and if they court any, it is only those for whom the prince has much personal favor, whom by their fawnings and flatteries they endeavor to fix to their own interests: and indeed Nature has so made us that we all love to be flattered, and to please ourselves with our own notions. The old crow loves his young, and the ape her cubs. Now if in such a court, made up of persons who envy all others, and only admire themselves, a person should but propose anything that he had either read in history or observed in his travels, the rest would think that the reputation of their wisdom would sink, and that their interest would be

much depressed, if they could not run it down: and if all other things failed, then they would fly to this, that such or such things pleased our ancestors, and it were well for us if we could but match them. They would set up their rest on such an answer, as a sufficient confutation of all that could be said; as if it were a great misfortune, that any should be found wiser than his ancestors; but though they willingly let go all the good things that were among those of former ages, yet if better things are proposed they cover themselves obstinately with this excuse of reverence to past times. I have met with these proud, morose, and absurd judgments of things in many places, particularly once in England."

"Were you ever there?" said I.

"Yes, I was," answered he, "and stayed some months there, not long after the rebellion in the west was suppressed with a great slaughter of the poor people that were engaged in it. I was then much obliged to that reverend prelate, John Morton, Archbishop of Canterbury, Cardinal, and Chancellor of England: a man," said he, "Peter (for Mr. More knows well what he was), that was not less venerable for his wisdom and virtues than for the high character he bore. He was of a middle stature, not broken with age; his looks begot reverence rather than fear; his conversation was easy, but serious and grave; he sometimes took pleasure to try the force of those that came as suitors to him upon business, by speaking sharply though decently to them, and by that he discovered their spirit and presence of mind, with which he was much delighted, when it did not grow up to impudence, as bearing a great resemblance to his own temper; and he looked on such persons as the fittest men for affairs. He spoke both gracefully and weightily; he was eminently skilled in the law, had a vast understanding and a prodigious memory; and those excellent talents with which nature had furnished him were improved by study and experience. When I was in England the King depended much on his counsels, and the government seemed to be chiefly supported by him; for from his youth he had been all along practised in affairs; and having passed through many traverses of fortune, he had with great cost acquired a vast stock of wisdom, which is not soon lost when it is purchased so dear.

"One day when I was dining with him there happened to

be at table one of the English lawyers, who took occasion to run out in a high commendation of the severe execution of justice upon thieves, who, as he said, were then hanged so fast that there were sometimes twenty on one gibbet; and upon that he said he could not wonder enough how it came to pass, that since so few escaped, there were yet so many thieves left who were still robbing in all places. Upon this, I who took the boldness to speak freely before the cardinal, said there was no reason to wonder at the matter, since this way of punishing thieves was neither just in itself nor good for the public; for as the severity was too great, so the remedy was not effectual; simple theft not being so great a crime that it ought to cost a man his life, no punishment how severe soever being able to restrain those from robbing who can find out no other way of livelihood. ' In this,' said I, ' not only you in England, but a great part of the world imitate some ill masters that are readier to chastise their scholars than to teach them. There are dreadful punishments enacted against thieves, but it were much better to make such good provisions by which every man might be put in a method how to live, and so be preserved from the fatal necessity of stealing and of dying for it.'

"' There has been care enough taken for that,' said he, ' there are many handicrafts, and there is husbandry, by which they may make a shift to live unless they have a greater mind to follow ill courses.'

"' That will not serve your turn,' said I, ' for many lose their limbs in civil or foreign wars, as lately in the Cornish rebellion, and some time ago in your wars with France, who being thus mutilated in the service of their king and country, can no more follow their old trades, and are too old to learn new ones: but since wars are only accidental things, and have intervals, let us consider those things that fall out every day. There is a great number of noblemen among you, that are themselves as idle as drones, that subsist on other men's labor, on the labor of their tenants, whom, to raise their revenues, they pare to the quick. This indeed is the only instance of their frugality, for in all other things they are prodigal, even to the beggaring of themselves: but besides this, they carry about with them a great number of idle fellows, who never learned any art by which they may gain their living; and these, as soon as either

their lord dies or they themselves fall sick, are turned out of
doors; for your lords are readier to feed idle people than to
take care of the sick; and often the heir is not able to keep
together so great a family as his predecessor did. Now when
the stomachs of those that are thus turned out of doors grow
keen, they rob no less keenly; and what else can they do? for
when, by wandering about, they have worn out both their
health and their clothes, and are tattered, and look ghastly,
men of quality will not entertain them, and poor men dare not
do it, knowing that one who has been bred up in idleness and
pleasure, and who was used to walk about with his sword and
buckler, despising all the neighborhood with an insolent scorn
as far below him, is not fit for the spade and mattock: nor will
he serve a poor man for so small a hire, and in so low a diet
as he can afford to give him.'

"To this he answered: 'This sort of men ought to be par-
ticularly cherished, for in them consists the force of the armies
for which we have occasion; since their birth inspires them
with a nobler sense of honor than is to be found among trades-
men or ploughmen.'

"'You may as well say,' replied I, 'that you must cherish
thieves on the account of wars, for you will never want the one
as long as you have the other; and as robbers prove sometimes
gallant soldiers, so soldiers often prove brave robbers; so near
an alliance there is between those two sorts of life. But this
bad custom, so common among you, of keeping many servants,
is not peculiar to this nation. In France there is yet a more
pestiferous sort of people, for the whole country is full of
soldiers, still kept up in time of peace, if such a state of a nation
can be called a peace: and these are kept in pay upon the same
account that you plead for those idle retainers about noblemen;
this being a maxim of those pretended statesmen that it is
necessary for the public safety to have a good body of veteran
soldiers ever in readiness. They think raw men are not to be
depended on, and they sometimes seek occasions for making
war, that they may train up their soldiers in the art of cutting
throats; or as Sallust observed, for keeping their hands in use,
that they may not grow dull by too long an intermission. But
France has learned to its cost how dangerous it is to feed such
beasts.

"'The fate of the Romans, Carthaginians, and Syrians, and many other nations and cities, which were both overturned and quite ruined by those standing armies, should make others wiser: and the folly of this maxim of the French appears plainly even from this, that their trained soldiers often find your raw men prove too hard for them; of which I will not say much, lest you may think I flatter the English. Every day's experience shows that the mechanics in the towns, or the clowns in the country, are not afraid of fighting with those idle gentlemen, if they are not disabled by some misfortune in their body, or dispirited by extreme want, so that you need not fear that those well-shaped and strong men (for it is only such that noblemen love to keep about them, till they spoil them) who now grow feeble with ease, and are softened with their effeminate manner of life, would be less fit for action if they were well bred and well employed. And it seems very unreasonable that for the prospect of a war, which you need never have but when you please, you should maintain so many idle men, as will always disturb you in time of peace, which is ever to be more considered than war. But I do not think that this necessity of stealing arises only from hence; there is another cause of it more peculiar to England.'

"'What is that?' said the cardinal.

"'The increase of pasture,' said I, 'by which your sheep, which are naturally mild, and easily kept in order, may be said now to devour men, and unpeople, not only villages, but towns; for wherever it is found that the sheep of any soil yield a softer and richer wool than ordinary, there the nobility and gentry, and even those holy men the abbots, not contented with the old rents which their farms yielded, nor thinking it enough that they, living at their ease, do no good to the public, resolve to do it hurt instead of good. They stop the course of agriculture, destroying houses and towns, reserving only the churches, and enclose grounds that they may lodge their sheep in them. As if forests and parks had swallowed up too little of the land, those worthy countrymen turn the best inhabited places in solitudes; for when an insatiable wretch, who is a plague to his country, resolves to enclose many thousand acres of ground, the owners as well as tenants are turned out of their possessions, by tricks, or by main force, or being wearied out with

ill-usage, they are forced to sell them. By which means those miserable people, both men and women, married and unmarried, old and young, with their poor but numerous families (since country business requires many hands), are all forced to change their seats, not knowing whither to go; and they must sell almost for nothing their household stuff, which could not bring them much money, even though they might stay for a buyer. When that little money is at an end, for it will be soon spent, what is left for them to do, but either to steal and so to be hanged (God knows how justly), or to go about and beg? And if they do this, they are put in prison as idle vagabonds; while they would willingly work, but can find none that will hire them; for there is no more occasion for country labor, to which they have been bred, when there is no arable ground left. One shepherd can look after a flock which will stock an extent of ground that would require many hands if it were to be ploughed and reaped. This likewise in many places raises the price of corn.

"'The price of wool is also so risen that the poor people who were wont to make cloth are no more able to buy it; and this likewise makes many of them idle. For since the increase of pasture, God has punished the avarice of the owners by a rot among the sheep, which has destroyed vast numbers of them; to us it might have seemed more just had it fell on the owners themselves. But suppose the sheep should increase ever so much, their price is not like to fall; since though they cannot be called a monopoly, because they are not engrossed by one person, yet they are in so few hands, and these are so rich, that as they are not pressed to sell them sooner than they have a mind to it, so they never do it till they have raised the price as high as possible. And on the same account it is, that the other kinds of cattle are so dear, because many villages being pulled down, and all country labor being much neglected, there are none who make it their business to breed them. The rich do not breed cattle as they do sheep, but buy them lean, and at low prices; and after they have fattened them on their grounds, sell them again at high rates. And I do not think that all the inconveniences this will produce are yet observed; for as they sell the cattle dear, so if they are consumed faster than the breeding countries from which they are brought can afford

them, then the stock must decrease, and this must needs end in great scarcity; and by these means this your island, which seemed as to this particular the happiest in the world, will suffer much by the cursed avarice of a few persons; besides this, the rising of corn makes all people lessen their families as much as they can; and what can those who are dismissed by them do, but either beg or rob? And to this last, a man of a great mind is much sooner drawn than to the former.

"'Luxury likewise breaks in apace upon you, to set forward your poverty and misery; there is an excessive vanity in apparel, and great cost in diet; and that not only in noblemen's families, but even among tradesmen, among the farmers themselves, and among all ranks of persons. You have also many infamous houses, and, besides those that are known, the taverns and alehouses are no better; add to these, dice, cards, tables, foot-ball, tennis, and quoits, in which money runs fast away; and those that are initiated into them, must in the conclusion betake themselves to robbing for a supply. Banish these plagues, and give orders that those who have dispeopled so much soil, may either rebuild the villages they have pulled down, or let out their grounds to such as will do it: restrain those engrossings of the rich, that are as bad almost as monopolies; leave fewer occasions to idleness; let agriculture be set up again, and the manufacture of the wool be regulated, that so there may be work found for those companies of idle people whom want forces to be thieves, or who, now being idle vagabonds or useless servants, will certainly grow thieves at last. If you do not find a remedy to these evils, it is a vain thing to boast of your severity in punishing theft, which though it may have the appearance of justice, yet in itself is neither just nor convenient. For if you suffer your people to be ill-educated, and their manners to be corrupted from their infancy, and then punish them for those crimes to which their first education disposed them, what else is to be concluded from this, but that you first make thieves and then punish them?'

"While I was talking thus, the counsellor who was present had prepared an answer, and had resolved to resume all I had said, according to the formality of a debate, in which things are generally repeated more faithfully than they are answered; as if the chief trial to be made were of men's memories.

" ' You have talked prettily for a stranger,' said he, ' having heard of many things among us which you have not been able to consider well; but I will make the whole matter plain to you, and will first repeat in order all that you have said, then I will show how much your ignorance of our affairs has misled you, and will in the last place answer all your arguments. And that I may begin where I promised, there were four things——'

" ' Hold your peace,' said the cardinal; ' this will take up too much time; therefore we will at present ease you of the trouble of answering, and reserve it to our next meeting, which shall be to-morrow, if Raphael's affairs and yours can admit of it. But, Raphael,' said he to me, ' I would gladly know upon what reason it is that you think theft ought not to be punished by death? Would you give way to it? Or do you propose any other punishment that will be more useful to the public? For since death does not restrain theft, if men thought their lives would be safe, what fear or force could restrain ill men? On the contrary, they would look on the mitigation of the punishment as an invitation to commit more crimes.'

" I answered: ' It seems to me a very unjust thing to take away a man's life for a little money; for nothing in the world can be of equal value with a man's life: and if it is said that it is not for the money that one suffers, but for his breaking the law, I must say extreme justice is an extreme injury; for we ought not to approve of these terrible laws that make the smallest offences capital, nor of that opinion of the Stoics that makes all crimes equal, as if there were no difference to be made between the killing a man and the taking his purse, between which, if we examine things impartially, there is no likeness nor proportion. God has commanded us not to kill, and shall we kill so easily for a little money? But if one shall say, that by that law we are only forbid to kill any, except when the laws of the land allow of it; upon the same grounds, laws may be made in some cases to allow of adultery and perjury: for God having taken from us the right of disposing, either of our own or of other people's lives, if it is pretended that the mutual consent of man in making laws can authorize manslaughter in cases in which God has given us no example, that it frees people from the obligation of the divine law, and so makes murder a lawful action; what is this, but to give a preference to human laws before the divine? '

"'And if this is once admitted, by the same rule men may in all other things put what restrictions they please upon the laws of God. If by the Mosaical law, though it was rough and severe, as being a yoke laid on an obstinate and servile nation, men were only fined and not put to death for theft, we cannot imagine that in this new law of mercy, in which God treats us with the tenderness of a father, he has given us a greater license to cruelty than he did to the Jews. Upon these reasons it is that I think putting thieves to death is not lawful; and it is plain and obvious that it is absurd, and of ill-consequence to the commonwealth, that a thief and a murderer should be equally punished; for if a robber sees that his danger is the same, if he is convicted of theft as if he were guilty of murder, this will naturally incite him to kill the person whom otherwise he would only have robbed, since if the punishment is the same, there is more security, and less danger of discovery, when he that can best make it is put out of the way; so that terrifying thieves too much, provokes them to cruelty.

"'But as to the question, What more convenient way of punishment can be found? I think it is much more easier to find out that than to invent anything that is worse; why should we doubt but the way that was so long in use among the old Romans, who understood so well the arts of government, was very proper for their punishment? They condemned such as they found guilty of great crimes, to work their whole lives in quarries, or to dig in mines with chains about them. But the method that I liked best, was that which I observed in my travels in Persia, among the Polylerits, who are a considerable and well-governed people. They pay a yearly tribute to the King of Persia; but in all other respects they are a free nation, and governed by their own laws. They lie far from the sea, and are environed with hills; and being contented with the productions of their own country, which is very fruitful, they have little commerce with any other nation; and as they, according to the genius of their country, have no inclination to enlarge their borders; so their mountains, and the pension they pay to the Persians, secure them from all invasions.

"'Thus they have no wars among them; they live rather conveniently than with splendor, and may be rather called a happy nation, than either eminent or famous; for I do not think

that they are known so much as by name to any but their next neighbors. Those that are found guilty of theft among them are bound to make restitution to the owner, and not as it is in other places, to the prince, for they reckon that the prince has no more right to the stolen goods than the thief; but if that which was stolen is no more in being, then the goods of the thieves are estimated, and restitution being made out of them, the remainder is given to their wives and children: and they themselves are condemned to serve in the public works, but are neither imprisoned, nor chained, unless there happened to be some extraordinary circumstances in their crimes. They go about loose and free, working for the public. If they are idle or backward to work, they are whipped; but if they work hard, they are well used and treated without any mark of reproach, only the lists of them are called always at night, and then they are shut up. They suffer no other uneasiness, but this of constant labor; for as they work for the public, so they are well entertained out of the public stock, which is done differently in different places. In some places, whatever is bestowed on them, is raised by a charitable contribution; and though this way may seem uncertain, yet so merciful are the inclinations of that people, that they are plentifully supplied by it; but in other places, public revenues are set aside for them; or there is a constant tax of a poll-money raised for their maintenance. In some places they are set to no public work, but every private man that has occasion to hire workmen goes to the market-places and hires them of the public, a little lower than he would do a freeman: if they go lazily about their task, he may quicken them with the whip.

"'By this means there is always some piece of work or other to be done by them; and beside their livelihood, they earn somewhat still to the public. They all wear a peculiar habit, of one certain color, and their hair is cropped a little above their ears, and a piece of one of their ears is cut off. Their friends are allowed to give them either meat, drink, or clothes so they are of their proper color; but it is death, both to the giver and taker, if they give them money; nor is it less penal for any freeman to take money from them, upon any account whatsoever: and it is also death for any of these slaves (so they are called) to handle arms. Those of every division of the

country are distinguished by a peculiar mark; which it is capital for them to lay aside, to go out of their bounds, or to talk with a slave of another jurisdiction; and the very attempt of an escape is no less penal than an escape itself; it is death for any other slave to be accessory to it; and if a freeman engages in it he is condemned to slavery. Those that discover it are rewarded—if freemen, in money; and if slaves, with liberty, together with a pardon for being accessory to it; that so they might find their account, rather in repenting of their engaging in such a design, than in persisting in it.

"' These are their laws and rules in relation to robbery, and it is obvious that they are as advantageous as they are mild and gentle; since vice is not only destroyed, and men preserved, but they treated in such a manner as to make them see the necessity of being honest, and of employing the rest of their lives in repairing the injuries they have formerly done to society. Nor is there any hazard of their falling back to their old customs: and so little do travellers apprehend mischief from them, that they generally make use of them for guides, from one jurisdiction to another; for there is nothing left them by which they can rob, or be the better for it, since, as they are disarmed, so the very having of money is a sufficient conviction: and as they are certainly punished if discovered, so they cannot hope to escape; for their habit being in all the parts of it different from what is commonly worn, they cannot fly away, unless they would go naked, and even then their cropped ear would betray them. The only danger to be feared from them is their conspiring against the government: but those of one division and neighborhood can do nothing to any purpose, unless a general conspiracy were laid among all the slaves of the several jurisdictions, which cannot be done, since they cannot meet or talk together; nor will any venture on a design where the concealment would be so dangerous and the discovery so profitable. None are quite hopeless of recovering their freedom, since by their obedience and patience, and by giving good grounds to believe that they will change their manner of life for the future, they may expect at last to obtain their liberty: and some are every year restored to it, upon the good character that is given of them.'

" When I had related all this, I added that I did not see why

such a method might not be followed with more advantage than could ever be expected from that severe justice which the counsellor magnified so much. To this he answered that it could never take place in England without endangering the whole nation. As he said this he shook his head, made some grimaces, and held his peace, while all the company seemed of his opinion, except the cardinal, who said that it was not easy to form a judgment of its success, since it was a method that never yet had been tried.

"' But if,' said he, ' when the sentence of death was passed upon a thief, the prince would reprieve him for a while, and make the experiment upon him, denying him the privilege of a sanctuary; and then if it had a good effect upon him, it might take place; and if it did not succeed, the worst would be, to execute the sentence on the condemned persons at last. And I do not see,' added he, ' why it would be either unjust, inconvenient, or at all dangerous, to admit of such a delay: in my opinion, the vagabonds ought to be treated in the same manner; against whom, though we have made many laws, yet we have not been able to gain our end.' When the cardinal had done, they all commended the motion, though they had despised it when it came from me; but more particularly commended what related to the vagabonds, because it was his own observation.

" I do not know whether it be worth while to tell what followed, for it was very ridiculous; but I shall venture at it, for as it is not foreign to this matter, so some good use may be made of it. There was a jester standing by, that counterfeited the fool so naturally that he seemed to be really one. The jests which he offered were so cold and dull that we laughed more at him than at them; yet sometimes he said, as it were by chance, things that were not unpleasant; so as to justify the old proverb, ' That he who throws the dice often, will sometimes have a lucky hit.' When one of the company had said that I had taken care of the thieves, and the cardinal had taken care of the vagabonds, so that there remained nothing but that some public provision might be made for the poor, whom sickness or old age had disabled from labor, ' Leave that to me,' said the fool, ' and I shall take care of them; for there is no sort of people whose sight I abhor more, having been so often

vexed with them, and with their sad complaints; but as dolefully soever as they have told their tale, they could never prevail so far as to draw one penny from me: for either I had no mind to give them anything, or when I had a mind to do it I had nothing to give them: and they now know me so well that they will not lose their labor, but let me pass without giving me any trouble, because they hope for nothing, no more in faith than if I were a priest: but I would have a law made, for sending all these beggars to monasteries, the men to the Benedictines to be made lay-brothers, and the women to be nuns.'

"The cardinal smiled, and approved of it in jest; but the rest liked it in earnest. There was a divine present, who though he was a grave, morose man, yet he was so pleased with this reflection that was made on the priests and the monks, that he began to play with the fool, and said to him, 'This will not deliver you from all beggars, except you take care of us friars.'

"'That is done already,' answered the fool, 'for the cardinal has provided for you, by what he proposed for restraining vagabonds, and setting them to work, for I know no vagabonds like you.'

"This was well entertained by the whole company, who, looking at the cardinal, perceived that he was not ill-pleased at it; only the friar himself was vexed, as may be easily imagined, and fell into such a passion that he could not forbear railing at the fool, and calling him knave, slanderer, backbiter, and son of perdition, and then cited some dreadful threatenings out of the Scriptures against him. Now the jester thought he was in his element, and laid about him freely.

"'Good friar,' said he, 'be not angry, for it is written, "In patience possess your soul."'

"The friar answered (for I shall give you his own words), 'I am not angry, you hangman; at least I do not sin in it, for the Psalmist says, "Be ye angry, and sin not."'

"Upon this the cardinal admonished him gently, and wished him to govern his passions.

"'No, my lord,' said he, 'I speak not but from a good zeal, which I ought to have; for holy men have had a good zeal, as it is said, "The zeal of thy house hath eaten me up;" and we sing in our church, that those, who mocked Elisha as he went up to the house of God, felt the effects of his zeal; which that mocker, that rogue, that scoundrel, will perhaps feel.'

"'You do this perhaps with a good intention,' said the cardinal; 'but in my opinion it were wiser in you, and perhaps better for you, not to engage in so ridiculous a contest with a fool.'

"'No, my lord,' answered he, 'that were not wisely done; for Solomon, the wisest of men, said, "Answer a fool according to his folly;" which I now do, and show him the ditch into which he will fall, if he is not aware of it; for if the many mockers of Elisha, who was but one bald man, felt the effect of his zeal, what will become of one mocker of so many friars, among whom there are so many bald men? We have likewise a bull, by which all that jeer us are excommunicated.'

"When the cardinal saw that there was no end of this matter, he made a sign to the fool to withdraw, turned the discourse another way, and soon after rose from the table, and, dismissing us, went to hear causes.

"Thus, Mr. More, I have run out into a tedious story, of the length of which I had been ashamed, if, as you earnestly begged it of me, I had not observed you to hearken to it, as if you had no mind to lose any part of it. I might have contracted it, but I resolved to give it to you at large, that you might observe how those that despised what I had proposed, no sooner perceived that the cardinal did not dislike it, but presently approved of it, fawned so on him, and flattered him to such a degree, that they in good earnest applauded those things that he only liked in jest. And from hence you may gather, how little courtiers would value either me or my counsels."

To this I answered: "You have done me a great kindness in this relation; for as everything has been related by you, both wisely and pleasantly, so you have made me imagine that I was in my own country, and grown young again, by recalling that good cardinal to my thoughts, in whose family I was bred from my childhood: and though you are upon other accounts very dear to me, yet you are the dearer, because you honor his memory so much; but after all this I cannot change my opinion; for I still think that if you could overcome that aversion which you have to the courts of princes, you might, by the advice which it is in your power to give, do a great deal of good to mankind; and this is the chief design that every good man ought to propose to himself in living; for your friend Plato thinks that nations will be happy, when either philosophers become kings

or kings become philosophers, it is no wonder if we are so far from that happiness, while philosophers will not think it their duty to assist kings with their councils.

"'They are not so base-minded,' said he, 'but that they would willingly do it: many of them have already done it by their books, if those that are in power would but hearken to their good advice.' But Plato judged right, that except kings themselves became philosophers, they who from their childhood are corrupted with false notions would never fall in entirely with the councils of philosophers, and this he himself found to be true in the person of Dionysius.

"Do not you think that if I were about any king, proposing good laws to him, and endeavoring to root out all the cursed seeds of evil that I found in him, I should either be turned out of his court or at least be laughed at for my pains? For instance, what could it signify if I were about the King of France, and were called into his Cabinet Council, where several wise men, in his hearing, were proposing many expedients, as by what arts and practices Milan may be kept, and Naples, that had so oft slipped out of their hands, recovered; how the Venetians, and after them the rest of Italy, may be subdued; and then how Flanders, Brabant, and all Burgundy, and some other kingdoms which he has swallowed already in his designs, may be added to his empire. One proposes a league with the Venetians, to be kept as long as he finds his account in it, and that he ought to communicate councils with them, and give them some share of the spoil, till his success makes him need or fear them less, and then it will be easily taken out of their hands. Another proposes the hiring the Germans, and the securing the Switzers by pensions. Another proposes the gaining the Emperor by money, which is omnipotent with him. Another proposes a peace with the King of Arragon, and, in order to cement it, the yielding up the King of Navarre's pretensions. Another thinks the Prince of Castile is to be wrought on, by the hope of an alliance; and that some of his courtiers are to be gained to the French faction by pensions. The hardest point of all is what to do with England: a treaty of peace is to be set on foot, and if their alliance is not to be depended on, yet it is to be made as firm as possible; and they are to be called friends, but suspected as enemies: therefore the Scots are to be kept in read-

iness, to be let loose upon England on every occasion: and some banished nobleman is to be supported underhand (for by the league it cannot be done avowedly) who has a pretension to the crown, by which means that suspected prince may be kept in awe.

"Now when things are in so great a fermentation, and so many gallant men are joining councils, how to carry on the war, if so mean a man as I should stand up, and wish them to change all their councils, to let Italy alone, and stay at home, since the Kingdom of France was indeed greater than could be well governed by one man; that therefore he ought not to think of adding others to it: and if after this, I should propose to them the resolutions of the Achorians, a people that lie on the southeast of Utopia, who long ago engaged in war, in order to add to the dominions of their prince another kingdom, to which he had some pretensions by an ancient alliance. This they conquered, but found that the trouble of keeping it was equal to that by which it was gained; that the conquered people were always either in rebellion or exposed to foreign invasions, while they were obliged to be incessantly at war, either for or against them, and consequently could never disband their army; that in the meantime they were oppressed with taxes, their money went out of the kingdom, their blood was spilt for the glory of their King, without procuring the least advantage to the people, who received not the smallest benefit from it even in time of peace; and that their manners being corrupted by a long war, robbery and murders everywhere abounded, and their laws fell into contempt; while their King, distracted with the care of two kingdoms, was the less able to apply his mind to the interests of either.

"When they saw this, and that there would be no end to these evils, they by joint councils made an humble address to their King, desiring him to choose which of the two kingdoms he had the greatest mind to keep, since he could not hold both; for they were too great a people to be governed by a divided king, since no man would willingly have a groom that should be in common between him and another. Upon which the good prince was forced to quit his new kingdom to one of his friends (who was not long after dethroned), and to be contented with his old one. To this I would add that after all

those warlike attempts, the vast confusions, and the consumption both of treasure and of people that must follow them; perhaps upon some misfortune, they might be forced to throw up all at last; therefore it seemed much more eligible that the King should improve his ancient kingdom all he could, and make it flourish as much as possible; that he should love his people, and be beloved of them; that he should live among them, govern them gently, and let other kingdoms alone, since that which had fallen to his share was big enough, if not too big for him. Pray how do you think would such a speech as this be heard?"

"I confess," said I, "I think not very well."

"But what," said he, "if I should sort with another kind of ministers, whose chief contrivances and consultations were, by what art the prince's treasures might be increased. Where one proposes raising the value of specie when the King's debts are large, and lowering it when his revenues were to come in, that so he might both pay much with a little, and in a little receive a great deal: another proposes a pretence of a war, that money might be raised in order to carry it on, and that a peace be concluded as soon as that was done; and this with such appearances of religion as might work on the people, and make them impute it to the piety of their prince, and to his tenderness for the lives of his subjects. A third offers some old musty laws, that have been antiquated by a long disuse; and which, as they had been forgotten by all the subjects, so they had been also broken by them; and proposes the levying the penalties of these laws, that as it would bring in a vast treasure, so there might be a very good pretence for it, since it would look like the executing a law, and the doing of justice. A fourth proposes the prohibiting of many things under severe penalties, especially such as were against the interest of the people, and then the dispensing with these prohibitions upon great compositions, to those who might find their advantage in breaking them. This would serve two ends, both of them acceptable to many; for as those whose avarice led them to transgress would be severely fined, so the selling licenses dear would look as if a prince were tender of his people, and would not easily, or at low rates, dispense with anything that might be against the public good.

"Another proposes that the judges must be made sure, that

they may declare always in favor of the prerogative, that they must be often sent for to court, that the King may hear them argue those points in which he is concerned; since how unjust soever any of his pretensions may be, yet still some one or other of them, either out of contradiction to others or the pride of singularity or to make their court, would find out some pretence or other to give the King a fair color to carry the point: for if the judges but differ in opinion, the clearest thing in the world is made by that means disputable, and truth being once brought in question, the King may then take advantage to expound the law for his own profit; while the judges that stand out will be brought over, either out of fear or modesty; and they being thus gained, all of them may be sent to the bench to give sentence boldly, as the King would have it; for fair pretences will never be wanting when sentence is to be given in the prince's favor. It will either be said that equity lies on his side, or some words in the law will be found sounding that way, or some forced sense will be put on them; and when all other things fail, the King's undoubted prerogative will be pretended, as that which is above all law; and to which a religious judge ought to have a special regard.

"Thus all consent to that maxim of Crassus, that a prince cannot have treasure enough, since he must maintain his armies out of it: that a king, even though he would, can do nothing unjustly; that all property is in him, not excepting the very persons of his subjects: and that no man has any other property, but that which the King out of his goodness thinks fit to leave him. And they think it is the prince's interest, that there be as little of this left as may be, as if it were his advantage that his people should have neither riches nor liberty; since these things make them less easy and less willing to submit to a cruel and unjust government; whereas necessity and poverty blunt them, make them patient, beat them down, and break that height of spirit, that might otherwise dispose them to rebel. Now what if after all these propositions were made, I should rise up and assert, that such councils were both unbecoming a king, and mischievous to him: and that not only his honor but his safety consisted more in his people's wealth, than in his own; if I should show that they choose a king for their own sake, and not for his; that by his care and endeavors they may

be both easy and safe; and that therefore a prince ought to take more care of his people's happiness than of his own, as a shepherd is to take more care of his flock than of himself.

"It is also certain that they are much mistaken that think the poverty of a nation is a means of the public safety. Who quarrel more than beggars? Who does more earnestly long for a change, than he that is uneasy in his present circumstances? And who run to create confusions with so desperate a boldness, as those who have nothing to lose hope to gain by them? If a king should fall under such contempt or envy, that he could not keep his subjects in their duty, but by oppression and ill-usage, and by rendering them poor and miserable, it were certainly better for him to quit his kingdom, than to retain it by such methods, as makes him while he keeps the name of authority, lose the majesty due to it. Nor is it so becoming the dignity of a king to reign over beggars, as over rich and happy subjects. And therefore Fabricius, a man of a noble and exalted temper, said, he would rather govern rich men than be rich himself; since for one man to abound in wealth and pleasure, when all about him are mourning and groaning, is to a gaoler and not a king. He is an unskilful physician, that cannot cure one disease without casting his patient into another: so he that can find no other way for correcting the errors of his people, but by taking from them the conveniences of life, shows that he knows not what it is to govern a free nation. He himself ought rather to shake off his sloth, or to lay down his pride; for the contempt or hatred that his people have for him, takes its rise from the vices in himself. Let him live upon what belongs to him, without wronging others, and accommodate his expense to his revenue. Let him punish crimes, and by his wise conduct let him endeavor to prevent them, rather than be severe when he has suffered them to be too common: let him not rashly revive laws that are abrogated by disuse, especially if they have been long forgotten, and never wanted; and let him never take any penalty for the breach of them, to which a judge would not give way in a private man, but would look on him as a crafty and unjust person for pretending to it.

"To these things I would add that law among the Macarians, a people that live not far from Utopia, by which their King, on the day on which he begins to reign, is tied by an oath con-

firmed by solemn sacrifices, never to have at once above 1,000 pounds of gold in his treasures, or so much silver as is equal to that in value. This law, they tell us, was made by an excellent king, who had more regard to the riches of his country than to his own wealth, and therefore provided against the heaping up of so much treasure as might impoverish the people. He thought that a moderate sum might be sufficient for any accident, if either the King had occasion for it against rebels, or the kingdom against the invasion of an enemy; but that it was not enough to encourage a prince to invade other men's rights, a circumstance that was the chief cause of his making that law. He also thought that it was a good provision for that free circulation of money, so necessary for the course of commerce and exchange: and when a king must distribute all those extraordinary accessions that increase treasure beyond the due pitch, it makes him less disposed to oppress his subjects. Such a king as this will be the terror of ill men, and will be beloved by all the good.

"If, I say, I should talk of these or such like things, to men that had taken their bias another way, how deaf would they be to all I could say?"

"No doubt, very deaf," answered I; "and no wonder, for one is never to offer at propositions or advice that we are certain will not be entertained. Discourses so much out of the road could not avail anything, nor have any effect on men whose minds were prepossessed with different sentiments. This philosophical way of speculation is not unpleasant among friends in a free conversation, but there is no room for it in the courts of princes where great affairs are carried on by authority."

"That is what I was saying," replied he, "that there is no room for philosophy in the courts of princes."

"Yes, there is," said I, "but not for this speculative philosophy that makes everything to be alike fitting at all times: but there is another philosophy that is more pliable, that knows its proper scene, accommodates itself to it, and teaches a man with propriety and decency to act that part which has fallen to his share. If when one of Plautus's comedies is upon the stage and a company of servants are acting their parts, you should come out in the garb of a philosopher, and repeat out of 'Octa-

via,' a discourse of Seneca's to Nero, would it not be better for you to say nothing than by mixing things of such different natures to make an impertinent tragi-comedy? For you spoil and corrupt the play that is in hand when you mix with it things of an opposite nature, even though they are much better. Therefore go through with the play that is acting, the best you can, and do not confound it because another that is pleasanter comes into your thoughts. It is even so in a commonwealth and in the councils of princes; if ill opinions cannot be quite rooted out, and you cannot cure some received vice according to your wishes, you must not therefore abandon the commonwealth; for the same reasons you should not forsake the ship in a storm because you cannot command the winds. You are not obliged to assault people with discourses that are out of their road, when you see that their received notions must prevent your making an impression upon them. You ought rather to cast about and to manage things with all the dexterity in your power, so that if you are not able to make them go well they may be as little ill as possible; for except all men were good everything cannot be right, and that is a blessing that I do not at present hope to see."

"According to your arguments," answered he, "all that I could be able to do would be to preserve myself from being mad while I endeavored to cure the madness of others; for if I speak truth, I must repeat what I have said to you; and as for lying, whether a philosopher can do it or not, I cannot tell; I am sure I cannot do it. But though these discourses may be uneasy and ungrateful to them, I do not see why they should seem foolish or extravagant: indeed if I should either propose such things as Plato has contrived in his commonwealth, or as the Utopians practise in theirs, though they might seem better, as certainly they are, yet they are so different from our establishment, which is founded on property, there being no such thing among them, that I could not expect that it would have any effect on them; but such discourses as mine, which only call past evils to mind and give warning of what may follow, have nothing in them that is so absurd that they may not be used at any time, for they can only be unpleasant to those who are resolved to run headlong the contrary way; and if we must let alone everything as absurd or extravagant which by reason

of the wicked lives of many may seem uncouth, we must, even among Christians, give over pressing the greatest part of those things that Christ hath taught us, though He has commanded us not to conceal them, but to proclaim on the house-tops that which he taught in secret.

" The greatest parts of his precepts are more opposite to the lives of the men of this age than any part of my discourse has been; but the preachers seemed to have learned that craft to which you advise me, for they observing that the world would not willingly suit their lives to the rules that Christ has given, have fitted his doctrine as if it had been a leaden rule, to their lives, that so some way or other they might agree with one another. But I see no other effect of this compliance except it be that men become more secure in their wickedness by it. And this is all the success that I can have in a court, for I must always differ from the rest, and then I shall signify nothing; or if I agree with them, I shall then only help forward their madness. I do not comprehend what you mean by your casting about, or by the bending and handling things so dexterously, that if they go not well they may go as little ill as may be; for in courts they will not bear with a man's holding his peace or conniving at what others do. A man must barefacedly approve of the worst counsels, and consent to the blackest designs: so that he would pass for a spy, or possibly for a traitor, that did but coldly approve of such wicked practices: and therefore when a man is engaged in such a society, he will be so far from being able to mend matters by his casting about, as you call it, that he will find no occasions of doing any good: the ill company will sooner corrupt him than be the better for him: or if notwithstanding all their ill company, he still remains steady and innocent, yet their follies and knavery will be imputed to him; and by mixing counsels with them, he must bear his share of all the blame that belongs wholly to others.

" It was no ill simile by which Plato set forth the unreasonableness of a philosopher's meddling with government. If a man, says he, was to see a great company run out every day into the rain, and take delight in being wet; if he knew that it would be to no purpose for him to go and persuade them to return to their houses, in order to avoid the storm, and that all that could be expected by his going to speak to them would be that he him-

self should be as wet as they, it would be best for him to keep within doors; and since he had not influence enough to correct other people's folly, to take care to preserve himself.

" Though to speak plainly my real sentiments, I must freely own that as long as there is any property, and while money is the standard of all other things, I cannot think that a nation can be governed either justly or happily: not justly, because the best things will fall to the share of the worst men; nor happily, because all things will be divided among a few (and even these are not in all respects happy), the rest being left to be absolutely miserable. Therefore when I reflect on the wise and good constitution of the Utopians—among whom all things are so well governed, and with so few laws; where virtue hath its due reward, and yet there is such an equality, that every man lives in plenty—when I compare with them so many other nations that are still making new laws, and yet can never bring their constitution to a right regulation, where notwithstanding everyone has his property; yet all the laws that they can invent have not the power either to obtain or preserve it, or even to enable men certainly to distinguish what is their own from what is another's; of which the many lawsuits that every day break out, and are eternally depending, give too plain a demonstration; when, I say, I balance all these things in my thoughts, I grow more favorable to Plato, and do not wonder that he resolved not to make any laws for such as would not submit to a community of all things: for so wise a man could not but foresee that the setting all upon a level was the only way to make a nation happy, which cannot be obtained so long as there is property: for when every man draws to himself all that he can compass, by one title or another, it must needs follow, that how plentiful soever a nation may be, yet a few dividing the wealth of it among themselves, the rest must fall into indigence.

" So that there will be two sorts of people among them, who deserve that their fortunes should be interchanged; the former useless, but wicked and ravenous; and the latter, who by their constant industry serve the public more than themselves, sincere and modest men. From whence I am persuaded, that till property is taken away there can be no equitable or just distribution of things, nor can the world be happily governed: for as long as that is maintained, the greatest and the far best part

of mankind will be still oppressed with a load of cares and anxieties. I confess without taking it quite away, those pressures that lie on a great part of mankind may be made lighter; but they can never be quite removed. For if laws were made to determine at how great an extent in soil, and at how much money every man must stop, to limit the prince that he might not grow too great, and to restrain the people that they might not become too insolent, and that none might factiously aspire to public employments; which ought neither to be sold, nor made burdensome by a great expense; since otherwise those that serve in them would be tempted to reimburse themselves by cheats and violence, and it would become necessary to find out rich men for undergoing those employments which ought rather to be trusted to the wise—these laws, I say, might have such effects, as good diet and care might have on a sick man, whose recovery is desperate: they might allay and mitigate the disease, but it could never be quite healed, nor the body politic be brought again to a good habit, as long as property remains; and it will fall out as in a complication of diseases, that by applying a remedy to one sore, you will provoke another; and that which removes the one ill symptom produces others, while the strengthening one part of the body weakens the rest."

"On the contrary," answered I, "it seems to me that men cannot live conveniently where all things are common: how can there be any plenty, where every man will excuse himself from labor? For as the hope of gain doth not excite him, so the confidence that he has in other men's industry may make him slothful: if people come to be pinched with want, and yet cannot dispose of anything as their own; what can follow upon this but perpetual sedition and bloodshed, especially when the reverence and authority due to magistrates fall to the ground? For I cannot imagine how that can be kept up among those that are in all things equal to one another."

"I do not wonder," said he, " that it appears so to you, since you have no notion, or at least no right one, of such a constitution: but if you had been in Utopia with me, and had seen their laws and rules, as I did, for the space of five years, in which I lived among them; and during which time I was so delighted with them, that indeed I should never have left them, if it had not been to make the discovery of that new world to the Euro-

peans; you would then confess that you had never seen a people so well constituted as they."

"You will not easily persuade me," said Peter, "that any nation in that new world is better governed than those among us. For as our understandings are not worse than theirs, so our government, if I mistake not, being more ancient, a long practice has helped us to find out many conveniences of life: and some happy chances have discovered other things to us, which no man's understanding could ever have invented."

"As for the antiquity, either of their government or of ours," said he, "you cannot pass a true judgment of it unless you had read their histories; for if they are to be believed, they had towns among them before these parts were so much as inhabited. And as for those discoveries, that have been either hit on by chance, or made by ingenious men, these might have happened there as well as here. I do not deny but we are more ingenious than they are, but they exceed us much in industry and application. They knew little concerning us before our arrival among them; they call us all by a general name of the nations that lie beyond the equinoctial line; for their chronicle mentions a shipwreck that was made on their coast 1,200 years ago; and that some Romans and Egyptians that were in the ship, getting safe ashore, spent the rest of their days among them; and such was their ingenuity, that from this single opportunity they drew the advantage of learning from those unlooked-for guests, and acquired all the useful arts that were then among the Romans, and which were known to these shipwrecked men: and by the hints that they gave them, they themselves found out even some of those arts which they could not fully explain; so happily did they improve that accident, of having some of our people cast upon their shore.

"But if such an accident has at any time brought any from thence into Europe, we have been so far from improving it, that we do not so much as remember it; as in after-times perhaps it will be forgot by our people that I was ever there. For though they from one such accident made themselves masters of all the good inventions that were among us; yet I believe it would be long before we should learn or put in practice any of the good institutions that are among them. And this is the true cause of their being better governed, and living happier than

we, though we come not short of them in point of understanding or outward advantages."

Upon this I said to him: "I earnestly beg you would describe that island very particularly to us. Be not too short, but set out in order all things relating to their soil, their rivers, their towns, their people, their manners, constitution, laws, and, in a word, all that you imagine we desire to know. And you may well imagine that we desire to know everything concerning them, of which we are hitherto ignorant."

"I will do it very willingly," said he, "for I have digested the whole matter carefully; but it will take up some time."

"Let us go then," said I, "first and dine, and then we shall have leisure enough."

He consented. We went in and dined, and after dinner came back and sat down in the same place. I ordered my servants to take care that none might come and interrupt us. And both Peter and I desired Raphael to be as good as his word. When he saw that we were very intent upon it, he paused a little to recollect himself, and began in this manner:

BOOK II

THE island of Utopia is in the middle 200 miles broad, and holds almost at the same breadth over a great part of it; but it grows narrower toward both ends. Its figure is not unlike a crescent: between its horns, the sea comes in eleven miles broad, and spreads itself into a great bay, which is environed with land to the compass of about 500 miles, and is well secured from winds. In this bay there is no great current; the whole coast is, as it were, one continued harbor, which gives all that live in the island great convenience for mutual commerce; but the entry into the bay, occasioned by rocks on the one hand, and shallows on the other, is very dangerous. In the middle of it there is one single rock which appears above water, and may therefore be easily avoided, and on the top of it there is a tower in which a garrison is kept; the other rocks lie under water, and are very dangerous. The channel is known only to the natives, so that if any stranger should enter into the bay, without one of their pilots, he would run great danger of shipwreck; for even they themselves could not pass it safe, if some marks that are on the coast did not direct their way; and if these should be but a little shifted, any fleet that might come against them, how great soever it were, would be certainly lost.

On the other side of the island there are likewise many harbors; and the coast is so fortified, both by nature and art, that a small number of men can hinder the descent of a great army. But they report (and there remain good marks of it to make it credible) that this was no island at first, but a part of the continent. Utopus that conquered it (whose name it still carries, for Abraxa was its first name) brought the rude and uncivilized inhabitants into such a good government, and to that measure of politeness, that they now far excel all the rest of mankind; having soon subdued them, he designed to separate them from

the continent, and to bring the sea quite round them. To accomplish this, he ordered a deep channel to be dug fifteen miles long; and that the natives might not think he treated them like slaves, he not only forced the inhabitants, but also his own soldiers, to labor in carrying it on. As he set a vast number of men to work, he beyond all men's expectations brought it to a speedy conclusion. And his neighbors who at first laughed at the folly of the undertaking, no sooner saw it brought to perfection than they were struck with admiration and terror.

There are fifty-four cities in the island, all large and well built: the manners, customs, and laws of which are the same, and they are all contrived as near in the same manner as the ground on which they stand will allow. The nearest lie at least twenty-four miles distance from one another, and the most remote are not so far distant but that a man can go on foot in one day from it to that which lies next it. Every city sends three of its wisest Senators once a year to Amaurot, to consult about their common concerns; for that is the chief town of the island, being situated near the centre of it, so that it is the most convenient place for their assemblies. The jurisdiction of every city extends at least twenty miles: and where the towns lie wider, they have much more ground: no town desires to enlarge its bounds, for the people consider themselves rather as tenants than landlords. They have built over all the country, farmhouses for husbandmen, which are well contrived, and are furnished with all things necessary for country labor. Inhabitants are sent by turns from the cities to dwell in them; no country family has fewer than forty men and women in it, besides two slaves. There is a master and a mistress set over every family; and over thirty families there is a magistrate.

Every year twenty of this family come back to the town, after they have stayed two years in the country; and in their room there are other twenty sent from the town, that they may learn country work from those that have been already one year in the country, as they must teach those that come to them the next from the town. By this means such as dwell in those country farms are never ignorant of agriculture, and so commit no errors, which might otherwise be fatal, and bring them under a scarcity of corn. But though there is every year such a shifting of the husbandmen, to prevent any man being forced against

his will to follow that hard course of life too long, yet many among them take such pleasure in it that they desire leave to continue in it many years. These husbandmen till the ground, breed cattle, hew wood, and convey it to the towns, either by land or water, as is most convenient. They breed an infinite multitude of chickens in a very curious manner; for the hens do not sit and hatch them, but vast numbers of eggs are laid in a gentle and equal heat, in order to be hatched, and they are no sooner out of the shell, and able to stir about, but they seem to consider those that feed them as their mothers, and follow them as other chickens do the hen that hatched them.

They breed very few horses, but those they have are full of mettle, and are kept only for exercising their youth in the art of sitting and riding them; for they do not put them to any work, either of ploughing or carriage, in which they employ oxen; for though their horses are stronger, yet they find oxen can hold out longer; and as they are not subject to so many diseases, so they are kept upon a less charge, and with less trouble; and even when they are so worn out, that they are no more fit for labor, they are good meat at last. They sow no corn, but that which is to be their bread; for they drink either wine, cider, or perry, and often water, sometimes boiled with honey or licorice, with which they abound; and though they know exactly how much corn will serve every town, and all that tract of country which belongs to it, yet they sow much more, and breed more cattle than are necessary for their consumption; and they give that overplus of which they make no use to their neighbors. When they want anything in the country which it does not produce, they fetch that from the town, without carrying anything in exchange for it. And the magistrates of the town take care to see it given them; for they meet generally in the town once a month, upon a festival day. When the time of harvest comes, the magistrates in the country send to those in the towns, and let them know how many hands they will need for reaping the harvest; and the number they call for being sent to them they commonly despatch it all in one day.

Of Their Towns, Particularly of Amaurot

He that knows one of their towns knows them all, they are so like one another, except where the situation makes some difference. I shall therefore describe one of them; and none is so proper as Amaurot; for as none is more eminent, all the rest yielding in precedence to this, because it is the seat of their Supreme Council, so there was none of them better known to me, I having lived five years altogether in it.

It lies upon the side of a hill, or rather a rising ground: its figure is almost square, for from the one side of it, which shoots up almost to the top of the hill, it runs down in a descent for two miles to the river Anider; but it is a little broader the other way that runs along by the bank of that river. The Anider rises about eighty miles above Amaurot, in a small spring at first, but other brooks falling into it, of which two are more considerable than the rest. As it runs by Amaurot, it is grown half a mile broad; but it still grows larger and larger, till after sixty miles course below it, it is lost in the ocean, between the town and the sea, and for some miles above the town, it ebbs and flows every six hours, with a strong current. The tide comes up for about thirty miles so full that there is nothing but salt water in the river, the fresh water being driven back with its force; and above that, for some miles, the water is brackish; but a little higher, as it runs by the town, it is quite fresh; and when the tide ebbs, it continues fresh all along to the sea. There is a bridge cast over the river, not of timber, but of fair stone, consisting of many stately arches; it lies at that part of the town which is farthest from the sea, so that ships without any hinderance lie all along the side of the town.

There is likewise another river that runs by it, which, though it is not great, yet it runs pleasantly, for it rises out of the same hill on which the town stands, and so runs down through it, and falls into the Anider. The inhabitants have fortified the fountain-head of this river, which springs a little without the town; so that if they should happen to be besieged, the enemy might not be able to stop or divert the course of the water, nor poison it; from thence it is carried in earthen pipes to the lower streets; and for those places of the town to which the water of

that shall river cannot be conveyed, they have great cisterns for receiving the rain-water, which supplies the want of the other. The town is compassed with a high and thick wall, in which there are many towers and forts; there is also a broad and deep dry ditch, set thick with thorns, cast round three sides of the town, and the river is instead of a ditch on the fourth side. The streets are very convenient for all carriage, and are well sheltered from the winds. Their buildings are good, and are so uniform that a whole side of a street looks like one house. The streets are twenty feet broad; there lie gardens behind all their houses; these are large but enclosed with buildings that on all hands face the streets; so that every house has both a door to the street, and a back door to the garden. Their doors have all two leaves, which, as they are easily opened, so they shut of their own accord; and there being no property among them, every man may freely enter into any house whatsoever. At every ten years' end they shift their houses by lots.

They cultivate their gardens with great care, so that they have vines, fruits, herbs, and flowers in them; and all is so well ordered, and so finely kept, that I never saw gardens anywhere that were both so fruitful and so beautiful as theirs. And this humor of ordering their gardens so well is not only kept up by the pleasure they find in it, but also by an emulation between the inhabitants of the several streets, who vie with each other; and there is indeed nothing belonging to the whole town that is both more useful and more pleasant. So that he who founded the town seems to have taken care of nothing more than of their gardens; for they say, the whole scheme of the town was designed at first by Utopus, but he left all that belonged to the ornament and improvement of it to be added by those that should come after him, that being too much for one man to bring to perfection. Their records, that contain the history of their town and State, are preserved with an exact care, and run backward 1,760 years. From these it appears that their houses were at first low and mean, like cottages, made of any sort of timber, and were built with mud walls and thatched with straw. But now their houses are three stories high: the fronts of them are faced with stone, plastering, or brick; and between the facings of their walls they throw in their rubbish. Their roofs are flat, and on them they lay a sort of plaster, which costs very lit-

tle, and yet is so tempered that it is not apt to take fire, and yet resists the weather more than lead. They have great quantities of glass among them, with which they glaze their windows. They use also in their windows a thin linen cloth, that is so oiled or gummed that it both keeps out the wind and gives free admission to the light.

Of Their Magistrates

THIRTY families choose every year a magistrate, who was anciently called the syphogrant, but is now called the philarch; and over every ten syphogrants, with the families subject to them, there is another magistrate, who was anciently called the tranibor, but of late the archphilarch. All the syphogrants, who are in number 200, choose the Prince out of a list of four, who are named by the people of the four divisions of the city; but they take an oath before they proceed to an election, that they will choose him whom they think most fit for the office. They give their voices secretly, so that it is not known for whom everyone gives his suffrage. The Prince is for life, unless he is removed upon suspicion of some design to enslave the people. The tranibors are new-chosen every year, but yet they are for the most part continued. All their other magistrates are only annual. The tranibors meet every third day, and oftener if necessary, and consult with the prince, either concerning the affairs of the State in general or such private differences as may arise sometimes among the people; though that falls out but seldom. There are always two syphogrants called into the council-chamber, and these are changed every day. It is a fundamental rule of their government that no conclusion can be made in anything that relates to the public till it has been first debated three several days in their Council. It is death for any to meet and consult concerning the State, unless it be either in their ordinary Council, or in the assembly of the whole body of the people.

These things have been so provided among them, that the prince and the tranibors may not conspire together to change the government and enslave the people; and therefore when anything of great importance is set on foot, it is sent to the syphogrants; who after they have communicated it to the fami-

lies that belong to their divisions, and have considered it among
themselves, make report to the Senate; and upon great occasions, the matter is referred to the Council of the whole island.
One rule observed in their Council, is, never to debate a thing
on the same day in which it is first proposed; for that is always
referred to the next meeting, that so men may not rashly, and in
the heat of discourse, engage themselves too soon, which might
bias them so much, that instead of consulting the good of the
public, they might rather study to support their first opinions,
and by a perverse and preposterous sort of shame, hazard their
country rather than endanger their own reputation, or venture
the being suspected to have wanted foresight in the expedients
that they at first proposed. And therefore to prevent this, they
take care that they may rather be deliberate than sudden in their
motions.

Of Their Trades, and Manner of Life

AGRICULTURE is that which is so universally understood
among them that no person, either man or woman, is ignorant
of it; they are instructed in it from their childhood, partly by
what they learn at school and partly by practice; they being led
out often into the fields, about the town, where they not only
see others at work, but are likewise exercised in it themselves.
Besides agriculture, which is so common to them all, every man
has some peculiar trade to which he applies himself, such as the
manufacture of wool, or flax, masonry, smith's work, or carpenter's work; for there is no sort of trade that is not in great
esteem among them. Throughout the island they wear the
same sort of clothes without any other distinction, except what
is necessary to distinguish the two sexes, and the married and
unmarried. The fashion never alters; and as it is neither disagreeable nor uneasy, so it is suited to the climate, and calculated both for their summers and winters. Every family makes
their own clothes; but all among them, women as well as men,
learn one or other of the trades formerly mentioned. Women,
for the most part, deal in wool and flax, which suit best with
their weakness, leaving the ruder trades to the men. The same
trade generally passes down from father to son, inclinations
often following descent; but if any man's genius lies another
way, he is by adoption translated into a family that deals in the

trade to which he is inclined: and when that is to be done, care is taken not only by his father, but by the magistrate, that he may be put to a discreet and good man. And if after a person has learned one trade, he desires to acquire another, that is also allowed, and is managed in the same manner as the former. When he has learned both, he follows that which he likes best, unless the public has more occasion for the other.

The chief, and almost the only business of the syphogrants, is to take care that no man may live idle, but that every one may follow his trade diligently: yet they do not wear themselves out with perpetual toil, from morning to night, as if they were beasts of burden, which, as it is indeed a heavy slavery, so it is everywhere the common course of life among all mechanics except the Utopians; but they dividing the day and night into twenty-four hours, appoint six of these for work; three of which are before dinner, and three after. They then sup, and at eight o'clock, counting from noon, go to bed and sleep eight hours. The rest of their time besides that taken up in work, eating and sleeping, is left to every man's discretion; yet they are not to abuse that interval to luxury and idleness, but must employ it in some proper exercise according to their various inclinations, which is for the most part reading. It is ordinary to have public lectures every morning before daybreak; at which none are obliged to appear but those who are marked out for literature; yet a great many, both men and women of all ranks, go to hear lectures of one sort of other, according to their inclinations. But if others, that are not made for contemplation, choose rather to employ themselves at that time in their trades, as many of them do, they are not hindered, but are rather commended, as men that take care to serve their country. After supper, they spend an hour in some diversion, in summer in their gardens, and in winter in the halls where they eat; where they entertain each other, either with music or discourse. They do not so much as know dice, or any such foolish and mischievous games: they have, however, two sorts of games not unlike our chess; the one is between several numbers, in which one number, as it were, consumes another: the other resembles a battle between the virtues and the vices, in which the enmity in the vices among themselves, and their agreement against virtue, is not unpleasantly represented; together with the spe-

cial oppositions between the particular virtues and vices; as also the methods by which vice either openly assaults or secretly undermines virtue; and virtue on the other hand resists it. But the time appointed for labor is to be narrowly examined, otherwise you may imagine, that since there are only six hours appointed for work, they may fall under a scarcity of necessary provisions. But it is so far from being true, that this time is not sufficient for supplying them with plenty of all things, either necessary or convenient, that it is rather too much; and this you will easily apprehend, if you consider how great a part of all other nations is quite idle.

First, women generally do little, who are the half of mankind; and if some few women are diligent, their husbands are idle: then consider the great company of idle priests, and of those that are called religious men; add to these all rich men, chiefly those that have estates in land, who are called noblemen and gentlemen, together with their families, made up of idle persons, that are kept more for show than use; add to these, all those strong and lusty beggars, that go about pretending some disease, in excuse for their begging; and upon the whole account you will find that the number of those by whose labors mankind is supplied, is much less than you perhaps imagined. Then consider how few of those that work are employed in labors that are of real service; for we who measure all things by money, give rise to many trades that are both vain and superfluous, and serve only to support riot and luxury. For if those who work were employed only in such things as the conveniences of life require, there would be such an abundance of them that the prices of them would so sink that tradesmen could not be maintained by their gains; if all those who labor about useless things were set to more profitable employments, and if all they that languish out their lives in sloth and idleness, every one of whom consumes as much as any two of the men that are at work, were forced to labor, you may easily imagine that a small proportion of time would serve for doing all that is either necessary, profitable, or pleasant to mankind, especially while pleasure is kept within its due bounds.

This appears very plainly in Utopia, for there, in a great city, and in all the territory that lies round it, you can scarce find 500, either men or women, by their age and strength, are capa-

ble of labor, that are not engaged in it; even the syphogrants, though excused by the law, yet do not excuse themselves, but work, that by their examples they may excite the industry of the rest of the people. The like exemption is allowed to those who, being recommended to the people by the priests, are by the secret suffrages of the syphogrants privileged from labor, that they may apply themselves wholly to study; and if any of these fall short of those hopes that they seemed at first to give, they are obliged to return to work. And sometimes a mechanic, that so employs his leisure hours, as to make a considerable advancement in learning, is eased from being a tradesman, and ranked among their learned men. Out of these they choose their ambassadors, their priests, their tranibors, and the prince himself, anciently called their Barzenes, but is called of late their Ademus.

And thus from the great numbers among them that are neither suffered to be idle, nor to be employed in any fruitless labor, you may easily make the estimate how much may be done in those few hours in which they are obliged to labor. But besides all that has been already said, it is to be considered that the needful arts among them are managed with less labor than anywhere else. The building or the repairing of houses among us employ many hands, because often a thriftless heir suffers a house that his father built to fall into decay, so that his successor must, at a great cost, repair that which he might have kept up with a small charge: it frequently happens that the same house which one person built at a vast expense is neglected by another, who thinks he has a more delicate sense of the beauties of architecture; and he suffering it to fall to ruin, builds another at no less charge. But among the Utopians all things are so regulated that men very seldom build upon a new piece of ground; and are not only very quick in repairing their houses, but show their foresight in preventing their decay: so that their buildings are preserved very long, with but little labor; and thus the builders to whom that care belongs are often without employment, except the hewing of timber and the squaring of stones, that the materials may be in readiness for raising a building very suddenly when there is any occasion for it.

As to their clothes, observe how little work is spent in them: while they are at labor, they are clothed with leather and skins,

cast carelessly about them, which will last seven years; and when they appear in public they put on an upper garment, which hides the other; and these are all of one color, and that is the natural color of the wool. As they need less woollen cloth than is used anywhere else, so that which they make use of is much less costly. They use linen cloth more; but that is prepared with less labor, and they value cloth only by the whiteness of the linen or the cleanness of the wool, without much regard to the fineness of the thread: while in other places, four or five upper garments of woollen cloth, of different colors, and as many vests of silk, will scarce serve one man; and while those that are nicer think ten are too few, every man there is content with one, which very often serves him two years. Nor is there anything that can tempt a man to desire more; for if he had them, he would neither be the warmer nor would he make one jot the better appearance for it. And thus, since they are all employed in some useful labor, and since they content themselves with fewer things, it falls out that there is a great abundance of all things among them: so that it frequently happens that, for want of other work, vast numbers are sent out to mend the highways. But when no public undertaking is to be performed, the hours of working are lessened. The magistrates never engage the people in unnecessary labor, since the chief end of the constitution is to regulate labor by the necessities of the public, and to allow all the people as much time as is necessary for the improvement of their minds, in which they think the happiness of life consists.

Of Their Traffic

BUT it is now time to explain to you the mutual intercourse of this people, their commerce, and the rules by which all things are distributed among them.

As their cities are composed of families, so their families are made up of those that are nearly related to one another. Their women, when they grow up, are married out; but all the males, both children and grandchildren, live still in the same house, in great obedience to their common parent, unless age has weakened his understanding; and in that case, he that is next to him in age comes in his room. But lest any city should become

either too great, or by any accident be dispeopled, provision is made that none of their cities may contain above 6,000 families, besides those of the country round it. No family may have less than ten and more than sixteen persons in it; but there can be no determined number for the children under age. This rule is easily observed, by removing some of the children of a more fruitful couple to any other family that does not abound so much in them.

By the same rule, they supply cities that do not increase so fast, from others that breed faster; and if there is any increase over the whole island, then they draw out a number of their citizens out of the several towns, and send them over to the neighboring continent; where, if they find that the inhabitants have more soil than they can well cultivate, they fix a colony, taking the inhabitants into their society, if they are willing to live with them; and where they do that of their own accord, they quickly enter into their method of life, and conform to their rules, and this proves a happiness to both nations; for according to their constitution, such care is taken of the soil that it becomes fruitful enough for both, though it might be otherwise too narrow and barren for any one of them. But if the natives refuse to conform themselves to their laws, they drive them out of those bounds which they mark out for themselves, and use force if they resist. For they account it a very just cause of war, for a nation to hinder others from possessing a part of that soil of which they make no use, but which is suffered to lie idle and uncultivated; since every man has by the law of nature a right to such a waste portion of the earth as is necessary for his subsistence. If an accident has so lessened the number of the inhabitants of any of their towns that it cannot be made up from the other towns of the island, without diminishing them too much, which is said to have fallen out but twice since they were first a people, when great numbers were carried off by the plague, the loss is then supplied by recalling as many as are wanted from their colonies; for they will abandon these, rather than suffer the towns in the island to sink too low.

But to return to their manner of living in society, the oldest man of every family, as has been already said, is its governor. Wives serve their husbands, and children their parents, and always the younger serves the elder. Every city is divided into

four equal parts, and in the middle of each there is a market-place: what is brought thither, and manufactured by the several families, is carried from thence to houses appointed for that purpose, in which all things of a sort are laid by themselves; and thither every father goes and takes whatsoever he or his family stand in need of, without either paying for it or leaving anything in exchange. There is no reason for giving a denial to any person, since there is such plenty of everything among them; and there is no danger of a man's asking for more than he needs; they have no inducements to do this, since they are sure that they shall always be supplied. It is the fear of want that makes any of the whole race of animals either greedy or ravenous; but besides fear, there is in man a pride that makes him fancy it a particular glory to excel others in pomp and excess. But by the laws of the Utopians, there is no room for this. Near these markets there are others for all sorts of provisions, where there are not only herbs, fruits, and bread, but also fish, fowl, and cattle.

There are also, without their towns, places appointed near some running water, for killing their beasts, and for washing away their filth, which is done by their slaves: for they suffer none of their citizens to kill their cattle, because they think that pity and good-nature, which are among the best of those affections that are born with us, are much impaired by the butchering of animals: nor do they suffer anything that is foul or unclean to be brought within their towns, lest the air should be infected by ill-smells which might prejudice their health. In every street there are great halls that lie at an equal distance from each other, distinguished by particular names. The syphogrants dwell in those that are set over thirty families, fifteen lying on one side of it, and as many on the other. In these halls they all meet and have their repasts. The stewards of every one of them come to the market-place at an appointed hour; and according to the number of those that belong to the hall, they carry home provisions. But they take more care of their sick than of any others: these are lodged and provided for in public hospitals: they have belonging to every town four hospitals, that are built without their walls, and are so large that they may pass for little towns: by this means, if they had ever such a number of sick persons, they could lodge them con-

veniently, and at such a distance, that such of them as are sick of infectious diseases may be kept so far from the rest that there can be no danger of contagion. The hospitals are furnished and stored with all things that are convenient for the ease and recovery of the sick; and those that are put in them are looked after with such tender and watchful care, and are so constantly attended by their skilful physicians, that as none is sent to them against their will, so there is scarce one in a whole town that, if he should fall ill, would not choose rather to go thither than lie sick at home.

After the steward of the hospitals has taken for the sick whatsoever the physician prescribes, then the best things that are left in the market are distributed equally among the halls, in proportion to their numbers, only, in the first place, they serve the Prince, the chief priest, the tranibors, the ambassadors, and strangers, if there are any, which indeed falls out but seldom, and for whom there are houses well furnished, particularly appointed for their reception when they come among them. At the hours of dinner and supper, the whole syphogranty being called together by sound of trumpet, they meet and eat together, except only such as are in the hospitals or lie sick at home. Yet after the halls are served, no man is hindered to carry provisions home from the market-place; for they know that none does that but for some good reason; for though any that will may eat at home, yet none does it willingly, since it is both ridiculous and foolish for any to give themselves the trouble to make ready an ill dinner at home, when there is a much more plentiful one made ready for him so near at hand. All the uneasy and sordid services about these halls are performed by their slaves; but the dressing and cooking their meat, and the ordering their tables, belong only to the women, all those of every family taking it by turns. They sit at three or more tables, according to their number; the men sit toward the wall, and the women sit on the other side, that if any of them should be taken suddenly ill, which is no uncommon case among women with child, she may, without disturbing the rest, rise and go to the nurses' room, who are there with the sucking children, where there is always clean water at hand, and cradles in which they may lay the young children, if there is occasion for it, and a fire that they may shift and dress them before it.

Every child is nursed by its own mother, if death or sickness does not intervene; and in that case the syphogrants' wives find out a nurse quickly, which is no hard matter; for anyone that can do it offers herself cheerfully; for as they are much inclined to that piece of mercy, so the child whom they nurse considers the nurse as its mother. All the children under five years old sit among the nurses, the rest of the younger sort of both sexes, till they are fit for marriage, either serve those that sit at table or, if they are not strong enough for that, stand by them in great silence, and eat what is given them; nor have they any other formality of dining. In the middle of the first table, which stands across the upper end of the hall, sit the syphogrant and his wife; for that is the chief and most conspicuous place; next to him sit two of the most ancient, for there go always four to a mess. If there is a temple within that syphogranty, the priest and his wife sit with the syphogrant above all the rest: next them there is a mixture of old and young, who are so placed, that as the young are set near others, so they are mixed with the more ancient; which they say was appointed on this account, that the gravity of the old people, and the reverence that is due to them, might restrain the younger from all indecent words and gestures. Dishes are not served up to the whole table at first, but the best are first set before the old, whose seats are distinguished from the young, and after them all the rest are served alike. The old men distribute to the younger any curious meats that happen to be set before them, if there is not such an abundance of them that the whole company may be served alike.

Thus old men are honored with a particular respect; yet all the rest fare as well as they. Both dinner and supper are begun with some lecture of morality that is read to them; but it is so short, that it is not tedious nor uneasy to them to hear it: from hence the old men take occasion to entertain those about them with some useful and pleasant enlargements; but they do not engross the whole discourse so to themselves, during their meals, that the younger may not put in for a share: on the contrary, they engage them to talk, that so they may in that free way of conversation find out the force of everyone's spirit, and observe his temper. They despatch their dinners quickly, but sit long at supper; because they go to work after the one, and

are to sleep after the other, during which they think the stomach carries on the concoction more vigorously. They never sup without music; and there is always fruit served up after meat; while they are at table, some burn perfumes and sprinkle about fragrant ointments and sweet waters: in short, they want nothing that may cheer up their spirits: they give themselves a large allowance that way, and indulge themselves in all such pleasures as are attended with no inconvenience. Thus do those that are in the towns live together; but in the country, where they live at great distance, everyone eats at home, and no family wants any necessary sort of provision, for it is from them that provisions are sent unto those that live in the towns.

Of the Travelling of the Utopians

IF any man has a mind to visit his friends that live in some other town, or desires to travel and see the rest of the country, he obtains leave very easily from the syphogrant and tranibors when there is no particular occasion for him at home: such as travel, carry with them a passport from the Prince, which both certifies the license that is granted for travelling, and limits the time of their return. They are furnished with a wagon, and a slave who drives the oxen and looks after them; but unless there are women in the company, the wagon is sent back at the end of the journey as a needless encumbrance. While they are on the road, they carry no provisions with them; yet they want nothing, but are everywhere treated as if they were at home. If they stay in any place longer than a night, everyone follows his proper occupation, and is very well used by those of his own trade; but if any man goes out of the city to which he belongs, without leave, and is found rambling without a passport, he is severely treated, he is punished as a fugitive, and sent home disgracefully; and if he falls again into the like fault, is condemned to slavery. If any man has a mind to travel only over the precinct of his own city, he may freely do it, with his father's permission and his wife's consent; but when he comes into any of the country houses, if he expects to be entertained by them, he must labor with them and conform to their rules: and if he does this, he may freely go over the whole precinct; being thus as useful to the city to which he belongs, as if he

were still within it. Thus you see that there are no idle persons among them, nor pretences of excusing any from labor. There are no taverns, no alehouses nor stews among them; nor any other occasions of corrupting each other, of getting into corners, or forming themselves into parties: all men live in full view, so that all are obliged, both to perform their ordinary tasks, and to employ themselves well in their spare hours. And it is certain that a people thus ordered must live in great abundance of all things; and these being equally distributed among them, no man can want, or be obliged to beg.

In their great Council at Amaurot, to which there are three sent from every town once a year, they examine what towns abound in provisions and what are under any scarcity, that so the one may be furnished from the other; and this is done freely, without any sort of exchange; for according to their plenty or scarcity they supply or are supplied from one another; so that indeed the whole island is, as it were, one family. When they have thus taken care of their whole country, and laid up stores for two years, which they do to prevent the ill-consequences of an unfavorable season, they order an exportation of the overplus, of corn, honey, wool, flax, wood, wax, tallow, leather, and cattle; which they send out commonly in great quantities to other nations. They order a seventh part of all these goods to be freely given to the poor of the countries to which they send them, and sell the rest at moderate rates. And by this exchange, they not only bring back those few things that they need at home (for indeed they scarce need anything but iron), but likewise a great deal of gold and silver; and by their driving this trade so long, it is not to be imagined how vast a treasure they have got among them: so that now they do not much care whether they sell off their merchandise for money in hand, or upon trust.

A great part of their treasure is now in bonds; but in all their contracts no private man stands bound, but the writing runs in the name of the town; and the towns that owe them money raise it from those private hands that owe it to them, lay it up in their public chamber, or enjoy the profit of it till the Utopians call for it; and they choose rather to let the greatest part of it lie in their hands who make advantage by it, than to call for it themselves: but if they see that any of their other neigh-

bors stand more in need of it, then they call it in and lend it to them: whenever they are engaged in war, which is the only occasion in which their treasure can be usefully employed, they make use of it themselves. In great extremities or sudden accidents they employ it in hiring foreign troops, whom they more willingly expose to danger than their own people: they give them great pay, knowing well that this will work even on their enemies, that it will engage them either to betray their own side, or at least to desert it, and that it is the best means of raising mutual jealousies among them: for this end they have an incredible treasure; but they do not keep it as a treasure, but in such a manner as I am almost afraid to tell, lest you think it so extravagant, as to be hardly credible. This I have the more reason to apprehend, because if I had not seen it myself, I could not have been easily persuaded to have believed it upon any man's report.

It is certain that all things appear incredible to us, in proportion as they differ from our own customs. But one who can judge aright will not wonder to find that, since their constitution differs so much from ours, their value of gold and silver should be measured by a very different standard; for since they have no use for money among themselves, but keep it as a provision against events which seldom happen, and between which there are generally long intervening intervals, they value it no farther than it deserves, that is, in proportion to its use. So that it is plain they must prefer iron either to gold or silver; for men can no more live without iron than without fire or water, but nature has marked out no use for the other metals, so essential as not easily to be dispensed with. The folly of men has enhanced the value of gold and silver, because of their scarcity. Whereas, on the contrary, it is their opinion that nature, as an indulgent parent, has freely given us all the best things in great abundance, such as water and earth, but has laid up and hid from us the things that are vain and useless.

If these metals were laid up in any tower in the kingdom, it would raise a jealousy of the Prince and Senate, and give birth to that foolish mistrust into which the people are apt to fall, a jealousy of their intending to sacrifice the interest of the public to their own private advantage. If they should work it into vessels or any sort of plate, they fear that the people might

grow too fond of it, and so be unwilling to let the plate be run down if a war made it necessary to employ it in paying their soldiers. To prevent all these inconveniences, they have fallen upon an expedient, which, as it agrees with their other policy, so is it very different from ours, and will scarce gain belief among us, who value gold so much and lay it up so carefully. They eat and drink out of vessels of earth, or glass, which make an agreeable appearance though formed of brittle materials: while they make their chamber-pots and close-stools of gold and silver; and that not only in their public halls, but in their private houses: of the same metals they likewise make chains and fetters for their slaves; to some of which, as a badge of infamy, they hang an ear-ring of gold, and make others wear a chain or coronet of the same metal; and thus they take care, by all possible means, to render gold and silver of no esteem. And from hence it is that while other nations part with their gold and silver as unwillingly as if one tore out their bowels, those of Utopia would look on their giving in all they possess of those (metals, when there was any use for them) but as the parting with a trifle, or as we would esteem the loss of a penny. They find pearls on their coast, and diamonds and carbuncles on their rocks; they do not look after them, but, if they find them by chance, they polish them, and with them they adorn their children, who are delighted with them, and glory in them during their childhood; but when they grow to years, and see that none but children use such baubles, they of their own accord, without being bid by their parents, lay them aside; and would be as much ashamed to use them afterward as children among us, when they come to years, are of their puppets and other toys.

I never saw a clearer instance of the opposite impressions that different customs make on people, than I observed in the ambassadors of the Anemolians, who came to Amaurot when I was there. As they came to treat of affairs of great consequence, the deputies from several towns met together to wait for their coming. The ambassadors of the nations that lie near Utopia, knowing their customs, and that fine clothes are in no esteem among them, that silk is despised, and gold is a badge of infamy, used to come very modestly clothed; but the Anemolians, lying more remote, and having

had little commerce with them, understanding that they were coarsely clothed, and all in the same manner, took it for granted that they had none of those fine things among them of which they made no use; and they being a vainglorious rather than a wise people, resolved to set themselves out with so much pomp, that they should look like gods, and strike the eyes of the poor Utopians with their splendor. Thus three ambassadors made their entry with 100 attendants, all clad in garments of different colors, and the greater part in silk; the ambassadors themselves, who were of the nobility of their country, were in cloth-of-gold, and adorned with massy chains, ear-rings, and rings of gold: their caps were covered with bracelets set full of pearls and other gems: in a word, they were set out with all those things that, among the Utopians, were the badges of slavery, the marks of infamy, or the playthings of children.

It was not unpleasant to see, on the one side, how they looked big, when they compared their rich habits with the plain clothes of the Utopians, who were come out in great numbers to see them make their entry: and, on the other, to observe how much they were mistaken in the impression which they hoped this pomp would have made on them. It appeared so ridiculous a show to all that had never stirred out of their country, and had not seen the customs of other nations, that though they paid some reverence to those that were the most meanly clad, as if they had been the ambassadors, yet when they saw the ambassadors themselves, so full of gold and chains, they looked upon them as slaves, and forbore to treat them with reverence. You might have seen the children, who were grown big enough to despise their playthings, and who had thrown away their jewels, call to their mothers, push them gently, and cry out, "See that great fool that wears pearls and gems, as if he were yet a child." While their mothers very innocently replied, "Hold your peace; this, I believe, is one of the ambassador's fools." Others censured the fashion of their chains, and observed that they were of no use; for they were too slight to bind their slaves, who could easily break them; and besides hung so loose about them that they thought it easy to throw them away, and so get from them.

But after the ambassadors had stayed a day among them, and saw so vast a quantity of gold in their houses, which was

as much despised by them as it was esteemed in other nations, and beheld more gold and silver in the chains and fetters of one slave than all their ornaments amounted to, their plumes fell, and they were ashamed of all that glory for which they had formerly valued themselves, and accordingly laid it aside; a resolution that they immediately took, when on their engaging in some free discourse with the Utopians, they discovered their sense of such things and their other customs. The Utopians wonder how any man should be so much taken with the glaring doubtful lustre of a jewel or a stone, that can look up to a star or to the sun himself; or how any should value himself because his cloth is made of a finer thread: for how fine soever that thread may be, it was once no better than the fleece of a sheep, and that sheep was a sheep still for all its wearing it. They wonder much to hear that gold which in itself is so useless a thing, should be everywhere so much esteemed, that even men for whom it was made, and by whom it has its value, should yet be thought of less value than this metal. That a man of lead, who has no more sense than a log of wood, and is as bad as he is foolish, should have many wise and good men to serve him, only because he has a great heap of that metal; and that if it should happen that by some accident or trick of law (which sometimes produces as great changes as chance itself) all this wealth should pass from the master to the meanest varlet of his whole family, he himself would very soon become one of his servants, as if he were a thing that belonged to his wealth, and so were bound to follow its fortune. But they much more admire and detest the folly of those who, when they see a rich man, though they neither owe him anything nor are in any sort dependent on his bounty, yet merely because he is rich give him little less than divine honors, even though they know him to be so covetous and base-minded that notwithstanding all his wealth he will not part with one farthing of it to them as long as he lives.

These and such like notions has that people imbibed, partly from their education, being bred in a country whose customs and laws are opposite to all such foolish maxims, and partly from their learning and studies; for though there are but few in any town that are so wholly excused from labor as to give themselves entirely up to their studies, these being only such

persons as discover from their childhood an extraordinary capacity and disposition for letters; yet their children, and a great part of the nation, both men and women, are taught to spend those hours in which they are not obliged to work, in reading: and this they do through the whole progress of life. They have all their learning in their own tongue, which is both a copious and pleasant language, and in which a man can fully express his mind. It runs over a great tract of many countries, but it is not equally pure in all places. They had never so much as heard of the names of any of those philosophers that are so famous in these parts of the world, before we went among them; and yet they had made the same discoveries as the Greeks, in music, logic, arithmetic, and geometry. But as they are almost in everything equal to the ancient philosophers, so they far exceed our modern logicians; for they have never yet fallen upon the barbarous niceties that our youth are forced to learn in those trifling logical schools that are among us; they are so far from minding chimeras, and fantastical images made in the mind, that none of them could comprehend what we meant when we talked to them of man in the abstract, as common to all men in particular (so that though we spoke of him as a thing that we could point at with our fingers, yet none of them could perceive him), and yet distinct from everyone, as if he were some monstrous Colossus or giant.

Yet for all this ignorance of these empty notions, they knew astronomy, and were perfectly acquainted with the motions of the heavenly bodies, and have many instruments, well contrived and divided, by which they very accurately compute the course and positions of the sun, moon, and stars. But for the cheat, of divining by the stars by their oppositions or conjunctions, it has not so much as entered into their thoughts. They have a particular sagacity, founded upon much observation, in judging of the weather, by which they know when they may look for rain, wind, or other alterations in the air; but as to the philosophy of these things, the causes of the saltness of the sea, of its ebbing and flowing, and of the origin and nature both of the heavens and the earth; they dispute of them, partly as our ancient philosophers have done, and partly upon some new hypothesis, in which, as they differ from them, so they do not in all things agree among themselves.

As to moral philosophy, they have the same disputes among them as we have here: they examine what are properly good both for the body and the mind, and whether any outward thing can be called truly good, or if that term belong only to the endowments of the soul. They inquire likewise into the nature of virtue and pleasure; but their chief dispute is concerning the happiness of a man, and wherein it consists? Whether in some one thing, or in a great many? They seem, indeed, more inclinable to that opinion that places, if not the whole, yet the chief part of a man's happiness in pleasure; and, what may seem more strange, they make use of arguments even from religion, notwithstanding its severity and roughness, for the support of that opinion so indulgent to pleasure; for they never dispute concerning happiness without fetching some arguments from the principles of religion, as well as from natural reason, since without the former they reckon that all our inquiries after happiness must be but conjectural and defective.

These are their religious principles, that the soul of man is immortal, and that God of his goodness has designed that it should be happy; and that he has therefore appointed rewards for good and virtuous actions, and punishments for vice, to be distributed after this life. Though these principles of religion are conveyed down among them by tradition, they think that even reason itself determines a man to believe and acknowledge them, and freely confess that if these were taken away no man would be so insensible as not to seek after pleasure by all possible means, lawful or unlawful; using only this caution, that a lesser pleasure might not stand in the way of a greater, and that no pleasure ought to be pursued that should draw a great deal of pain after it; for they think it the maddest thing in the world to pursue virtue, that is a sour and difficult thing; and not only to renounce the pleasures of life, but willingly to undergo much pain and trouble, if a man has no prospect of a reward. And what reward can there be for one that has passed his whole life, not only without pleasure, but in pain, if there is nothing to be expected after death? Yet they do not place happiness in all sorts of pleasures, but only in those that in themselves are good and honest.

There is a party among them who place happiness in bare virtue; others think that our natures are conducted by virtue

to happiness, as that which is the chief good of man. They define virtue thus, that it is a living according to nature, and think that we are made by God for that end; they believe that a man then follows the dictates of nature when he pursues or avoids things according to the direction of reason; they say that the first dictate of reason is the kindling in us of a love and reverence for the Divine Majesty, to whom we owe both all that we have and all that we can ever hope for. In the next place, reason directs us to keep our minds as free from passion and as cheerful as we can, and that we should consider ourselves as bound by the ties of good-nature and humanity to use our utmost endeavors to help forward the happiness of all other persons; for there never was any man such a morose and severe pursuer of virtue, such an enemy to pleasure, that though he set hard rules for men to undergo much pain, many watchings, and other rigors, yet did not at the same time advise them to do all they could, in order to relieve and ease the miserable, and who did not represent gentleness and good-nature as amiable dispositions. And from thence they infer that if a man ought to advance the welfare and comfort of the rest of mankind, there being no virtue more proper and peculiar to our nature, than to ease the miseries of others, to free from trouble and anxiety, in furnishing them with the comforts of life, in which pleasure consists, nature much more vigorously leads them to do all this for himself.

A life of pleasure is either a real evil, and in that case we ought not to assist others in their pursuit of it, but on the contrary, to keep them from it all we can, as from that which is most hurtful and deadly; or if it is a good thing, so that we not only may, but ought to help others to it, why, then, ought not a man to begin with himself? Since no man can be more bound to look after the good of another than after his own; for nature cannot direct us to be good and kind to others, and yet at the same time to be unmerciful and cruel to ourselves. Thus, as they define virtue to be living according to nature, so they imagine that nature prompts all people on to seek after pleasure, as the end of all they do. They also observe that in order to our supporting the pleasures of life, nature inclines us to enter into society; for there is no man so much raised above the rest of mankind as to be the only favorite of nature

who, on the contrary, seems to have placed on a level all those that belong to the same species. Upon this they infer that no man ought to seek his own conveniences so eagerly as to prejudice others; and therefore they think that not only all agreements between private persons ought to be observed, but likewise that all those laws ought to be kept, which either a good prince has published in due form, or to which a people that is neither oppressed with tyranny nor circumvented by fraud, has consented, for distributing those conveniences of life which afford us all our pleasures.

They think it is an evidence of true wisdom for a man to pursue his own advantages as far as the laws allow it. They account it piety to prefer the public good to one's private concerns; but they think it unjust for a man to seek for pleasure by snatching another man's pleasures from him. And on the contrary, they think it a sign of a gentle and good soul, for a man to dispense with his own advantage for the good of others; and that by this means a good man finds as much pleasure one way as he parts with another; for as he may expect the like from others when he may come to need it, so if that should fail him, yet the sense of a good action, and the reflections that he makes on the love and gratitude of those whom he has so obliged, gives the mind more pleasure than the body could have found in that from which it had restrained itself. They are also persuaded that God will make up the loss of those small pleasures, with a vast and endless joy, of which religion easily convinces a good soul.

Thus, upon an inquiry into the whole matter, they reckon that all our actions, and even all our virtues, terminate in pleasure, as in our chief end and greatest happiness; and they call every motion or state, either of body or mind, in which nature teaches us to delight, a pleasure. Thus they cautiously limit pleasure only to those appetites to which nature leads us; for they say that nature leads us only to those delights to which reason as well as sense carries us, and by which we neither injure any other person nor lose the possession of greater pleasures, and of such as draw no troubles after them; but they look upon those delights which men by a foolish though common mistake call pleasure, as if they could change as easily the nature of things as the use of words; as things that greatly obstruct their real

happiness, instead of advancing it, because they so entirely possess the minds of those that are once captivated by them with a false notion of pleasure, that there is no room left for pleasures of a truer or purer kind.

There are many things that in themselves have nothing that is truly delightful; on the contrary, they have a good deal of bitterness in them; and yet from our perverse appetites after forbidden objects, are not only ranked among the pleasures, but are made even the greatest designs of life. Among those who pursue these sophisticated pleasures, they reckon such as I mentioned before, who think themselves really the better for having fine clothes; in which they think they are doubly mistaken, both in the opinion that they have of their clothes, and in that they have of themselves; for if you consider the use of clothes, why should a fine thread be thought better than a coarse one? And yet these men, as if they had some real advantages beyond others, and did not owe them wholly to their mistakes, look big, seem to fancy themselves to be more valuable, and imagine that a respect is due to them for the sake of a rich garment, to which they would not have pretended if they had been more meanly clothed; and even resent it as an affront, if that respect is not paid them. It is also a great folly to be taken with outward marks of respect, which signify nothing: for what true or real pleasure can one man find in another's standing bare, or making legs to him? Will the bending another man's knees give ease to yours? And will the head's being bare cure the madness of yours? And yet it is wonderful to see how this false notion of pleasure bewitches many who delight themselves with the fancy of their nobility, and are pleased with this conceit, that they are descended from ancestors who have been held for some successions rich, and who have had great possessions; for this is all that makes nobility at present; yet they do not think themselves a whit the less noble, though their immediate parents have left none of this wealth to them, or though they themselves have squandered it away.

The Utopians have no better opinion of those who are much taken with gems and precious stones, and who account it a degree of happiness, next to a divine one, if they can purchase one that is very extraordinary; especially if it be of that sort

of stones that is then in greatest request; for the same sort is not at all times universally of the same value; nor will men buy it unless it be dismounted and taken out of the gold; the jeweller is then made to give good security, and required solemnly to swear that the stone is true, that by such an exact caution a false one might not be bought instead of a true: though if you were to examine it, your eye could find no difference between the counterfeit and that which is true; so that they are all one to you as much as if you were blind. Or can it be thought that they who heap up a useless mass of wealth, not for any use that it is to bring them, but merely to please themselves with the contemplation of it, enjoy any true pleasure in it? The delight they find is only a false shadow of joy. Those are no better whose error is somewhat different from the former, and who hide it, out of their fear of losing it; for what other name can fit the hiding it in the earth, or rather the restoring it to it again, it being thus cut off from being useful, either to its owner or to the rest of mankind? And yet the owner having hid it carefully, is glad, because he thinks he is now sure of it. If it should be stolen, the owner, though he might live perhaps ten years after the theft, of which he knew nothing, would find no difference between his having or losing it; for both ways it was equally useless to him.

Among those foolish pursuers of pleasure they reckon all that delight in hunting, in fowling, or gaming: of whose madness they have only heard, for they have no such things among them. But they have asked us, what sort of pleasure is it that men can find in throwing the dice? For if there were any pleasure in it, they think the doing of it so often should give one a surfeit of it: and what pleasure can one find in hearing the barking and howling of dogs, which seem rather odious than pleasant sounds? Nor can they comprehend the pleasure of seeing dogs run after a hare, more than of seeing one dog run after another; for if the seeing them run is that which gives the pleasure, you have the same entertainment to the eye on both these occasions, since that is the same in both cases: but if the pleasure lies in seeing the hare killed and torn by the dogs, this ought rather to stir pity, that a weak, harmless and fearful hare should be devoured by strong, fierce, and cruel dogs. Therefore all this business of hunting is, among the Utopians, turned

over to their butchers; and those, as has been already said, are all slaves; and they look on hunting as one of the basest parts of a butcher's work: for they account it both more profitable and more decent to kill those beasts that are more necessary and useful to mankind; whereas the killing and tearing of so small and miserable an animal can only attract the huntsman with a false show of pleasure, from which he can reap but small advantage. They look on the desire of the bloodshed, even of beasts, as a mark of a mind that is already corrupted with cruelty, or that at least by the frequent returns of so brutal a pleasure must degenerate into it.

Thus, though the rabble of mankind look upon these, and on innumerable other things of the same nature, as pleasures, the Utopians, on the contrary, observing that there is nothing in them truly pleasant, conclude that they are not to be reckoned among pleasures: for though these things may create some tickling in the senses (which seems to be a true notion of pleasure), yet they imagine that this does not arise from the thing itself, but from a depraved custom, which may so vitiate a man's taste, that bitter things may pass for sweet; as women with child think pitch or tallow tastes sweeter than honey; but as a man's sense when corrupted, either by a disease or some ill habit, does not change the nature of other things, so neither can it change the nature of pleasure.

They reckon up several sorts of pleasures, which they call true ones: some belong to the body and others to the mind. The pleasures of the mind lie in knowledge, and in that delight which the contemplation of truth carries with it; to which they add the joyful reflections on a well-spent life, and the assured hopes of a future happiness. They divide the pleasures of the body into two sorts; the one is that which gives our senses some real delight, and is performed, either by recruiting nature, and supplying those parts which feed the internal heat of life by eating and drinking; or when nature is eased of any surcharge that oppresses it; when we are relieved from sudden pain, or that which arises from satisfying the appetite which nature has wisely given to lead us to the propagation of the species. There is another kind of pleasure that arises neither from our receiving what the body requires, nor its being relieved when overcharged, and yet by a secret, unseen virtue affects the

senses, raises the passions, and strikes the mind with generous impressions; this is the pleasure that arises from music. Another kind of bodily pleasure is that which results from an undisturbed and vigorous constitution of body, when life and active spirits seem to actuate every part. This lively health, when entirely free from all mixture of pain, of itself gives an inward pleasure, independent of all external objects of delight; and though this pleasure does not so powerfully affect us, nor act so strongly on the senses as some of the others, yet it may be esteemed as the greatest of all pleasures, and almost all the Utopians reckon it the foundation and basis of all the other joys of life; since this alone makes the state of life easy and desirable; and when this is wanting, a man is really capable of no other pleasure. They look upon freedom from pain, if it does not rise from perfect health, to be a state of stupidity rather than of pleasure.

This subject has been very narrowly canvassed among them; and it has been debated whether a firm and entire health could be called a pleasure or not? Some have thought that there was no pleasure but what was excited by some sensible motion in the body. But this opinion has been long ago excluded from among them, so that now they almost universally agree that health is the greatest of all bodily pleasures; and that as there is a pain in sickness, which is as opposite in its nature to pleasure as sickness itself is to health, so they hold that health is accompanied with pleasure: and if any should say that sickness is not really pain, but that it only carries pain along with it, they look upon that as a fetch of subtilty, that does not much alter the matter. It is all one, in their opinion, whether it be said that health is in itself a pleasure, or that it begets a pleasure, as fire gives heat; so it be granted, that all those whose health is entire have a true pleasure in the enjoyment of it: and they reason thus—what is the pleasure of eating, but that a man's health which had been weakened, does, with the assistance of food, drive away hunger, and so recruiting itself recovers its former vigor? And being thus refreshed, it finds a pleasure in that conflict; and if the conflict is pleasure, the victory must yet breed a greater pleasure, except we fancy that it becomes stupid as soon as it has obtained that which it pursued, and so neither knows nor rejoices in its own welfare. If it is said that health

cannot be felt, they absolutely deny it; for what man is in health that does not perceive it when he is awake? Is there any man that is so dull and stupid as not to acknowledge that he feels a delight in health? And what is delight but another name for pleasure?

But of all pleasures, they esteem those to be most valuable that lie in the mind, the chief of which arises out of true virtue, and the witnesses of a good conscience. They account health the chief pleasure that belongs to the body; for they think that the pleasure of eating and drinking, and all the other delights of sense, are only so far desirable as they give or maintain health. But they are not pleasant in themselves, otherwise than as they resist those impressions that our natural infirmities are still making upon us: for as a wise man desires rather to avoid diseases than to take physic, and to be freed from pain, rather than to find ease by remedies; so it is more desirable not to need this sort of pleasure, than to be obliged to indulge it. If any man imagines that there is a real happiness in these enjoyments, he must then confess that he would be the happiest of all men if he were to lead his life in perpetual hunger, thirst, and itching, and by consequence in perpetual eating, drinking, and scratching himself; which anyone may easily see would be not only a base but a miserable state of life. These are indeed the lowest of pleasures, and the least pure; for we can never relish them, but when they are mixed with the contrary pains. The pain of hunger must give us the pleasure of eating; and here the pain out-balances the pleasure; and as the pain is more vehement, so it lasts much longer; for as it begins before the pleasure, so it does not cease but with the pleasure that extinguishes it, and both expire together.

They think, therefore, none of those pleasures is to be valued any further than as it is necessary; yet they rejoice in them, and with due gratitude acknowledge the tenderness of the great Author of nature, who has planted in us appetites, by which those things that are necessary for our preservation are likewise made pleasant to us. For how miserable a thing would life be, if those daily diseases of hunger and thirst were to be carried off by such bitter drugs as we must use for those diseases that return seldomer upon us? And thus these pleasant as well as proper gifts of nature maintain the strength and the sprightliness of our bodies.

They also entertain themselves with the other delights let in at their eyes, their ears, and their nostrils, as the pleasant relishes and seasonings of life, which nature seems to have marked out peculiarly for man; since no other sort of animals contemplates the figure and beauty of the universe; nor is delighted with smells, any further than as they distinguish meats by them; nor do they apprehend the concords or discords of sound; yet in all pleasures whatsoever they take care that a lesser joy does not hinder a greater, and that pleasure may never breed pain, which they think always follows dishonest pleasures. But they think it madness for a man to wear out the beauty of his face, or the force of his natural strength; to corrupt the sprightliness of his body by sloth and laziness, or to waste it by fasting; that it is madness to weaken the strength of his constitution, and reject the other delights of life; unless by renouncing his own satisfaction, he can either serve the public or promote the happiness of others, for which he expects a greater recompense from God. So that they look on such a course of life as the mark of a mind that is both cruel to itself, and ungrateful to the Author of nature, as if we would not be beholden to Him for His favors, and therefore reject all His blessings; as one who should afflict himself for the empty shadow of virtue; or for no better end than to render himself capable of bearing those misfortunes which possibly will never happen.

This is their notion of virtue and of pleasure; they think that no man's reason can carry him to a truer idea of them, unless some discovery from heaven should inspire him with sublimer notions. I have not now the leisure to examine whether they think right or wrong in this matter: nor do I judge it necessary, for I have only undertaken to give you an account of their constitution, but not to defend all their principles. I am sure, that whatsoever may be said of their notions, there is not in the whole world either a better people or a happier government: their bodies are vigorous and lively; and though they are but of a middle stature, and have neither the fruitfullest soil nor the purest air in the world, yet they fortify themselves so well by their temperate course of life, against the unhealthiness of their air, and by their industry they so cultivate their soil, that there is nowhere to be

seen a greater increase both of corn and cattle, nor are there anywhere healthier men and freer from diseases: for one may there see reduced to practice, not only all the arts that the husbandman employs in manuring and improving an ill soil, but whole woods plucked up by the roots, and in other places new ones planted, where there were none before.

Their principal motive for this is the convenience of carriage, that their timber may be either near their towns or growing on the banks of the sea or of some rivers, so as to be floated to them; for it is a harder work to carry wood at any distance over land, than corn. The people are industrious, apt to learn, as well as cheerful and pleasant; and none can endure more labor, when it is necessary; but except in that case they love their ease. They are unwearied pursuers of knowledge; for when we had given them some hints of the learning and discipline of the Greeks, concerning whom we only instructed them (for we know that there was nothing among the Romans, except their historians and their poets, that they would value much), it was strange to see how eagerly they were set on learning that language. We began to read a little of it to them, rather in compliance with their importunity, than out of any hopes of their reaping from it any great advantage. But after a very short trial, we found they made such progress, that we saw our labor was like to be more successful than we could have expected. They learned to write their characters and to pronounce their language so exactly, had so quick an apprehension, they remembered it so faithfully, and became so ready and correct in the use of it, that it would have looked like a miracle if the greater part of those whom we taught had not been men both of extraordinary capacity and of a fit age for instruction. They were for the greatest part chosen from among their learned men, by their chief Council, though some studied it of their own accord. In three years' time they became masters of the whole language, so that they read the best of the Greek authors very exactly. I am indeed apt to think that they learned that language the more easily, from its having some relation to their own. I believe that they were a colony of the Greeks; for though their language comes nearer the

Persian, yet they retain many names, both for their towns and magistrates, that are of Greek derivation.

I happened to carry a great many books with me, instead of merchandise, when I sailed my fourth voyage; for I was so far from thinking of soon coming back, that I rather thought never to have returned at all, and I gave them all my books, among which were many of Plato's and some of Aristotle's works. I had also Theophrastus "On Plants," which, to my great regret, was imperfect; for having laid it carelessly by, while we were at sea, a monkey had seized upon it, and in many places torn out the leaves. They have no books of grammar but Lascares, for I did not carry Theodorus with me; nor have they any dictionaries but Hesichius and Dioscorides. They esteem Plutarch highly, and were much taken with Lucian's wit and with his pleasant way of writing. As for the poets, they have Aristophanes, Homer, Euripides, and Sophocles of Aldus's edition; and for historians Thucydides, Herodotus, and Herodian. One of my companions, Thricius Apinatus, happened to carry with him some of Hippocrates's works, and Galen's "Microtechne," which they hold in great estimation; for though there is no nation in the world that needs physic so little as they do, yet there is not any that honors it so much: they reckon the knowledge of it one of the pleasantest and most profitable parts of philosophy, by which, as they search into the secrets of nature, so they not only find this study highly agreeable, but think that such inquiries are very acceptable to the Author of nature; and imagine that as He, like the inventors of curious engines among mankind, has exposed this great machine of the universe to the view of the only creatures capable of contemplating it, so an exact and curious observer, who admires His workmanship, is much more acceptable to Him than one of the herd, who, like a beast incapable of reason, looks on this glorious scene with the eyes of a dull and unconcerned spectator.

The minds of the Utopians, when fenced with a love for learning, are very ingenious in discovering all such arts as are necessary to carry it to perfection. Two things they owe to us, the manufacture of paper and the art of printing: yet they are not so entirely indebted to us for these discoveries but that a great part of the invention was their own. We showed them some books printed by Aldus, we explained to them the way of

making paper, and the mystery of printing; but as we had never practised these arts, we described them in a crude and superficial manner. They seized the hints we gave them, and though at first they could not arrive at perfection, yet by making many essays they at last found out and corrected all their errors, and conquered every difficulty. Before this they only wrote on parchment, on reeds, or on the bark of trees; but now they have established the manufacture of paper, and set up printing-presses, so that if they had but a good number of Greek authors they would be quickly supplied with many copies of them: at present, though they have no more than those I have mentioned, yet by several impressions they have multiplied them into many thousands.

If any man was to go among them that had some extraordinary talent, or that by much travelling had observed the customs of many nations (which made us to be so well received), he would receive a hearty welcome; for they are very desirous to know the state of the whole world. Very few go among them on the account of traffic, for what can a man carry to them but iron or gold or silver, which merchants desire rather to export than import to a strange country: and as for their exportation, they think it better to manage that themselves than to leave it to foreigners, for by this means, as they understand the state of the neighboring countries better, so they keep up the art of navigation, which cannot be maintained but by much practice.

Of Their Slaves, and of Their Marriages

THEY do not make slaves of prisoners of war, except those that are taken in battle; nor of the sons of their slaves, nor of those of other nations: the slaves among them are only such as are condemned to that state of life for the commission of some crime, or, which is more common, such as their merchants find condemned to die in those parts to which they trade, whom they sometimes redeem at low rates; and in other places have them for nothing. They are kept at perpetual labor, and are always chained, but with this difference, that their own natives are treated much worse than others; they are considered as more profligate than the rest, and since they could not be restrained by the advantages of so excellent an education, are

judged worthy of harder usage. Another sort of slaves are the poor of the neighboring countries, who offer of their own accord to come and serve them; they treat these better, and use them in all other respects as well as their own countrymen, except their imposing more labor upon them, which is no hard task to those that have been accustomed to it; and if any of these have a mind to go back to their own country, which indeed falls out but seldom, as they do not force them to stay, so they do not send them away empty-handed.

I have already told you with what care they look after their sick, so that nothing is left undone that can contribute either to their ease or health: and for those who are taken with fixed and incurable diseases, they use all possible ways to cherish them, and to make their lives as comfortable as possible. They visit them often, and take great pains to make their time pass off easily: but when any is taken with a torturing and lingering pain, so that there is no hope, either of recovery or ease, the priests and magistrates come and exhort them, that since they are now unable to go on with the business of life, are become a burden to themselves and to all about them, and they have really outlived themselves, they should no longer nourish such a rooted distemper, but choose rather to die, since they cannot live but in much misery: being assured, that if they thus deliver themselves from torture, or are willing that others should do it, they shall be happy after death. Since by their acting thus, they lose none of the pleasures but only the troubles of life, they think they behave not only reasonably, but in a manner consistent with religion and piety; because they follow the advice given them by their priests, who are the expounders of the will of God. Such as are wrought on by these persuasions, either starve themselves of their own accord, or take opium, and by that means die without pain. But no man is forced on this way of ending his life; and if they cannot be persuaded to it, this does not induce them to fail in their attendance and care of them; but as they believe that a voluntary death, when it is chosen upon such an authority, is very honorable, so if any man takes away his own life without the approbation of the priests and the Senate, they give him none of the honors of a decent funeral, but throw his body into a ditch.

Their women are not married before eighteen, nor their men

before two-and-twenty, and if any of them run into forbidden embraces before marriage they are severely punished, and the privilege of marriage is denied them, unless they can obtain a special warrant from the Prince. Such disorders cast a great reproach upon the master and mistress of the family in which they happen, for it is supposed that they have failed in their duty. The reason of punishing this so severely is, because they think that if they were not strictly restrained from all vagrant appetites, very few would engage in a state in which they venture the quiet of their whole lives, by being confined to one person, and are obliged to endure all the inconveniences with which it is accompanied.

In choosing their wives they use a method that would appear to us very absurd and ridiculous, but it is constantly observed among them, and is accounted perfectly consistent with wisdom. Before marriage some grave matron presents the bride naked, whether she is a virgin or a widow, to the bridegroom; and after that some grave man presents the bridegroom naked to the bride. We indeed both laughed at this, and condemned it as very indecent. But they, on the other hand, wondered at the folly of the men of all other nations, who, if they are but to buy a horse of a small value, are so cautious that they will see every part of him, and take off both his saddle and all his other tackle, that there may be no secret ulcer hid under any of them; and that yet in the choice of a wife, on which depends the happiness or unhappiness of the rest of his life, a man should venture upon trust, and only see about a hand's-breadth of the face, all the rest of the body being covered, under which there may lie hid what may be contagious as well as loathsome. All men are not so wise as to choose a woman only for her good qualities; and even wise men consider the body as that which adds not a little to the mind: and it is certain there may be some such deformity covered with the clothes as may totally alienate a man from his wife when it is too late to part from her. If such a thing is discovered after marriage, a man has no remedy but patience. They therefore think it is reasonable that there should be good provision made against such mischievous frauds.

There was so much the more reason for them to make a regulation in this matter, because they are the only people of those

parts that neither allow of polygamy nor of divorces, except in the case of adultery or insufferable perverseness; for in these cases the Senate dissolves the marriage, and grants the injured person leave to marry again; but the guilty are made infamous, and are never allowed the privilege of a second marriage. None are suffered to put away their wives against their wills, from any great calamity that may have fallen on their persons; for they look on it as the height of cruelty and treachery to abandon either of the married persons when they need most the tender care of their comfort, and that chiefly in the case of old age, which as it carries many diseases along with it, so it is a disease of itself. But it frequently falls out that when a married couple do not well agree, they by mutual consent separate, and find out other persons with whom they hope they may live more happily. Yet this is not done without obtaining leave of the Senate, which never admits of a divorce but upon a strict inquiry made, both by the Senators and their wives, into the grounds upon which it is desired; and even when they are satisfied concerning the reasons of it, they go on but slowly, for they imagine that too great easiness in granting leave for new marriages would very much shake the kindness of married people. They punish severely those that defile the marriage-bed. If both parties are married they are divorced, and the injured persons may marry one another, or whom they please; but the adulterer and the adulteress are condemned to slavery. Yet if either of the injured persons cannot shake off the love of the married person, they may live with them still in that state, but they must follow them to that labor to which the slaves are condemned; and sometimes the repentance of the condemned, together with the unshaken kindness of the innocent and injured person, has prevailed so far with the Prince that he has taken off the sentence; but those that relapse after they are once pardoned are punished with death.

Their law does not determine the punishment for other crimes; but that is left to the Senate, to temper it according to the circumstances of the fact. Husbands have power to correct their wives, and parents to chastise their children, unless the fault is so great that a public punishment is thought necessary for striking terror into others. For the most part, slavery is the punishment even of the greatest crimes; for as

that is no less terrible to the criminals themselves than death, so they think the preserving them in a state of servitude is more for the interest of the commonwealth than killing them; since as their labor is a greater benefit to the public than their death could be, so the sight of their misery is a more lasting terror to other men than that which would be given by their death. If their slaves rebel, and will not bear their yoke and submit to the labor that is enjoined them, they are treated as wild beasts that cannot be kept in order, neither by a prison nor by their chains, and are at last put to death. But those who bear their punishment patiently, and are so much wrought on by that pressure that lies so hard on them that it appears they are really more troubled for the crimes they have committed than for the miseries they suffer, are not out of hope but that at last either the Prince will, by his prerogative, or the people by their intercession, restore them again to their liberty, or at least very much mitigate their slavery. He that tempts a married woman to adultery is no less severely punished than he that commits it; for they believe that a deliberate design to commit a crime is equal to the fact itself: since its not taking effect does not make the person that miscarried in his attempt at all the less guilty.

They take great pleasure in fools, and as it is thought a base and unbecoming thing to use them ill, so they do not think it amiss for people to divert themselves with their folly: and, in their opinion, this is a great advantage to the fools themselves: for if men were so sullen and severe as not at all to please themselves with their ridiculous behavior and foolish sayings, which is all that they can do to recommend themselves to others, it could not be expected that they would be so well provided for, nor so tenderly used as they must otherwise be. If any man should reproach another for his being misshaped or imperfect in any part of his body, it would not at all be thought a reflection on the person so treated, but it would be accounted scandalous in him that had upbraided another with what he could not help. It is thought a sign of a sluggish and sordid mind not to preserve carefully one's natural beauty; but it is likewise infamous among them to use paint. They all see that no beauty recommends a wife so much to her husband as the probity of her life, and her obedience: for as some few are caught

and held only by beauty, so all are attracted by the other excellences which charm all the world.

As they fright men from committing crimes by punishments, so they invite them to the love of virtue by public honors: therefore they erect statues to the memories of such worthy men as have deserved well of their country, and set these in their market-places, both to perpetuate the remembrance of their actions, and to be an incitement to their posterity to follow their example.

If any man aspires to any office, he is sure never to compass it: they all live easily together, for none of the magistrates are either insolent or cruel to the people: they affect rather to be called fathers, and by being really so, they well deserve the name; and the people pay them all the marks of honor the more freely, because none are exacted from them. The Prince himself has no distinction, either of garments or of a crown; but is only distinguished by a sheaf of corn carried before him; as the high-priest is also known by his being preceded by a person carrying a wax light.

They have but few laws, and such is their constitution that they need not many. They very much condemn other nations, whose laws, together with the commentaries on them, swell up to so many volumes; for they think it an unreasonable thing to oblige men to obey a body of laws that are both of such a bulk and so dark as not to be read and understood by every one of the subjects.

They have no lawyers among them, for they consider them as a sort of people whose profession it is to disguise matters and to wrest the laws; and therefore they think it is much better that every man should plead his own cause, and trust it to the judge, as in other places the client trusts it to a counsellor. By this means they both cut off many delays, and find out truth more certainly: for after the parties have laid open the merits of the cause, without those artifices which lawyers are apt to suggest, the judge examines the whole matter, and supports the simplicity of such well-meaning persons, whom otherwise crafty men would be sure to run down: and thus they avoid those evils which appear very remarkably among all those nations that labor under a vast load of laws. Every one of them is skilled in their law, for as it is a very short study, so

the plainest meaning of which words are capable is always the sense of their laws. And they argue thus: all laws are promulgated for this end, that every man may know his duty; and therefore the plainest and most obvious sense of the words is that which ought to be put upon them; since a more refined exposition cannot be easily comprehended, and would only serve to make the laws become useless to the greater part of mankind, and especially to those who need most the direction of them: for it is all one, not to make a law at all, or to couch it in such terms that without a quick apprehension, and much study, a man cannot find out the true meaning of it; since the generality of mankind are both so dull and so much employed in their several trades that they have neither the leisure nor the capacity requisite for such an inquiry.

Some of their neighbors, who are masters of their own liberties, having long ago, by the assistance of the Utopians, shaken off the yoke of tyranny, and being much taken with those virtues which they observe among them, have come to desire that they would send magistrates to govern them; some changing them every year, and others every five years. At the end of their government they bring them back to Utopia, with great expressions of honor and esteem, and carry away others to govern in their stead. In this they seem to have fallen upon a very good expedient for their own happiness and safety; for since the good or ill condition of a nation depends so much upon their magistrates, they could not have made a better choice than by pitching on men whom no advantages can bias; for wealth is of no use to them, since they must so soon go back to their own country; and they being strangers among them, are not engaged in any of their heats or animosities; and it is certain that when public judicatories are swayed, either by avarice or partial affections, there must follow a dissolution of justice, the chief sinew of society.

The Utopians call those nations that come and ask magistrates from them, neighbors; but those to whom they have been of more particular service, friends. And as all other nations are perpetually either making leagues or breaking them, they never enter into an alliance with any State. They think leagues are useless things, and believe that if the common ties of humanity do not knit men together, the faith of promises will have

no great effect; and they are the more confirmed in this by what they see among the nations round about them, who are no strict observers of leagues and treaties. We know how religiously they are observed in Europe, more particularly where the Christian doctrine is received, among whom they are sacred and inviolable; which is partly owing to the justice and goodness of the princes themselves, and partly to the reverence they pay to the popes; who as they are most religious observers of their own promises, so they exhort all other princes to perform theirs; and when fainter methods do not prevail, they compel them to it by the severity of the pastoral censure, and think that it would be the most indecent thing possible if men who are particularly distinguished by the title of the "faithful" should not religiously keep the faith of their treaties. But in that newfound world, which is not more distant from us in situation than the people are in their manners and course of life, there is no trusting to leagues, even though they were made with all the pomp of the most sacred ceremonies; on the contrary, they are on this account the sooner broken, some slight pretence being found in the words of the treaties, which are purposely couched in such ambiguous terms that they can never be so strictly bound but they will always find some loophole to escape at; and thus they break both their leagues and their faith. And this is done with such impudence, that those very men who value themselves on having suggested these expedients to their princes, would with a haughty scorn declaim against such craft, or, to speak plainer, such fraud and deceit, if they found private men make use of it in their bargains, and would readily say that they deserved to be hanged.

By this means it is, that all sorts of justice passes in the world for a low-spirited and vulgar virtue, far below the dignity of royal greatness. Or at least, there are set up two sorts of justice; the one is mean, and creeps on the ground, and therefore becomes none but the lower part of mankind, and so must be kept in severely by many restraints that it may not break out beyond the bounds that are set to it. The other is the peculiar virtue of princes, which as it is more majestic than that which becomes the rabble, so takes a freer compass; and thus lawful and unlawful are only measured by pleasure and interest. These practices of the princes that lie about Utopia, who

make so little account of their faith, seem to be the reasons that determine them to engage in no confederacies; perhaps they would change their mind if they lived among us; but yet though treaties were more religiously observed, they would still dislike the custom of making them; since the world has taken up a false maxim upon it, as if there were no tie of nature uniting one nation to another, only separated perhaps by a mountain or a river, and that all were born in a state of hostility, and so might lawfully do all that mischief to their neighbors against which there is no provision made by treaties; and that when treaties are made, they do not cut off the enmity, or restrain the license of preying upon each other, if by the unskilfulness of wording them there are not effectual provisos made against them. They, on the other hand, judge that no man is to be esteemed our enemy that has never injured us; and that the partnership of the human nature is instead of a league. And that kindness and good-nature unite men more effectually and with greater strength than any agreements whatsoever; since thereby the engagements of men's hearts become stronger than the bond and obligation of words.

Of Their Military Discipline

They detest war as a very brutal thing; and which, to the reproach of human nature, is more practised by men than by any sort of beasts. They, in opposition to the sentiments of almost all other nations, think that there is nothing more inglorious than that glory that is gained by war. And therefore though they accustom themselves daily to military exercises and the discipline of war—in which not only their men but their women likewise are trained up, that in cases of necessity they may not be quite useless—yet they do not rashly engage in war, unless it be either to defend themselves, or their friends, from any unjust aggressors; or out of good-nature or in compassion assist an oppressed nation in shaking off the yoke of tyranny. They indeed help their friends, not only in defensive, but also in offensive wars; but they never do that unless they had been consulted before the breach was made, and being satisfied with the grounds on which they went, they had found that all demands of reparation were rejected, so that a war was unavoida-

ble. This they think to be not only just, when one neighbor makes an inroad on another, by public order, and carry away the spoils; but when the merchants of one country are oppressed in another, either under pretence of some unjust laws, or by the perverse wresting of good ones. This they count a juster cause of war than the other, because those injuries are done under some color of laws.

This was the only ground of that war in which they engaged with the Nephelogetes against the Aleopolitanes, a little before our time; for the merchants of the former having, as they thought, met with great injustice among the latter, which, whether it was in itself right or wrong, drew on a terrible war, in which many of their neighbors were engaged; and their keenness in carrying it on being supported by their strength in maintaining it, it not only shook some very flourishing States, and very much afflicted others, but after a series of much mischief ended in the entire conquest and slavery of the Aleopolitanes, who though before the war they were in all respects much superior to the Nephelogetes, were yet subdued; but though the Utopians had assisted them in the war, yet they pretended to no share of the spoil.

But though they so vigorously assist their friends in obtaining reparation for the injuries they have received in affairs of this nature, yet if any such frauds were committed against themselves, provided no violence was done to their persons, they would only on their being refused satisfaction forbear trading with such a people. This is not because they consider their neighbors more than their own citizens; but since their neighbors trade everyone upon his own stock, fraud is a more sensible injury to them than it is to the Utopians, among whom the public in such a case only suffers. As they expect nothing in return for the merchandise they export but that in which they so much abound, and is of little use to them, the loss does not much affect them; they think therefore it would be too severe to revenge a loss attended with so little inconvenience, either to their lives or their subsistence, with the death of many persons; but if any of their people is either killed or wounded wrongfully, whether it be done by public authority or only by private men, as soon as they hear of it they send ambassadors, and demand that the guilty persons may be delivered up to

them; and if that is denied, they declare war; but if it be complied with, the offenders are condemned either to death or slavery.

They would be both troubled and ashamed of a bloody victory over their enemies, and think it would be as foolish a purchase as to buy the most valuable goods at too high a rate. And in no victory do they glory so much as in that which is gained by dexterity and good conduct, without bloodshed. In such cases they appoint public triumphs, and erect trophies to the honor of those who have succeeded; for then do they reckon that a man acts suitably to his nature when he conquers his enemy in such a way as that no other creature but a man could be capable of, and that is by the strength of his understanding. Bears, lions, boars, wolves, and dogs, and all other animals employ their bodily force one against another, in which as many of them are superior to men, both in strength and fierceness, so they are all subdued by his reason and understanding.

The only design of the Utopians in war is to obtain that by force, which if it had been granted them in time would have prevented the war; or if that cannot be done, to take so severe a revenge on those that have injured them that they may be terrified from doing the like for the time to come. By these ends they measure all their designs, and manage them so that it is visible that the appetite of fame or vainglory does not work so much on them as a just care of their own security.

As soon as they declare war, they take care to have a great many schedules, that are sealed with their common seal, affixed in the most conspicuous places of their enemies' country. This is carried secretly, and done in many places all at once. In these they promise great rewards to such as shall kill the prince, and lesser in proportion to such as shall kill any other persons, who are those on whom, next to the prince himself, they cast the chief balance of the war. And they double the sum to him that, instead of killing the person so marked out, shall take him alive and put him in their hands. They offer not only indemnity, but rewards, to such of the persons themselves that are so marked, if they will act against their countrymen; by this means those that are named in their schedules become not only distrustful of their fellow-citizens, but are jealous of one another, and are much distracted by fear and danger; for it has

often fallen out that many of them, and even the Prince himself, have been betrayed by those in whom they have trusted most; for the rewards that the Utopians offer are so unmeasurably great, that there is no sort of crime to which men cannot be drawn by them. They consider the risk that those run who undertake such services, and offer a recompense proportioned to the danger; not only a vast deal of gold, but great revenues in lands, that lie among other nations that are their friends, where they may go and enjoy them very securely; and they observe the promises they make of this kind most religiously.

They very much approve of this way of corrupting their enemies, though it appears to others to be base and cruel; but they look on it as a wise course, to make an end of what would be otherwise a long war, without so much as hazarding one battle to decide it. They think it likewise an act of mercy and love to mankind to prevent the great slaughter of those that must otherwise be killed in the progress of the war, both on their own side and on that of their enemies, by the death of a few that are most guilty; and that in so doing they are kind even to their enemies, and pity them no less than their own people, as knowing that the greater part of them do not engage in the war of their own accord, but are driven into it by the passions of their prince.

If this method does not succeed with them, then they sow seeds of contention among their enemies, and animate the prince's brother, or some of the nobility, to aspire to the crown. If they cannot disunite them by domestic broils, then they engage their neighbors against them, and make them set on foot some old pretensions, which are never wanting to princes when they have occasion for them. These they plentifully supply with money, though but very sparingly with any auxiliary troops: for they are so tender of their own people, that they would not willingly exchange one of them, even with the prince of their enemies' country.

But as they keep their gold and silver only for such an occasion, so when that offers itself they easily part with it, since it would be no inconvenience to them though they should reserve nothing of it to themselves. For besides the wealth that they have among them at home, they have a vast treasure abroad, many nations round about them being deep in their debt: so

that they hire soldiers from all places for carrying on their wars, but chiefly from the Zapolets, who live 500 miles east of Utopia. They are a rude, wild, and fierce nation, who delight in the woods and rocks, among which they were born and bred up. They are hardened both against heat, cold, and labor, and know nothing of the delicacies of life. They do not apply themselves to agriculture, nor do they care either for their houses or their clothes. Cattle is all that they look after; and for the greatest part they live either by hunting, or upon rapine; and are made, as it were, only for war. They watch all opportunities of engaging in it, and very readily embrace such as are offered them. Great numbers of them will frequently go out, and offer themselves for a very low pay, to serve any that will employ them: they know none of the arts of life, but those that lead to the taking it away; they serve those that hire them, both with much courage and great fidelity; but will not engage to serve for any determined time, and agree upon such terms, that the next day they may go over to the enemies of those whom they serve, if they offer them a greater encouragement: and will perhaps return to them the day after that, upon a higher advance of their pay.

There are few wars in which they make not a considerable part of the armies of both sides: so it often falls out that they who are related, and were hired in the same country, and so have lived long and familiarly together, forgetting both their relations and former friendship, kill one another upon no other consideration than that of being hired to it for a little money, by princes of different interests; and such a regard have they for money, that they are easily wrought on by the difference of one penny a day to change sides. So entirely does their avarice influence them; and yet this money, which they value so highly, is of little use to them; for what they purchase thus with their blood, they quickly waste on luxury, which among them is but of a poor and miserable form.

This nation serves the Utopians against all people whatsoever, for they pay higher than any other. The Utopians hold this for a maxim, that as they seek out the best sort of men for their own use at home, so they make use of this worst sort of men for the consumption of war, and therefore they hire them with the offers of vast rewards, to expose themselves to all

sorts of hazards, out of which the greater part never returns to claim their promises. Yet they make them good most religiously to such as escape. This animates them to adventure again, whenever there is occasion for it; for the Utopians are not at all troubled how many of these happen to be killed, and reckon it a service done to mankind if they could be a means to deliver the world from such a lewd and vicious sort of people, that seem to have run together as to the drain of human nature. Next to these they are served in their wars with those upon whose account they undertake them, and with the auxiliary troops of their other friends, to whom they join a few of their own people, and send some men of eminent and approved virtue to command in chief. There are two sent with him, who during his command are but private men, but the first is to succeed him if he should happen to be either killed or taken; and in case of the like misfortune to him, the third comes in his place; and thus they provide against ill events, that such accidents as may befall their generals may not endanger their armies.

When they draw out troops of their own people, they take such out of every city as freely offer themselves, for none are forced to go against their wills, since they think that if any man is pressed that wants courage, he will not only act faintly, but by his cowardice dishearten others. But if an invasion is made on their country they make use of such men, if they have good bodies, though they are not brave; and either put them aboard their ships or place them on the walls of their towns, that being so posted they may find no opportunity of flying away; and thus either shame, the heat of action, or the impossibility of flying, bears down their cowardice; they often make a virtue of necessity and behave themselves well, because nothing else is left them. But as they force no man to go into any foreign war against his will, so they do not hinder those women who are willing to go along with their husbands; on the contrary, they encourage and praise them, and they stand often next their husbands in the front of the army. They also place together those who are related, parents and children, kindred, and those that are mutually allied, near one another; that those whom nature has inspired with the greatest zeal for assisting one another, may be the nearest and readiest to do it; and it is

matter of great reproach if husband or wife survive one another, or if a child survives his parents, and therefore when they come to be engaged in action they continue to fight to the last man, if their enemies stand before them.

And as they use all prudent methods to avoid the endangering their own men, and if it is possible let all the action and danger fall upon the troops that they hire, so if it becomes necessary for themselves to engage, they then charge with as much courage as they avoided it before with prudence: nor is it a fierce charge at first, but it increases by degrees; and as they continue in action, they grow more obstinate and press harder upon the enemy, insomuch that they will much sooner die than give ground; for the certainty that their children will be well looked after when they are dead, frees them from all that anxiety concerning them which often masters men of great courage; and thus they are animated by a noble and invincible resolution. Their skill in military affairs increases their courage; and the wise sentiments which, according to the laws of their country, are instilled into them in their education, give additional vigor to their minds: for as they do not undervalue life so as prodigally to throw it away, they are not so indecently fond of it as to preserve it by base and unbecoming methods. In the greatest heat of action, the bravest of their youth, who have devoted themselves to that service, single out the general of their enemies, set on him either openly or by ambuscade, pursue him everywhere, and when spent and wearied out, are relieved by others, who never give over the pursuit; either attacking him with close weapons when they can get near him, or with those which wound at a distance, when others get in between them; so that unless he secures himself by flight, they seldom fail at last to kill or to take him prisoner.

When they have obtained a victory, they kill as few as possible, and are much more bent on taking many prisoners than on killing those that fly before them; nor do they ever let their men so loose in the pursuit of their enemies, as not to retain an entire body still in order; so that if they have been forced to engage the last of their battalions before they could gain the day, they will rather let their enemies all escape than pursue them, when their own army is in disorder; remembering well what has often fallen out to themselves, that when the main

body of their army has been quite defeated and broken, when their enemies imagining the victory obtained, have let themselves loose into an irregular pursuit, a few of them that lay for a reserve, waiting a fit opportunity, have fallen on them in their chase, and when straggling in disorder and apprehensive of no danger, but counting the day their own, have turned the whole action, and wrestling out of their hands a victory that seemed certain and undoubted, while the vanquished have suddenly become victorious.

It is hard to tell whether they are more dexterous in laying or avoiding ambushes. They sometimes seem to fly when it is far from their thoughts; and when they intend to give ground, they do it so that it is very hard to find out their design. If they see they are ill posted, or are like to be overpowered by numbers, they then either march off in the night with great silence, or by some stratagem delude their enemies: if they retire in the daytime, they do it in such order, that it is no less dangerous to fall upon them in a retreat than in a march. They fortify their camps with a deep and large trench, and throw up the earth that is dug out of it for a wall; nor do they employ only their slaves in this, but the whole army works at it, except those that are then upon the guard; so that when so many hands are at work, a great line and a strong fortification are finished in so short a time that it is scarce credible. Their armor is very strong for defence, and yet is not so heavy as to make them uneasy in their marches; they can even swim with it. All that are trained up to war practise swimming. Both horse and foot make great use of arrows, and are very expert. They have no swords, but fight with a pole-axe that is both sharp and heavy, by which they thrust or strike down an enemy. They are very good at finding out warlike machines, and disguise them so well, that the enemy does not perceive them till he feels the use of them; so that he cannot prepare such a defence as would render them useless; the chief consideration had in the making them is that they may be easily carried and managed.

If they agree to a truce, they observe it so religiously that no provocations will make them break it. They never lay their enemies' country waste nor burn their corn, and even in their marches they take all possible care that neither horse nor foot

may tread it down, for they do not know but that they may have use for it themselves. They hurt no man whom they find disarmed, unless he is a spy. When a town is surrendered to them, they take it into their protection; and when they carry a place by storm, they never plunder it, but put those only to the sword that opposed the rendering of it up, and make the rest of the garrison slaves, but for the other inhabitants, they do them no hurt; and if any of them had advised a surrender, they give them good rewards out of the estates of those that they condemn, and distribute the rest among their auxiliary troops, but they themselves take no share of the spoil.

When a war is ended, they do not oblige their friends to reimburse their expenses; but they obtain them of the conquered, either in money, which they keep for the next occasion, or in lands, out of which a constant revenue is to be paid them; by many increases, the revenue which they draw out from several countries on such occasions, is now risen to above 700,000 ducats a year. They send some of their own people to receive these revenues, who have orders to live magnificently, and like princes, by which means they consume much of it upon the place; and either bring over the rest to Utopia, or lend it to that nation in which it lies. This they most commonly do, unless some great occasion, which falls out but very seldom, should oblige them to call for it all. It is out of these lands that they assign rewards to such as they encourage to adventure on desperate attempts. If any prince that engages in war with them is making preparations for invading their country, they prevent him, and make his country the seat of the war; for they do not willingly suffer any war to break in upon their island; and if that should happen, they would only defend themselves by their own people, but would not call for auxiliary troops to their assistance.

Of the Religions of the Utopians

THERE are several sorts of religions, not only in different parts of the island, but even in every town; some worshipping the sun, others the moon or one of the planets: some worship such men as have been eminent in former times for virtue or glory, not only as ordinary deities, but as the supreme God:

yet the greater and wiser sort of them worship none of these, but adore one eternal, invisible, infinite, and incomprehensible Deity; as a being that is far above all our apprehensions, that is spread over the whole universe, not by His bulk, but by His power and virtue; Him they call the Father of All, and acknowledge that the beginnings, the increase, the progress, the vicissitudes, and the end of all things come only from Him; nor do they offer divine honors to any but to Him alone. And indeed, though they differ concerning other things, yet all agree in this, that they think there is one Supreme Being that made and governs the world, whom they call in the language of their country Mithras. They differ in this, that one thinks the god whom he worships is this Supreme Being, and another thinks that his idol is that God; but they all agree in one principle, that whoever is this Supreme Being, He is also that great Essence to whose glory and majesty all honors are ascribed by the consent of all nations.

By degrees, they fall off from the various superstitions that are among them, and grow up to that one religion that is the best and most in request; and there is no doubt to be made but that all the others had vanished long ago, if some of those who advised them to lay aside their superstitions had not met with some unhappy accident, which being considered as inflicted by heaven, made them afraid that the God whose worship had like to have been abandoned, had interposed, and revenged themselves on those who despised their authority.

After they had heard from us an account of the doctrine, the course of life, and the miracles of Christ, and of the wonderful constancy of so many martyrs, whose blood, so willingly offered up by them, was the chief occasion of spreading their religion over a vast number of nations; it is not to be imagined how inclined they were to receive it. I shall not determine whether this proceeded from any secret inspiration of God, or whether it was because it seemed so favorable to that community of goods, which is an opinion so particular as well as so dear to them; since they perceived that Christ and his followers lived by that rule, and that it was still kept up in some communities among the sincerest sort of Christians. From whichsoever of these motives it might be, true it is that many of them came over to our religion, and were initiated

into it by baptism. But as two of our number were dead, so none of the four that survived were in priest's orders; we therefore could only baptize them; so that to our great regret they could not partake of the other sacraments, that can only be administered by priests; but they are instructed concerning them, and long most vehemently for them. They have had great disputes among themselves, whether one chosen by them to be a priest would not be thereby qualified to do all the things that belong to that character, even though he had no authority derived from the Pope; and they seemed to be resolved to choose some for that employment, but they had not done it when I left them.

Those among them that have not received our religion, do not fright any from it, and use none ill that goes over to it; so that all the while I was there, one man was only punished on this occasion. He being newly baptized, did, notwithstanding all that we could say to the contrary, dispute publicly concerning the Christian religion with more zeal than discretion; and with so much heat, that he not only preferred our worship to theirs, but condemned all their rites as profane; and cried out against all that adhered to them, as impious and sacrilegious persons, that were to be damned to everlasting burnings. Upon his having frequently preached in this manner, he was seized, and after trial he was condemned to banishment, not for having disparaged their religion, but for his inflaming the people to sedition: for this is one of their most ancient laws, that no man ought to be punished for his religion. At the first constitution of their government, Utopus having understood that before his coming among them the old inhabitants had been engaged in great quarrels concerning religion, by which they were so divided among themselves, that he found it an easy thing to conquer them, since instead of uniting their forces against him, every different party in religion fought by themselves; after he had subdued them, he made a law that every man might be of what religion he pleased, and might endeavor to draw others to it by force of argument, and by amicable and modest ways, but without bitterness against those of other opinions; but that he ought to use no other force but that of persuasion, and was neither to mix with it reproaches nor violence; and such as did otherwise were to be condemned to banishment or slavery.

This law was made by Utopus, not only for preserving the public peace, which he saw suffered much by daily contentions and irreconcilable heats, but because he thought the interest of religion itself required it. He judged it not fit to determine anything rashly, and seemed to doubt whether those different forms of religion might not all come from God, who might inspire men in a different manner, and be pleased with this variety; he therefore thought it indecent and foolish for any man to threaten and terrify another to make him believe what did not appear to him to be true. And supposing that only one religion was really true, and the rest false, he imagined that the native force of truth would at last break forth and shine bright, if supported only by the strength of argument, and attended to with a gentle and unprejudiced mind; while, on the other hand, if such debates were carried on with violence and tumults, as the most wicked are always the most obstinate, so the best and most holy religion might be choked with superstition, as corn is with briars and thorns.

He therefore left men wholly to their liberty, that they might be free to believe as they should see cause; only he made a solemn and severe law against such as should so far degenerate from the dignity of human nature as to think that our souls died with our bodies, or that the world was governed by chance, without a wise overruling Providence: for they all formerly believed that there was a state of rewards and punishments to the good and bad after this life; and they now look on those that think otherwise as scarce fit to be counted men, since they degrade so noble a being as the soul, and reckon it no better than a beast's: thus they are far from looking on such men as fit for human society, or to be citizens of a well-ordered commonwealth; since a man of such principles must needs, as oft as he dares do it, despise all their laws and customs: for there is no doubt to be made that a man who is afraid of nothing but the law, and apprehends nothing after death, will not scruple to break through all the laws of his country, either by fraud or force, when by this means he may satisfy his appetites. They never raise any that hold these maxims, either to honors or offices, nor employ them in any public trust, but despise them, as men of base and sordid minds: yet they do not punish them, because

they lay this down as a maxim that a man cannot make himself believe anything he pleases; nor do they drive any to dissemble their thoughts by threatenings, so that men are not tempted to lie or disguise their opinions; which being a sort of fraud, is abhorred by the Utopians. They take care indeed to prevent their disputing in defence of these opinions, especially before the common people; but they suffer, and even encourage them to dispute concerning them in private with their priests and other grave men, being confident that they will be cured of those mad opinions by having reason laid before them.

There are many among them that run far to the other extreme, though it is neither thought an ill nor unreasonable opinion, and therefore is not at all discouraged. They think that the souls of beasts are immortal, though far inferior to the dignity of the human soul, and not capable of so great a happiness. They are almost all of them very firmly persuaded that good men will be infinitely happy in another state; so that though they are compassionate to all that are sick, yet they lament no man's death, except they see him loth to depart with life; for they look on this as a very ill presage, as if the soul, conscious to itself of guilt, and quite hopeless, was afraid to leave the body, from some secret hints of approaching misery. They think that such a man's appearance before God cannot be acceptable to him, who being called on, does not go out cheerfully, but is backward and unwilling, and is, as it were, dragged to it. They are struck with horror when they see any die in this manner, and carry them out in silence and with sorrow, and praying God that he would be merciful to the errors of the departed soul, they lay the body in the ground; but when any die cheerfully, and full of hope, they do not mourn for them, but sing hymns when they carry out their bodies, and commending their souls very earnestly to God: their whole behavior is then rather grave than sad, they burn the body, and set up a pillar where the pile was made, with an inscription to the honor of the deceased.

When they come from the funeral, they discourse of his good life and worthy actions, but speak of nothing oftener and with more pleasure than of his serenity at the hour of death. They think such respect paid to the memory of good

men is both the greatest incitement to engage others to follow their example, and the most acceptable worship that can be offered them; for they believe that though by the imperfection of human sight they are invisible to us, yet they are present among us, and hear those discourses that pass concerning themselves. They believe it inconsistent with the happiness of departed souls not to be at liberty to be where they will, and do not imagine them capable of the ingratitude of not desiring to see those friends with whom they lived on earth in the strictest bonds of love and kindness: besides they are persuaded that good men after death have these affections and all other good dispositions increased rather than diminished, and therefore conclude that they are still among the living, and observe all they say or do. From hence they engage in all their affairs with the greater confidence of success, as trusting to their protection; while this opinion of the presence of their ancestors is a restraint that prevents their engaging in ill designs.

They despise and laugh at auguries, and the other vain and superstitious ways of divination, so much observed among other nations; but have great reverence for such miracles as cannot flow from any of the powers of nature, and look on them as effects and indications of the presence of the Supreme Being, of which they say many instances have occurred among them; and that sometimes their public prayers, which upon great and dangerous occasions they have solemnly put up to God, with assured confidence of being heard, have been answered in a miraculous manner.

They think the contemplating God in His works, and the adoring Him for them, is a very acceptable piece of worship to Him.

There are many among them, that upon a motive of religion neglect learning, and apply themselves to no sort of study; nor do they allow themselves any leisure time, but are perpetually employed, believing that by the good things that a man does he secures to himself that happiness that comes after death. Some of these visit the sick; others mend highways, cleanse ditches, repair bridges, or dig turf, gravel, or stones. Others fell and cleave timber, and bring wood, corn, and other necessaries on carts into their towns. Nor do these

only serve the public, but they serve even private men, more than the slaves themselves do; for if there is anywhere a rough, hard, and sordid piece of work to be done, from which many are frightened by the labor and loathsomeness of it, if not the despair of accomplishing it, they cheerfully, and of their own accord, take that to their share; and by that means, as they ease others very much, so they afflict themselves, and spend their whole life in hard labor; and yet they do not value themselves upon this, nor lessen other people's credit to raise their own; but by their stooping to such servile employments, they are so far from being despised, that they are so much the more esteemed by the whole nation.

Of these there are two sorts; some live unmarried and chaste, and abstain from eating any sort of flesh; and thus weaning themselves from all the pleasures of the present life, which they account hurtful, they pursue, even by the hardest and painfullest methods possible, that blessedness which they hope for hereafter; and the nearer they approach to it, they are the more cheerful and earnest in their endeavors after it. Another sort of them is less willing to put themselves to much toil, and therefore prefer a married state to a single one; and as they do not deny themselves the pleasure of it, so they think the begetting of children is a debt which they owe to human nature and to their country; nor do they avoid any pleasure that does not hinder labor, and therefore eat flesh so much the more willingly, as they find that by this means they are the more able to work; the Utopians look upon these as the wiser sect, but they esteem the others as the most holy. They would indeed laugh at any man, who from the principles of reason would prefer an unmarried state to a married, or a life of labor to an easy life; but they reverence and admire such as do it from the motives of religion. There is nothing in which they are more cautious than in giving their opinion positively concerning any sort of religion. The men that lead those severe lives are called in the language of their country Brutheskas, which answers to those we call religious orders.

Their priests are men of eminent piety, and therefore they are but few, for there are only thirteen in every town, one for every temple; but when they go to war, seven of these go out with their forces, and seven others are chosen to supply

their room in their absence; but these enter again upon their employment when they return; and those who served in their absence attend upon the high-priest, till vacancies fall by death; for there is one set over all the rest. They are chosen by the people as the other magistrates are, by suffrages given in secret, for preventing of factions; and when they are chosen they are consecrated by the College of Priests. The care of all sacred things, the worship of God, and an inspection into the manners of the people, are committed to them. It is a reproach to a man to be sent for by any of them, or for them to speak to him in secret, for that always gives some suspicion. All that is incumbent on them is only to exhort and admonish the people; for the power of correcting and punishing ill men belongs wholly to the Prince and to the other magistrates. The severest thing that the priest does is the excluding those that are desperately wicked from joining in their worship. There is not any sort of punishment more dreaded by them than this, for as it loads them with infamy, so it fills them with secret horrors, such is their reverence to their religion; nor will their bodies be long exempted from their share of trouble; for if they do not very quickly satisfy the priests of the truth of their repentance, they are seized on by the Senate, and punished for their impiety. The education of youth belongs to the priests, yet they do not take so much care of instructing them in letters as in forming their minds and manners aright; they use all possible methods to infuse very early into the tender and flexible minds of children such opinions as are both good in themselves and will be useful to their country. For when deep impressions of these things are made at that age, they follow men through the whole course of their lives, and conduce much to preserve the peace of the government, which suffers by nothing more than by vices that rise out of ill-opinions. The wives of their priests are the most extraordinary women of the whole country; sometimes the women themselves are made priests, though that falls out but seldom, nor are any but ancient widows chosen into that order.

None of the magistrates has greater honor paid him than is paid the priests; and if they should happen to commit any crime, they would not be questioned for it. Their punishment is left to God, and to their own consciences; for they do not

think it lawful to lay hands on any man, how wicked soever he is, that has been in a peculiar manner dedicated to God; nor do they find any great inconvenience in this, both because they have so few priests, and because these are chosen with much caution, so that it must be a very unusual thing to find one who merely out of regard to his virtue, and for his being esteemed a singularly good man, was raised up to so great a dignity, degenerate into corruption and vice. And if such a thing should fall out, for man is a changeable creature, yet there being few priests, and these having no authority but what rises out of the respect that is paid them, nothing of great consequence to the public can proceed from the indemnity that the priests enjoy.

They have indeed very few of them, lest greater numbers sharing in the same honor might make the dignity of that order which they esteem so highly to sink in its reputation. They also think it difficult to find out many of such an exalted pitch of goodness, as to be equal to that dignity which demands the exercise of more than ordinary virtues. Nor are the priests in greater veneration among them than they are among their neighboring nations, as you may imagine by that which I think gives occasion for it.

When the Utopians engage in battle, the priests who accompany them to the war, apparelled in their sacred vestments, kneel down during the action, in a place not far from the field; and lifting up their hands to heaven, pray, first for peace, and then for victory to their own side, and particularly that it may be gained without the effusion of much blood on either side; and when the victory turns to their side, they run in among their own men to restrain their fury; and if any of their enemies see them, or call to them, they are preserved by that means; and such as can come so near them as to touch their garments, have not only their lives, but their fortunes secured to them; it is upon this account that all the nations round about consider them so much, and treat them with such reverence, that they have been often no less able to preserve their own people from the fury of their enemies, than to save their enemies from their rage; for it has sometimes fallen out, that when their armies have been in disorder, and forced to fly, so that their enemies were running upon the slaughter and spoil,

the priests by interposing have separated them from one another, and stopped the effusion of more blood; so that by their mediation a peace has been concluded on very reasonable terms; nor is there any nation about them so fierce, cruel, or barbarous as not to look upon their persons as sacred and inviolable.

The first and the last day of the month, and of the year, is a festival. They measure their months by the course of the moon, and their years by the course of the sun. The first days are called in their language the Cynemernes, and the last the Trapemernes; which answers in our language to the festival that begins, or ends, the season.

They have magnificent temples, that are not only nobly built, but extremely spacious; which is the more necessary, as they have so few of them; they are a little dark within, which proceeds not from any error in the architecture, but is done with design; for their priests think that too much light dissipates the thoughts, and that a more moderate degree of it both recollects the mind and raises devotion. Though there are many different forms of religion among them, yet all these, how various soever, agree in the main point, which is the worshipping of the Divine Essence; and therefore there is nothing to be seen or heard in their temples in which the several persuasions among them may not agree; for every sect performs those rites that are peculiar to it, in their private houses, nor is there anything in the public worship that contradicts the particular ways of those different sects. There are no images for God in their temples, so that everyone may represent Him to his thoughts, according to the way of his religion; nor do they call this one God by any other name than that of Mithras, which is the common name by which they all express the Divine Essence, whatsoever otherwise they think it to be; nor are there any prayers among them but such as every one of them may use without prejudice to his own opinion.

They meet in their temples on the evening of the festival that concludes a season: and not having yet broke their fast, they thank God for their good success during that year or month, which is then at an end; and the next day being that which begins the new season, they meet early in their temples, to pray for the happy progress of all their affairs during that

period upon which they then enter. In the festival which concludes the period, before they go to the temple, both wives and children fall on their knees before their husbands or parents, and confess everything in which they have either erred or failed in their duty, and beg pardon for it. Thus all little discontents in families are removed, that they may offer up their devotions with a pure and serene mind; for they hold it a great impiety to enter upon them with disturbed thoughts, or with a consciousness of their bearing hatred or anger in their hearts to any person whatsoever; and think that they should become liable to severe punishments if they presumed to offer sacrifices without cleansing their hearts, and reconciling all their differences. In the temples, the two sexes are separated, the men go to the right hand, and the women to the left; and the males and females all place themselves before the head and master or mistress of that family to which they belong; so that those who have the government of them at home may see their deportment in public; and they intermingle them so, that the younger and the older may be set by one another; for if the younger sort were all set together, they would perhaps trifle away that time too much in which they ought to beget in themselves that religious dread of the Supreme Being, which is the greatest and almost the only incitement to virtue.

They offer up no living creature in sacrifice, nor do they think it suitable to the Divine Being, from whose bounty it is that these creatures have derived their lives, to take pleasure in their deaths, or the offering up of their blood. They burn incense and other sweet odors, and have a great number of wax lights during their worship; not out of any imagination that such oblations can add anything to the divine nature, which even prayers cannot do; but as it is a harmless and pure way of worshipping God, so they think those sweet savors and lights, together with some other ceremonies, by a secret and unaccountable virtue, elevate men's souls, and inflame them with greater energy and cheerfulness during the divine worship.

All the people appear in the temples in white garments, but the priest's vestments are parti-colored, and both the work and colors are wonderful. They are made of no rich materials,

for they are neither embroidered nor set with precious stones, but are composed of the plumes of several birds, laid together with so much art and so neatly, that the true value of them is far beyond the costliest materials. They say that in the ordering and placing those plumes some dark mysteries are represented, which pass down among their priests in a secret tradition concerning them; and that they are as hieroglyphics, putting them in mind of the blessings that they have received from God, and of their duties both to Him and to their neighbors. As soon as the priest appears in those ornaments, they all fall prostrate on the ground, with so much reverence and so deep a silence that such as look on cannot but be struck with it, as if it were the effect of the appearance of a deity. After they have been for some time in this posture, they all stand up, upon a sign given by the priest, and sing hymns to the honor of God, some musical instruments playing all the while. These are quite of another form than those used among us: but as many of them are much sweeter than ours, so others are made use of by us.

Yet in one thing they very much exceed us; all their music, both vocal and instrumental, is adapted to imitate and express the passions, and is so happily suited to every occasion, that whether the subject of the hymn be cheerful or formed to soothe or trouble the mind, or to express grief or remorse, the music takes the impression of whatever is represented, affects and kindles the passions, and works the sentiments deep into the hearts of the hearers. When this is done, both priests and people offer up very solemn prayers to God in a set form of words; and these are so composed, that whatsoever is pronounced by the whole assembly may be likewise applied by every man in particular to his own condition; in these they acknowledge God to be the author and governor of the world, and the fountain of all the good they receive, and therefore offer up to Him their thanksgiving; and in particular bless Him for His goodness in ordering it so that they are born under the happiest government in the world, and are of a religion which they hope is the truest of all others: but if they are mistaken, and if there is either a better government or a religion more acceptable to God, they implore Him goodness to let them know it, vowing that they resolve to follow Him

whithersoever He leads them. But if their government is the best, and their religion the truest, then they pray that He may fortify them in it, and bring all the world both to the same rules of life, and to the same opinions concerning Himself; unless, according to the unsearchableness of His mind, He is pleased with a variety of religions. Then they pray that God may give them an easy passage at last to Himself; not presuming to set limits to Him, how early or late it should be; but if it may be wished for, without derogating from His supreme authority, they desire to be quickly delivered, and to be taken to Himself, though by the most terrible kind of death, rather than to be detained long from seeing Him by the most prosperous course of life. When this prayer is ended, they all fall down again upon the ground, and after a little while they rise up, go home to dinner, and spend the rest of the day in diversion or military exercises.

Thus have I described to you, as particularly as I could, the constitution of that commonwealth, which I do not only think the best in the world, but indeed the only commonwealth that truly deserves that name. In all other places it is visible, that while people talk of a commonwealth, every man only seeks his own wealth; but there, where no man has any property, all men zealously pursue the good of the public: and, indeed, it is no wonder to see men act so differently; for in other commonwealths, every man knows that unless he provides for himself, how flourishing soever the commonwealth may be, he must die of hunger; so that he sees the necessity of preferring his own concerns to the public; but in Utopia, where every man has a right to everything, they all know that if care is taken to keep the public stores full, no private man can want anything; for among them there is no unequal distribution, so that no man is poor, none in necessity; and though no man has anything, yet they are all rich; for what can make a man so rich as to lead a serene and cheerful life, free from anxieties; neither apprehending want himself, nor vexed with the endless complaints of his wife? He is not afraid of the misery of his children, nor is he contriving how to raise a portion for his daughters, but is secure in this, that both he and his wife, his children and grandchildren, to as many generations as he can fancy, will all live both plentifully

and happily; since among them there is no less care taken of those who were once engaged in labor, but grow afterward unable to follow it, than there is elsewhere of these that continue still employed.

I would gladly hear any man compare the justice that is among them with that of all other nations; among whom, may I perish, if I see anything that looks either like justice or equity: for what justice is there in this, that a nobleman, a goldsmith, a banker, or any other man, that either does nothing at all, or at best is employed in things that are of no use to the public, should live in great luxury and splendor, upon what is so ill acquired; and a mean man, a carter, a smith, or a ploughman, that works harder even than the beasts themselves, and is employed in labors so necessary, that no commonwealth could hold out a year without them, can only earn so poor a livelihood, and must lead so miserable a life, that the condition of the beasts is much better than theirs? For as the beasts do not work so constantly, so they feed almost as well, and with more pleasure; and have no anxiety about what is to come, whilst these men are depressed by a barren and fruitless employment, and tormented with the apprehensions of want in their old age; since that which they get by their daily labor does but maintain them at present, and is consumed as fast as it comes in, there is no overplus left to lay up for old age.

Is not that government both unjust and ungrateful, that is so prodigal of its favors to those that are called gentlemen, or goldsmiths, or such others who are idle, or live either by flattery, or by contriving the arts of vain pleasure; and on the other hand, takes no care of those of a meaner sort, such as ploughmen, colliers, and smiths, without whom it could not subsist? But after the public has reaped all the advantage of their service, and they come to be oppressed with age, sickness, and want, all their labors and the good they have done is forgotten; and all the recompense given them is that they are left to die in great misery. The richer sort are often endeavoring to bring the hire of laborers lower, not only by their fraudulent practices, but by the laws which they procure to be made to that effect; so that though it is a thing most unjust in itself, to give such small rewards to those who de-

serve so well of the public, yet they have given those hardships the name and color of justice, by procuring laws to be made for regulating them.

Therefore I must say that, as I hope for mercy, I can have no other notion of all the other governments that I see or know, than that they are a conspiracy of the rich, who on pretence of managing the public only pursue their private ends, and devise all the ways and arts they can find out; first, that they may, without danger, preserve all that they have so ill acquired, and then that they may engage the poor to toil and labor for them at as low rates as possible, and oppress them as much as they please. And if they can but prevail to get these contrivances established by the show of public authority, which is considered as the representative of the whole people, then they are accounted laws. Yet these wicked men after they have, by a most insatiable covetousness, divided that among themselves with which all the rest might have been well supplied, are far from that happiness that is enjoyed among the Utopians: for the use as well as the desire of money being extinguished, much anxiety and great occasions of mischief is cut off with it. And who does not see that the frauds, thefts, robberies, quarrels, tumults, contentions, seditions, murders, treacheries, and witchcrafts, which are indeed rather punished than restrained by the severities of law, would all fall off, if money were not any more valued by the world? Men's fears, solicitudes, cares, labors, and watchings, would all perish in the same moment with the value of money: even poverty itself, for the relief of which money seems most necessary, would fall. But, in order to the apprehending this aright, take one instance.

Consider any year that has been so unfruitful that many thousands have died of hunger; and yet if at the end of that year a survey was made of the granaries of all the rich men that have hoarded up the corn, it would be found that there was enough among them to have prevented all that consumption of men that perished in misery; and that if it had been distributed among them, none would have felt the terrible effects of that scarcity; so easy a thing would it be to supply all the necessities of life, if that blessed thing called money, which is pretended to be invented for procuring them, was

not really the only thing that obstructed their being procured!

I do not doubt but rich men are sensible of this, and that they well know how much a greater happiness it is to want nothing necessary than to abound in many superfluities, and to be rescued out of so much misery than to abound with so much wealth; and I cannot think but the sense of every man's interest, added to the authority of Christ's commands, who as He was infinitely wise, knew what was best, and was not less good in discovering it to us, would have drawn all the world over to the laws of the Utopians, if pride, that plague of human nature, that source of so much misery, did not hinder it; for this vice does not measure happiness so much by its own conveniences as by the miseries of others; and would not be satisfied with being thought a goddess, if none were left that were miserable, over whom she might insult. Pride thinks its own happiness shines the brighter by comparing it with the misfortunes of other persons; that by displaying its own wealth, they may feel their poverty the more sensibly. This is that infernal serpent that creeps into the breasts of mortals, and possesses them too much to be easily drawn out; and therefore I am glad that the Utopians have fallen upon this form of government, in which I wish that all the world could be so wise as to imitate them; for they have indeed laid down such a scheme and foundation of policy, that as men live happily under it, so it is like to be of great continuance; for they having rooted out of the minds of their people all the seeds both of ambition and faction, there is no danger of any commotion at home; which alone has been the ruin of many States that seemed otherwise to be well secured; but as long as they live in peace at home, and are governed by such good laws, the envy of all their neighboring princes, who have often though in vain attempted their ruin, will never be able to put their State into any commotion or disorder.

When Raphael had thus made an end of speaking, though many things occurred to me, both concerning the manners and laws of that people, that seemed very absurd, as well in their way of making war, as in their notions of religion and divine matters; together with several other particulars, but

chiefly what seemed the foundation of all the rest, their living in common, without the use of money, by which all nobility, magnificence, splendor, and majesty, which, according to the common opinion, are the true ornaments of a nation, would be quite taken away;—yet since I perceived that Raphael was weary, and was not sure whether he could easily bear contradiction, remembering that he had taken notice of some who seemed to think they were bound in honor to support the credit of their own wisdom, by finding out something to censure in all other men's inventions, besides their own; I only commended their constitution, and the account he had given of it in general; and so taking him by the hand, carried him to supper, and told him I would find out some other time for examining this subject more particularly, and for discoursing more copiously upon it; and indeed I shall be glad to embrace an opportunity of doing it. In the meanwhile, though it must be confessed that he is both a very learned man, and a person who has obtained a great knowledge of the world, I cannot perfectly agree to everything he has related; however, there are many things in the Commonwealth of Utopia that I rather wish, than hope, to see followed in our governments.

NEW ATLANTIS

BY

FRANCIS BACON
Lord Verulam

NEW ATLANTIS

WE sailed from Peru, where we had continued by the space of one whole year, for China and Japan, by the South Sea, taking with us victuals for twelve months; and had good winds from the east, though soft and weak, for five months' space and more. But then the wind came about, and settled in the west for many days, so as we could make little or no way, and were sometimes in purpose to turn back. But then again there arose strong and great winds from the south, with a point east; which carried us up, for all that we could do, toward the north: by which time our victuals failed us, though we had made good spare of them. So that finding ourselves, in the midst of the greatest wilderness of waters in the world, without victual, we gave ourselves for lost men, and prepared for death. Yet we did lift up our hearts and voices to God above, who showeth His wonders in the deep; beseeching Him of His mercy that as in the beginning He discovered the face of the deep, and brought forth dry land, so He would now discover land to us, that we might not perish.

And it came to pass that the next day about evening we saw within a kenning before us, toward the north, as it were thick clouds, which did put us in some hope of land, knowing how that part of the South Sea was utterly unknown, and might have islands or continents that hitherto were not come to light. Wherefore we bent our course thither, where we saw the appearance of land, all that night; and in the dawning of next day we might plainly discern that it was a land flat to our sight, and full of boscage, which made it show the more dark. And after an hour and a half's sailing, we entered into a good haven, being the port of a fair city. Not great, indeed, but well built, and that gave a pleasant view from the sea. And we thinking every minute long till we were on land, came close to the shore and offered to land. But straightway we

saw divers of the people, with batons in their hands, as it were forbidding us to land: yet without any cries or fierceness, but only as warning us off, by signs that they made. Whereupon being not a little discomfited, we were advising with ourselves what we should do. During which time there made forth to us a small boat, with about eight persons in it, whereof one of them had in his hand a tipstaff of a yellow cane, tipped at both ends with blue, who made aboard our ship, without any show of distrust at all. And when he saw one of our number present himself somewhat afore the rest, he drew forth a little scroll of parchment (somewhat yellower than our parchment, and shining like the leaves of writing-tables, but otherwise soft and flexible), and delivered it to our foremost man. In which scroll were written in ancient Hebrew, and in ancient Greek, and in good Latin of the school, and in Spanish these words: " Land ye not, none of you, and provide to be gone from this coast within sixteen days, except you have further time given you; meanwhile, if you want fresh water, or victual, or help for your sick, or that your ship needeth repair, write down your wants, and you shall have that which belongeth to mercy." This scroll was signed with a stamp of cherubim's wings, not spread, but hanging downward; and by them a cross.

This being delivered, the officer returned, and left only a servant with us to receive our answer. Consulting hereupon among ourselves, we were much perplexed. The denial of landing, and hasty warning us away, troubled us much: on the other side, to find that the people had languages, and were so full of humanity, did comfort us not a little. And above all, the sign of the cross to that instrument was to us a great rejoicing, and as it were a certain presage of good. Our answer was in the Spanish tongue, " That for our ship, it was well; for we had rather met with calms and contrary winds, than any tempests. For our sick, they were many, and in very ill case; so that if they were not permitted to land, they ran in danger of their lives." Our other wants we set down in particular, adding, " That we had some little store of merchandise, which if it pleased them to deal for, it might supply our wants, without being chargeable unto them." We offered some reward in pistolets unto the servant, and a piece of crimson velvet

to be presented to the officer; but the servant took them not, nor would scarce look upon them; and so left us, and went back in another little boat which was sent for him.

About three hours after we had despatched our answer, there came toward us a person (as it seemed) of a place. He had on him a gown with wide sleeves, of a kind of water chamolet, of an excellent azure color, far more glossy than ours; his under-apparel was green, and so was his hat, being in the form of a turban, daintify made, and not so huge as the Turkish turbans; and the locks of his hair came down below the brims of it. A reverend man was he to behold. He came in a boat, gilt in some part of it, with four persons more only in that boat; and was followed by another boat, wherein were some twenty. When he was come within a flight-shot of our ship, signs were made to us that we should send forth some to meet him upon the water, which we presently did in our ship-boat, sending the principal man amongst us save one, and four of our number with him. When we were come within six yards of their boat, they called to us to stay, and not to approach farther, which we did.

And thereupon the man, whom I before described, stood up, and with a loud voice in Spanish asked, "Are ye Christians?" We answered, "We were;" fearing the less, because of the cross we had seen in the subscription. At which answer the said person lift up his right hand toward heaven, and drew it softly to his mouth (which is the gesture they use, when they thank God), and then said: "If ye will swear, all of you, by the merits of the Saviour, that ye are no pirates; nor have shed blood, lawfully or unlawfully, within forty days past; you may have license to come on land." We said, "We were all ready to take that oath." Whereupon one of those that were with him, being (as it seemed) a notary, made an entry of this act. Which done, another of the attendants of the great person, which was with him in the same boat, after his lord had spoken a little to him, said aloud: "My lord would have you know that it is not of pride, or greatness, that he cometh not aboard your ship; but for that in your answer you declare that you have many sick amongst you, he was warned by the conservator of health of the city that he should keep a distance." We bowed ourselves toward him and answered: "We were

his humble servants; and accounted for great honor and singular humanity toward us, that which was already done; but hoped well that the nature of the sickness of our men was not infectious."

So he returned; and awhile after came the notary to us aboard our ship, holding in his hand a fruit of that country, like an orange, but of color between orange-tawny and scarlet, which cast a most excellent odor. He used it (as it seemed) for a preservative against infection. He gave us our oath, " By the name of Jesus, and His merits," and after told us that the next day, by six of the clock in the morning, we should be sent to, and brought to the strangers' house (so he called it), where we should be accommodated of things, both for our whole and for our sick. So he left us; and when we offered him some pistolets, he smiling, said, " He must not be twice paid for one labor: " meaning (as I take it) that he had salary sufficient of the State for his service. For (as I after learned) they call an officer that taketh rewards twice paid.

The next morning early there came to us the same officer that came to us at first, with his cane, and told us he came to conduct us to the strangers' house; and that he had prevented the hour, because we might have the whole day before us for our business. " For," said he, " if you will follow my advice, there shall first go with me some few of you, and see the place, and how it may be made convenient for you; and then you may send for your sick, and the rest of your number which ye will bring on land." We thanked him and said, "That his care which he took of desolate strangers, God would reward." And so six of us went on land with him; and when we were on land, he went before us, and turned to us and said " he was but our servant and our guide." He led us through three fair streets; and all the way we went there were gathered some people on both sides, standing in a row; but in so civil a fashion, as if it had been, not to wonder at us, but to welcome us; and divers of them, as we passed by them, put their arms a little abroad, which is their gesture when they bid any welcome.

The strangers' house is a fair and spacious house, built of brick, of somewhat a bluer color than our brick; and with handsome windows, some of glass, some of a kind of cambric

oiled. He brought us first into a fair parlor above stairs, and then asked us "what number of persons we were? and how many sick?" We answered, "We were in all (sick and whole) one-and-fifty persons, whereof our sick were seventeen." He desired us have patience a little, and to stay till he came back to us, which was about an hour after; and then he led us to see the chambers which were provided for us, being in number nineteen. They having cast it (as it seemeth) that four of those chambers, which were better than the rest, might receive four of the principal men of our company; and lodge them alone by themselves; and the other fifteen chambers were to lodge us, two and two together. The chambers were handsome and cheerful chambers, and furnished civilly. Then he led us to a long gallery, like a dorture, where he showed us all along the one side (for the other side was but wall and window) seventeen cells, very neat ones, having partitions of cedar wood. Which gallery and cells, being in all forty (many more than we needed), were instituted as an infirmary for sick persons. And he told us withal, that as any of our sick waxed well, he might be removed from his cell to a chamber; for which purpose there were set forth ten spare chambers, besides the number we spake of before.

This done, he brought us back to the parlor, and lifting up his cane a little (as they do when they give any charge or command), said to us: "Ye are to know that the custom of the land requireth that after this day and to-morrow (which we give you for removing your people from your ship), you are to keep within doors for three days. But let it not trouble you, nor do not think yourselves restrained, but rather left to your rest and ease. You shall want nothing; and there are six of our people appointed to attend you for any business you may have abroad." We gave him thanks with all affection and respect, and said, "God surely is manifested in this land." We offered him also twenty pistolets; but he smiled, and only said: "What? Twice paid!" And so he left us. Soon after our dinner was served in; which was right good viands, both for bread and meat: better than any collegiate diet that I have known in Europe. We had also drink of three sorts, all wholesome and good: wine of the grape; a drink of grain, such as is with us our ale, but more clear; and a kind of cider

made of a fruit of that country, a wonderful pleasing and refreshing drink. Besides, there were brought in to us great store of those scarlet oranges for our sick; which (they said) were an assured remedy for sickness taken at sea. There was given us also a box of small gray or whitish pills, which they wished our sick should take, one of the pills every night before sleep; which (they said) would hasten their recovery.

The next day, after that our trouble of carriage and removing of our men and goods out of our ship was somewhat settled and quiet, I thought good to call our company together, and, when they were assembled, said unto them: " My dear friends, let us know ourselves, and how it standeth with us. We are men cast on land, as Jonas was out of the whale's belly, when we were as buried in the deep; and now we are on land, we are but between death and life, for we are beyond both the Old World and the New; and whether ever we shall see Europe, God only knoweth. It is a kind of miracle hath brought us hither, and it must be little less that shall bring us hence. Therefore in regard of our deliverance past, and our danger present and to come, let us look up to God, and every man reform his own ways. Besides, we are come here among a Christian people, full of piety and humanity. Let us not bring that confusion of face upon ourselves, as to show our vices or unworthiness before them. Yet there is more, for they have by commandment (though in form of courtesy) cloistered us within these walls for three days; who knoweth whether it be not to take some taste of our manners and conditions? And if they find them bad, to banish us straightway; if good, to give us further time. For these men that they have given us for attendance, may withal have an eye upon us. Therefore, for God's love, and as we love the weal of our souls and bodies, let us so behave ourselves as we may be at peace with God and may find grace in the eyes of this people."

Our company with one voice thanked me for my good admonition, and promised me to live soberly and civilly, and without giving any the least occasion of offence. So we spent our three days joyfully, and without care, in expectation what would be done with us when they were expired. During which time, we had every hour joy of the amendment of our sick, who thought themselves cast into some divine pool of healing, they mended so kindly and so fast.

The morrow after our three days were past, there came to us a new man, that we had not seen before, clothed in blue as the former was, save that his turban was white with a small red cross on top. He had also a tippet of fine linen. At his coming in, he did bend to us a little, and put his arms abroad. We of our parts saluted him in a very lowly and submissive manner; as looking that from him we should receive sentence of life or death. He desired to speak with some few of us. Whereupon six of us only stayed, and the rest avoided the room. He said: " I am by office, governor of this house of strangers, and by vocation, I am a Christian priest, and therefore am come to you to offer you my service, both as strangers and chiefly as Christians. Some things I may tell you, which I think you will not be unwilling to hear. The State hath given you license to stay on land for the space of six weeks; and let it not trouble you if your occasions ask further time, for the law in this point is not precise; and I do not doubt but myself shall be able to obtain for you such further time as shall be convenient. Ye shall also understand that the strangers' house is at this time rich and much aforehand; for it hath laid up revenue these thirty-seven years, for so long it is since any stranger arrived in this part; and therefore take ye no care; the State will defray you all the time you stay. Neither shall you stay one day the less for that. As for any merchandise you have brought, ye shall be well used, and have your return, either in merchandise or in gold and silver, for to us it is all one. And if you have any other request to make, hide it not; for ye shall find we will not make your countenance to fall by the answer ye shall receive. Only this I must tell you, that none of you must go above a karan [that is with them a mile and a half] from the walls of the city, without special leave."

We answered, after we had looked awhile upon one another, admiring this gracious and parent-like usage, that we could not tell what to say, for we wanted words to express our thanks; and his noble free offers left us nothing to ask. It seemed to us that we had before us a picture of our salvation in heaven; for we that were awhile since in the jaws of death, were now brought into a place where we found nothing but consolations. For the commandment laid upon us, we would

not fail to obey it, though it was impossible but our hearts should be inflamed to tread further upon this happy and holy ground. We added that our tongues should first cleave to the roofs of our mouths ere we should forget either this reverend person or this whole nation, in our prayers. We also most humbly besought him to accept of us as his true servants, by as just a right as ever men on earth were bounden; laying and presenting both our persons and all we had at his feet. He said he was a priest, and looked for a priest's reward, which was our brotherly love and the good of our souls and bodies. So he went from us, not without tears of tenderness in his eyes, and left us also confused with joy and kindness, saying among ourselves that we were come into a land of angels, which did appear to us daily, and prevent us with comforts, which we thought not of, much less expected.

The next day, about ten of the clock, the governor came to us again, and after salutations said familiarly that he was come to visit us, and called for a chair and sat him down; and we, being some ten of us (the rest were of the meaner sort or else gone abroad), sat down with him; and when we were set he began thus: "We of this island of Bensalem (for so they called it in their language) have this: that by means of our solitary situation, and of the laws of secrecy, which we have for our travellers, and our rare admission of strangers; we know well most part of the habitable world, and are ourselves unknown. Therefore because he that knoweth least is fittest to ask questions, it is more reason, for the entertainment of the time, that ye ask me questions, than that I ask you." We answered, that we humbly thanked him that he would give us leave so to do. And that we conceived by the taste we had already, that there was no worldly thing on earth more worthy to be known than the state of that happy land. But above all, we said, since that we were met from the several ends of the world, and hoped assuredly that we should meet one day in the kingdom of heaven (for that we were both parts Christians), we desired to know (in respect that land was so remote, and so divided by vast and unknown seas from the land where our Saviour walked on earth) who was the apostle of that nation, and how it was converted to the faith? It appeared in his face that he took great contentment in this our question; he said: "Ye knit my heart

to you by asking this question in the first place; for it showeth that you first seek the kingdom of heaven; and I shall gladly, and briefly, satisfy your demand.

"About twenty years after the ascension of our Saviour it came to pass, that there was seen by the people of Renfusa (a city upon the eastern coast of our island, within sight, the night was cloudy and calm), as it might be some mile in the sea, a great pillar of light; not sharp, but in form of a column, or cylinder, rising from the sea, a great way up toward heaven; and on the top of it was seen a large cross of light, more bright and resplendent than the body of the pillar. Upon which so strange a spectacle, the people of the city gathered apace together upon the sands, to wonder; and so after put themselves into a number of small boats to go nearer to this marvellous sight. But when the boats were come within about sixty yards of the pillar, they found themselves all bound, and could go no further, yet so as they might move to go about, but might not approach nearer; so as the boats stood all as in a theatre, beholding this light, as a heavenly sign. It so fell out that there was in one of the boats one of the wise men of the Society of Saloman's House (which house, or college, my good brethren, is the very eye of this kingdom), who having awhile attentively and devoutly viewed and contemplated this pillar and cross, fell down upon his face; and then raised himself upon his knees, and lifting up his hands to heaven, made his prayers in this manner:

"'Lord God of heaven and earth; thou hast vouchsafed of thy grace, to those of our order to know thy works of creation, and true secrets of them; and to discern, as far as appertaineth to the generations of men, between divine miracles, works of nature, works of art and impostures, and illusions of all sorts. I do here acknowledge and testify before this people that the thing we now see before our eyes is thy finger, and a true miracle. And forasmuch as we learn in our books that thou never workest miracles, but to a divine and excellent end (for the laws of nature are thine own laws, and thou exceedest them not but upon great cause), we most humbly beseech thee to prosper this great sign, and to give us the interpretation and use of it in mercy; which thou dost in some part secretly promise, by sending it unto us.'

"When he had made his prayer, he presently found the boat

he was in movable and unbound; whereas all the rest remained still fast; and taking that for an assurance of leave to approach, he caused the boat to be softly and with silence rowed toward the pillar; but ere he came near it, the pillar and cross of light broke up, and cast itself abroad, as it were, into a firmament of many stars, which also vanished soon after, and there was nothing left to be seen but a small ark or chest of cedar, dry and not wet at all with water, though it swam; and in the fore end of it, which was toward him, grew a small green branch of palm; and when the wise man had taken it with all reverence into his boat, it opened of itself, and there were found in it a book and a letter, both written in fine parchment, and wrapped in sindons of linen. The book contained all the canonical books of the Old and New Testament, according as you have them (for we know well what the churches with you receive), and the Apocalypse itself; and some other books of the New Testament, which were not at that time written, were nevertheless in the book. And for the letter, it was in these words:

"'I, Bartholomew, a servant of the Highest, and apostle of Jesus Christ, was warned by an angel that appeared to me in a vision of glory, that I should commit this ark to the floods of the sea. Therefore I do testify and declare unto that people where God shall ordain this ark to come to land, that in the same day is come unto them salvation and peace, and good-will from the Father, and from the Lord Jesus.'

"There was also in both these writings, as well the book as the letter, wrought a great miracle, conform to that of the apostles, in the original gift of tongues. For there being at that time, in this land, Hebrews, Persians, and Indians, besides the natives, everyone read upon the book and letter, as if they had been written in his own language. And thus was this land saved from infidelity (as the remain of the old world was from water) by an ark, through the apostolical and miraculous evangelism of St. Bartholomew." And here he paused, and a messenger came and called him forth from us. So this was all that passed in that conference.

The next day the same governor came again to us, immediately after dinner, and excused himself, saying that the day before he was called from us somewhat abruptly, but now he would make us amends, and spend time with us, if we held his

company and conference agreeable. We answered that we held it so agreeable and pleasing to us, as we forgot both dangers past, and fears to come, for the time we heard him speak; and that we thought an hour spent with him was worth years of our former life. He bowed himself a little to us, and after we were set again, he said, " Well, the questions are on your part."

One of our number said, after a little pause, that there was a matter we were no less desirous to know than fearful to ask, lest we might presume too far. But, encouraged by his rare humanity toward us (that could scarce think ourselves strangers, being his vowed and professed servants), we would take the hardness to propound it; humbly beseeching him, if he thought it not fit to be answered, that he would pardon it, though he rejected it. We said, we well observed those his words, which he formerly spake, that this happy island, where we now stood, was known to few, and yet knew most of the nations of the world, which we found to be true, considering they had the languages of Europe, and knew much of our State and business; and yet we in Europe (notwithstanding all the remote discoveries and navigations of this last age) never heard any of the least inkling or glimpse of this island. This we found wonderful strange; for that all nations have interknowledge one of another, either by voyage into foreign parts, or by strangers that come to them; and though the traveller into a foreign country doth commonly know more by the eye than he that stayeth at home can by relation of the traveller; yet both ways suffice to make a mutual knowledge, in some degree, on both parts. But for this island, we never heard tell of any ship of theirs that had been seen to arrive upon any shore of Europe; no, nor of either the East or West Indies, nor yet of any ship of any other part of the world, that had made return for them. And yet the marvel rested not in this. For the situation of it (as his lordship said) in the secret conclave of such a vast sea might cause it. But then, that they should have knowledge of the languages, books, affairs, of those that lie such a distance from them, it was a thing we could not tell what to make of; for that it seemed to us a condition and propriety of divine powers and beings, to be hidden and unseen to others, and yet to have others open, and as in a light to them.

At this speech the governor gave a gracious smile and said

that we did well to ask pardon for this question we now asked, for that it imported, as if we thought this land a land of magicians, that sent forth spirits of the air into all parts, to bring them news and intelligence of other countries. It was answered by us all, in all possible humbleness, but yet with a countenance taking knowledge, that we knew that he spake it but merrily. That we were apt enough to think there was somewhat supernatural in this island, but yet rather as angelical than magical. But to let his lordship know truly what it was that made us tender and doubtful to ask this question, it was not any such conceit, but because we remembered he had given a touch in his former speech, that this land had laws of secrecy touching strangers. To this he said, "You remember it aright; and therefore in that I shall say to you, I must reserve some particulars, which it is not lawful for me to reveal, but there will be enough left to give you satisfaction.

"You shall understand (that which perhaps you will scarce think credible) that about 3,000 years ago, or somewhat more, the navigation of the world (especially for remote voyages) was greater than at this day. Do not think with yourselves, that I know not how much it is increased with you, within these threescore years; I know it well, and yet I say, greater then than now; whether it was, that the example of the ark, that saved the remnant of men from the universal deluge, gave men confidence to venture upon the waters, or what it was; but such is the truth. The Phœnicians, and especially the Tyrians, had great fleets; so had the Carthaginians their colony, which is yet farther west. Toward the east the shipping of Egypt, and of Palestine, was likewise great. China also, and the great Atlantis (that you call America), which have now but junks and canoes, abounded then in tall ships. This island (as appeareth by faithful registers of those times) had then 1,500 strong ships, of great content. Of all this there is with you sparing memory, or none; but we have large knowledge thereof.

"At that time this land was known and frequented by the ships and vessels of all the nations before named. And (as it cometh to pass) they had many times men of other countries, that were no sailors, that came with them; as Persians, Chaldeans, Arabians, so as almost all nations of might and fame resorted hither; of whom we have some stirps and little tribes

with us at this day. And for our own ships, they went sundry voyages, as well to your straits, which you call the Pillars of Hercules, as to other parts in the Atlantic and Mediterranean seas; as to Paguin (which is the same with Cambalaine) and Quinzy, upon the Oriental seas, as far as to the borders of the East Tartary.

" At the same time, and an age after or more, the inhabitants of the great Atlantis did flourish. For though the narration and description which is made by a great man with you, that the descendants of Neptune planted there, and of the magnificent temple, palace, city, and hill; and the manifold streams of goodly navigable rivers, which as so many chains environed the same site and temple; and the several degrees of ascent, whereby men did climb up to the same, as if it had been a Scala Cœli; be all poetical and fabulous; yet so much is true, that the said country of Atlantis, as well that of Peru, then called Coya, as that of Mexico, then named Tyrambel, were mighty and proud kingdoms, in arms, shipping, and riches; so mighty, as at one time, or at least within the space of ten years, they both made two great expeditions; they of Tyrambel through the Atlantic to the Mediterranean Sea; and they of Coya, through the South Sea upon this our island; and for the former of these, which was into Europe, the same author among you, as it seemeth, had some relation from the Egyptian priest, whom he citeth. For assuredly, such a thing there was. But whether it were the ancient Athenians that had the glory of the repulse and resistance of those forces, I can say nothing; but certain it is there never came back either ship or man from that voyage. Neither had the other voyage of those of Coya upon us had better fortune, if they had not met with enemies of greater clemency. For the King of this island, by name Altabin, a wise man and a great warrior, knowing well both his own strength and that of his enemies, handled the matter so as he cut off their land forces from their ships, and entoiled both their navy and their camp with a greater power than theirs, both by sea and land; and compelled them to render themselves without striking a stroke; and after they were at his mercy, contenting himself only with their oath, that they should no more bear arms against him, dismissed them all in safety.

" But the divine revenge overtook not long after those proud

enterprises. For within less than the space of 100 years the Great Atlantis was utterly lost and destroyed; not by a great earthquake, as your man saith, for that whole tract is little subject to earthquakes, but by a particular deluge, or inundation; those countries having at this day far greater rivers, and far higher mountains to pour down waters, than any part of the old world. But it is true that the same inundation was not deep, nor past forty foot, in most places, from the ground, so that although it destroyed man and beast generally, yet some few wild inhabitants of the wood escaped. Birds also were saved by flying to the high trees and woods. For as for men, although they had buildings in many places higher than the depth of the water, yet that inundation, though it were shallow, had a long continuance, whereby they of the vale that were not drowned perished for want of food, and other things necessary. So as marvel you not at the thin population of America, nor at the rudeness and ignorance of the people; for you must account your inhabitants of America as a young people, younger a thousand years at the least than the rest of the world, for that there was so much time between the universal flood and their particular inundation.

" For the poor remnant of human seed which remained in their mountains, peopled the country again slowly, by little and little, and being simple and a savage people (not like Noah and his sons, which was the chief family of the earth), they were not able to leave letters, arts, and civility to their posterity; and having likewise in their mountainous habitations been used, in respect of the extreme cold of those regions, to clothe themselves with the skins of tigers, bears, and great hairy goats, that they have in those parts; when after they came down into the valley, and found the intolerable heats which are there, and knew no means of lighter apparel, they were forced to begin the custom of going naked, which continueth at this day. Only they take great pride and delight in the feathers of birds, and this also they took from those their ancestors of the mountains, who were invited unto it, by the infinite flight of birds, that came up to the high grounds, while the waters stood below. So you see, by this main accident of time, we lost our traffic with the Americans, with whom of all others, in regard they lay nearest to us, we had most commerce. As for the other

parts of the world, it is most manifest that in the ages following (whether it were in respect of wars, or by a natural revolution of time) navigation did everywhere greatly decay, and specially far voyages (the rather by the use of galleys, and such vessels as could hardly brook the ocean) were altogether left and omitted. So then, that part of intercourse which could be from other nations to sail to us, you see how it hath long since ceased; except it were by some rare accident, as this of yours. But now of the cessation of that other part of intercourse, which might be by our sailing to other nations, I must yield you some other cause. But I cannot say if I shall say truly, but our shipping, for number, strength, mariners, pilots, and all things that appertain to navigation, is as great as ever; and therefore why we should sit at home, I shall now give you an account by itself; and it will draw nearer, to give you satisfaction, to your principal question.

"There reigned in this land, about 1,900 years ago, a King, whose memory of all others we most adore; not superstitiously, but as a divine instrument, though a mortal man: his name was Salomana; and we esteem him as the lawgiver of our nation. This King had a large heart, inscrutable for good; and was wholly bent to make his kingdom and people happy. He, therefore, taking into consideration how sufficient and substantive this land was, to maintain itself without any aid at all of the foreigner; being 5,000 miles in circuit, and of rare fertility of soil, in the greatest part thereof; and finding also the shipping of this country might be plentifully set on work, both by fishing and by transportations from port to port, and likewise by sailing unto some small islands that are not far from us, and are under the crown and laws of this State; and recalling into his memory the happy and flourishing estate wherein this land then was, so as it might be a thousand ways altered to the worse, but scarce any one way to the better; though nothing wanted to his noble and heroical intentions, but only (as far as human foresight might reach) to give perpetuity to that which was in his time so happily established, therefore among his other fundamental laws of this kingdom he did ordain the interdicts and prohibitions which we have touching entrance of strangers; which at that time (though it was after the calamity of America) was frequent; doubting novelties and commixture of man-

ners. It is true, the like law against the admission of strangers without license is an ancient law in the Kingdom of China, and yet continued in use. But there it is a poor thing; and hath made them a curious, ignorant, fearful, foolish nation. But our lawgiver made his law of another temper. For first, he hath preserved all points of humanity, in taking order and making provision for the relief of strangers distressed; whereof you have tasted."

At which speech (as reason was) we all rose up and bowed ourselves. He went on: "That King also still desiring to join humanity and policy together; and thinking it against humanity to detain strangers here against their wills, and against policy that they should return and discover their knowledge of this estate, he took this course; he did ordain, that of the strangers that should be permitted to land, as many at all times might depart as many as would; but as many as would stay, should have very good conditions, and means to live from the State. Wherein he saw so far, that now in so many ages since the prohibition, we have memory not of one ship that ever returned, and but of thirteen persons only, at several times, that chose to return in our bottoms. What those few that returned may have reported abroad, I know not. But you must think, whatsoever they have said, could be taken where they came but for a dream. Now for our travelling from hence into parts abroad, our lawgiver thought fit altogether to restrain it. So is it not in China. For the Chinese sail where they will, or can; which showeth, that their law of keeping out strangers is a law of pusillanimity and fear. But this restraint of ours hath one only exception, which is admirable; preserving the good which cometh by communicating with strangers, and avoiding the hurt: and I will now open it to you.

"And here I shall seem a little to digress, but you will by and by find it pertinent. Ye shall understand, my dear friends, that among the excellent acts of that King, one above all hath the pre-eminence. It was the erection and institution of an order, or society, which we call Saloman's House, the noblest foundation, as we think, that ever was upon the earth, and the lantern of this kingdom. It is dedicated to the study of the works and creatures of God. Some think it beareth the founder's name a little corrupted, as if it should be Solomon's House.

But the records write it as it is spoken. So as I take it to be denominate of the King of the Hebrews, which is famous with you, and no strangers to us; for we have some parts of his works which with you are lost; namely, that natural history which he wrote of all plants, from the cedar of Libanus to the moss that groweth out of the wall; and of all things that have life and motion. This maketh me think that our King finding himself to symbolize, in many things, with that King of the Hebrews, which lived many years before him, honored him with the title of this foundation. And I am the rather induced to be of this opinion, for that I find in ancient records, this order or society is sometimes called Solomon's House, and sometimes the College of the Six Days' Works, whereby I am satisfied that our excellent King had learned from the Hebrews that God had created the world and all that therein is within six days: and therefore he instituted that house, for the finding out of the true nature of all things, whereby God might have the more glory in the workmanship of them, and men the more fruit in their use of them, did give it also that second name.

" But now to come to our present purpose. When the King had forbidden to all his people navigation into any part that was not under his crown, he made nevertheless this ordinance; that every twelve years there should be set forth out of this kingdom, two ships, appointed to several voyages; that in either of these ships there should be a mission of three of the fellows or brethren of Saloman's House, whose errand was only to give us knowledge of the affairs and state of those countries to which they were designed; and especially of the sciences, arts, manufactures, and inventions of all the world; and withal to bring unto us books, instruments, and patterns in every kind: that the ships, after they had landed the brethren, should return; and that the brethren should stay abroad till the new mission, the ships are not otherwise fraught than with store of victuals, and good quantity of treasure to remain with the brethren, for the buying of such things, and rewarding of such persons, as they should think fit. Now for me to tell you how the vulgar sort of mariners are contained from being discovered at land, and how they must be put on shore for any time, color themselves under the names of other nations, and to what places these voyages have been designed; and what places of rendez-

vous are appointed for the new missions, and the like circumstances of the practice, I may not do it, neither is it much to your desire. But thus you see we maintain a trade, not for gold, silver, or jewels, nor for silks, nor for spices, nor any other commodity of matter; but only for God's first creature, which was light; to have light, I say, of the growth of all parts of the world."

And when he had said this, he was silent, and so were we all; for indeed we were all astonished to hear so strange things so probably told. And he perceiving that we were willing to say somewhat, but had it not ready, in great courtesy took us off, and descended to ask us questions of our voyage and fortunes, and in the end concluded that we might do well to think with ourselves what time of stay we would demand of the State, and bade us not to scant ourselves; for he would procure such time as we desired. Whereupon we all rose up and presented ourselves to kiss the skirt of his tippet, but he would not suffer us, and so took his leave. But when it came once among our people that the State used to offer conditions to strangers that would stay, we had work enough to get any of our men to look to our ship, and to keep them from going presently to the governor to crave conditions; but with much ado we restrained them, till we might agree what course to take.

We took ourselves now for freemen, seeing there was no danger of our utter perdition, and lived most joyfully, going abroad and seeing what was to be seen in the city and places adjacent, within our tedder; and obtaining acquaintance with many of the city, not of the meanest quality, at whose hands we found such humanity, and such a freedom and desire to take strangers, as it were, into their bosom, as was enough to make us forget all that was dear to us in our own countries; and continually we met with many things, right worthy of observation and relation; as indeed, if there be a mirror in the world, worthy to hold men's eyes, it is that country. One day there were two of our company bidden to a feast of the family, as they call it; a most natural, pious, and reverend custom it is, showing that nation to be compounded of all goodness. This is the manner of it; it is granted to any man that shall live to see thirty persons descended of his body, alive together, and all above three years old, to make this feast, which is done at the cost of the

State. The father of the family, whom they call the tirsan, two days before the feast, taketh to him three of such friends as he liketh to choose, and is assisted also by the governor of the city or place where the feast is celebrated; and all the persons of the family, of both sexes, are summoned to attend him. These two days the tirsan sitteth in consultation, concerning the good estate of the family. There, if there be any discord or suits between any of the family, they are compounded and appeased. There, if any of the family be distressed or decayed, order is taken for their relief, and competent means to live. There, if any be subject to vice, or take ill-courses, they are reproved and censured. So, likewise, direction is given touching marriages, and the courses of life which any of them should take, with divers other the like orders and advices. The governor sitteth to the end, to put in execution, by his public authority, the decrees and orders of the tirsan, if they should be disobeyed, though that seldom needeth; such reverence and obedience they give to the order of nature.

The tirsan doth also then ever choose one man from among his sons, to live in house with him, who is called ever after the Son of the Vine. The reason will hereafter appear. On the feast day, the father, or tirsan, cometh forth after divine service into a large room where the feast is celebrated; which room hath a half-pace at the upper end. Against the wall, in the middle of the half-pace, is a chair placed for him, with a table and carpet before it. Over the chair is a state, made round or oval, and it is of ivy; an ivy somewhat whiter than ours, like the leaf of a silver-asp, but more shining; for it is green all winter. And the state is curiously wrought with silver and silk of divers colors, broiding or binding in the ivy; and is ever of the work of some of the daughters of the family, and veiled over at the top, with a fine net of silk and silver. But the substance of it is true ivy; whereof after it is taken down, the friends of the family are desirous to have some leaf or sprig to keep. The tirsan cometh forth with all his generation or lineage, the males before him, and the females following him; and if there be a mother, from whose body the whole lineage is descended, there is a traverse placed in a loft above on the right hand of the chair, with a privy door, and a carved window of glass, leaded with gold and blue; where she sitteth, but is not seen.

When the tirsan is come forth, he sitteth down in the chair; and all the lineage place themselves against the wall, both at his back, and upon the return of the half-pace, in order of their years, without difference of sex, and stand upon their feet. When he is set, the room being always full of company, but well kept and without disorder, after some pause there cometh in from the lower end of the room a taratan (which is as much as a herald), and on either side of him two young lads: whereof one carrieth a scroll of their shining yellow parchment, and the other a cluster of grapes of gold, with a long foot or stalk. The herald and children are clothed with mantles of sea-water-green satin; but the herald's mantle is streamed with gold, and hath a train. Then the herald with three courtesies, or rather inclinations, cometh up as far as the half-pace, and there first taketh into his hand the scroll. This scroll is the King's charter, containing gift of revenue, and many privileges, exemptions, and points of honor, granted to the father of the family; and it is ever styled and directed, " To such an one, our well-beloved friend and creditor," which is a title proper only to this case. For they say, the King is debtor to no man, but for propagation of his subjects; the seal set to the King's charter is the King's image, embossed or moulded in gold; and though such charters be expedited of course, and as of right, yet they are varied by discretion, according to the number and dignity of the family. This charter the herald readeth aloud; and while it is read, the father, or tirsan, standeth up, supported by two of his sons, such as he chooseth.

Then the herald mounteth the half-pace, and delivereth the charter into his hand: and with that there is an acclamation, by all that are present, in their language, which is thus much, " Happy are the people of Bensalem." Then the herald taketh into his hand from the other child the cluster of grapes, which is of gold; both the stalk, and the grapes. But the grapes are daintily enamelled; and if the males of the family be the greater number, the grapes are enamelled purple, with a little sun set on the top; if the females, then they are enamelled into a greenish yellow, with a crescent on the top. The grapes are in number as many as there are descendants of the family. This golden cluster the herald delivereth also to the tirsan; who presently delivereth it over to that son that he had formerly

chosen, to be in house with him: who beareth it before his father, as an ensign of honor, when he goeth in public ever after; and is thereupon called the Son of the Vine. After this ceremony ended the father, or tirsan, retireth, and after some time cometh forth again to dinner, where he sitteth alone under the state, as before; and none of his descendants sit with him, of what degree or dignity so ever, except he hap to be of Saloman's House. He is served only by his own children, such as are male; who perform unto him all service of the table upon the knee, and the women only stand about him, leaning against the wall. The room below his half-pace hath tables on the sides for the guests that are bidden; who are served with great and comely order; and toward the end of dinner (which in the greatest feasts with them lasteth never above an hour and a half) there is a hymn sung, varied according to the invention of him that composeth it (for they have excellent poesy), but the subject of it is always the praises of Adam, and Noah, and Abraham; whereof the former two peopled the world, and the last was the father of the faithful: concluding ever with a thanksgiving for the nativity of our Saviour, in whose birth the births of all are only blessed.

Dinner being done, the tirsan retireth again; and having withdrawn himself alone into a place, where he maketh some private prayers, he cometh forth the third time, to give the blessing; with all his descendants, who stand about him as at the first. Then he calleth them forth by one and by one, by name as he pleaseth, though seldom the order of age be inverted. The person that is called (the table being before removed) kneeleth down before the chair, and the father layeth his hand upon his head, or her head, and giveth the blessing in these words: "Son of Bensalem (or daughter of Bensalem), thy father saith it; the man by whom thou hast breath and life speaketh the word; the blessing of the everlasting Father, the Prince of Peace, and the Holy Dove be upon thee, and make the days of thy pilgrimage good and many." This he saith to every of them; and that done, if there be any of his sons of eminent merit and virtue, so they be not above two, he calleth for them again, and saith, laying his arm over their shoulders, they standing: "Sons, it is well you are born, give God the praise, and persevere to the end;" and withal delivereth to either of

them a jewel, made in the figure of an ear of wheat, which they ever after wear in the front of their turban, or hat; this done, they fall to music and dances, and other recreations, after their manner, for the rest of the day. This is the full order of that feast.

By that time six or seven days were spent, I was fallen into straight acquaintance with a merchant of that city, whose name was Joabin. He was a Jew and circumcised; for they have some few stirps of Jews yet remaining among them, whom they leave to their own religion. Which they may the better do, because they are of a far differing disposition from the Jews in other parts. For whereas they hate the name of Christ, and have a secret inbred rancor against the people among whom they live; these, contrariwise, give unto our Saviour many high attributes, and love the nation of Bensalem extremely. Surely this man of whom I speak would ever acknowledge that Christ was born of a Virgin; and that he was more than a man; and he would tell how God made him ruler of the seraphim, which guard his throne; and they call him also the Milken Way, and the Eliah of the Messiah, and many other high names, which though they be inferior to his divine majesty, yet they are far from the language of other Jews. And for the country of Bensalem, this man would make no end of commending it, being desirous by tradition among the Jews there to have it believed that the people thereof were of the generations of Abraham, by another son, whom they call Nachoran; and that Moses by a secret cabala ordained the laws of Bensalem which they now use; and that when the Messias should come, and sit in his throne at Hierusalem, the King of Bensalem should sit at his feet, whereas other kings should keep a great distance. But yet setting aside these Jewish dreams, the man was a wise man and learned, and of great policy and excellently seen in the laws and customs of that nation.

Among other discourses one day I told him, I was much affected with the relation I had from some of the company of their custom in holding the feast of the family, for that, methought, I had never heard of a solemnity wherein nature did so much preside. And because propagation of families proceedeth from the nuptial copulation, I desired to know of him what laws and customs they had concerning marriage, and

whether they kept marriage well, and whether they were tied to one wife? For that where population is so much affected, and such as with them it seemed to be, there is commonly permission of plurality of wives. To this he said:

"You have reason for to commend that excellent institution of the feast of the family; and indeed we have experience, that those families that are partakers of the blessings of that feast, do flourish and prosper ever after, in an extraordinary manner. But hear me now, and I will tell you what I know. You shall understand that there is not under the heavens so chaste a nation as this of Bensalem, nor so free from all pollution or foulness. It is the virgin of the world; I remember, I have read in one of your European books, of a holy hermit among you, that desired to see the spirit of fornication, and there appeared to him a little foul ugly Ethiope; but if he had desired to see the spirit of chastity of Bensalem, it would have appeared to him in the likeness of a fair beautiful cherub. For there is nothing, among mortal men, more fair and admirable than the chaste minds of this people.

"Know, therefore, that with them there are no stews, no dissolute houses, no courtesans, nor anything of that kind. Nay, they wonder, with detestation, at you in Europe, which permit such things. They say ye have put marriage out of office; for marriage is ordained a remedy for unlawful concupiscence; and natural concupiscence seemeth as a spur to marriage. But when men have at hand a remedy, more agreeable to their corrupt will, marriage is almost expulsed. And therefore there are with you seen infinite men that marry not, but choose rather a libertine and impure single life, than to be yoked in marriage; and many that do marry, marry late, when the prime and strength of their years are past. And when they do marry, what is marriage to them but a very bargain; wherein is sought alliance, or portion, or reputation, with some desire (almost indifferent) of issue; and not the faithful nuptial union of man and wife, that was first instituted. Neither is it possible that those that have cast away so basely so much of their strength, should greatly esteem children (being of the same matter) as chaste men do. So likewise during marriage is the case much amended, as it ought to be if those things were tolerated only for necessity; no, but they remain still as a very affront to marriage.

"The haunting of those dissolute places, or resort to courtesans, are no more punished in married men than in bachelors. And the depraved custom of change, and the delight in meretricious embracements (where sin is turned into art), maketh marriage a dull thing, and a kind of imposition or tax. They hear you defend these things, as done to avoid greater evils; as advoutries, deflowering of virgins, unnatural lust, and the like. But they say this is a preposterous wisdom; and they call it Lot's offer, who to save his guests from abusing, offered his daughters; nay, they say further, that there is little gained in this; for that the same vices and appetites do still remain and abound, unlawful lust being like a furnace, that if you stop the flames altogether it will quench, but if you give it any vent it will rage; as for masculine love, they have no touch of it; and yet there are not so faithful and inviolate friendships in the world again as are there, and to speak generally (as I said before) I have not read of any such chastity in any people as theirs. And their usual saying is that whosoever is unchaste cannot reverence himself; and they say that the reverence of a man's self, is, next religion, the chiefest bridle of all vices."

And when he had said this the good Jew paused a little; whereupon I, far more willing to hear him speak on than to speak myself; yet thinking it decent that upon his pause of speech I should not be altogether silent, said only this; that I would say to him, as the widow of Sarepta said to Elias: "that he was come to bring to memory our sins;" and that I confess the righteousness of Bensalem was greater than the righteousness of Europe. At which speech he bowed his head, and went on this manner:

"They have also many wise and excellent laws, touching marriage. They allow no polygamy. They have ordained that none do intermarry, or contract, until a month be past from their first interview. Marriage without consent of parents they do not make void, but they mulct it in the inheritors; for the children of such marriages are not admitted to inherit above a third part of their parents' inheritance. I have read in a book of one of your men, of a feigned commonwealth, where the married couple are permitted, before they contract, to see one another naked. This they dislike; for they think it a scorn to give a refusal after so familiar knowledge; but because of many

hidden defects in men and women's bodies, they have a more civil way; for they have near every town a couple of pools (which they call Adam and Eve's pools), where it is permitted to one of the friends of the man, and another of the friends of the woman, to see them severally bathe naked."

And as we were thus in conference, there came one that seemed to be a messenger, in a rich huke, that spake with the Jew; whereupon he turned to me, and said, "You will pardon me, for I am commanded away in haste." The next morning he came to me again, joyful as it seemed, and said: "There is word come to the governor of the city, that one of the fathers of Salomon's House will be here this day seven-night; we have seen none of them this dozen years. His coming is in state; but the cause of this coming is secret. I will provide you and your fellows of a good standing to see his entry." I thanked him, and told him I was most glad of the news.

The day being come he made his entry. He was a man of middle stature and age, comely of person, and had an aspect as if he pitied men. He was clothed in a robe of fine black cloth and wide sleeves, and a cape: his under-garment was of excellent white linen down to the foot, girt with a girdle of the same; and a sindon or tippet of the same about his neck. He had gloves that were curious, and set with stone; and shoes of peach-colored velvet. His neck was bare to the shoulders. His hat was like a helmet, or Spanish montero; and his locks curled below it decently; they were of color brown. His beard was cut round and of the same color with his hair, somewhat lighter. He was carried in a rich chariot, without wheels, litter-wise, with two horses at either end, richly trapped in blue velvet embroidered; and two footmen on each side in the like attire. The chariot was all of cedar, gilt and adorned with crystal; save that the fore end had panels of sapphires set in borders of gold, and the hinder end the like of emeralds of the Peru color. There was also a sun of gold, radiant upon the top, in the midst; and on the top before a small cherub of gold, with wings displayed. The chariot was covered with cloth-of-gold tissued upon blue. He had before him fifty attendants, young men all, in white satin loose coats up to the mid-leg, and stockings of white silk; and shoes of blue velvet; and hats of blue velvet, with fine plumes of divers colors, set round like

hat-bands. Next before the chariot went two men, bare-headed, in linen garments down to the foot, girt, and shoes of blue velvet, who carried the one a crosier, the other a pastoral staff like a sheep-hook; neither of them of metal, but the crosier of balm-wood, the pastoral staff of cedar. Horsemen he had none, neither before nor behind his chariot; as it seemeth, to avoid all tumult and trouble. Behind his chariot went all the officers and principals of the companies of the city. He sat alone, upon cushions, of a kind of excellent plush, blue; and under his foot curious carpets of silk of divers colors, like the Persian, but far finer. He held up his bare hand, as he went, as blessing the people, but in silence. The street was wonderfully well kept; so that there was never any army had their men stand in better battle-array than the people stood. The windows likewise were not crowded, but everyone stood in them, as if they had been placed.

When the show was passed, the Jew said to me, " I shall not be able to attend you as I would, in regard of some charge the city hath laid upon me for the entertaining of this great person." Three days after the Jew came to me again, and said: " Ye are happy men; for the father of Salomon's House taketh knowledge of your being here, and commanded me to tell you that he will admit all your company to his presence, and have private conference with one of you, that ye shall choose; and for this hath appointed the next day after to-morrow. And because he meaneth to give you his blessing, he hath appointed it in the forenoon." We came at our day and hour, and I was chosen by my fellows for the private access. We found him in a fair chamber, richly hanged, and carpeted under foot, without any degrees to the state; he was set upon a low throne richly adorned, and a rich cloth of state over his head of blue satin embroidered. He was alone, save that he had two pages of honor, on either hand one, finely attired in white. His undergarments were the like that we saw him wear in the chariot; but instead of his gown, he had on him a mantle with a cape, of the same fine black, fastened about him. When we came in, as we were taught, we bowed low at our first entrance; and when we were come near his chair, he stood up, holding forth his hand ungloved, and in posture of blessing; and we every one of us stooped down and kissed the end of his tippet. That

done, the rest departed, and I remained. Then he warned the pages forth of the room, and caused me to sit down beside him, and spake to me thus in the Spanish tongue:
"God bless thee, my son; I will give thee the greatest jewel I have. For I will impart unto thee, for the love of God and men, a relation of the true state of Salomon's House. Son, to make you know the true state of Salomon's House, I will keep this order. First, I will set forth unto you the end of our foundation. Secondly, the preparations and instruments we have for our works. Thirdly, the several employments and functions whereto our fellows are assigned. And fourthly, the ordinances and rites which we observe.

"The end of our foundation is the knowledge of causes, and secret motions of things; and the enlarging of the bounds of human empire, to the effecting of all things possible.

"The preparations and instruments are these: We have large and deep caves of several depths; the deepest are sunk 600 fathoms; and some of them are digged and made under great hills and mountains; so that if you reckon together the depth of the hill and the depth of the cave, they are, some of them, above three miles deep. For we find that the depth of a hill and the depth of a cave from the flat are the same thing; both remote alike from the sun and heaven's beams, and from the open air. These caves we call the lower region. And we use them for all coagulations, indurations, refrigerations, and conservations of bodies. We use them likewise for the imitation of natural mines and the producing also of new artificial metals, by compositions and materials which we use and lay there for many years. We use them also sometimes (which may seem strange) for curing of some diseases, and for prolongation of life, in some hermits that choose to live there, well accommodated of all things necessary, and indeed live very long; by whom also we learn many things.

"We have burials in several earths, where we put divers cements, as the Chinese do their porcelain. But we have them in greater variety, and some of them more fine. We also have great variety of composts and soils, for the making of the earth fruitful.

"We have high towers, the highest about half a mile in height, and some of them likewise set upon high mountains,

so that the vantage of the hill with the tower is in the highest of them three miles at least. And these places we call the upper region, account the air between the high places and the low as a middle region. We use these towers, according to their several heights and situations, for insulation, refrigeration, conservation, and for the view of divers meteors—as winds, rain, snow, hail, and some of the fiery meteors also. And upon them in some places are dwellings of hermits, whom we visit sometimes and instruct what to observe.

"We have great lakes, both salt and fresh, whereof we have use for the fish and fowl. We use them also for burials of some natural bodies, for we find a difference in things buried in earth, or in air below the earth, and things buried in water. We have also pools, of which some do strain fresh water out of salt, and others by art do turn fresh water into salt. We have also some rocks in the midst of the sea, and some bays upon the shore for some works, wherein are required the air and vapor of the sea. We have likewise violent streams and cataracts, which serve us for many motions; and likewise engines for multiplying and enforcing of winds to set also on divers motions.

"We have also a number of artificial wells and fountains, made in imitation of the natural sources and baths, as tincted upon vitriol, sulphur, steel, brass, lead, nitre, and other minerals; and again, we have little wells for infusions of many things, where the waters take the virtue quicker and better than in vessels or basins. And among them we have a water, which we call water of paradise, being by that we do it made very sovereign for health and prolongation of life.

"We have also great and spacious houses, where we imitate and demonstrate meteors—as snow, hail, rain, some artificial rains of bodies and not of water, thunders, lightnings; also generations of bodies in air—as frogs, flies, and divers others.

"We have also certain chambers, which we call chambers of health, where we qualify the air as we think good and proper for the cure of divers diseases and preservation of health.

"We have also fair and large baths, of several mixtures, for the cure of diseases, and the restoring of man's body from arefaction; and others for the confirming of it in strength of sinews, vital parts, and the very juice and substance of the body.

"We have also large and various orchards and gardens,

wherein we do not so much respect beauty as variety of ground and soil, proper for divers trees and herbs, and some very spacious, where trees and berries are set, whereof we make divers kinds of drinks, beside the vineyards. In these we practise likewise all conclusions of grafting, and inoculating, as well of wild-trees as fruit-trees, which produceth many effects. And we make by art, in the same orchards and gardens, trees and flowers, to come earlier or later than their seasons, and to come up and bear more speedily than by their natural course they do. We make them also by art greater much than their nature; and their fruit greater and sweeter, and of differing taste, smell, color, and figure, from their nature. And many of them we so order as that they become of medicinal use.

" We have also means to make divers plants rise by mixtures of earths without seeds, and likewise to make divers new plants, differing from the vulgar, and to make one tree or plant turn into another.

" We have also parks, and enclosures of all sorts, of beasts and birds; which we use not only for view or rareness, but likewise for dissections and trials, that thereby may take light what may be wrought upon the body of man. Wherein we find many strange effects: as continuing life in them, though divers parts, which you account vital, be perished and taken forth; resuscitating of some that seem dead in appearance, and the like. We try also all poisons, and other medicines upon them, as well of chirurgery as physic. By art likewise we make them greater or smaller than their kind is, and contrariwise dwarf them and stay their growth; we make them more fruitful and bearing than their kind is, and contrariwise barren and not generative. Also we make them differ in color, shape, activity, many ways. We find means to make commixtures and copulations of divers kinds, which have produced many new kinds, and them not barren, as the general opinion is. We make a number of kinds of serpents, worms, flies, fishes of putrefaction, whereof some are advanced (in effect) to be perfect creatures, like beasts or birds, and have sexes, and do propagate. Neither do we this by chance, but we know beforehand of what matter and commixture, what kind of those creatures will arise.

" We have also particular pools where we make trials upon fishes, as we have said before of beasts and birds.

"We have also places for breed and generation of those kinds of worms and flies which are of special use; such as are with you your silkworms and bees.

"I will not hold you long with recounting of our brew-houses, bake-houses, and kitchens, where are made divers drinks, breads, and meats, rare and of special effects. Wines we have of grapes, and drinks of other juice, of fruits, of grains, and of roots, and of mixtures with honey, sugar, manna, and fruits dried and decocted; also of the tears or wounding of trees and of the pulp of canes. And these drinks are of several ages, some to the age or last of forty years. We have drinks also brewed with several herbs and roots and spices; yea, with several fleshes and white meats; whereof some of the drinks are such as they are in effect meat and drink both, so that divers, especially in age, do desire to live with them with little or no meat or bread. And above all we strive to have drinks of extreme thin parts, to insinuate into the body, and yet without all biting, sharpness, or fretting; insomuch as some of them put upon the back of your hand, will with a little stay pass through to the palm, and yet taste mild to the mouth. We have also waters, which we ripen in that fashion, as they become nourishing, so that they are indeed excellent drinks, and many will use no other. Bread we have of several grains, roots, and kernels; yea, and some of flesh, and fish, dried; with divers kinds of leavings and seasonings; so that some do extremely move appetites, some do nourish so as divers do live of them, without any other meat, who live very long. So for meats, we have some of them so beaten, and made tender, and mortified, yet without all corrupting, as a weak heat of the stomach will turn them into good chilus, as well as a strong heat would meat otherwise prepared. We have some meats also and bread, and drinks, which, taken by men, enable them to fast long after; and some other, that used make the very flesh of men's bodies sensibly more hard and tough, and their strength far greater than otherwise it would be.

"We have dispensatories or shops of medicines; wherein you may easily think, if we have such variety of plants, and living creatures, more than you have in Europe (for we know what you have), the simples, drugs, and ingredients of medicines, must likewise be in so much the greater variety. We have

them likewise of divers ages, and long fermentations. And for their preparations, we have not only all manner of exquisite distillations, and separations, and especially by gentle heats, and percolations through divers strainers, yea, and substances; but also exact forms of composition, whereby they incorporate almost as they were natural simples.

" We have also divers mechanical arts, which you have not; and stuffs made by them, as papers, linen, silks, tissues, dainty works of feathers of wonderful lustre, excellent dyes, and many others, and shops likewise as well for such as are not brought into vulgar use among us, as for those that are. For you must know, that of the things before recited, many of them are grown into use throughout the kingdom, but yet, if they did flow from our invention, we have of them also for patterns and principals.

" We have also furnaces of great diversities, and that keep great diversity of heats; fierce and quick, strong and constant, soft and mild, blown, quiet, dry, moist, and the like. But above all we have heats, in imitation of the sun's and heavenly bodies' heats, that pass divers inequalities, and as it were orbs, progresses, and returns whereby we produce admirable effects. Besides, we have heats of dungs, and of bellies and maws of living creatures and of their bloods and bodies, and of hays and herbs laid up moist, of lime unquenched, and such like. Instruments also which generate heat only by motion. And farther, places for strong insulations; and, again, places under the earth, which by nature or art yield heat. These divers heats we use as the nature of the operation which we intend requireth.

" We have also perspective houses, where we make demonstrations of all lights and radiations and of all colors; and out of things uncolored and transparent we can represent unto you all several colors, not in rainbows, as it is in gems and prisms, but of themselves single. We represent also all multiplications of light, which we carry to great distance, and make so sharp as to discern small points and lines. Also all colorations of light: all delusions and deceits of the sight, in figures, magnitudes, motions, colors; all demonstrations of shadows. We find also divers means, yet unknown to you, of producing of light, originally from divers bodies. We procure means of seeing objects afar off, as in the heaven and remote places; and represent things near as afar off, and things afar off as near;

making feigned distances. We have also helps for the sight far above spectacles and glasses in use; we have also glasses and means to see small and minute bodies, perfectly and distinctly; as the shapes and colors of small flies and worms, grains, and flaws in gems which cannot otherwise be seen, observations in urine and blood not otherwise to be seen. We make artificial rainbows, halos, and circles about light. We represent also all manner of reflections, refractions, and multiplications of visual beams of objects.

" We have also precious stones, of all kinds, many of them of great beauty and to you unknown; crystals likewise, and glasses of divers kind; and among them some of metals vitrificated, and other materials, besides those of which you make glass. Also a number of fossils and imperfect minerals, which you have not. Likewise loadstones of prodigious virtue, and other rare stones, both natural and artificial.

" We have also sound-houses, where we practise and demonstrate all sounds and their generation. We have harmony which you have not, of quarter-sounds and lesser slides of sounds. Divers instruments of music likewise to you unknown, some sweeter than any you have; with bells and rings that are dainty and sweet. We represent small sounds as great and deep, likewise great sounds extenuate and sharp; we make divers tremblings and warblings of sounds, which in their original are entire. We represent and imitate all articulate sounds and letters, and the voices and notes of beasts and birds. We have certain helps which, set to the ear, do further the hearing greatly; we have also divers strange and artificial echoes, reflecting the voice many times, and, as it were, tossing it; and some that give back the voice louder than it came, some shriller and some deeper; yea, some rendering the voice, differing in the letters or articulate sound from that they receive. We have all means to convey sounds in trunks and pipes, in strange lines and distances.

" We have also perfume-houses, wherewith we join also practices of taste. We multiply smells which may seem strange: we imitate smells, making all smells to breathe out of other mixtures than those that give them. We make divers imitations of taste likewise, so that they will deceive any man's taste. And in this house we contain also a confiture-house,

where we make all sweatmeats, dry and moist, and divers pleasant wines, milks, broths, and salads, far in greater variety than you have.

"We have also engine-houses, where are prepared engines and instruments for all sorts of motions. There we imitate and practise to make swifter motions than any you have, either out of your muskets or any engine that you have; and to make them and multiply them more easily and with small force, by wheels and other means, and to make them stronger and more violent than yours are, exceeding your greatest cannons and basilisks. We represent also ordnance and instruments of war and engines of all kinds; and likewise new mixtures and compositions of gunpowder, wild-fires burning in water and unquenchable, also fire-works of all variety, both for pleasure and use. We imitate also flights of birds; we have some degrees of flying in the air. We have ships and boats for going under water and brooking of seas, also swimming-girdles and supporters. We have divers curious clocks and other like motions of return, and some perpetual motions. We imitate also motions of living creatures by images of men, beasts, birds, fishes, and serpents; we have also a great number of other various motions, strange for equality, fineness, and subtilty.

"We have also a mathematical-house, where are represented all instruments, as well of geometry as astronomy, exquisitely made.

"We have also houses of deceits of the senses, where we represent all manner of feats of juggling, false apparitions, impostures and illusions, and their fallacies. And surely you will easily believe that we, that have so many things truly natural which induce admiration, could in a world of particulars deceive the senses if we would disguise those things, and labor to make them more miraculous. But we do hate all impostures and lies, insomuch as we have severely forbidden it to all our fellows, under pain of ignominy and fines, that they do not show any natural work or thing adorned or swelling, but only pure as it is, and without all affectation of strangeness.

"These are, my son, the riches of Salomon's House.

"For the several employments and offices of our fellows, we have twelve that sail into foreign countries under the names of other nations (for our own we conceal), who bring us the

books and abstracts, and patterns of experiments of all other parts. These we call merchants of light.

"We have three that collect the experiments which are in all books. These we call depredators.

"We have three that collect the experiments of all mechanical arts, and also of liberal sciences, and also of practices which are not brought into arts. These we call mystery-men.

"We have three that try new experiments, such as themselves think good. These we call pioneers or miners.

"We have three that draw the experiments of the former four into titles and tables, to give the better light for the drawing of observations and axioms out of them. These we call compilers. We have three that bend themselves, looking into the experiments of their fellows, and cast about how to draw out of them things of use and practice for man's life and knowledge, as well for works as for plain demonstration of causes, means of natural divinations, and the easy and clear discovery of the virtues and parts of bodies. These we call dowry-men or benefactors.

"Then after divers meetings and consults of our whole number, to consider of the former labors and collections, we have three that take care out of them to direct new experiments, of a higher light, more penetrating into nature than the former. These we call lamps.

"We have three others that do execute the experiments so directed, and report them. These we call inoculators.

"Lastly, we have three that raise the former discoveries by experiments into greater observations, axioms, and aphorisms. These we call interpreters of nature.

"We have also, as you must think, novices and apprentices, that the succession of the former employed men do not fail; besides a great number of servants and attendants, men and women. And this we do also: we have consultations, which of the inventions and experiences which we have discovered shall be published, and which not; and take all an oath of secrecy for the concealing of those which we think fit to keep secret; though some of those we do reveal sometime to the State, and some not.

"For our ordinances and rites we have two very long and fair galleries. In one of these we place patterns and samples

of all manner of the more rare and excellent inventions; in the other we place the statues of all principal inventors. There we have the statue of your Columbus, that discovered the West Indies, also the inventor of ships, your monk that was the inventor of ordnance and of gunpowder, the inventor of music, the inventor of letters, the inventor of printing, the inventor of observations of astronomy, the inventor of works in metal, the inventor of glass, the inventor of silk of the worm, the inventor of wine, the inventor of corn and bread, the inventor of sugars; and all these by more certain tradition than you have. Then we have divers inventors of our own, of excellent works; which, since you have not seen, it were too long to make descriptions of them; and besides, in the right understanding of those descriptions you might easily err. For upon every invention of value we erect a statue to the inventor, and give him a liberal and honorable reward. These statues are some of brass, some of marble and touchstone, some of cedar and other special woods gilt and adorned; some of iron, some of silver, some of gold.

"We have certain hymns and services, which we say daily, of laud and thanks to God for His marvellous works. And forms of prayers, imploring His aid and blessing for the illumination of our labors; and turning them into good and holy uses.

"Lastly, we have circuits or visits, of divers principal cities of the kingdom; where as it cometh to pass we do publish such new profitable inventions as we think good. And we do also declare natural divinations of diseases, plagues, swarms of hurtful creatures, scarcity, tempest, earthquakes, great inundations, comets, temperature of the year, and divers other things; and we give counsel thereupon, what the people shall do for the prevention and remedy of them."

And when he had said this he stood up, and I, as I had been taught, knelt down; and he laid his right hand upon my head, and said: "God bless thee, my son, and God bless this relation which I have made. I give thee leave to publish it, for the good of other nations; for we here are in God's bosom, a land unknown." And so he left me; having assigned a value of about 2,000 ducats for a bounty to me and my fellows. For they give great largesses, where they come, upon all occasions.

[THE REST WAS NOT PERFECTED.]

THE CITY OF THE SUN

BY

THOMAS CAMPANELLA

THE CITY OF THE SUN

A Poetical Dialogue between a Grandmaster of the Knights Hospitallers and a Genoese Sea-Captain, his guest.

G.M. Prithee, now, tell me what happened to you during that voyage?

Capt. I have already told you how I wandered over the whole earth. In the course of my journeying I came to Taprobane, and was compelled to go ashore at a place, where through fear of the inhabitants I remained in a wood. When I stepped out of this I found myself on a large plain immediately under the equator.

G.M. And what befell you here?

Capt. I came upon a large crowd of men and armed women, many of whom did not understand our language, and they conducted me forthwith to the City of the Sun.

G.M. Tell me after what plan this city is built and how it is governed.

Capt. The greater part of the city is built upon a high hill, which rises from an extensive plain, but several of its circles extend for some distance beyond the base of the hill, which is of such a size that the diameter of the city is upward of two miles, so that its circumference becomes about seven. On account of the humped shape of the mountain, however, the diameter of the city is really more than if it were built on a plain.

It is divided into seven rings or huge circles named from the seven planets, and the way from one to the other of these is by four streets and through four gates, that look toward the four points of the compass. Furthermore, it is so built that if the first circle were stormed, it would of necessity entail a double amount of energy to storm the second; still more to storm the third; and in each succeeding case the strength and

energy would have to be doubled; so that he who wishes to capture that city must, as it were, storm it seven times. For my own part, however, I think that not even the first wall could be occupied, so thick are the earthworks and so well fortified is it with breastworks, towers, guns, and ditches.

When I had been taken through the northern gate (which is shut with an iron door so wrought that it can be raised and let down, and locked in easily and strongly, its projections running into the grooves of the thick posts by a marvellous device), I saw a level space seventy paces* wide between the first and second walls. From hence can be seen large palaces, all joined to the wall of the second circuit in such a manner as to appear all one palace. Arches run on a level with the middle height of the palaces, and are continued round the whole ring. There are galleries for promenading upon these arches, which are supported from beneath by thick and well-shaped columns, enclosing arcades like peristyles, or cloisters of an abbey.

But the palaces have no entrances from below, except on the inner or concave partition, from which one enters directly to the lower parts of the building. The higher parts, however, are reached by flights of marble steps, which lead to galleries for promenading on the inside similar to those on the outside. From these one enters the higher rooms, which are very beautiful, and have windows on the concave and convex partitions. These rooms are divided from one another by richly decorated walls. The convex or outer wall of the ring is about eight spans thick; the concave, three; the intermediate walls are one, or perhaps one and a half. Leaving this circle one gets to the second plain, which is nearly three paces narrower than the first. Then the first wall of the second ring is seen adorned above and below with similar galleries for walking, and there is on the inside of it another interior wall enclosing palaces. It has also similar peristyles supported by columns in the lower part, but above are excellent pictures, round the ways into the upper houses. And so on afterward through similar spaces and double walls, enclosing palaces, and adorned with galleries for walking, extending along their outer side, and supported by columns, till the last circuit is reached, the way being still over a level plain.

<p style="text-align:center">* A pace was 1⅕ yard, 1,000 paces making a mile.</p>

But when the two gates, that is to say, those of the outmost and the inmost walls, have been passed, one mounts by means of steps so formed that an ascent is scarcely discernible, since it proceeds in a slanting direction, and the steps succeed one another at almost imperceptible heights. On the top of the hill is a rather spacious plain, and in the midst of this there rises a temple built with wondrous art.

G.M. Tell on, I pray you! Tell on! I am dying to hear more.

Capt. The temple is built in the form of a circle; it is not girt with walls, but stands upon thick columns, beautifully grouped. A very large dome, built with great care in the centre or pole, contains another small vault as it were rising out of it, and in this is a spiracle, which is right over the altar. There is but one altar in the middle of the temple, and this is hedged round by columns. The temple itself is on a space of more than 350 paces. Without it, arches measuring about eight paces extend from the heads of the columns outward, whence other columns rise about three paces from the thick, strong, and erect wall. Between these and the former columns there are galleries for walking, with beautiful pavements, and in the recess of the wall, which is adorned with numerous large doors, there are immovable seats, placed as it were between the inside columns, supporting the temple. Portable chairs are not wanting, many and well adorned. Nothing is seen over the altar but a large globe, upon which the heavenly bodies are painted, and another globe upon which there is a representation of the earth. Furthermore, in the vault of the dome there can be discerned representations of all the stars of heaven from the first to the sixth magnitude, with their proper names and power to influence terrestrial things marked in three little verses for each. There are the poles and greater and lesser circles according to the right latitude of the place, but these are not perfect because there is no wall below. They seem, too, to be made in their relation to the globes on the altar. The pavement of the temple is bright with precious stones. Its seven golden lamps hang always burning, and these bear the names of the seven planets.

At the top of the building several small and beautiful cells surround the small dome, and behind the level space above the bands or arches of the exterior and interior columns there are

many cells, both small and large, where the priests and religious officers dwell to the number of forty-nine.

A revolving flag projects from the smaller dome, and this shows in what quarter the wind is. The flag is marked with figures up to thirty-six, and the priests know what sort of year the different kinds of winds bring and what will be the changes of weather on land and sea. Furthermore, under the flag a book is always kept written with letters of gold.

G.M. I pray you, worthy hero, explain to me their whole system of government; for I am anxious to hear it.

Capt. The great ruler among them is a priest whom they call by the name Hoh, though we should call him Metaphysic. He is head over all, in temporal and spiritual matters, and all business and lawsuits are settled by him, as the supreme authority. Three princes of equal power—viz., Pon, Sin, and Mor—assist him, and these in our tongue we should call Power, Wisdom, and Love. To Power belongs the care of all matters relating to war and peace. He attends to the military arts, and, next to Hoh, he is ruler in every affair of a warlike nature. He governs the military magistrates and the soldiers, and has the management of the munitions, the fortifications, the storming of places, the implements of war, the armories, the smiths and workmen connected with matters of this sort.

But Wisdom is the ruler of the liberal arts, of mechanics, of all sciences with their magistrates and doctors, and of the discipline of the schools. As many doctors as there are, are under his control. There is one doctor who is called Astrologus; a second, Cosmographus; a third, Arithmeticus; a fourth, Geometra; a fifth, Historiographus; a sixth, Poeta; a seventh, Logicus; an eighth, Rhetor; a ninth, Grammaticus; a tenth, Medicus; an eleventh, Physiologus; a twelfth, Politicus; a thirteenth, Moralis. They have but one book, which they call Wisdom, and in it all the sciences are written with conciseness and marvellous fluency of expression. This they read to the people after the custom of the Pythagoreans. It is Wisdom who causes the exterior and interior, the higher and lower walls of the city to be adorned with the finest pictures, and to have all the sciences painted upon them in an admirable manner. On the walls of the temple and on the dome, which is let down when the priest gives an address, lest the sounds of his voice,

CITY OF THE SUN

being scattered, should fly away from his audience, there are pictures of stars in their different magnitudes, with the powers and motions of each, expressed separately in three little verses.

On the interior wall of the first circuit all the mathematical figures are conspicuously painted—figures more in number than Archimedes or Euclid discovered, marked symmetrically, and with the explanation of them neatly written and contained each in a little verse. There are definitions and propositions, etc. On the exterior convex wall is first an immense drawing of the whole earth, given at one view. Following upon this, there are tablets setting forth for every separate country the customs both public and private, the laws, the origins and the power of the inhabitants; and the alphabets the different people use can be seen above that of the City of the Sun.

On the inside of the second circuit, that is to say of the second ring of buildings, paintings of all kinds of precious and common stones, of minerals and metals, are seen; and a little piece of the metal itself is also there with an apposite explanation in two small verses for each metal or stone. On the outside are marked all the seas, rivers, lakes, and streams which are on the face of the earth; as are also the wines and the oils and the different liquids, with the sources from which the last are extracted, their qualities and strength. There are also vessels built into the wall above the arches, and these are full of liquids from one to 300 years old, which cure all diseases. Hail and snow, storms and thunder, and whatever else takes place in the air, are represented with suitable figures and little verses. The inhabitants even have the art of representing in stone all the phenomena of the air, such as the wind, rain, thunder, the rainbow, etc.

On the interior of the third circuit all the different families of trees and herbs are depicted, and there is a live specimen of each plant in earthenware vessels placed upon the outer partition of the arches. With the specimens there are explanations as to where they were first found, what are their powers and natures, and resemblances to celestial things and to metals, to parts of the human body and to things in the sea, and also as to their uses in medicine, etc. On the exterior wall are all the races of fish found in rivers, lakes, and seas, and their habits and values, and ways of breeding, training, and living, the pur-

poses for which they exist in the world, and their uses to man. Further, their resemblances to celestial and terrestrial things, produced both by nature and art, are so given that I was astonished when I saw a fish which was like a bishop, one like a chain, another like a garment, a fourth like a nail, a fifth like a star, and others like images of those things existing among us, the relation in each case being completely manifest. There are sea-urchins to be seen, and the purple shell-fish and mussels; and whatever the watery world possesses worthy of being known is there fully shown in marvellous characters of painting and drawing.

On the fourth interior wall all the different kinds of birds are painted, with their natures, sizes, customs, colors, manner of living, etc.; and the only real phœnix is possessed by the inhabitants of this city. On the exterior are shown all the races of creeping animals, serpents, dragons, and worms; the insects, the flies, gnats, beetles, etc., in their different states, strength, venoms, and uses, and a great deal more than you or I can think of.

On the fifth interior they have all the larger animals of the earth, as many in number as would astonish you. We indeed know not the thousandth part of them, for on the exterior wall also a great many of immense size are also portrayed. To be sure, of horses alone, how great a number of breeds there is and how beautiful are the forms there cleverly displayed!

On the sixth interior are painted all the mechanical arts, with the several instruments for each and their manner of use among different nations. Alongside, the dignity of such is placed, and their several inventors are named. But on the exterior all the inventors in science, in warfare, and in law are represented. There I saw Moses, Osiris, Jupiter, Mercury, Lycurgus, Pompilius, Pythagoras, Zamolxis, Solon, Charondas, Phoroneus, with very many others. They even have Mahomet, whom nevertheless they hate as a false and sordid legislator. In the most dignified position I saw a representation of Jesus Christ and of the twelve Apostles, whom they consider very worthy and hold to be great. Of the representations of men, I perceived Cæsar, Alexander, Pyrrhus, and Hannibal in the highest place; and other very renowned heroes in peace and war, especially Roman heroes, were painted in lower positions, under

the galleries. And when I asked with astonishment whence they had obtained our history, they told me that among them there was a knowledge of all languages, and that by perseverance they continually send explorers and ambassadors over the whole earth, who learn thoroughly the customs, forces, rule and histories of the nations, bad and good alike. These they apply all to their own republic, and with this they are well pleased. I learned that cannon and typography were invented by the Chinese before we knew of them. There are magistrates who announce the meaning of the pictures, and boys are accustomed to learn all the sciences, without toil and as if for pleasure; but in the way of history only until they are ten years old.

Love is foremost in attending to the charge of the race. He sees that men and women are so joined together, that they bring forth the best offspring. Indeed, they laugh at us who exhibit a studious care for our breed of horses and dogs, but neglect the breeding of human beings. Thus the education of the children is under his rule. So also is the medicine that is sold, the sowing and collecting of fruits of the earth and of trees, agriculture, pasturage, the preparations for the months, the cooking arrangements, and whatever has any reference to food, clothing, and the intercourse of the sexes. Love himself is ruler, but there are many male and female magistrates dedicated to these arts.

Metaphysic, then, with these three rulers, manages all the above-named matters, and even by himself alone nothing is done; all business is discharged by the four together, but in whatever Metaphysic inclines to the rest are sure to agree.

G.M. Tell me, please, of the magistrates, their services and duties, of the education and mode of living, whether the government is a monarchy, a republic, or an aristocracy.

Capt. This race of men came there from India, flying from the sword of the Magi, a race of plunderers and tyrants who laid waste their country, and they determined to lead a philosophic life in fellowship with one another. Although the community of wives is not instituted among the other inhabitants of their province, among them it is in use after this manner: All things are common with them, and their dispensation is by the authority of the magistrates. Arts and honors and pleasures are common, and are held in such a manner that no one can appropriate anything to himself.

They say that all private property is acquired and improved for the reason that each one of us by himself has his own home and wife and children. From this, self-love springs. For when we raise a son to riches and dignities, and leave an heir to much wealth, we become either ready to grasp at the property of the State, if in any case fear should be removed from the power which belongs to riches and rank; or avaricious, crafty, and hypocritical, if anyone is of slender purse, little strength, and mean ancestry. But when we have taken away self-love, there remains only love for the State.

G.M. Under such circumstances no one will be willing to labor, while he expects others to work, on the fruit of whose labors he can live, as Aristotle argues against Plato.

Capt. I do not know how to deal with that argument, but I declare to you that they burn with so great a love for their fatherland, as I could scarcely have believed possible; and indeed with much more than the histories tell us belonged to the Romans, who fell willingly for their country, inasmuch as they have to a greater extent surrendered their private property. I think truly that the friars and monks and clergy of our country, if they were not weakened by love for their kindred and friends or by the ambition to rise to higher dignities, would be less fond of property, and more imbued with a spirit of charity toward all, as it was in the time of the apostles, and is now in a great many cases.

G.M. St. Augustine may say that, but I say that among this race of men, friendship is worth nothing, since they have not the chance of conferring mutual benefits on one another.

Capt. Nay, indeed. For it is worth the trouble to see that no one can receive gifts from another. Whatever is necessary they have, they receive it from the community, and the magistrate takes care that no one receives more than he deserves. Yet nothing necessary is denied to anyone. Friendship is recognized among them in war, in infirmity, in the art contests, by which means they aid one another mutually by teaching. Sometimes they improve themselves mutually with praises, with conversation, with actions, and out of the things they need. All those of the same age call one another brothers. They call all over twenty-two years of age, fathers; those that are less than twenty-two are named sons. Moreover, the magistrates gov-

ern well, so that no one in the fraternity can do injury to another.

G.M. And how?

Capt. As many names of virtues as there are among us, so many magistrates there are among them. There is a magistrate who is named Magnanimity, another Fortitude, a third Chastity, a fourth Liberality, a fifth Criminal and Civil Justice, a sixth Comfort, a seventh Truth, an eighth Kindness, a tenth Gratitude, an eleventh Cheerfulness, a twelfth Exercise, a thirteenth Sobriety, etc. They are elected to duties of that kind, each one to that duty for excellence in which he is known from boyhood to be most suitable. Wherefore among them neither robbery nor clever murders, nor lewdness, incest, adultery, or other crimes of which we accuse one another, can be found. They accuse themselves of ingratitude and malignity when any-one denies a lawful satisfaction to another of indolence, of sadness, of anger, of scurrility, of slander, and of lying, which curseful thing they thoroughly hate. Accused persons undergoing punishment are deprived of the common table, and other honors, until the judge thinks that they agree with their correction.

G.M. Tell me the manner in which the magistrates are chosen.

Capt. You would not rightly understand this, unless you first learned their manner of living. That you may know, then, men and women wear the same kind of garment, suited for war. The women wear the toga below the knee, but the men above; and both sexes are instructed in all the arts together. When this has been done as a start, and before their third year, the boys learn the language and the alphabet on the walls by walking round them. They have four leaders, and four elders, the first to direct them, the second to teach them, and these are men approved beyond all others. After some time they exercise themselves with gymnastics, running, quoits, and other games, by means of which all their muscles are strengthened alike. Their feet are always bare, and so are their heads as far as the seventh ring. Afterward they lead them to the offices of the trades, such as shoemaking, cooking, metal-working, carpentry, painting, etc. In order to find out the bent of the genius of each one, after their seventh year, when they have already gone

through the mathematics on the walls, they take them to the readings of all the sciences; there are four lectures at each reading, and in the course of four hours the four in their order explain everything.

For some take physical exercise or busy themselves with public services or functions, others apply themselves to reading. Leaving these studies all are devoted to the more abstruse subjects, to mathematics, to medicine, and to other sciences. There are continual debate and studied argument among them, and after a time they become magistrates of those sciences or mechanical arts in which they are the most proficient; for everyone follows the opinion of his leader and judge, and goes out to the plains to the works of the field, and for the purpose of becoming acquainted with the pasturage of the dumb animals. And they consider him the more noble and renowned who has dedicated himself to the study of the most arts and knows how to practise them wisely. Wherefore they laugh at us in that we consider our workmen ignoble, and hold those to be noble who have mastered no pursuit, but live in ease and are so many slaves given over to their own pleasure and lasciviousness; and thus, as it were, from a school of vices so many idle and wicked fellows go forth for the ruin of the State.

The rest of the officials, however, are chosen by the four chiefs, Hoh, Pon, Sin and Mor, and by the teachers of that art over which they are fit to preside. And these teachers know well who is most suited for rule. Certain men are proposed by the magistrates in council, they themselves not seeking to become candidates, and he opposes who knows anything against those brought forward for election, or, if not, speaks in favor of them. But no one attains to the dignity of Hoh except him who knows the histories of the nations, and their customs and sacrifices and laws, and their form of government, whether a republic or a monarchy. He must also know the names of the lawgivers and the inventors in science, and the laws and the history of the earth and the heavenly bodies. They think it also necessary that he should understand all the mechanical arts, the physical sciences, astrology and mathematics. Nearly every two days they teach our mechanical art. They are not allowed to overwork themselves, but frequent practice and the paintings render learning easy to them. Not too much care

is given to the cultivation of languages, as they have a goodly number of interpreters who are grammarians in the State. But beyond everything else it is necessary that Hoh should understand metaphysics and theology; that he should know thoroughly the derivations, foundations, and demonstrations of all the arts and sciences; the likeness and difference of things; necessity, fate, and the harmonies of the universe; power, wisdom, and the love of things and of God; the stages of life and its symbols; everything relating to the heavens, the earth, and the sea; and the ideas of God, as much as mortal man can know of him. He must also be well read in the prophets and in astrology. And thus they know long beforehand who will be Hoh. He is not chosen to so great a dignity unless he has attained his thirty-fifth year. And this office is perpetual, because it is not known who may be too wise for it or who too skilled in ruling.

G.M. Who indeed can be so wise? If even anyone has a knowledge of the sciences it seems that he must be unskilled in ruling.

Capt. This very question I asked them and they replied thus: "We, indeed, are more certain that such a very learned man has the knowledge of governing, than you who place ignorant persons in authority, and consider them suitable merely because they have sprung from rulers or have been chosen by a powerful faction. But our Hoh, a man really the most capable to rule, is for all that never cruel nor wicked, nor a tyrant, inasmuch as he possesses so much wisdom. This, moreover, is not unknown to you, that the same argument cannot apply among you, when you consider that man the most learned who knows most of grammar, or logic, or of Aristotle or any other author. For such knowledge as this of yours much servile labor and memory work are required, so that a man is rendered unskilful, since he has contemplated nothing but the words of books and has given his mind with useless result to the consideration of the dead signs of things. Hence he knows not in what way God rules the universe, nor the ways and customs of nature and the nations. Wherefore he is not equal to our Hoh. For that one cannot know so many arts and sciences thoroughly, who is not esteemed for skilled ingenuity, very apt at all things, and therefore at ruling especially. This also is plain to us that he

who knows only one science, does not really know either that or the others, and he who is suited for only one science and has gathered his knowledge from books, is unlearned and unskilled. But this is not the case with intellects prompt and expert in every branch of knowledge and suitable for the consideration of natural objects, as it is necessary that our Hoh should be. Besides in our State the sciences are taught with a facility (as you have seen) by which more scholars are turned out by us in one year than by you in ten, or even fifteen. Make trial, I pray you, of these boys."

In this matter I was struck with astonishment at their truthful discourse and at the trial of their boys, who did not understand my language well. Indeed it is necessary that three of them should be skilled in our tongue, three in Arabic, three in Polish, and three in each of the other languages, and no recreation is allowed them unless they become more learned. For that they go out to the plain for the sake of running about and hurling arrows and lances, and of firing harquebuses, and for the sake of hunting the wild animals and getting a knowledge of plants and stones, and agriculture and pasturage; sometimes the band of boys does one thing, sometimes another.

They do not consider it necessary that the three rulers assisting Hoh should know other than the arts having reference to their rule, and so they have only a historical knowledge of the arts which are common to all. But their own they know well, to which certainly one is dedicated more than another. Thus Power is the most learned in the equestrian art, in marshalling the army, in the marking out of camps, in the manufacture of every kind of weapon and of warlike machines, in planning stratagems, and in every affair of a military nature. And for these reasons, they consider it necessary that these chiefs should have been philosophers, historians, politicians, and physicists. Concerning the other two triumvirs, understand remarks similar to those I have made about Power.

G.M. I really wish that you would recount all their public duties, and would distinguish between them, and also that you would tell clearly how they are all taught in common.

Capt. They have dwellings in common and dormitories, and couches and other necessaries. But at the end of every six months they are separated by the masters. Some shall sleep in

this ring, some in another; some in the first apartment, and some in the second; and these apartments are marked by means of the alphabet on the lintel. There are occupations, mechanical and theoretical, common to both men and women, with this difference, that the occupations which require more hard work, and walking a long distance, are practised by men, such as ploughing, sowing, gathering the fruits, working at the threshing-floor, and perchance at the vintage. But it is customary to choose women for milking the cows and for making cheese. In like manner, they go to the gardens near to the outskirts of the city both for collecting the plants and for cultivating them. In fact, all sedentary and stationary pursuits are practised by the women, such as weaving, spinning, sewing, cutting the hair, shaving, dispensing medicines, and making all kinds of garments. They are, however, excluded from working in wood and the manufacture of arms. If a woman is fit to paint, she is not prevented from doing so; nevertheless, music is given over to the women alone, because they please the more, and of a truth to boys also. But the women have not the practise of the drum and the horn.

And they prepare their feasts and arrange the tables in the following manner. It is the peculiar work of the boys and girls under twenty to wait at the tables. In every ring there are suitable kitchens, barns, and stores of utensils for eating and drinking, and over every department an old man and an old woman preside. These two have at once the command of those who serve, and the power of chastising, or causing to be chastised, those who are negligent or disobedient; and they also examine and mark each one, both male and female, who excels in his or her duties.

All the young people wait upon the older ones who have passed the age of forty, and in the evening when they go to sleep the master and mistress command that those should be sent to work in the morning, upon whom in succession the duty falls, one or two to separate apartments. The young people, however, wait upon one another, and that alas! with some unwillingness. They have first and second tables, and on both sides there are seats. On one side sit the women, on the other the men; and as in the refectories of the monks, there is no noise. While they are eating a young man reads a book from

a platform, intoning distinctly and sonorously, and often the magistrates question them upon the more important parts of the reading. And truly it is pleasant to observe in what manner these young people, so beautiful and clothed in garments so suitable, attend to them, and to see at the same time so many friends, brothers, sons, fathers, and mothers all in their turn living together with so much honesty, propriety, and love. So each one is given a napkin, a plate, fish, and a dish of food. It is the duty of the medical officers to tell the cooks what repasts shall be prepared on each day, and what food for the old, what for the young, and what for the sick. The magistrates receive the full-grown and fatter portion, and they from their share always distribute something to the boys at the table who have shown themselves more studious in the morning at the lectures and debates concerning wisdom and arms. And this is held to be one of the most distinguished honors. For six days they ordain to sing with music at table. Only a few, however, sing; or there is one voice accompanying the lute and one for each other instrument. And when all alike in service join their hands, nothing is found to be wanting. The old men placed at the head of the cooking business and of the refectories of the servants praise the cleanliness of the streets, the houses, the vessels, the garments, the workshops, and the warehouses.

They wear white under-garments to which adheres a covering, which is at once coat and legging, without wrinkles. The borders of the fastenings are furnished with globular buttons, extended round and caught up here and there by chains. The coverings of the legs descend to the shoes and are continued even to the heels. Then they cover the feet with large socks, or, as it were, half-buskins fastened by buckles, over which they wear a half-boot, and besides, as I have already said, they are clothed with a toga. And so aptly fitting are the garments, that when the toga is destroyed, the different parts of the whole body are straightway discerned, no part being concealed. They change their clothes for different ones four times in the year, that is when the sun enters respectively the constellations Aries, Cancer, Libra, and Capricorn, and according to the circumstances and necessity as decided by the officer of health. The keepers of clothes for the different rings are wont to distribute them, and it is marvellous that they have at the same time as

many garments as there is need for, some heavy and some slight, according to the weather. They all use white clothing, and this is washed in each month with lye or soap, as are also the workshops of the lower trades, the kitchens, the pantries, the barns, the store-houses, the armories, the refectories, and the baths.

Moreover, the clothes are washed at the pillars of the peristyles, and the water is brought down by means of canals which are continued as sewers. In every street of the different rings there are suitable fountains, which send forth their water by means of canals, the water being drawn up from nearly the bottom of the mountain by the sole movement of a cleverly contrived handle. There is water in fountains and in cisterns, whither the rain-water collected from the roofs of the houses is brought through pipes full of sand. They wash their bodies often, according as the doctor and master command. All the mechanical arts are practised under the peristyles, but the speculative are carried on above in the walking galleries and ramparts where are the more splendid paintings, but the more sacred ones are taught in the temple. In the halls and wings of the rings there are solar time-pieces and bells, and hands by which the hours and seasons are marked off.

G.M. Tell me about their children.

Capt. When their women have brought forth children, they suckle and rear them in temples set apart for all. They give milk for two years or more as the physician orders. After that time the weaned child is given into the charge of the mistresses, if it is a female, and to the masters, if it is a male. And then with other young children they are pleasantly instructed in the alphabet, and in the knowledge of the pictures, and in running, walking, and wrestling; also in the historical drawings, and in languages; and they are adorned with a suitable garment of different colors. After their sixth year they are taught natural science, and then the mechanical sciences. The men who are weak in intellect are sent to farms, and when they have become more proficient some of them are received into the State. And those of the same age and born under the same constellation are especially like one another in strength and in appearance, and hence arises much lasting concord in the State, these men honoring one another with mutual love and help. Names are

given to them by Metaphysicus, and that not by chance, but designedly, and according to each one's peculiarity, as was the custom among the ancient Romans. Wherefore one is called Beautiful *(Pulcher)*, another the Big-nosed *(Naso)*, another the Fat-legged *(Cranipes)*, another Crooked *(Torvus)*, another Lean *(Macer)*, and so on. But when they have become very skilled in their professions and done any great deed in war or in time of peace, a cognomen from art is given to them, such as Beautiful the Great Painter *(Pulcher, Pictor Magnus)*, the Golden One *(Aureus)*, the Excellent One *(Excellens)*, or the Strong *(Strenuus)*; or from their deeds, such as Naso the Brave *(Nason Fortis)*, or the Cunning, or the Great, or Very Great Conqueror; or from the enemy anyone has overcome, Africanus, Asiaticus, Etruscus; or if anyone has overcome Manfred or Tortelius, he is called Macer Manfred or Tortelius, and so on. All these cognomens are added by the higher magistrates, and very often with a crown suitable to the deed or art, and with the flourish of music. For gold and silver are reckoned of little value among them except as material for their vessels and ornaments, which are common to all.

G.M. Tell me, I pray you, is there no jealousy among them or disappointment to that one who has not been elected to a magistracy, or to any other dignity to which he aspires?

Capt. Certainly not. For no one wants either necessaries or luxuries. Moreover, the race is managed for the good of the commonwealth, and not of private individuals, and the magistrates must be obeyed. They deny what we hold—viz., that it is natural to man to recognize his offspring and to educate them, and to use his wife and house and children as his own. For they say that children are bred for the preservation of the species and not for individual pleasure, as St. Thomas also asserts. Therefore the breeding of children has reference to the commonwealth, and not to individuals, except in so far as they are constituents of the commonwealth. And since individuals for the most part bring forth children wrongly and educate them wrongly, they consider that they remove destruction from the State, and therefore for this reason, with most sacred fear, they commit the education of the children, who, as it were, are the element of the republic, to the care of magistrates; for the safety of the community is not that of a few. And thus they

distribute male and female breeders of the best natures according to philosophical rules. Plato thinks that this distribution ought to be made by lot, lest some men seeing that they are kept away from the beautiful women, should rise up with anger and hatred against the magistrates; and he thinks further that those who do not deserve cohabitation with the more beautiful women, should be deceived while the lots are being led out of the city by the magistrates, so that at all times the women who are suitable should fall to their lot, not those whom they desire.

This shrewdness, however, is not necessary among the inhabitants of the City of the Sun. For with them deformity is unknown. When the women are exercised they get a clear complexion, and become strong of limb, tall and agile, and with them beauty consists in tallness and strength. Therefore, if any woman dyes her face, so that it may become beautiful, or uses high-heeled boots so that she may appear tall, or garments with trains to cover her wooden shoes, she is condemned to capital punishment. But if the women should even desire them, they have no facility for doing these things. For who indeed would give them this facility? Further, they assert that among us abuses of this kind arise from the leisure and sloth of women. By these means they lose their color and have pale complexions, and become feeble and small. For this reason they are without proper complexions, use high sandals, and become beautiful not from strength, but from slothful tenderness. And thus they ruin their own tempers and natures, and consequently those of their offspring. Furthermore, if at any time a man is taken captive with ardent love for a certain woman, the two are allowed to converse and joke together, and to give one another garlands of flowers or leaves, and to make verses. But if the race is endangered, by no means is further union between them permitted. Moreover, the love born of eager desire is not known among them; only that born of friendship.

Domestic affairs and partnerships are of little account, because, excepting the sign of honor, each one receives what he is in need of. To the heroes and heroines of the republic, it is customary to give the pleasing gifts of honor, beautiful wreaths, sweet food, or splendid clothes, while they are feasting. In the daytime all use white garments within the city, but at night or outside the city they use red garments either of wool

or silk. They hate black as they do dung, and therefore they dislike the Japanese, who are fond of black. Pride they consider the most execrable vice, and one who acts proudly is chastised with the most ruthless correction. Wherefore no one thinks it lowering to wait at table or to work in the kitchen or fields. All work they call discipline, and thus they say that it is honorable to go on foot, to do any act of nature, to see with the eye, and to speak with the tongue; and when there is need, they distinguish philosophically between tears and spittle.

Every man who, when he is told off to work, does his duty, is considered very honorable. It is not the custom to keep slaves. For they are enough, and more than enough, for themselves. But with us, alas! it is not so. In Naples there exist 70,000 souls, and out of these scarcely 10,000 or 15,000 do any work, and they are always lean from overwork and are getting weaker every day. The rest become a prey to idleness, avarice, ill-health, lasciviousness, usury, and other vices, and contaminate and corrupt very many families by holding them in servitude for their own use, by keeping them in poverty and slavishness, and by imparting to them their own vices. Therefore public slavery ruins them; useful works, in the field, in military service, and in arts, except those which are debasing, are not cultivated, the few who do practise them doing so with much aversion.

But in the City of the Sun, while duty and work are distributed among all, it only falls to each one to work for about four hours every day. The remaining hours are spent in learning joyously, in debating, in reading, in reciting, in writing, in walking, in exercising the mind and body, and with play. They allow no game which is played while sitting, neither the single die nor dice, nor chess, nor others like these. But they play with the ball, with the sack, with the hoop, with wrestling, with hurling at the stake. They say, moreover, that grinding poverty renders men worthless, cunning, sulky, thievish, insidious, vagabonds, liars, false witnesses, etc.; and that wealth makes them insolent, proud, ignorant, traitors, assumers of what they know not, deceivers, boasters, wanting in affection, slanderers, etc. But with them all the rich and poor together make up the community. They are rich because they want nothing, poor because they possess nothing; and consequently they are not

slaves to circumstances, but circumstances serve them. And on this point they strongly recommend the religion of the Christians, and especially the life of the apostles.

G.M. This seems excellent and sacred, but the community of women is a thing too difficult to attain. The holy Roman Clement says that wives ought to be common in accordance with the apostolic institution, and praises Plato and Socrates, who thus teach, but the Glossary interprets this community with regard to obedience. And Tertullian agrees with the Glossary, that the first Christians had everything in common except wives.

Capt. These things I know little of. But this I saw among the inhabitants of the City of the Sun, that they did not make this exception. And they defend themselves by the opinion of Socrates, of Cato, of Plato, and of St. Clement; but, as you say, they misunderstand the opinions of these thinkers. And the inhabitants of the solar city ascribe this to their want of education, since they are by no means learned in philosophy. Nevertheless, they send abroad to discover the customs of nations, and the best of these they always adopt. Practice makes the women suitable for war and other duties. Thus they agree with Plato, in whom I have read these same things. The reasoning of our Cajetan does not convince me, and least of all that of Aristotle. This thing, however, existing among them is excellent and worthy of imitation—viz., that no physical defect renders a man incapable of being serviceable except the decrepitude of old age, since even the deformed are useful for consultation. The lame serve as guards, watching with the eyes which they possess. The blind card wool with their hands, separating the down from the hairs, with which latter they stuff the couches and sofas; those who are without the use of eyes and hands give the use of their ears or their voice for the convenience of the State, and if one has only one sense he uses it in the farms. And these cripples are well treated, and some become spies, telling the officers of the State what they have heard.

G.M. Tell me now, I pray you, of their military affairs. Then you may explain their arts, ways of life and sciences, and lastly their religion.

Capt. The triumvir, Power, has under him all the magistrates of arms, of artillery, of cavalry, of foot-soldiers, of archi-

tects, and of strategists; and the masters and many of the most excellent workmen obey the magistrates, the men of each art paying allegiance to their respective chiefs. Moreover, Power is at the head of all the professors of gymnastics, who teach military exercise, and who are prudent generals, advanced in age. By these the boys are trained after their twelfth year. Before this age, however, they have been accustomed to wrestling, running, throwing the weight, and other minor exercises, under inferior masters. But at twelve they are taught how to strike at the enemy, at horses and elephants, to handle the spear, the sword, the arrow, and the sling; to manage the horse, to advance and to retreat, to remain in order of battle, to help a comrade in arms, to anticipate the enemy by cunning, and to conquer.

The women also are taught these arts under their own magistrates and mistresses, so that they may be able if need be to render assistance to the males in battles near the city. They are taught to watch the fortifications lest at some time a hasty attack should suddenly be made. In this respect they praise the Spartans and Amazons. The women know well also how to let fly fiery balls, and how to make them from lead; how to throw stones from pinnacles and to go in the way of an attack. They are accustomed also to give up wine unmixed altogether, and that one is punished most severely who shows any fear.

The inhabitants of the City of the Sun do not fear death, because they all believe that the soul is immortal, and that when it has left the body it is associated with other spirits, wicked or good, according to the merits of this present life. Although they are partly followers of Brahma and Pythagoras, they do not believe in the transmigration of souls, except in some cases by a distinct decree of God. They do not abstain from injuring an enemy of the republic and of religion, who is unworthy of pity. During the second month the army is reviewed, and every day there is practice of arms, either in the cavalry plain or within the walls. Nor are they ever without lectures on the science of war. They take care that the accounts of Moses, of Joshua, of David, of Judas Maccabæus, of Cæsar, of Alexander, of Scipio, of Hannibal, and other great soldiers should be read. And then each one gives his own opinion as to whether these generals acted well or ill, usefully or honorably, and then the teacher answers and says who are right.

CITY OF THE SUN

G.M. With whom do they wage war, and for what reasons, since they are so prosperous?

Capt. Wars might never occur, nevertheless they are exercised in military tactics and in hunting, lest perchance they should become effeminate and unprepared for any emergency. Besides, there are four kingdoms in the island, which are very envious of their prosperity, for this reason that the people desire to live after the manner of the inhabitants of the City of the Sun, and to be under their rule rather than that of their own kings. Wherefore the State often makes war upon these because, being neighbors, they are usurpers and live impiously, since they have not an object of worship and do not observe the religion of other nations or of the Brahmins. And other nations of India, to which formerly they were subject, rise up as it were in rebellion, as also do the Taprobanese, whom they wanted to join them at first. The warriors of the City of the Sun, however, are always the victors. As soon as they suffered from insult or disgrace or plunder, or when their allies have been harassed, or a people have been oppressed by a tyrant of the State (for they are always the advocates of liberty), they go immediately to the Council for deliberation. After they have knelt in the presence of God, that he might inspire their consultation, they proceed to examine the merits of the business, and thus war is decided on. Immediately after, a priest, whom they call Forensic, is sent away. He demands from the enemy the restitution of the plunder, asks that the allies should be freed from oppression, or that the tyrant should be deposed. If they deny these things war is declared by invoking the vengeance of God—the God of Sabaoth—for destruction of those who maintain an unjust cause. But if the enemy refuse to reply, the priest gives him the space of one hour for his answer, if he is a king, but three if it is a republic, so that they cannot escape giving a response. And in this manner is war undertaken against the insolent enemies of natural rights and of religion. When war has been declared, the deputy of Power performs everything, but Power, like the Roman dictator, plans and wills everything, so that hurtful tardiness may be avoided. And when anything of great moment arises he consults Hoh and Wisdom and Love.

Before this, however, the occasion of war and the justice of

making an expedition are declared by a herald in the great Council. All from twenty years and upward are admitted to this Council, and thus the necessaries are agreed upon. All kinds of weapons stand in the armories, and these they use often in sham fights. The exterior walls of each ring are full of guns prepared by their labors, and they have other engines for hurling which are called cannons, and which they take into battle upon mules and asses and carriages. When they have arrived in an open plain they enclose in the middle the provisions, engines of war, chariots, ladders, and machines, and all fight courageously. Then each one returns to the standards, and the enemy thinking that they are giving and preparing to flee, are deceived and relax their order: then the warriors of the City of the Sun, wheeling into wings and columns on each side, regain their breath and strength, and ordering the artillery to discharge their bullets they resume the fight against a disorganized host. And they observe many ruses of this kind. They overcome all mortals with their stratagems and engines. Their camp is fortified after the manner of the Romans. They pitch their tents and fortify with wall and ditch with wonderful quickness. The masters of works, of engines and hurling machines, stand ready, and the soldiers understand the use of the spade and the axe.

Five, eight, or ten leaders learned in the order of battle and in strategy consult together concerning the business of war, and command their bands after consultation. It is their wont to take out with them a body of boys, armed and on horses, so that they may learn to fight, just as the whelps of lions and wolves are accustomed to blood. And these in time of danger betake themselves to a place of safety, along with many armed women. After the battle the women and boys soothe and relieve the pain of the warriors, and wait upon them and encourage them with embraces and pleasant words. How wonderful a help is this! For the soldiers, in order that they may acquit themselves as sturdy men in the eyes of their wives and offspring, endure hardships, and so love makes them conquerors. He who in the fight first scales the enemy's walls receives after the battle of a crown of grass, as a token of honor, and at the presentation the women and boys applaud loudly; that one who affords aid to an ally gets a civic crown of oak-leaves; he who

kills a tyrant dedicates his arms in the temple and receives from Hoh the cognomen of his deed, and other warriors obtain other kinds of crowns.

Every horse-soldier carries a spear and two strongly tempered pistols, narrow at the mouth, hanging from his saddle. And to get the barrels of their pistols narrow they pierce the metal which they intend to convert into arms. Further, every cavalry soldier has a sword and a dagger. But the rest, who form the light-armed troops, carry a metal cudgel. For if the foe cannot pierce their metal for pistols and cannot make swords, they attack him with clubs, shatter and overthrow him. Two chains of six spans length hang from the club, and at the end of these are iron balls, and when these are aimed at the enemy they surround his neck and drag him to the ground; and in order that they may be able to use the club more easily, they do not hold the reins with their hands, but use them by means of the feet. If perchance the reins are interchanged above the trappings of the saddle, the ends are fastened to the stirrups with buckles, and not to the feet. And the stirrups have an arrangement for swift movement of the bridle, so that they draw in or let out the rein with marvellous celerity. With the right foot they turn the horse to the left, and with the left to the right. This secret, moreover, is not known to the Tartars. For, although they govern the reins with their feet, they are ignorant nevertheless of turning them and drawing them in and letting them out by means of the block of the stirrups. The light-armed cavalry with them are the first to engage in battle, then the men forming the phalanx with their spears, then the archers for whose services a great price is paid, and who are accustomed to fight in lines crossing one another as the threads of cloth, some rushing forward in their turn and others receding. They have a band of lancers strengthening the line of battle, but they make trial of the swords only at the end.

After the battle they celebrate the military triumphs after the manner of the Romans, and even in a more magnificent way. Prayers by the way of thank-offerings are made to God, and then the general presents himself in the temple, and the deeds, good and bad, are related by the poet or historian, who according to custom was with the expedition. And the greatest chief, Hoh, crowns the general with laurel and distributes little gifts

and honors to all the valorous soldiers, who are for some days free from public duties. But this exemption from work is by no means pleasing to them, since they know not what it is to be at leisure, and so they help their companions. On the other hand, they who have been conquered through their own fault, or have lost the victory, are blamed; and they who were the first to take to flight are in no way worthy to escape death, unless when the whole army asks their lives, and each one takes upon himself a part of their punishment. But this indulgence is rarely granted, except when there are good reasons favoring it. But he who did not bear help to an ally or friend is beaten with rods. That one who did not obey orders is given to the beasts, in an enclosure, to be devoured, and a staff is put in his hand, and if he should conquer the lions and the bears that are there, which is almost impossible, he is received into favor again. The conquered States or those willingly delivered up to them, forthwith have all things in common, and receive a garrison and magistrates from the City of the Sun, and by degrees they are accustomed to the ways of the city, the mistress of all, to which they even send their sons to be taught without contributing anything for expense.

It would be too great trouble to tell you about the spies and their master, and about the guards and laws and ceremonies, both within and without the State, which you can of yourself imagine. Since from childhood they are chosen according to their inclination and the star under which they were born, therefore each one working according to his natural propensity does his duty well and pleasantly, because naturally. The same things I may say concerning strategy and the other functions.

There are guards in the city by day and by night, and they are placed at the four gates, and outside the walls of the seventh ring, above the breastworks and towers and inside mounds. These places are guarded in the day by women, in the night by men. And lest the guard should become weary of watching, and in case of a surprise, they change them every three hours, as is the custom with our soldiers. At sunset, when the drum and symphonia sound, the armed guards are distributed. Cavalry and infantry make use of hunting as the symbol of war, and practise games and hold festivities in the plains. Then the music strikes up, and freely they pardon the offences and

faults of the enemy, and after the victories they are kind to them, if it has been decreed that they should destroy the walls of the enemy's city and take their lives. All these things are done on the same day as the victory, and afterward they never cease to load the conquered with favors, for they say that there ought to be no fighting, except when the conquerors give up the conquered, not when they kill them. If there is a dispute among them concerning injury or any other matter (for they themselves scarcely ever contend except in matters of honor), the chief and his magistrates chastise the accused one secretly, if he has done harm in deeds after he has been first angry. If they wait until the time of the battle for the verbal decision, they must give vent to their anger against the enemy, and he who in battle shows the most daring deeds is considered to have defended the better and truer cause in the struggle, and the other yields, and they are punished justly. Nevertheless, they are not allowed to come to single combat, since right is maintained by the tribunal, and because the unjust cause is often apparent when the more just succumbs, and he who professes to be the better man shows this in public fight.

G.M. This is worth while, so that factions should not be cherished for the harm of the fatherland, and so that civil wars might not occur, for by means of these a tyrant often arises, as the examples of Rome and Athens show. Now, I pray you, tell me of their works and matter connected therewith.

Capt. I believe that you have already heard about their military affairs and about their agricultural and pastoral life, and in what way these are common to them, and how they honor with the first grade of nobility whoever is considered to have knowledge of these. They who are skilful in more arts than these they consider still nobler, and they set that one apart for teaching the art in which he is most skilful. The occupations which require the most labor, such as working in metals and building, are the most praiseworthy among them. No one declines to go to these occupations, for the reason that from the beginning their propensities are well known, and among them, on account of the distribution of labor, no one does work harmful to him, but only that which is necessary for him. The occupations entailing less labor belong to the women. All of them are expected to know how to swim, and for this reason

ponds are dug outside the walls of the city and within them near to the fountains.

Commerce is of little use to them, but they know the value of money, and they count for the use of their ambassadors and explorers, so that with it they may have the means of living. They receive merchants into their States from the different countries of the world, and these buy the superfluous goods of the city. The people of the City of the Sun refuse to take money, but in importing they accept in exchange those things of which they are in need, and sometimes they buy with money; and the young people in the City of the Sun are much amused when they see that for a small price they receive so many things in exchange. The old men, however, do not laugh. They are unwilling that the State should be corrupted by the vicious customs of slaves and foreigners. Therefore they do business at the gates, and sell those whom they have taken in war or keep them for digging ditches and other hard work without the city, and for this reason they always send four bands of soldiers to take care of the fields, and with them there are the laborers. They go out of the four gates from which roads with walls on both sides of them lead to the sea, so that goods might easily be carried over them and foreigners might not meet with difficulty on their way.

To strangers they are kind and polite; they keep them for three days at the public expense; after they have first washed their feet, they show them their city and its customs, and they honor them with a seat at the Council and public table, and there are men whose duty it is to take care of and guard the guests. But if strangers should wish to become citizens of their State, they try them first for a month on a farm, and for another month in the city, then they decide concerning them, and admit them with certain ceremonies and oaths.

Agriculture is much followed among them; there is not a span of earth without cultivation, and they observe the winds and propitious stars. With the exception of a few left in the city all go out armed, and with flags and drums and trumpets sounding, to the fields, for the purposes of ploughing, sowing, digging, hoeing, reaping, gathering fruit and grapes; and they set in order everything, and do their work in a very few hours and with much care. They use wagons fitted with sails which

CITY OF THE SUN

are borne along by the wind even when it is contrary, by the marvellous contrivance of wheels within wheels.

And when there is no wind a beast draws along a huge cart, which is a grand sight,

The guardians of the land move about in the meantime, armed and always in their proper turn. They do not use dung and filth for manuring the fields, thinking that the fruit contracts something of their rottenness, and when eaten gives a short and poor subsistence, as women who are beautiful with rouge and from want of exercise bring forth feeble offspring. Wherefore they do not as it were paint the earth, but dig it up well and use secret remedies, so that fruit is borne quickly and multiplies, and is not destroyed. They have a book for this work, which they call the Georgics. As much of the land as is necessary is cultivated, and the rest is used for the pasturage of cattle.

The excellent occupation of breeding and rearing horses, oxen, sheep, dogs, and all kinds of domestic and tame animals is in the highest esteem among them as it was in the time of Abraham. And the animals are led so to pair that they may be able to breed well.

Fine pictures of oxen, horses, sheep, and other animals are placed before them. They do not turn out horses with mares to feed, but at the proper time they bring them together in an enclosure of the stables in their fields. And this is done when they observe that the constellation Archer is in favorable conjunction with Mars and Jupiter. For the oxen they observe the Bull, for the sheep the Ram, and so on in accordance with art. Under the Pleiades they keep a drove of hens and ducks and geese, which are driven out by the women to feed near the city. The women only do this when it is a pleasure to them. There are also places enclosed, where they make cheese, butter, and milk-food. They also keep capons, fruit, and other things, and for all these matters there is a book which they call the Bucolics. They have an abundance of all things, since everyone likes to be industrious, their labors being slight and profitable. They are docile, and that one among them who is head of the rest in duties of this kind they call king. For they say that this is the proper name of the leaders, and it does not belong to ignorant persons. It is wonderful to see how men and

women march together collectively, and always in obedience to the voice of the king. Nor do they regard him with loathing as we do, for they know that although he is greater than themselves, he is for all that their father and brother. They keep groves and woods for wild animals, and they often hunt.

The science of navigation is considered very dignified by them, and they possess rafts and triremes, which go over the waters without rowers or the force of the wind, but by a marvellous contrivance. And other vessels they have which are moved by the winds. They have a correct knowledge of the stars, and of the ebb and flow of the tide. They navigate for the sake of becoming acquainted with nations and different countries and things. They injure nobody, and they do not put up with injury, and they never go to battle unless when provoked. They assert that the whole earth will in time come to live in accordance with their customs, and consequently they always find out whether there be a nation whose manner of living is better and more approved than the rest. They admire the Christian institutions and look for a realization of the apostolic life in vogue among themselves and in us. There are treaties between them and the Chinese and many other nations, both insular and continental, such as Siam and Calicut, which they are only just able to explore. Furthermore, they have artificial fires, battles on sea and land, and many strategic secrets. Therefore they are nearly always victorious.

G.M. Now it would be very pleasant to learn with what foods and drinks they are nourished, and in what way and for how long they live.

Capt. Their food consists of flesh, butter, honey, cheese, garden herbs, and vegetables of various kinds. They were unwilling at first to slay animals, because it seemed cruel; but thinking afterward that is was also cruel to destroy herbs which have a share of sensitive feeling, they saw that they would perish from hunger unless they did an unjustifiable action for the sake of justifiable ones, and so now they all eat meat. Nevertheless, they do not kill willingly useful animals, such as oxen and horses. They observe the difference between useful and harmful foods, and for this they employ the science of medicine. They always change their food. First they eat flesh, then fish, then afterward they go back to flesh, and nature is

never incommoded or weakened. The old people use the more digestible kind of food, and take three meals a day, eating only a little. But the general community eat twice, and the boys four times, that they may satisfy nature. The length of their lives is generally 100 years, but often they reach 200.

As regards drinking, they are extremely moderate. Wine is never given to young people until they are ten years old, unless the state of their health demands it. After their tenth year they take it diluted with water, and so do the women, but the old men of fifty and upward use little or no water. They eat the most healthy things, according to the time of the year.

They think nothing harmful which is brought forth by God, except when there has been abuse by taking too much. And therefore in the summer they feed on fruits, because they are moist and juicy and cool, and counteract the heat and dryness. In the winter they feed on dry articles, and in the autumn they eat grapes, since they are given by God to remove melancholy and sadness; and they also make use of scents to a great degree. In the morning, when they have all risen they comb their hair and wash their faces and hands with cold water. Then they chew thyme or rock-parsley or fennel, or rub their hands with these plants. The old men make incense, and with their faces to the east repeat the short prayer which Jesus Christ taught us. After this they go to wait upon the old men, some go to the dance, and others to the duties of the State. Later on they meet at the early lectures, then in the temple, then for bodily exercise. Then for a little while they sit down to rest, and at length they go to dinner.

Among them there is never gout in the hands or feet, nor catarrh, nor sciatica, nor grievous colics, nor flatulency, nor hard breathing. For these diseases are caused by indigestion and flatulency, and by frugality and exercise they remove every humor and spasm. Wherefore it is unseemly in the extreme to be seen vomiting or spitting, since they say that this is a sign either of little exercise, or of ignoble sloth, or of drunkenness, or gluttony. They suffer rather from swellings or from the dry spasm, which they relieve with plenty of good and juicy food. They heal fevers with pleasant baths and with milk-food, and with a pleasant habitation in the country and by gradual exercise. Unclean diseases cannot be prevalent with them

because they often clean their bodies by bathing in wine, and soothe them with aromatic oil, and by the sweat of exercise they diffuse the poisonous vapor which corrupts the blood and the marrow. They do suffer a little from consumption, because they cannot perspire at the breast, but they never have asthma, for the humid nature of which a heavy man is required. They cure hot fevers with cold potations of water, but slight ones with sweet smells, with cheese-bread or sleep, with music or dancing. Tertiary fevers are cured by bleeding, by rhubarb or by a similar drawing remedy, or by water soaked in the roots of plants, with purgative and sharp-tasting qualities. But it is rarely that they take purgative medicines. Fevers occurring every fourth day are cured easily by suddenly startling the unprepared patients, and by means of herbs producing effects opposite to the humors of this fever. All these secrets they told me in opposition to their own wishes. They take more diligent pains to cure the lasting fevers, which they fear more, and they strive to counteract these by the observation of stars and of plants, and by prayers to God. Fevers recurring every fifth, sixth, eighth or more days, you never find whenever heavy humors are wanting.

They use baths, and moreover they have warm ones according to the Roman custom, and they make use also of olive oil. They have found out, too, a great many secret cures for the preservation of cleanliness and health. And in other ways they labor to cure the epilepsy, with which they are often troubled.

G.M. A sign this disease is of wonderful cleverness, for from it Hercules, Scotus, Socrates, Callimachus, and Mahomet have suffered.

Capt. They cure by means of prayers to heaven, by strengthening the head, by acids, by planned gymnastics, and with fat cheese-bread sprinkled with the flour of wheaten corn. They are very skilled in making dishes, and in them they put spice, honey, butter, and many highly strengthening spices, and they temper their richness with acids, so that they never vomit. They do not drink ice-cold drinks nor artificial hot drinks, as the Chinese do; for they are not without aid against the humors of the body, on account of the help they get from the natural heat of the water; but they strengthen it with crushed garlic, with vinegar, with wild thyme, with mint, and

with basil, in the summer or in time of special heaviness. They know also a secret for renovating life after about the seventieth year, and for ridding it of affliction, and this they do by a pleasing and indeed wonderful art.

G.M. Thus far you have said nothing concerning their sciences and magistrates.

Capt. Undoubtedly I have. But since you are so curious I will add more. Both when it is new moon and full moon they call a council after a sacrifice. To this all from twenty years upward are admitted, and each one is asked separately to say what is wanting in the State, and which of the magistrates have discharged their duties rightly and which wrongly. Then after eight days all the magistrates assemble, to wit, Hoh first, and with him Power, Wisdom, and Love. Each one of the three last has three magistrates under him, making in all thirteen, and they consider the affairs of the arts pertaining to each one of them: Power, of war; Wisdom, of the sciences; Love, of food, clothing, education, and breeding. The masters of all the bands, who are captains of tens, of fifties, of hundreds, also assemble, the women first and then the men. They argue about those things which are for the welfare of the State, and they choose the magistrates from among those who have already been named in the great Council. In this manner they assemble daily, Hoh and his three princes, and they correct, confirm, and execute the matters passing to them, as decisions in the elections; other necessary questions they provide of themselves. They do not use lots unless when they are altogether doubtful how to decide. The eight magistrates under Hoh, Power, Wisdom, and Love are changed according to the wish of the people, but the first four are never changed, unless they, taking counsel with themselves, give up the dignity of one to another, whom among them they know to be wiser, more renowned, and more nearly perfect. And then they are obedient and honorable, since they yield willingly to the wiser man and are taught by him. This, however, rarely happens. The principals of the sciences, except Metaphysic, who is Hoh himself, and is, as it were, the architect of all science, having rule over all, are attached to Wisdom. Hoh is ashamed to be ignorant of any possible thing. Under Wisdom therefore are Grammar, Logic, Physics, Medicine, Astrology, Astronomy, Geometry,

Cosmography, Music, Perspective, Arithmetic, Poetry, Rhetoric, Painting, Sculpture. Under the triumvir Love are Breeding, Agriculture, Education, Medicine, Clothing, Pasturage, Coining.

G.M. What about their judges?

Capt. This is the point I was just thinking of explaining. Everyone is judged by the first master of his trade, and thus all the head artificers are judges. They punish with exile, with flogging, with blame, with deprivation of the common table, with exclusion from the church and from the company of women. When there is a case in which great injury has been done, it is punished with death, and they repay an eye with an eye, a nose for a nose, a tooth for a tooth, and so on, according to the law of retaliation. If the offence is wilful the Council decides. When there is strife and it takes place undesignedly, the sentence is mitigated; nevertheless, not by the judge but by the triumvirate, from whom even it may be referred to Hoh, not on account of justice but of mercy, for Hoh is able to pardon. They have no prisons, except one tower for shutting up rebellious enemies, and there is no written statement of a case, which we commonly call a lawsuit. But the accusation and witnesses are produced in the presence of the judge and Power; the accused person makes his defence, and he is immediately acquitted or condemned by the judge; and if he appeals to the triumvirate, on the following day he is acquitted or condemned. On the third day he is dismissed through the mercy and clemency of Hoh, or receives the inviolable rigor of his sentence. An accused person is reconciled to his accuser and to his witnesses, as it were, with the medicine of his complaint, that is, with embracing and kissing.

No one is killed or stoned unless by the hands of the people, the accuser and the witnesses beginning first. For they have no executioners and lictors, lest the State should sink into ruin. The choice of death is given to the rest of the people, who enclose the lifeless remains in little bags and burn them by the application of fire, while exhorters are present for the purpose of advising concerning a good death. Nevertheless, the whole nation laments and beseeches God that his anger may be appeased, being in grief that it should, as it were, have to cut off a rotten member of the State. Certain officers talk to and con-

vince the accused man by means of arguments until he himself acquiesces in the sentence of death passed upon him, or else he does not die. But if a crime has been committed against the liberty of the republic, or against God, or against the supreme magistrates, there is immediate censure without pity. These only are punished with death. He who is about to die is compelled to state in the presence of the people and with religious scrupulousness the reasons for which he does not deserve death, and also the sins of the others who ought to die instead of him, and further the mistakes of the magistrates. If, moreover, it should seem right to the person thus asserting, he must say why the accused ones are deserving of less punishment than he. And if by his arguments he gains the victory he is sent into exile, and appeases the State by means of prayers and sacrifices and good life ensuing. They do not torture those named by the accused person, but they warn them. Sins of frailty and ignorance are punished only with blaming, and with compulsory continuation as learners under the law and discipline of those sciences or arts against which they have sinned. And all these things they have mutually among themselves, since they seem to be in very truth members of the same body, and one of another.

This further I would have you know, that if a transgressor, without waiting to be accused, goes of his own accord before a magistrate, accusing himself and seeking to make amends, that one is liberated from the punishment of a secret crime, and since he has not been accused of such a crime, his punishment is changed into another. They take special care that no one should invent slander, and if this should happen they meet the offence with the punishment of retaliation. Since they always walk about and work in crowds, five witnesses are required for the conviction of a transgressor. If the case is otherwise, after having threatened him, he is released after he has sworn an oath as the warrant of good conduct. Or if he is accused a second or third time, his increased punishment rests on the testimony of three or two witnesses. They have but few laws, and these short and plain, and written upon a flat table, and hanging to the doors of the temple, that is between the columns. And on single columns can be seen the essences of things described in the very terse style of Metaphysic—viz., the essences of God, of

the angels, of the world, of the stars, of man, of fate, of virtue, all done with great wisdom. The definitions of all the virtues are also delineated here, and here is the tribunal, where the judges of all the virtues have their seat. The definition of a certain virtue is written under that column where the judges for the aforesaid virtue sit, and when a judge gives judgment he sits and speaks thus: O son, thou hast sinned against this sacred definition of beneficence, or of magnanimity, or of another virtue, as the case may be. And after discussion the judge legally condemns him to the punishment for the crime of which he is accused—viz., for injury, for despondency, for pride, for ingratitude, for sloth, etc. But the sentences are certain and true correctives, savoring more of clemency than of actual punishment.

G.M. Now you ought to tell me about their priests, their sacrifices, their religion, and their belief.

Capt. The chief priest is Hoh, and it is the duty of all the superior magistrates to pardon sins. Therefore the whole State by secret confession, which we also use, tell their sins to the magistrates, who at once purge their souls and teach those that are inimical to the people. Then the sacred magistrates themselves confess their own sinfulness to the three supreme chiefs, and together they confess the faults of one another, though no special one is named, and they confess especially the heavier faults and those harmful to the State. At length the triumvirs confess their sinfulness to Hoh himself, who forthwith recognizes the kinds of sins that are harmful to the State, and succors with timely remedies. Then he offers sacrifices and prayers to God. And before this he confesses the sins of the whole people, in the presence of God, and publicly in the temple, above the altar, as often as it had been necessary that the fault should be corrected. Nevertheless, no transgressor is spoken of by his name. In this manner he absolves the people by advising them that they should beware of sins of the aforesaid kind. Afterward he offers sacrifice to God, that he should pardon the State and absolve it of its sins, and to teach and defend it. Once in every year the chief priests of each separate subordinate State confess their sins in the presence of Hoh. Thus he is not ignorant of the wrongdoings of the provinces, and forthwith he removes them with all human and heavenly remedies.

CITY OF THE SUN

Sacrifice is conducted after the following manner: Hoh asks the people which one among them wishes to give himself as a sacrifice to God for the sake of his fellows. He is then placed upon the fourth table, with ceremonies and the offering up of prayers: the table is hung up in a wonderful manner by means of four ropes passing through four cords attached to firm pulley-blocks in the small dome of the temple. This done they cry to the God of mercy, that he may accept the offering, not of a beast as among the heathen, but of a human being. Then Hoh orders the ropes to be drawn and the sacrifice is pulled up above to the centre of the small dome, and there it dedicates itself with the most fervent supplications. Food is given to it through a window by the priests, who live around the dome, but it is allowed a very little to eat, until it has atoned for the sins of the State. There with prayer and fasting he cries to the God of heaven that he might accept its willing offering. And after twenty or thirty days, the anger of God being appeased, the sacrifice becomes a priest, or sometimes, though rarely, returns below by means of the outer way for the priests. Ever after, this man is treated with great benevolence and much honor, for the reason that he offered himself unto death for the sake of his country. But God does not require death.

The priests above twenty-four years of age offer praises from their places in the top of the temple. This they do in the middle of the night, at noon, in the morning and in the evening, to wit, four times a day they sing their chants in the presence of God. It is also their work to observe the stars and to note with the astrolabe their motions and influences upon human things, and to find out their powers. Thus they know in what part of the earth any change has been or will be, and at what time it has taken place, and they send to find whether the matter be as they have it. They make a note of predictions, true and false, so that they may be able from experience to predict most correctly. The priests, moreover, determine the hours for breeding and the days for sowing, reaping, and gathering the vintage, and are, as it were, the ambassadors and intercessors and connection between God and man. And it is from among them mostly that Hoh is elected. They write very learned treatises and search into the sciences. Below they never descend, unless for their dinner and supper, so that the essence of their heads do not

descend to the stomachs and liver. Only very seldom, and that as a cure for the ills of solitude, do they have converse with women. On certain days Hoh goes up to them and deliberates with them concerning the matters which he has lately investigated for the benefit of the State and all the nations of the world.

In the temple beneath, one priest always stands near the altar praying for the people, and at the end of every hour another succeeds him, just as we are accustomed in solemn prayer to change every fourth hour. And this method of supplication they call perpetual prayer. After a meal they return thanks to God. Then they sing the deeds of the Christian, Jewish, and Gentile heroes, and of those of all other nations, and this is very delightful to them. Forsooth, no one is envious of another. They sing a hymn to Love, one to Wisdom, and one each to all the other virtues, and this they do under the direction of the ruler of each virtue. Each one takes the woman he loves most, and they dance for exercise with propriety and stateliness under the peristyles. The women wear their long hair all twisted together and collected into one knot on the crown of the head, but in rolling it they leave one curl. The men, however, have one curl only and the rest of their hair around the head is shaven off. Further, they wear a slight covering, and above this a round hat a little larger than the size of their head. In the fields they use caps, but at home each one wears a biretta, white, red, or another color according to his trade or occupation. Moreover, the magistrates use grander and more imposing-looking coverings for the head.

They hold great festivities when the sun enters the four cardinal points of the heavens, that is, when he enters Cancer, Libra, Capricorn, and Aries. On these occasions they have very learned, splendid, and, as it were, comic performances. They celebrate also every full and every new moon with a festival, as also they do the anniversaries of the founding of the city, and of the days when they have won victories or done any other great achievement. The celebrations take place with the music of female voices, with the noise of trumpets and drums, and the firing of salutations. The poets sing the praises of the most renowned leaders and the victories. Nevertheless, if any of them should deceive even by disparaging a foreign hero, he is

punished. No one can exercise the function of a poet who invents that which is not true, and a license like this they think to be a pest of our world, for the reason that it puts a premium upon virtue and often assigns it to unworthy persons, either from fear of flattery, or ambition, or avarice.

For the praise of no one is a statue erected until after his death; but while he is alive, who has found out new arts and very useful secrets, or who has rendered great service to the State either at home or on the battle-field, his name is written in the book of heroes. They do not bury dead bodies, but burn them, so that a plague may not arise from them, and so that they may be converted into fire, a very noble and powerful thing, which has its ning from the sun and returns to it. And for the above rea s no chance is given for idolatry. The statues and picture of the heroes, however, are there, and the splendid women set apart to become mothers often look at them. Prayers are made from the S to the four horizontal corners of the world—in the moi ng o the rising sun, then to the setting sun, then to the south, and lastly to the north; and in the contrary order in the evening, first to the setting sun, to the rising sun, to the north, and at length to the south. They repeat but one prayer, which asks for health of body and of mind, and happiness for themselves and all people, and they conclude it with the petition "As it seems best to God." The public prayer for all is long, and it is poured forth to heaven. For this reason the altar is round and is divided crosswise by ways at right angles to one another. By these ways Hoh enters after he has repeated the four prayers, and he prays looking up to heaven. And then a great mystery is seen by them. The priestly vestments are of a beauty and meaning like to those of Aaron. They resemble nature and they surpass Art.

They divide the seasons according to the revolution of the sun, and not of the stars, and they observe yearly by how much time the one precedes the other. They hold that the sun approaches nearer and nearer, and therefore by ever-lessening circles reaches the tropics and the equator every year a little sooner. They measure months by the course of the moon, years by that of the sun. They praise Ptolemy, admire Copernicus, but place Aristarchus and Philolaus before him. They take great pains in endeavoring to understand the construction

of the world, and whether or not it will perish, and at what time. They believe that the true oracle of Jesus Christ is by the signs in the sun, in the moon, and in the stars, which signs do not thus appear to many of us foolish ones. Therefore they wait for the renewing of the age, and perchance for its end.

They say that it is very doubtful whether the world was made from nothing, or from the ruins of other worlds, or from chaos, but they certainly think that it was made, and did not exist from eternity. Therefore they disbelieve in Aristotle, whom they consider a logican and not a philosopher. From analogies, they can draw many arguments against the eternity of the world. The sun and the stars they, so to speak, regard as the living representatives and signs of God, as the temples and holy living altars, and they honor but do not worship them. Beyond all other things they venerate the sun, but they consider no created thing worthy the adoration of worship. This they give to God alone, and thus they serve Him, that they may not come into the power of a tyrant and fall into misery by undergoing punishment by creatures of revenge. They contemplate and know God under the image of the Sun, and they call it the sign of God, His face and living image, by means of which light, heat, life, and the making of all things good and bad proceed. Therefore they have built an altar like to the sun in shape, and the priests praise God in the sun and in the stars, as it were His altars, and in the heavens, His temple as it were; and they pray to good angels, who are, so to speak, the intercessors living in the stars, their strong abodes. For God long since set signs of their beauty in heaven, and of His glory in the sun. They say there is but one heaven, and that the planets move and rise of themselves when they approach the sun or are in conjunction with it.

They assert two principles of the physics of things below, namely, that the sun is the father, and the earth the mother; the air is an impure part of the heavens; all fire is derived from the sun. The sea is the sweat of earth, or the fluid of earth combusted, and fused within its bowels, but is the bond of union between air and earth, as the blood is of the spirit and flesh of animals. The world is a great animal, and we live within it as worms live within us. Therefore we do not belong to the system of stars, sun, and earth, but to God only; for in respect to them which seek only to amplify themselves, we are

born and live by chance; but in respect to God, whose instruments we are, we are formed by prescience and design, and for a high end. Therefore we are bound to no father but God, and receive all things from Him. They hold as beyond question the immortality of souls, and that these associate with good angels after death, or with bad angels, according as they have likened themselves in this life to either. For all things seek their like. They differ little from us as to places of reward and punishment. They are in doubt whether there are other worlds beyond ours, and account it madness to say there is nothing. Nonentity is incompatible with the infinite entity of God. They lay down two principles of metaphysics, entity which is the highest God, and nothingness which is the defect of entity. Evil and sin come of the propensity to nothingness; the sin having its cause not efficient, but in deficiency. Deficiency is, they say, of power, wisdom, or will. Sin they place in the last of these three, because he who knows and has the power to do good is bound also to have the will, for will arises out of them. They worship God in trinity, saying God is the Supreme Power, whence proceeds the highest Wisdom, which is the same with God, and from these comes Love, which is both power and wisdom; but they do not distinguish persons by name, as in our Christian law, which has not been revealed to them. This religion, when its abuses have been removed, will be the future mistress of the world, as great theologians teach and hope. Therefore Spain found the New World (though its first discoverer, Columbus, greatest of heroes, was a Genoese), that all nations should be gathered under one law. We know not what we do, but God knows, whose instruments we are. They sought new regions for lust of gold and riches, but God works to a higher end. The sun strives to burn up the earth, not to produce plants and men, but God guides the battle to great issues. His the praise, to Him the glory!

G.M. Oh, if you knew what our astrologers say of the coming age, and of our age, that has in it more history within 100 years than all the world had in 4,000 years before! of the wonderful inventions of printing and guns, and the use of the magnet, and how it all comes of Mercury, Mars, the Moon, and the Scorpion!

Capt. Ah, well! God gives all in His good time. They astrologize too much.

OCEANA

BY

JAMES HARRINGTON

OCEANA

PART I

THE PRELIMINARIES

Showing the Principles of Government

JANOTTI, the most excellent describer of the Commonwealth of Venice, divides the whole series of government into two times or periods: the one ending with the liberty of Rome, which was the course or empire, as I may call it, of ancient prudence, first discovered to mankind by God himself in the fabric of the Commonwealth of Israel, and afterward picked out of his footsteps in nature, and unanimously followed by the Greeks and Romans; the other beginning with the arms of Cæsar, which, extinguishing liberty, were the transition of ancient into modern prudence, introduced by those inundations of Huns, Goths, Vandals, Lombards, Saxons, which, breaking the Roman Empire, deformed the whole face of the world with those ill-features of government, which at this time are become far worse in these western parts, except Venice, which, escaping the hands of the barbarians by virtue of its impregnable situation, has had its eye fixed upon ancient prudence, and is attained to a perfection even beyond the copy.

Relation being had to these two times, government (to define it *de jure,* or according to ancient prudence) is an art whereby a civil society of men is instituted and preserved upon the foundation of common right or interest; or, to follow Aristotle and Livy, it is the empire of laws, and not of men.

And government (to define it *de facto,* or according to modern prudence) is an art whereby some man, or some few men, subject a city or a nation, and rule it according to his or their private interest; which, because the laws in such cases are made according to the interest of a man, or of some few families, may be said to be the empire of men, and not of laws.

The former kind is that which Machiavel (whose books are neglected) is the only politician that has gone about to re-

trieve; and that Leviathan (who would have his book imposed upon the universities) goes about to destroy. For "it is," says he, "another error of Aristotle's politics that in a well-ordered commonwealth, not men should govern, but the laws. What man that has his natural senses, though he can neither write nor read, does not find himself governed by them he fears, and believes can kill or hurt him when he obeys not? Or, who believes that the law can hurt him, which is but words and paper, without the hands and swords of men?" I confess that the magistrate upon his bench is that to the law which a gunner upon his platform is to his cannon. Nevertheless, I should not dare to argue with a man of any ingenuity after this manner. A whole army, though they can neither write nor read, are not afraid of a platform, which they know is but earth or stone; nor of a cannon, which, without a hand to give fire to it, is but cold iron; therefore a whole army is afraid of one man. But of this kind is the ratiocination of Leviathan, as I shall show in divers places that come in my way, throughout his whole politics, or worse; as where he says, "Of Aristotle and of Cicero, of the Greeks, and of the Romans, who lived under popular States, that they derived those rights, not from the principles of nature, but transcribed them into their books out of the practice of their own commonwealths, as grammarians describe the rules of language out of poets." Which is as if a man should tell famous Harvey that he transcribed his circulation of the blood, not out of the principles of nature, but out of the anatomy of this or that body.

To go on therefore with his preliminary discourse, I shall divide it, according to the two definitions of government relating to Janotti's two times, in two parts: the first, treating of the principles of government in general, and according to the ancients; the second, treating of the late governments of Oceana in particular, and in that of modern prudence.

Government, according to the ancients, and their learned disciple Machiavel, the only politician of later ages, is of three kinds: the government of one man, or of the better sort, or of the whole people; which, by their more learned names, are called monarchy, aristocracy, and democracy. These they hold, through their proneness to degenerate, to be all evil. For whereas they that govern should govern according to reason, if they govern according to passion they do that which they should not do. Wherefore, as reason and passion are two things, so government by reason is one thing, and the corruption of government by passion is another thing, but not always another government: as a body that is alive is one

thing, and a body that is dead is another thing, but not always another creature, though the corruption of one comes at length to be the generation of another. The corruption then of monarchy is called tyranny; that of aristocracy, oligarchy; and that of democracy, anarchy. But legislators, having found these three governments at the best to be naught, have invented another, consisting of a mixture of them all, which only is good. This is the doctrine of the ancients.

But Leviathan is positive that they are all deceived, and that there is no other government in nature than one of the three; as also that the flesh of them cannot stink, the names of their corruptions being but the names of men's fancies, which will be understood when we are shown which of them was *Senatus Populusque Romanus*.

To go my own way, and yet to follow the ancients, the principles of government are twofold: internal, or the goods of the mind; and external, or the goods of fortune. The goods of the mind are natural or acquired virtues, as wisdom, prudence, and courage, etc. The goods of fortune are riches. There be goods also of the body, as health, beauty, strength; but these are not to be brought into account upon this score, because if a man or an army acquires victory or empire, it is more from their discipline, arms, and courage than from their natural health, beauty, or strength, in regard that a people conquered may have more of natural strength, beauty, and health, and yet find little remedy. The principles of government then are in the goods of the mind, or in the goods of fortune. To the goods of the mind answers authority; to the goods of fortune, power or empire. Wherefore Leviathan, though he be right where he says that "riches are power," is mistaken where he says that "prudence, or the reputation of prudence, is power;" for the learning or prudence of a man is no more power than the learning or prudence of a book or author, which is properly authority. A learned writer may have authority though he has no power; and a foolish magistrate may have power, though he has otherwise no esteem or authority. The difference of these two is observed by Livy in Evander, of whom he says that he governed rather by the authority of others than by his own power.

To begin with riches, in regard that men are hung upon these, not of choice as upon the other, but of necessity and by the teeth; forasmuch as he who wants bread is his servant that will feed him, if a man thus feeds a whole people, they are under his empire.

Empire is of two kinds, domestic and national, or foreign and provincial.

Domestic empire is founded upon dominion.

Dominion is property, real or personal; that is to say, in lands, or in money and goods.

Lands, or the parts and parcels of a territory, are held by the proprietor or proprietors, lord or lords of it, in some proportion; and such (except it be in a city that has little or no land, and whose revenue is in trade) as is the proportion or balance of dominion or property in land, such is the nature of the empire.

If one man be sole landlord of a territory, or overbalance the people, for example, three parts in four, he is grand seignior; for so the Turk is called from his property, and his empire is absolute monarchy.

If the few or a nobility, or a nobility with the clergy, be landlords, or overbalance the people to the like proportion, it makes the Gothic balance (to be shown at large in the second part of this discourse), and the empire is mixed monarchy, as that of Spain, Poland, and late of Oceana.

And if the whole people be landlords, or hold the lands so divided among them that no one man, or number of men, within the compass of the few or aristocracy, overbalance them, the empire (without the interposition of force) is a commonwealth.

If force be interposed in any of these three cases, it must either frame the government to the foundation, or the foundation to the government; or holding the government not according to the balance, it is not natural, but violent; and therefore if it be at the devotion of a prince, it is tyranny; if at the devotion of the few, oligarchy; or if in the power of the people, anarchy. Each of which confusions, the balance standing otherwise, is but of short continuance, because against the nature of the balance, which, not destroyed, destroys that which opposes it.

But there be certain other confusions, which, being rooted in the balance, are of longer continuance, and of worse consequence; as, first, where a nobility holds half the property, or about that proportion, and the people the other half; in which case, without altering the balance there is no remedy but the one must eat out the other, as the people did the nobility in Athens, and the nobility the people in Rome. Secondly, when a prince holds about half the dominion, and the people the other half (which was the case of the Roman emperors, planted partly upon their military colonies and partly upon the Senate and the people), the government becomes a very shambles, both of the princes and the people. Somewhat of this nature are certain governments at this day, which are said to subsist

by confusion. In this case, to fix the balance is to entail misery; but in the three former, not to fix it is to lose the government. Wherefore it being unlawful in Turkey that any should possess land but the Grand Seignior, the balance is fixed by the law, and that empire firm. Nor, though the kings often sell was the throne of Oceana known to shake, until the statute of alienations broke the pillars, by giving way to the nobility to sell their estates. While Lacedæmon held to the division of land made by Lycurgus, it was immovable; but, breaking that, could stand no longer. This kind of law fixing the balance in lands is called agrarian, and was first introduced by God himself, who divided the land of Canaan to his people by lots, and is of such virtue that wherever it has held, that government has not altered, except by consent; as in that unparalleled example of the people of Israel, when being in liberty they would needs choose a king. But without an agrarian law, government, whether monarchical, aristocratical, or popular, has no long lease.

As for dominion, personal or in money, it may now and then stir up a Melius or a Manlius, which, if the Commonwealth be not provided with some kind of dictatorian power, may be dangerous, though it has been seldom or never successful; because to property producing empire, it is required that it should have some certain root or foothold, which, except in land, it cannot have, being otherwise as it were upon the wing.

Nevertheless, in such cities as subsist mostly by trade, and have little or no land, as Holland and Genoa, the balance of treasure may be equal to that of land in the cases mentioned.

But Leviathan, though he seems to skew at antiquity, following his furious master Carneades, has caught hold of the public sword, to which he reduces all manner and matter of government; as, where he affirms this opinion (that any monarch receives his power by covenant; that is to say, upon conditions) " to proceed from the not understanding this easy truth, that covenants being but words and breath, have no power to oblige, contain, constrain, or protect any man, but what they have from the public sword." But as he said of the law, that without this sword it is but paper, so he might have thought of this sword, that without a hand it is but cold iron. The hand which holds this sword is the militia of a nation; and the militia of a nation is either an army in the field, or ready for the field upon occasion. But an army is a beast that has a great belly, and must be fed: wherefore this will come to what pastures you have, and what pastures you have will come to the balance of property, without which the

public sword is but a name or mere spitfrog. Wherefore, to set that which Leviathan says of arms and of contracts a little straighter, he that can graze this beast with the great belly, as the Turk does his Timariots, may well deride him that imagines he received his power by covenant, or is obliged to any such toy: it being in this case only that covenants are but words and breath. But if the property of the nobility, stocked with their tenants and retainers, be the pasture of that beast, the ox knows his master's crib; and it is impossible for a king in such a constitution to reign otherwise than by covenant; or if he break it, it is words that come to blows.

"But," says he, "when an assembly of men is made sovereign, then no man imagines any such covenant to have part in the institution." But what was that by Publicola of appeal to the people, or that whereby the people had their tribunes? "Fie," says he, "nobody is so dull as to say that the people of Rome made a covenant with the Romans, to hold the sovereignty on such or such conditions, which, not performed, the Romans might depose the Roman people." In which there be several remarkable things; for he holds the Commonwealth of Rome to have consisted of one assembly, whereas it consisted of the Senate and the people; that they were not upon covenant, whereas every law enacted by them was a covenant between them; that the one assembly was made sovereign, whereas the people, who only were sovereign, were such from the beginning, as appears by the ancient style of their covenants or laws—"The Senate has resolved, the people have decreed;" that a council being made sovereign, cannot be made such upon conditions, whereas the Decemvirs being a council that was made sovereign, was made such upon conditions; that all conditions or covenants making a sovereign being made, are void; whence it must follow that, the Decemviri being made, were ever after the lawful government of Rome, and that it was unlawful for the Commonwealth of Rome to depose the Decemvirs; as also that Cicero, if he wrote otherwise out of his commonwealth, did not write out of nature. But to come to others that see more of this balance.

You have Aristotle full of it in divers places, especially where he says, that "immoderate wealth, as where one man or the few have greater possessions than the equality or the frame of the commonwealth will bear, is an occasion of sedition, which ends for the greater part in monarchy; and that for this cause the ostracism has been received in divers places, as in Argos and Athens. But that it were better to prevent the growth in the beginning, than, when it has got head, to seek the remedy of such an evil."

Machiavel has missed it very narrowly and more dangerously; for, not fully perceiving that if a commonwealth be galled by the gentry it is by their overbalance, he speaks of the gentry as hostile to popular governments, and of popular governments as hostile to the gentry; and makes us believe that the people in such are so enraged against them, that where they meet a gentleman they kill him: which can never be proved by any one example, unless in civil war, seeing that even in Switzerland the gentry are not only safe, but in honor. But the balance, as I have laid it down, though unseen by Machiavel, is that which interprets him, and that which he confirms by his judgment in many others as well as in this place, where he concludes, " That he who will go about to make a commonwealth where there be many gentlemen, unless he first destroys them, undertakes an impossibility. And that he who goes about to introduce monarchy where the condition of the people is equal, shall never bring it to pass, unless he cull out such of them as are the most turbulent and ambitious, and make them gentlemen or noblemen, not in name but in effect; that is, by enriching them with lands, castles, and treasures, that may gain them power among the rest, and bring in the rest to dependence upon themselves, to the end that, they maintaining their ambition by the prince, the prince may maintain his power by them."

Wherefore, as in this place I agree with Machiavel, that a nobility or gentry, overbalancing a popular government, is the utter bane and destruction of it; so I shall show in another, that a nobility or gentry, in a popular government, not overbalancing it, is the very life and soul of it.

By what has been said, it should seem that we may lay aside further disputes of the public sword, or of the right of the militia; which, be the government what it will, or let it change how it can, is inseparable from the overbalance in dominion: nor, if otherwise stated by the law or custom (as in the Commonwealth of Rome, where the people having the sword, the nobility came to have the overbalance), avails it to any other end than destruction. For as a building swaying from the foundation must fall, so it fares with the law swaying from reason, and the militia from the balance of dominion. And thus much for the balance of national or domestic empire, which is in dominion.

The balance of foreign or provincial empire is of a contrary nature. A man may as well say that it is unlawful for him who has made a fair and honest purchase to have tenants, as for a government that has made a just progress and enlargement of itself to have provinces. But how a province

may be justly acquired appertains to another place. In this I am to show no more than how or upon what kind of balance it is to be held; in order whereto I shall first show upon what kind of balance it is not to be held. It has been said, that national or independent empire, of what kind soever, is to be exercised by them that have the proper balance of dominion in the nation; wherefore provincial or dependent empire is not to be exercised by them that have the balance of dominion in the province, because that would bring the government from provincial and dependent, to national and independent. Absolute monarchy, as that of the Turks, neither plants its people at home nor abroad, otherwise than as tenants for life or at will; wherefore its national and provincial government is all one. But in governments that admit the citizen or subject to dominion in lands, the richest are they that share most of the power at home; whereas the richest among the provincials, though native subjects, or citizens that have been transplanted, are least admitted to the government abroad; for men, like flowers or roots being transplanted, take after the soil wherein they grow. Wherefore the Commonwealth of Rome, by planting colonies of its citizens within the bounds of Italy, took the best way of propagating itself, and naturalizing the country; whereas if it had planted such colonies without the bounds of Italy, it would have alienated the citizens, and given a root to liberty abroad, that might have sprung up foreign or savage, and hostile to her: wherefore it never made any such dispersion of itself and its strength, till it was under the yoke of the Emperors, who, disburdening themselves of the people, as having less apprehension of what they could do abroad than at home, took a contrary course.

The Mamelukes (which, till any man show me the contrary, I shall presume to have been a commonwealth consisting of an army, whereof the common soldier was the people, the commissioned officer the Senate, and the general the prince) were foreigners, and by nation Circassians, that governed Egypt; wherefore these never durst plant themselves upon dominion, which growing naturally up into the national interest, must have dissolved the foreign yoke in that province.

The like in some sort may be said of Venice, the government whereof is usually mistaken; for Venice, though it does not take in the people, never excluded them. This commonwealth, the orders whereof are the most democratical or popular of all others, in regard of the exquisite rotation of the Senate, at the first institution took in the whole people; they that now live under the government without participation of

it, are such as have since either voluntarily chosen so to do, or were subdued by arms. Wherefore the subject of Venice is governed by provinces, and the balance of dominion not standing, as has been said, with provincial government; as the Mamelukes durst not cast their government upon this balance in their provinces, lest the national interest should have rooted out the foreign, so neither dare the Venetians take in their subjects upon this balance, lest the foreign interest should root out the national (which is that of the 3,000 now governing), and by diffusing the commonwealth throughout her territories, lose the advantage of her situation, by which in great part it subsists. And such also is the government of the Spaniard in the Indies, to which he deputes natives of his own country, not admitting the creoles to the government of those provinces, though descended from Spaniards.

But if a prince or a commonwealth may hold a territory that is foreign in this, it may be asked why he may not hold one that is native in the like manner? To which I answer, because he can hold a foreign by a native territory, but not a native by a foreign; and as hitherto I have shown what is not the provincial balance, so by this answer it may appear what it is, namely, the overbalance of a native territory to a foreign; for as one country balances itself by the distribution of property according to the proportion of the same, so one country overbalances another by advantage of divers kinds. For example, the Commonwealth of Rome overbalanced her provinces by the vigor of a more excellent government opposed to a crazier; or by a more exquisite militia opposed to one inferior in courage or discipline. The like was that of the Mamelukes, being a hardy people, to the Egyptians, that were a soft one. And the balance of situation is in this kind of wonderful effect; seeing the King of Denmark, being none of the most potent princes, is able at the Sound to take toll of the greatest; and as this King, by the advantage of the land, can make the sea tributary, so Venice, by the advantage of the sea, in whose arms she is impregnable, can make the land to feed her gulf. For the colonies in the Indies, they are yet babes that cannot live without sucking the breasts of their mother cities, but such as I mistake if when they come of age they do not wean themselves; which causes me to wonder at princes that delight to be exhausted in that way. And so much for the principles of power, whether national or provincial, domestic or foreign; being such as are external, and founded in the goods of fortune.

I come to the principles of authority, which are internal, and founded upon the goods of the mind. These the legisla-

tor that can unite in his government with those of fortune, comes nearest to the work of God, whose government consists of heaven and earth; which was said by Plato, though in different words, as, when princes should be philosophers, or philosophers princes, the world would be happy. And says Solomon: "There is an evil which I have seen under the sun, which proceeds from the ruler (*enimvero neque nobilem, neque ingenuum, nec libertinum quidem armis præponere, regia utilitas est*). Folly is set in great dignity, and the rich (either in virtue and wisdom, in the goods of the mind, or those of fortune upon that balance which gives them a sense of the national interest) sit in low places. I have seen servants upon horses, and princes walking as servants upon the earth." Sad complaints, that the principles of power and of authority, the goods of the mind and of fortune, do not meet and twine in the wreath or crown of empire! Wherefore, if we have anything of piety or of prudence, let us raise ourselves out of the mire of private interest to the contemplation of virtue, and put a hand to the removal of "this evil from under the sun;" this evil against which no government that is not secured can be good; this evil from which the government that is secure must be perfect. Solomon tells us that the cause of it is from the ruler, from those principles of power, which, balanced upon earthly trash, exclude the heavenly treasures of virtue, and that influence of it upon government which is authority. We have wandered the earth to find out the balance of power; but to find out that of authority we must ascend, as I said, nearer heaven, or to the image of God, which is the soul of man.

The soul of man (whose life or motion is perpetual contemplation or thought) is the mistress of two potent rivals, the one reason, the other passion, that are in continual suit; and, according as she gives up her will to these or either of them, is the felicity or misery which man partakes in this mortal life.

For, as whatever was passion in the contemplation of a man, being brought forth by his will into action, is vice and the bondage of sin; so whatever was reason in the contemplation of a man, being brought forth by his will into action, is virtue and the freedom of soul.

Again, as those actions of a man that were sin acquire to himself repentance or shame, and affect others with scorn or pity, so those actions of a man that are virtue acquire to himself honor, and upon others authority.

Now government is no other than the soul of a nation or city: wherefore that which was reason in the debate of a

commonwealth being brought forth by the result, must be virtue; and forasmuch as the soul of a city or nation is the sovereign power, her virtue must be law. But the government whose law is virtue, and whose virtue is law, is the same whose empire is authority, and whose authority is empire.

Again, if the liberty of a man consists in the empire of his reason, the absence whereof would betray him to the bondage of his passions, then the liberty of a commonwealth consists in the empire of her laws, the absence whereof would betray her to the lust of tyrants. And these I conceive to be the principles upon which Aristotle and Livy (injuriously accused by Leviathan for not writing out of nature) have grounded their assertion, " that a commonwealth is an empire of laws and not of men." But they must not carry it so. " For," says he, " the liberty, whereof there is so frequent and honorable mention in the histories and philosophy of the ancient Greeks and Romans, and the writings and discourses of those that from them have received all their learning in the politics, is not the liberty of particular men, but the liberty of the commonwealth." He might as well have said that the estates of particular men in a commonwealth are not the riches of particular men, but the riches of the commonwealth; for equality of estates causes equality of power, and equality of power is the liberty, not only of the commonwealth, but of every man.

But sure a man would never be thus irreverent with the greatest authors, and positive against all antiquity, without some certain demonstration of truth—and what is it? Why, " there is written on the turrets of the city of Lucca in great characters at this day the word LIBERTAS; yet no man can thence infer that a particular man has more liberty or immunity from the service of the commonwealth there than in Constantinople. Whether a commonwealth be monarchical or popular, the freedom is the same." The mountain has brought forth, and we have a little equivocation! For to say that a Lucchese has no more liberty or immunity from the laws of Lucca than a Turk has from those of Constantinople; and to say that a Lucchese has no more liberty or immunity by the laws of Lucca, than a Turk has by those of Constantinople, are pretty different speeches. The first may be said of all governments alike; the second scarce of any two; much less of these, seeing it is known that, whereas the greatest Bashaw is a tenant, as well of his head as of his estate, at the will of his lord, the meanest Lucchese that has land is a freeholder of both, and not to be controlled but by the law, and that framed by every private man to no other end (or they may thank themselves) than to protect the liberty of every private

man, which by that means comes to be the liberty of the commonwealth.

But seeing they that make the laws in commonwealths are but men, the main question seems to be, how a commonwealth comes to be an empire of laws, and not of men? Or how the debate or result of a commonwealth is so sure to be according to reason; seeing they who debate, and they who resolve, be but men? "And as often as reason is against a man, so often will a man be against reason."

This is thought to be a shrewd saying, but will do no harm; for be it so that reason is nothing but interest, there be divers interests, and so divers reasons.

As first, there is private reason, which is the interest of a private man.

Secondly, there is reason of state, which is the interest (or error, as was said by Solomon) of the ruler or rulers, that is to say, of the prince, of the nobility, or of the people.

Thirdly, there is that reason, which is the interest of mankind, or of the whole. "Now if we see even in those natural agents that want sense, that as in themselves they have a law which directs them in the means whereby they tend to their own perfection, so likewise that another law there is, which touches them as they are sociable parts united into one body, a law which binds them each to serve to others' good, and all to prefer the good of the whole, before whatsoever their own particular; as when stones, or heavy things, forsake their ordinary wont or centre, and fly upward, as if they heard themselves commanded to let go the good they privately wish, and to relieve the present distress of nature in common." There is a common right, law of nature, or interest of the whole, which is more excellent, and so acknowledged to be by the agents themselves, than the right or interest of the parts only. "Wherefore, though it may be truly said that the creatures are naturally carried forth to their proper utility or profit, that ought not to be taken in too general a sense; seeing divers of them abstain from their own profit, either in regard of those of the same kind, or at least of their young."

Mankind then must either be less just than the creature, or acknowledge also his common interest to be common right. And if reason be nothing else but interest, and the interest of mankind be the right interest, then the reason of mankind must be right reason. Now compute well; for if the interest of popular government come the nearest to the interest of mankind, then the reason of popular government must come the nearest to right reason.

But it may be said that the difficulty remains yet; for be the interest of popular government right reason, a man does not look upon reason as it is right or wrong in itself, but as it makes for him or against him. Wherefore, unless you can show such orders of a government as, like those of God in nature, shall be able to constrain this or that creature to shake off that inclination which is more peculiar to it, and take up that which regards the common good or interest, all this is to no more end than to persuade every man in a popular government not to carve himself of that which he desires most, but to be mannerly at the public table, and give the best from himself to decency and the common interest. But that such orders may be established as may, nay must, give the upper hand in all cases to common right or interest, notwithstanding the nearness of that which sticks to every man in private, and this in a way of equal certainty and facility, is known even to girls, being no other than those that are of common practice with them in divers cases. For example, two of them have a cake yet undivided, which was given between them: that each of them therefore might have that which is due, "Divide," says one to the other, "and I will choose; or let me divide, and you shall choose." If this be but once agreed upon, it is enough; for the divident, dividing unequally, loses, in regard that the other takes the better half; wherefore she divides equally, and so both have right. "Oh, the depth of the wisdom of God!" and yet "by the mouths of babes and sucklings has He set forth His strength;" that which great philosophers are disputing upon in vain is brought to light by two harmless girls, even the whole mystery of a commonwealth, which lies only in dividing and choosing. Nor has God (if his works in nature be understood) left so much to mankind to dispute upon as who shall divide and who choose, but distributed them forever into two orders, whereof the one has the natural right of dividing, and the other of choosing. For example:

A commonwealth is but a civil society of men: let us take any number of men (as twenty) and immediately make a commonwealth. Twenty men (if they be not all idiots, perhaps if they be) can never come so together but there will be such a difference in them that about a third will be wiser, or at least less foolish than all the rest; these upon acquaintance, though it be but small, will be discovered, and, as stags that have the largest heads, lead the herd; for while the six, discoursing and arguing one with another, show the eminence of their parts, the fourteen discover things that they never thought on; or are cleared in divers truths which had for-

merly perplexed them. Wherefore, in matter of common concernment, difficulty, or danger, they hang upon their lips, as children upon their fathers; and the influence thus acquired by the six, the eminence of whose parts are found to be a stay and comfort to the fourteen, is the authority of the fathers. Wherefore this can be no other than a natural aristocracy diffused by God throughout the whole body of mankind to this end and purpose; and therefore such as the people have not only a natural but a positive obligation to make use of as their guides; as where the people of Israel are commanded to "take wise men, and understanding, and known among their tribes, to be made rulers over them." The six then approved of, as in the present case, are the senate, not by hereditary right, or in regard of the greatness of their estates only, which would tend to such power as might force or draw the people, but by election for their excellent parts, which tends to the advancement of the influence of their virtue or authority that leads the people. Wherefore the office of the senate is not to be commanders, but counsellors, of the people; and that which is proper to counsellors is first to debate, and afterward to give advice in the business whereupon they have debated, whence the decrees of the senate are never laws, nor so called; and these being maturely framed, it is their duty to propose in the case to the people. Wherefore the senate is no more than the debate of the commonwealth. But to debate is to discern or put a difference between things that, being alike, are not the same; or it is separating and weighing this reason against that, and that reason against this, which is dividing.

The senate then having divided, who shall choose? Ask the girls: for if she that divided must have chosen also, it had been little worse for the other in case she had not divided at all, but kept the whole cake to herself, in regard that being to choose, too, she divided accordingly. Wherefore if the senate have any further power than to divide, the commonwealth can never be equal. But in a commonwealth consisting of a single council, there is no other to choose than that which divided; whence it is, that such a council fails not to scramble—that is, to be factious, there being no other dividing of the cake in that case but among themselves.

Nor is there any remedy but to have another council to choose. The wisdom of the few may be the light of mankind; but the interest of the few is not the profit of mankind nor of a commonwealth. Wherefore, seeing we have granted interest to be reason, they must not choose lest it put out their light. But as the council dividing consists of the wisdom of

the commonwealth, so the assembly or council choosing should consist of the interest of the commonwealth: as the wisdom of the commonwealth is in the aristocracy, so the interest of the commonwealth is in the whole body of the people. And whereas this, in case the commonwealth consist of a whole nation, is too unwieldy a body to be assembled, this council is to consist of such a representative as may be equal, and so constituted, as can never contract any other interest than that of the whole people; the manner whereof, being such as is best shown by exemplification, I remit to the model. But in the present case, the six dividing, and the fourteen choosing, must of necessity take in the whole interest of the twenty.

Dividing and choosing, in the language of a commonwealth, is debating and resolving; and whatsoever, upon debate of the senate, is proposed to the people, and resolved by them, is enacted by the authority of the fathers, and by the power of the people, which concurring, make a law.

But the law being made, says Leviathan, "is but words and paper without the hands and swords of men;" wherefore as these two orders of a commonwealth, namely, the senate and the people, are legislative, so of necessity there must be a third to be executive of the laws made, and this is the magistracy; in which order, with the rest being wrought up by art, the commonwealth consists of "the senate proposing, the people resolving, and the magistracy executing;" whereby partaking of the aristocracy as in the senate, of the democracy as in the people, and of monarchy as in the magistracy, it is complete. Now there being no other commonwealth but this in art or nature, it is no wonder if Machiavel has shown us that the ancients held this only to be good; but it seems strange to me that they should hold that there could be any other: for if there be such a thing as pure monarchy, yet that there should be such a one as pure aristocracy or pure democracy is not in my understanding. But the magistracy, both in number and function, is different in different commonwealths. Nevertheless there is one condition of it that must be the same in every one, or it dissolves the commonwealth where it is wanting. And this is no less than that, as the hand of the magistrate is the executive power of the law, so the head of the magistrate is answerable to the people, that his execution be according to the law; by which Leviathan may see that the hand or sword that executes the law is in it and not above it.

Now whether I have rightly transcribed these principles of a commonwealth out of nature, I shall appeal to God and to the world—to God in the fabric of the Commonwealth of

Israel, and to the world in the universal series of ancient prudence. But in regard the same commonwealths will be opened at large in the Council of legislators, I shall touch them for the present but slightly, beginning with that of Israel.

The Commonwealth of Israel consisted of the Senate, the people, and the magistracy.

The people by their first division, which was genealogical, were contained under their thirteen tribes, houses, or families; whereof the first-born in each was prince of his tribe, and had the leading of it: the tribe of Levi only, being set apart to serve at the altar, had no other prince but the high-priest. In their second division they were divided locally by their agrarian, or the distribution of the land of Canaan to them by lot, the tithe of all remaining to Levi; whence, according to their local division, the tribes are reckoned but twelve.

The assemblies of the people thus divided were methodically gathered by trumpets to the congregation: which was, it should seem, of two sorts. For if it were called with one trumpet only, the princes of the tribes and the elders only assembled; but if it were called with two, the whole people gathered themselves to the congregation, for so it is rendered by the English; but in the Greek it is called *Ecclesia*, or the Church of God, and by the Talmudist the great " Synagogue." The word *Ecclesia* was also anciently and properly used for the civil congregations, or assemblies of the people in Athens, Lacedæmon, and Ephesus, where it is so called in Scripture, though it be otherwise rendered by the translators, not much as I conceive to their commendation, seeing by that means they have lost us a good lesson, the apostles borrowing that name for their spiritual congregations, to the end that we might see they intended the government of the church to be democratical or popular, as is also plain in the rest of their constitutions.

The church or congregation of the people of Israel assembled in a military manner, and had the result of the commonwealth, or the power of confirming all their laws, though proposed even by God himself; as where they make him king, and where they reject or depose him as civil magistrate, and elect Saul. It is manifest that he gives no such example to a legislator in a popular government as to deny or evade the power of the people, which were a contradiction; but though he deservedly blames the ingratitude of the people in that action, he commands Samuel, being next under himself supreme magistrate, " to hearken to their voice " (for where the suffrage of the people goes for nothing, it is no common-

wealth), and comforts him, saying, "They have not rejected thee, but they have rejected me that I should not reign over them." But to reject him that he should not reign over them, was as civil magistrate to depose him. The power therefore which the people had to depose even God himself as he was civil magistrate, leaves little doubt but that they had power to have rejected any of those laws confirmed by them throughout the Scripture, which, to omit the several parcels, are generally contained under two heads: those that were made by covenant with the people in the land of Moab, and those which were made by covenant with the people in Horeb; which two, I think, amount to the whole body of the Israelitish laws.

But if all and every one of the laws of Israel being proposed by God, were no otherwise enacted than by covenant with the people, then that only which was resolved by the people of Israel was their law; and so the result of that commonwealth was in the people. Nor had the people the result only in matter of law, but the power in some cases of judicature; as also the right of levying war, cognizance in matter of religion, and the election of their magistrates, as the judge or dictator, the king, the prince: which functions were exercised by the *Synagoga magna*, or Congregation of Israel, not always in one manner, for sometimes they were performed by the suffrage of the people, *vivâ voce*, sometimes by the lot only, and at others by the ballot, or by a mixture of the lot with the suffrage, as in the case of Eldad and Medad, which I shall open with the Senate.

The Senate of Israel, called in the Old Testament the Seventy Elders, and in the New the Sanhedrim (which word is usually translated "the Council"), was appointed by God, and consisted of seventy elders besides Moses, which were at first elected by the people, but in what manner is rather intimated than shown. Nevertheless, because I cannot otherwise understand the passage concerning Eldad and Medad, of whom it is said "that they were of them that were written, but went not up to the tabernacle," then with the Talmudists I conceive that Eldad and Medad had the suffrage of the tribes, and so were written as competitors for magistracy; but coming afterward to the lot, failed of it, and therefore went not up to the tabernacle, or place of confirmation by God, or to the session-house of the Senate, with the Seventy upon whom the lot fell to be senators; for the session-house of the Sanhedrim was first in the court of the tabernacle, and afterward in that of the Temple, where it came to be called the stone chamber or pavement. If this were the ballot of Israel, that of Venice is the same transposed; for in Venice

the competitor is chosen as it were by the lot, in regard that the electors are so made, and the magistrate is chosen by the "suffrage of the great Council or assembly of the people." But the Sanhedrim of Israel being thus constituted, Moses, for his time, and after him his successor, sat in the midst of it as prince or archon, and at his left hand the orator or father of the Senate; the rest, or the bench, coming round with either horn like a crescent, had a scribe attending upon the tip of it.

This Senate, in regard the legislator of Israel was infallible, and the laws given by God such as were not fit to be altered by men, is much different in the exercise of their power from all other senates, except that of the Areopagus in Athens, which also was little more than a supreme judicatory; for it will hardly, as I conceive, be found that the Sanhedrim proposed to the people till the return of the children of Israel out of captivity under Esdras, at which time there was a new law made—namely, for a kind of excommunication, or rather banishment, which had never been before in Israel. Nevertheless it is not to be thought that the Sanhedrim had not always that right, which from the time of Esdras is more frequently exercised, of proposing to the people, but that they forebore it in regard of the fulness and infallibility of the law already made, whereby it was needless. Wherefore the function of this Council, which is very rare in a senate, was executive, and consisted in the administration of the law made; and whereas the Council itself is often understood in Scripture by the priest and the Levite, there is no more in that save only that the priests and the Levites, who otherwise had no power at all, being in the younger years of this commonwealth, those that were best studied in the laws were the most frequently elected into the Sanhedrim. For the courts, consisting of three-and-twenty elders sitting in the gates of every city, and the triumvirates of judges constituted almost in every village, which were parts of the executive magistracy subordinate to the Sanhedrim, I shall take them at better leisure, and in the larger discourse; but these being that part of this commonwealth which was instituted by Moses upon the advice of Jethro the priest of Midian (as I conceive a heathen), are to me a sufficient warrant even from God himself, who confirmed them, to make further use of human prudence, wherever I find it bearing a testimony to itself, whether in heathen commonwealths or others; and the rather, because so it is, that we who have the holy Scriptures, and in them the original of a commonwealth, made by the same hand that made the world, are either altogether blind or negligent of it; while the heathens have all written theirs,

as if they had had no other copy; as, to be more brief in the present account of that which you shall have more at large hereafter:

Athens consisted of the Senate of the Bean proposing, of the Church or Assembly of the people resolving, and too often debating, which was the ruin of it; as also of the Senate of the Areopagus, the nine archons, with divers other magistrates, executing.

Lacedæmon consisted of the Senate proposing, of the Church or congregation of the people resolving only, and never debating, which was the long life of it; and of the two kings, the court of the ephors, with divers other magistrates, executing.

Carthage consisted of the Senate proposing and sometimes resolving too, of the people resolving and sometimes debating too, for which fault she was reprehended by Aristotle; and she had her suffetes, and her hundred men, with other magistrates, executing.

Rome consisted of the Senate proposing, the *concio* or people resolving, and too often debating, which caused her storms; as also of the consuls, censors, ædiles, tribunes, prætors, quæstors, and other magistrates, executing.

Venice consists of the Senate, or *pregati*, proposing, and sometimes resolving too, of the great Council or Assembly of the people, in whom the result is constitutively; as also of the doge, the signory, the censors, the dieci, the quazancies, and other magistrates, executing.

The proceeding of the Commonwealths of Switzerland and Holland is of a like nature, though after a more obscure manner; for the sovereignties, whether cantons, provinces, or cities, which are the people, send their deputies, commissioned and instructed by themselves (wherein they reserve the result in their own power), to the provincial or general convention, or Senate, where the deputies debate, but have no other power of result than what was conferred upon them by the people, or is further conferred by the same upon further occasion. And for the executive part they have magistrates or judges in every canton, province, or city, besides those which are more public, and relate to the league, as for adjusting controversies between one canton, province, or city and another, or the like between such persons as are not of the same canton, province, or city.

But that we may observe a little further how the heathen politicians have written, not only out of nature, but as it were out of Scripture: as in the Commonwealth of Israel, God is said to have been king, so the commonwealth where the law

is king, is said by Aristotle to be "the kingdom of God." And where by the lusts or passions of men a power is set above that of the law deriving from reason, which is the dictate of God, God in that sense is rejected or deposed that he should not reign over them, as he was in Israel. And yet Leviathan will have it that "by reading of these Greek and Latin [he might as well in this sense have said Hebrew] authors, young men, and all others that are unprovided of the antidote of solid reason, receiving a strong and delightful impression of the great exploits of war achieved by the conductors of their armies, receive withal a pleasing idea of all they have done besides, and imagine their great prosperity not to have proceeded from the emulation of particular men, but from the virtue of their popular form of government, not considering the frequent seditions and civil wars produced by the imperfection of their polity." Where, first, the blame he lays to the heathen authors, is in his sense laid to the Scripture; and whereas he holds them to be young men, or men of no antidote that are of like opinions, it should seem that Machiavel, the sole retriever of this ancient prudence, is to his solid reason a beardless boy that has newly read Livy. And how solid his reason is, may appear where he grants the great prosperity of ancient commonwealths, which is to give up the controversy. For such an effect must have some adequate cause, which to evade he insinuates that it was nothing else but the emulation of particular men, as if so great an emulation could have been generated without as great virtue, so great virtue without the best education, and best education without the best law, or the best laws any otherwise than by the excellency of their polity.

But if some of these commonwealths, as being less perfect in their polity than others, have been more seditious, it is not more an argument of the infirmity of this or that commonwealth in particular, than of the excellency of that kind of polity in general, which if they, that have not altogether reached, have nevertheless had greater prosperity, what would befall them that should reach?

In answer to which question let me invite Leviathan, who of all other governments gives the advantage to monarchy for perfection, to a better disquisition of it by these three assertions.

The first, that the perfection of government lies upon such a libration in the frame of it, that no man or men in or under it can have the interest, or, having the interest, can have the power to disturb it with sedition.

The second, that monarchy, reaching the perfection of the

kind, reaches not to the perfection of government, but must have some dangerous flaw in it.

The third, that popular government, reaching the perfection of the kind, reaches the perfection of government, and has no flaw in it.

The first assertion requires no proof.

For the proof of the second, monarchy, as has been shown, is of two kinds: the one by arms, the other by a nobility, and there is no other kind in art or nature; for if there have been anciently some governments called kingdoms, as one of the Goths in Spain, and another of the Vandals in Africa, where the King ruled without a nobility, and by a council of the people only, it is expressly said by the authors that mention them that the kings were but the captains, and that the people not only gave them laws, but deposed them as often as they pleased. Nor is it possible in reason that it should be otherwise in like cases; wherefore these were either no monarchies, or had greater flaws in them than any other.

But for a monarchy by arms, as that of the Turk (which, of all models that ever were, comes up to the perfection of the kind), it is not in the wit or power of man to cure it of this dangerous flaw, that the Janizaries have frequent interest and perpetual power to raise sedition, and to tear the magistrate, even the prince himself, in pieces. Therefore the monarchy of Turkey is no perfect government.

And for a monarchy by nobility, as of late in Oceana (which of all other models, before the declination of it, came up to the perfection in that kind), it was not in the power or wit of man to cure it of that dangerous flaw; that the nobility had frequent interest and perpetual power by their retainers and tenants to raise sedition; and (whereas the Janizaries occasion this kind of calamity no sooner than they make an end of it) to levy a lasting war, to the vast effusion of blood, and that even upon occasions wherein the people, but for their dependence upon their lords, had no concernment, as in the feud of the Red and White. The like has been frequent in Spain, France, Germany, and other monarchies of this kind; wherefore monarchy by a nobility is no perfect government.

For the proof of the third assertion: Leviathan yields it to me, that there is no other commonwealth but monarchical or popular; wherefore if no monarchy be a perfect government, then either there is no perfect government, or it must be popular, for which kind of constitution I have something more to say than Leviathan has said or ever will be able to say for monarchy. As,

First, that it is the government that was never conquered

by any monarch, from the beginning of the world to this day; for if the commonwealths of Greece came under the yoke of the Kings of Macedon, they were first broken by themselves.

Secondly, that it is the government that has frequently led mighty monarchs in triumph.

Thirdly, that it is the government, which, if it has been seditious, it has not been so from any imperfection in the kind, but in the particular constitution; which, wherever the like has happened, must have been unequal.

Fourthly, that it is the government, which, if it has been anything near equal, was never seditious; or let him show me what sedition has happened in Lacedæmon or Venice.

Fifthly, that it is the government, which, attaining to perfect equality, has such a libration in the frame of it, that no man living can show which way any man or men, in or under it, can contract any such interest or power as should be able to disturb the commonwealth with sedition, wherefore an equal commonwealth is that only which is without flaw, and contains in it the full perfection of government. But to return.

By what has been shown in reason and experience, it may appear, that though commonwealths in general be governments of the senate proposing, the people resolving, and the magistracy executing, yet some are not so good at these orders as others, through some impediment or defect in the frame, balance, or capacity of them, according to which they are of divers kinds.

The first division of them is into such as are single, as Israel, Athens, Lacedæmon, etc.; and such as are by leagues, as those of the Achæans, Ætolians, Lycians, Switz, and Hollanders.

The second (being Machiavel's) is into such as are for preservation, as Lacedæmon and Venice, and such as are for increase, as Athens and Rome; in which I can see no more than that the former takes in no more citizens than are necessary for defence, and the latter so many as are capable of increase.

The third division (unseen hitherto) is into equal and unequal, and this is the main point, especially as to domestic peace and tranquillity; for to make a commonwealth unequal, is to divide it into parties, which sets them at perpetual variance, the one party endeavoring to preserve their eminence and inequality, and the other to attain to equality; whence the people of Rome derived their perpetual strife with the nobility and Senate. But in an equal commonwealth there can be no more strife than there can be overbalance in equal weights; wherefore the Commonwealth of Venice, being that

which of all others is the most equal in the constitution, is that wherein there never happened any strife between the Senate and the people.

An equal commonwealth is such a one as is equal both in the balance or foundation, and in the superstructure; that is to say, in her agrarian law and in her rotation.

An equal agrarian is a perpetual law, establishing and preserving the balance of dominion by such a distribution, that no one man or number of men, within the compass of the few or aristocracy, can come to overpower the whole people by their possessions in lands.

As the agrarian answers to the foundation, so does rotation to the superstructures.

Equal rotation is equal vicissitude in government, or succession to magistracy conferred for such convenient terms, enjoying equal vacations, as take in the whole body by parts, succeeding others, through the free election or suffrage of the people.

The contrary, whereunto is prolongation of magistracy, which, trashing the wheel of rotation, destroys the life or natural motion of a commonwealth.

The election or suffrage of the people is most free, where it is made or given in such a manner that it can neither oblige nor disoblige another, nor through fear of an enemy, or bashfulness toward a friend, impair a man's liberty.

Wherefore, says Cicero, the tablet or ballot of the people of Rome (who gave their votes by throwing tablets or little pieces of wood secretly into urns marked for the negative or affirmative) was a welcome constitution to the people, as that which, not impairing the assurance of their brows, increased the freedom of their judgment. I have not stood upon a more particular description of this ballot, because that of Venice exemplified in the model is of all others the most perfect.

An equal commonwealth (by that which has been said) is a government established upon an equal agrarian, arising into the superstructures or three orders, the Senate debating and proposing, the people resolving, and the magistracy executing, by an equal rotation through the suffrage of the people given by the ballot. For though rotation may be without the ballot, and the ballot without rotation, yet the ballot not only as to the ensuing model includes both, but is by far the most equal way; for which cause under the name of the ballot I shall hereafter understand both that and rotation too.

Now having reasoned the principles of an equal commonwealth, I should come to give an instance of such a one in

experience, if I could find it; but if this work be of any value, it lies in that it is the first example of a commonwealth that is perfectly equal. For Venice, though it comes the nearest, yet is a commonwealth for preservation; and such a one, considering the paucity of citizens taken in, and the number not taken in, is externally unequal; and though every commonwealth that holds provinces must in that regard be such, yet not to that degree. Nevertheless, Venice internally, and for her capacity, is by far the most equal, though it has not, in my judgment, arrived at the full perfection of equality; both because her laws supplying the defect of an agrarian are not so clear nor effectual at the foundation, nor her superstructures, by the virtue of her ballot or rotation, exactly librated; in regard that through the paucity of her citizens her greater magistracies are continually wheeled through a few hands, as is confessed by Janotti, where he says, that if a gentleman comes once to be *Savio di terra ferma*, it seldom happens that he fails from thenceforward to be adorned with some one of the greater magistracies, as *Savi di mare, Savi di terra ferma, Savi Grandi*, counsellors, those of the decemvirate or dictatorian council, the *aurogatori*, or censors, which require no vacation or interval. Wherefore if this in Venice, or that in Lacedæmon, where the kings were hereditary, and the Senators (though elected by the people) for life, cause no inequality (which is hard to be conceived) in a commonwealth for preservation, or such a one as consists of a few citizens; yet is it manifest that it would cause a very great one in a commonwealth for increase, or consisting of the many, which, by engrossing the magistracies in a few hands, would be obstructed in their rotation.

But there be who say (and think it a strong objection) that, let a commonwealth be as equal as you can imagine, two or three men when all is done will govern it; and there is that in it which, notwithstanding the pretended sufficiency of a popular State, amounts to a plain confession of the imbecility of that policy, and of the prerogative of monarchy; forasmuch as popular governments in difficult cases have had recourse to dictatorian power, as in Rome.

To which I answer, that as truth is a spark to which objections are like bellows, so in this respect our commonwealth shines; for the eminence acquired by suffrage of the people in a commonwealth, especially if it be popular and equal, can be ascended by no other steps than the universal acknowledgment of virtue: and where men excel in virtue, the commonwealth is stupid and unjust, if accordingly they do not excel in authority. Wherefore this is both the advantage of virtue,

which has her due encouragement, and of the commonwealth, which has her due services. These are the philosophers which Plato would have to be princes, the princes which Solomon would have to be mounted, and their steeds are those of authority, not empire; or, if they be buckled to the chariot of empire, as that of the dictatorian power, like the chariot of the sun, it is glorious for terms and vacations or intervals. And as a commonwealth is a government of laws and not of men, so is this the principality of virtue, and not of man; if that fail or set in one, it rises in another who is created his immediate successor. And this takes away that vanity from under the sun, which is an error proceeding more or less from all other rulers under heaven but an equal commonwealth.

These things considered, it will be convenient in this place to speak a word to such as go about to insinuate to the nobility or gentry a fear of the people, or to the people a fear of the nobility or gentry, as if their interests were destructive to each other; when indeed an army may as well consist of soldiers without officers, or of officers without soldiers, as a commonwealth, especially such a one as is capable of greatness, of a people without a gentry, or of a gentry without a people. Wherefore this, though not always so intended, as may appear by Machiavel, who else would be guilty, is a pernicious error. There is something first in the making of a commonwealth, then in the governing of it, and last of all in the leading of its armies, which, though there be great divines, great lawyers, great men in all professions, seems to be peculiar only to the genius of a gentleman.

For so it is in the universal series of story, that if any man has founded a commonwealth, he was first a gentleman. Moses had his education by the daughter of Pharaoh; Theseus and Solon, of noble birth, were held by the Athenians worthy to be kings; Lycurgus was of the royal blood; Romulus and Numa princes; Brutus and Publicola patricians; the Gracchi, that lost their lives for the people of Rome and the restitution of that commonwealth, were the sons of a father adorned with two triumphs, and of Cornelia the daughter of Scipio, who being demanded in marriage by King Ptolemy, disdained to become the Queen of Egypt. And the most renowned Olphaus Megaletor, sole legislator, as you will see anon, of the Commonwealth of Oceana, was derived from a noble family; nor will it be any occasion of scruple in this case, that Leviathan affirms the politics to be no ancienter than his book "*De Cive.*" Such also as have got any fame in the civil government of a commonwealth, or by the leading of its

armies, have been gentlemen; for so in all other respects were those plebeian magistrates elected by the people of Rome, being of known descents and of equal virtues, except only that they were excluded from the name by the usurpation of the patricians. Holland, through this defect at home, has borrowed princes for generals, and gentlemen of divers nations for commanders: and the Switzers, if they have any defect in this kind, rather lend their people to the colors of other princes, than make that noble use of them at home which should assert the liberty of mankind. For where there is not a nobility to hearten the people, they are slothful, regardless of the world, and of the public interest of liberty, as even those of Rome had been without their gentry: wherefore let the people embrace the gentry in peace, as the light of their eyes; and in war, as the trophy of their arms; and if Cornelia disdained to be Queen of Egypt, if a Roman consul looked down from his tribunal upon the greatest king, let the nobility love and cherish the people that afford them a throne so much higher in a commonwealth, in the acknowledgment of their virtue, than the crowns of monarchs.

But if the equality of a commonwealth consist in the equality first of the agrarian, and next of the rotation, then the inequality of a commonwealth must consist in the absence or inequality of the agrarian, or of the rotation, or of both.

Israel and Lacedæmon, which commonwealths (as the people of this, in Josephus, claims kindred of that) have great resemblance, were each of them equal in their agrarian, and unequal in their rotation, especially Israel, where the Sanhedrim, or Senate, first elected by the people, as appears by the words of Moses, took upon them ever after, without any precept of God, to substitute their successors by ordination; which having been there of civil use, as excommunication, community of goods, and other customs of the Essenes, who were many of them converted, came afterward to be introduced into the Christian Church. And the election of the judge, *suffes,* or dictator, was irregular, both for the occasion, the term, and the vacation of that magistracy; as you find in the book of Judges, where it is often repeated, that in those days there was no king in Israel—that is, no judge; and in the first of Samuel, where Eli judged Israel forty years, and Samuel, all his life. In Lacedæmon the election of the Senate being by suffrage of the people, though for life, was not altogether so unequal, yet the hereditary right of kings, were it not for the agrarian, had ruined her.

Athens and Rome were unequal as to their agrarian, that of Athens being infirm, and this of Rome none at all; for

it were more anciently carried it was never observed. Whence, by the time of Tiberius Gracchus, the nobility had almost eaten the people quite out of their lands, which they held in the occupation of tenants and servants, whereupon the remedy being too late, and too vehemently applied, that commonwealth was ruined.

These also were unequal in their rotation, but in a contrary manner. Athens, in regard that the Senate (chosen at once by lot, not by suffrage, and changed every year, not in part, but in the whole) consisted not of the natural aristocracy, nor sitting long enough to understand or to be perfect in their office, had no sufficient authority to restrain the people from that perpetual turbulence in the end, which was their ruin, notwithstanding the efforts of Nicias, who did all a man could do to help it. But as Athens, by the headiness of the people, so Rome fell by the ambition of the nobility, through the want of an equal rotation; which, if the people had got into the Senate, and timely into the magistracies (whereof the former was always usurped by the patricians, and the latter for the most part) they had both carried and held their agrarian, and that had rendered that commonwealth immovable.

But let a commonwealth be equal or unequal, it must consist, as has been shown by reason and all experience, of the three general orders; that is to say, of the Senate debating and proposing, of the people resolving, and of the magistracy executing. Wherefore I can never wonder enough at Leviathan, who, without any reason or example, will have it that a commonwealth consists of a single person, or of a single assembly; nor can I sufficiently pity those "thousand gentlemen, whose minds, which otherwise would have wavered, he has framed (as is affirmed by himself) in to a conscientious obedience (for so he is pleased to call it) of such a government."

But to finish this part of the discourse, which I intend for as complete an epitome of ancient prudence, and in that of the whole art of politics, as I am able to frame in so short a time:

The two first orders, that is to say, the Senate and the people, are legislative, whereunto answers that part of this science which by politicians is entitled "of laws;" and the third order is executive, to which answers that part of the same science which is styled "of the frame and course of courts or judicatories." A word to each of these will be necessary.

And first for laws: they are either ecclesiastical or civil, such as concern religion or government.

Laws, ecclesiastical, or such as concern religion, according to the universal course of ancient prudence, are in the power of the magistrate; but, according to the common practice of modern prudence, since the papacy, torn out of his hands.

But, as a government pretending to liberty, and yet suppressing liberty of conscience (which, because religion not according to a man's conscience can to him be none at all, is the main), must be a contradiction, so a man that, pleading for the liberty of private conscience, refuses liberty to the national conscience, must be absurd.

A commonwealth is nothing else but the national conscience. And if the conviction of a man's private conscience produces his private religion, the conviction of the national conscience must produce a national religion. Whether this be well reasoned, as also whether these two may stand together, will best be shown by the examples of the ancient commonwealths taken in their order.

In that of Israel the government of the national religion appertained not to the priests and Levites, otherwise than as they happened to be of the Sanhedrim, or Senate, to which they had no right at all but by election. It is in this capacity therefore that the people are commanded, under pain of death, " to hearken to them, and to do according to the sentence of the law which they should teach;" but in Israel the law ecclesiastical and civil was the same, therefore the Sanhedrim, having the power of one, had the power of both. But as the national religion appertained to the jurisdiction of the Sanhedrim, so the liberty of conscience appertained, from the same date, and by the same right, to the prophets and their disciples; as where it is said, " I will raise up a prophet, . . . and whoever will not hearken to my words which he shall speak in my name, I will require it of him." The words relate to prophetic right, which was above all the orders of this commonwealth; whence Elijah not only refused to obey the King, but destroyed his messengers with fire. And whereas it was not lawful by the national religion to sacrifice in any other place than the Temple, a prophet was his own temple, and might sacrifice where he would, as Elijah did in Mount Carmel. By this right John the Baptist and our Saviour, to whom it more particularly related, had their disciples, and taught the people, whence is derived our present right of gathered congregations; wherefore the Christian religion grew up according to the orders of the Commonwealth of Israel, and not against them. Nor was liberty of conscience infringed by this government, till the civil liberty of the same was lost, as under Herod, Pilate, and Tiberius, a three-piled tyranny.

To proceed, Athens preserved her religion, by the testimony of Paul, with great superstition: if Alcibiades, that atheistical fellow, had not showed them a pair of heels, they had shaven off his head for shaving their Mercuries, and making their gods look ridiculously upon them without beards. Nevertheless, if Paul reasoned with them, they loved news, for which he was the more welcome; and if he converted Dionysius the Areopagite, that is, one of the senators, there followed neither any hurt to him, nor loss of honor to Dionysius. And for Rome, if Cicero, in his most excellent book "*De Natura Deorum,*" overthrow the national religion of that commonwealth, he was never the further from being consul. But there is a meanness and poorness in modern prudence, not only to the damage of civil government, but of religion itself; for to make a man in matter of religion, which admits not of sensible demonstration (*jurare in verba magistri*), engage to believe no otherwise than is believed by my lord bishop, or Goodman Presbyter, is a pedantism that has made the sword to be a rod in the hands of schoolmasters; by which means, whereas the Christian religion is the furthest of any from countenancing war, there never was a war of religion but since Christianity, for which we are beholden to the Pope; for the Pope not giving liberty of conscience to princes and commonwealths, they cannot give that to their subjects which they have not themselves, whence both princes and subjects, either through his instigation or their own disputes, have introduced that execrable custom, never known in the world before, of fighting for religion, and denying the magistrate to have any jurisdiction concerning it, whereas the magistrate's losing the power of religion loses the liberty of conscience, which in that case has nothing to protect it. But if the people be otherwise taught, it concerns them to look about them, and to distinguish between the shrieking of the lapwing and the voice of the turtle.

To come to civil laws: if they stand one way and the balance another, it is the case of a government which of necessity must be new modelled; wherefore your lawyers, advising you upon the like occasions to fit your government to their laws, are no more to be regarded than your tailor if he should desire you to fit your body to his doublet. There is also danger in the plausible pretence of reforming the law, except the government be first good, in which case it is a good tree, and (trouble not yourselves overmuch) brings not forth evil fruit; otherwise, if the tree be evil, you can never reform the fruit, or if a root that is naught bring forth fruit of this kind that seems to be good, take the more heed, for it is the

ranker poison. It was nowise probable, if Augustus had not made excellent laws, that the bowels of Rome could have come to be so miserably eaten out by the tyranny of Tiberius and his successors. The best rule as to your laws in general is, that they be few. Rome, by the testimony of Cicero, was best governed under those of the twelve tables; and by that of Tacitus, *Plurimæ leges, corruptissima respublica.* You will be told that where the laws be few they leave much to arbitrary power; but where they be many, they leave more, the laws in this case, according to Justinian and the best lawyers, being as litigious as the suitors. Solon made few, Lycurgus fewer, laws; and commonwealths have the fewest at this day of all other governments.

Now to conclude this part with a word *de judiciis,* or of the constitution or course of courts; it is a discourse not otherwise capable of being well managed but by particular examples, both the constitution and course of courts being divers in different governments, but best beyond compare in Venice, where they regard not so much the arbitrary power of their courts as the constitution of them, whereby that arbitrary power being altogether unable to retard or do hurt to business, produces and must produce the quickest despatch, and the most righteous dictates of justice that are perhaps in human nature. The manner I shall not stand in this place to describe, because it is exemplified at large in the judicature of the people of Oceana. And thus much of ancient prudence, and the first branch of this preliminary discourse.

The Second Part of the Preliminaries

In the second part I shall endeavor to show the rise, progress, and declination of modern prudence.

The date of this kind of policy is to be computed, as was shown, from those inundations of Goths, Vandals, Huns, and Lombards that overwhelmed the Roman Empire. But as there is no appearance in the bulk or constitution of modern prudence, that it should ever have been able to come up and grapple with the ancient, so something of necessity must have interposed whereby this came to be enervated, and that to receive strength and encouragement. And this was the execrable reign of the Roman emperors taking rise from (that *felix scelus*) the arms of Cæsar, in which storm the ship of the Roman Commonwealth was forced to disburden itself of that precious freight, which never since could emerge or raise its head but in the Gulf of Venice.

OCEANA

It is said in Scripture, "Thy evil is of thyself, O Israel!" to which answers that of the moralists, "None is hurt but by himself," as also the whole matter of the politics; at present this example of the Romans, who, through a negligence committed in their agrarian laws, let in the sink of luxury, and forfeited the inestimable treasure of liberty for themselves and their posterity.

Their agrarian laws were such whereby their lands ought to have been divided among the people, either without mention of a colony, in which case they were not obliged to change their abode; or with mention and upon condition of a colony, in which case they were to change their abode, and leaving the city, to plant themselves upon the lands so assigned. The lands assigned, or that ought to have been assigned, in either of these ways, were of three kinds: such as were taken from the enemy and distributed to the people; or such as were taken from the enemy, and, under color of being reserved to the public use, were through stealth possessed by the nobility; or such as were bought with the public money to be distributed. Of the laws offered in these cases, those which divided the lands taken from the enemy, or purchased with the public money, never occasioned any dispute; but such as drove at dispossessing the nobility of their usurpations, and dividing the common purchase of the sword among the people, were never touched but they caused earthquakes, nor could they ever be obtained by the people; or being obtained, be observed by the nobility, who not only preserved their prey, but growing vastly rich upon it, bought the people by degrees quite out of those shares that had been conferred upon them. This the Gracchi coming too late to perceive, found the balance of the commonwealth to be lost; but putting the people (when they had least force) by forcible means upon the recovery of it, did ill, seeing it neither could nor did tend to any more than to show them by worse effects that what the wisdom of their leaders had discovered was true. For, quite contrary to what has happened in Oceana, where, the balance falling to the people, they have overthrown the nobility, that nobility of Rome, under the conduct of Sylla, overthrew the people and the commonwealth; seeing Sylla first introduced that new balance, which was the foundation of the succeeding monarchy, in the plantation of military colonies, instituted by his distribution of the conquered lands, not now of enemies, but of citizens, to forty-seven legions of his soldiers; so that how he came to be perpetual dictator, or other magistrates to succeed him in like power, is no miracle.

These military colonies (in which manner succeeding emperors continued, as Augustus by the distribution of the vete-

rans, whereby he had overcome Brutus and Cassius to plant their soldiery) consisted of such as I conceive were they that are called *milites beneficiarii;* in regard that the tenure of their lands was by way of benefices, that is, for life, and upon condition of duty or service in the war upon their own charge. These benefices Alexander Severus granted to the heirs of the incumbents, but upon the same conditions. And such was the dominion by which the Roman emperors gave their balance. But to the beneficiaries, as was no less than necessary for the safety of the prince, a matter of 8,000 by the example of Augustus were added, which departed not from his sides, but were his perpetual guard, called Pretorian bands; though these, according to the incurable flaw already observed in this kind of government, became the most frequent butchers of their lords that are to be found in story. Thus far the Roman monarchy is much the same with that at this day in Turkey, consisting of a camp and a horse-quarter; a camp in regard of the Spahis and Janizaries, the perpetual guard of the prince, except they also chance to be liquorish after his blood; and a horse-quarter in regard of the distribution of his whole land to tenants for life, upon condition of continual service, or as often as they shall be commanded at their own charge by timars, being a word which they say signifies benefices, that it shall save me a labor of opening the government.

But the fame of Mahomet and his prudence is especially founded in this, that whereas the Roman monarchy, except that of Israel, was the most imperfect, the Turkish is the most perfect that ever was. Which happened in that the Roman (as the Israelitish of the Sanhedrim and the congregation) had a mixture of the Senate and the people; and the Turkish is pure. And that this was pure, and the other mixed, happened not through the wisdom of the legislators, but the different genius of the nations; the people of the Eastern parts, except the Israelites, which is to be attributed to their agrarian, having been such as scarce ever knew any other condition than that of slavery; and these of the Western having ever had such a relish of liberty, as through what despair soever could never be brought to stand still while the yoke was putting on their necks, but by being fed with some hopes of reserving to themselves some part of their freedom.

Wherefore Julius Cæsar (saith Suetonius) contented himself in naming half the magistrates, to leave the rest to the suffrage of the people. And Mæcenas, though he would not have Augustus to give the people their liberty, would not have him take it quite away. Whence this empire, being neither hawk nor buzzard, made a flight accordingly; and the prince being per-

petually tossed (having the avarice of the soldiery on this hand to satisfy upon the people, and the Senate and the people on the other to be defended from the soldiery), seldom died any other death than by one horn of this dilemma, as is noted more at large by Machiavel.

But the Pretorian bands, those bestial executioners of their captain's tyranny upon others, and of their own upon him, having continued from the time of Augustus, were by Constantine the Great (incensed against them for taking part with his adversary Maxentius) removed from their strong garrison which they held in Rome, and distributed into divers provinces. The benefices of the soldiers that were hitherto held for life and upon duty, were by this prince made hereditary, so that the whole foundation whereupon this empire was first built being now removed, shows plainly that the emperors must long before this have found out some other way of support; and this was by stipendiating the Goths, a people that, deriving their roots from the northern parts of Germany, or out of Sweden, had, through their victories obtained against Domitian, long since spread their branches to so near a neighborhood with the Roman territories that they began to overshadow them. For the emperors making use of them in their armies, as the French do at this day of the Switz, gave them that under the notion of a stipend, which they received as tribute, coming, if there were any default in the payment, so often to distrain for it, that in the time of Honorius they sacked Rome, and possessed themselves of Italy. And such was the transition of ancient into modern prudence, or that breach, which being followed in every part of the Roman Empire with inundations of Vandals, Huns, Lombards, Franks, Saxons, overwhelmed ancient languages, learning, prudence, manners, cities, changing the names of rivers, countries, seas, mountains, and men; Camillus, Cæsar, and Pompey, being come to Edmund, Richard, and Geoffrey.

To open the groundwork or balance of these new politicians: "*Feudum*," says Calvin the lawyer, " is a Gothic word of divers significations; for it is taken either for war, or for a possession of conquered lands, distributed by the victor to such of his captains and soldiers as had merited in his wars, upon condition to acknowledge him to be their perpetual lord, and themselves to be his subjects."

Of these there were three kinds or orders: the first of nobility distinguished by the titles of dukes, marquises, earls, and these being gratified with the cities, castles, and villages of the conquered Italians, their feuds participated of royal dignity, and were called *regalia*, by which they had right to coin money, create magistrates, take toll, customs, confiscations, and the like.

Feuds of the second order were such as, with the consent of the King, were bestowed by these feudatory princes upon men of inferior quality, called their barons, on condition that next to the King they should defend the dignities and fortunes of their lords in arms.

The lowest order of feuds were such, as being conferred by those of the second order upon private men, whether noble or not noble, obliged them in the like duty to their superiors; these were called vavasors. And this is the Gothic balance, by which all the kingdoms this day in Christendom were at first erected; for which cause, if I had time, I should open in this place the Empire of Germany, and the Kingdoms of France, Spain, and Poland; but so much as has been said being sufficient for the discovery of the principles of modern prudence in general, I shall divide the remainder of my discourse, which is more particular, into three parts:

The first, showing the constitution of the late monarchy of Oceana;

The second, the dissolution of the same; and

The third, the generation of the present commonwealth.

The constitution of the late monarchy of Oceana is to be considered in relation to the different nations by whom it has been successively subdued and governed. The first of these were the Romans, the second the Teutons, the third the Scandians, and the fourth the Neustrians.

The government of the Romans, who held it as a province, I shall omit, because I am to speak of their provincial government in another place, only it is to be remembered here, that if we have given over running up and down naked, and with dappled hides, learned to write and read, and to be instructed with good arts, for all these we are beholden to the Romans, either immediately or mediately by the Teutons; for that the Teutons had the arts from no other hand is plain enough by their language, which has yet no word to signify either writing or reading, but what is derived from the Latin. Furthermore, by the help of these arts so learned, we have been capable of that religion which we have long since received; wherefore it seems to me that we ought not to detract from the memory of the Romans, by whose means we are, as it were, of beasts become men, and by whose means we might yet of obscure and ignorant men (if we thought not too well of ourselves) become a wise and a great people.

The Romans having governed Oceana provincially, the Teutons were the first that introduced the form of the late monarchy. To these succeeded the Scandians, of whom (because their reign was short, as also because they made little alteration

in the government as to the form) I shall take no notice. But the Teutons going to work upon the Gothic balance, divided the whole nation into three sorts of feuds, that of ealdorman, that of king's thane, and that of middle thane.

When the kingdom was first divided into precincts will be as hard to show as when it began first to be governed; it being impossible that there should be any government without some division. The division that was in use with the Teutons was by counties, and every county had either its ealdorman or high reeve. The title of ealdorman came in time to eorl, or erl, and that of high reeve to high sheriff.

Earl of the shire or county denoted the king's thane, or tenant by grand sergeantry or knight's service, in chief or *in capite;* his possessions were sometimes the whole territory from whence he had his denomination, that is, the whole county; sometimes more than one county, and sometimes less, the remaining part being in the crown. He had also sometimes a third, or some other customary part of the profits of certain cities, boroughs, or other places within his earldom. For an example of the possessions of earls in ancient times, Ethelred had to him and his heirs the whole Kingdom of Mercia, containing three or four counties; and there were others that had little less.

King's thane was also an honorary title, to which he was qualified that had five hides of land held immediately of the King by service of personal attendance; insomuch that if a churl or countryman had thriven to this proportion, having a church, a kitchen, a bell-house (that is, a hall with a bell in it to call his family to dinner), a borough-gate with a seat (that is, a porch) of his own, and any distinct office in the King's court, then was he the King's thane. But the proportion of a hide-land, otherwise called *caruca,* or a plough-land, is difficult to be understood, because it was not certain; nevertheless it is generally conceived to be so much as may be managed with one plough, and would yield the maintenance of the same, with the appurtenances in all kinds.

The middle thane was feudal, but not honorary; he was also called a vavasor, and his lands a vavasory, which held of some mesne lord, and not immediately of the King.

Possessions and their tenures, being of this nature, show the balance of the Teuton monarchy; wherein the riches of earls were so vast that to arise from the balance of their dominion to their power, they were not only called *reguli,* or little kings, but were such indeed; their jurisdiction being of two sorts, either that which was exercised by them in the court of their countries, or in the high court of the kingdom.

In the territory denominating an earl, if it were all his own, the courts held, and the profits of that jurisdiction were to his own use and benefit. But if he had but some part of his county, then his jurisdiction and courts, saving perhaps in those possessions that were his own, were held by him to the King's use and benefit; that is, he commonly supplied the office which the sheriffs regularly executed in counties that had no earls, and whence they came to be called viscounts. The court of the county that had an earl was held by the earl and the bishop of the diocese, after the manner of the sheriffs' turns to this day; by which means both the ecclesiastical and temporal laws were given in charge together to the country. The causes of vavasors or vavasories appertained to the cognizance of this court, where wills were proved, judgment and execution given, cases criminal and civil determined.

The King's thanes had the like jurisdiction in their thane lands as lords in their manors, where they also kept courts.

Besides these in particular, both the earls and King's thanes, together with the bishops, abbots, and vavasors, or middle thanes, had in the high court or parliament in the kingdom a more public jurisdiction, consisting first of deliberative power for advising upon and assenting to new laws; secondly, of giving counsel in matters of state; and thirdly, of judicature upon suits and complaints. I shall not omit to enlighten the obscurity of these times, in which there is little to be found of a methodical constitution of this high court, by the addition of an argument, which I conceive to bear a strong testimony to itself, though taken out of a late writing that conceals the author. "It is well known," says he, "that in every quarter of the realm a great many boroughs do yet send burgesses to the parliament which nevertheless be so anciently and so long since decayed and gone to naught, that they cannot be showed to have been of any reputation since the Conquest, much less to have obtained any such privilege by the grant of any succeeding king: wherefore these must have had this right by more ancient usage, and before the Conquest, they being unable now to show whence they derived it."

This argument, though there be more, I shall pitch upon as sufficient to prove: First, that the lower sort of the people had right to session in Parliament during the time of the Teutons. Secondly, that they were qualified to the same by election in their boroughs, and if knights of the shire, as no doubt they are, be as ancient in the counties. Thirdly, if it be a good argument to say, that the commons during the reign of the Teutons were elected into Parliament because they are so now, and no man can show when this custom began, I see not which way

it should be an ill one to say that the commons during the reign of the Teutons constituted also a distinct house because they do so now, unless any man can show that they did ever sit in the same house with the lords. Wherefore to conclude this part, I conceive for these, and other reasons to be mentioned hereafter, that the Parliament of the Teutons consisted of the King, the lords spiritual and temporal, and the commons of the nation, notwithstanding the style of divers acts of Parliament, which runs, as that of Magna Charta, in the King's name only, seeing the same was nevertheless enacted by the King, peers, and commons of the land, as is testified in those words by a subsequent act.

The monarchy of the Teutons had stood in this posture about 220 years; when Turbo, Duke of Neustria, making his claim to the crown of one of their kings that died childless, followed it with successful arms, and, being possessed of the kingdom, used it as conquered, distributing the earldoms, thane-lands, bishoprics, and prelacies of the whole realm among his Neustrians. From this time the earl came to be called *comes,* consul, and *dux,* though consul and dux grew afterward out of use; the King's thanes came to be called barons, and their lands baronies; the middle thane holding still of a mesne lord, retained the name of vavasor.

The earl or comes continued to have the third part of the pleas of the county paid to him by the sheriff or vice-comes, now a distinct officer in every county depending upon the King; saving that such earls as had their counties to their own use were now counts-palatine, and had under the King regal jurisdiction; insomuch that they constituted their own sheriffs, granted pardons, and issued writs in their own names; nor did the King's writ of ordinary justice run in their dominions till a late statute, whereby much of this privilege was taken away.

For barons they came from henceforth to be in different times of three kinds: barons by their estates and tenures, barons by writ, and barons created by letters-patent. From Turbo the first to Adoxus the seventh king from the Conquest, barons had their denomination from their possessions and tenures. And these were either spiritual or temporal; for not only the thanelands, but the possessions of bishops, as also of some twenty-six abbots, and two priors, were now erected into baronies, whence the lords spiritual that had suffrage in the Teuton Parliament as spiritual lords came to have it in the Neustrian Parliament as barons, and were made subject, which they had not formerly been, to knights' service in chief. Barony coming henceforth to signify all honorary possessions as well of earls as barons, and baronage to denote all kinds of lords as well

spiritual as temporal having right to sit in Parliament, the baronies in this sense were sometimes more, and sometimes fewer, but commonly about 200 or 250, containing in them a matter of 60,000 *feuda militum*, or knights' fees, whereof some 28,000 were in the clergy.

It is ill-luck that no man can tell what the land of a knight's fee, reckoned in some writs at £40 a year, and in others at £10, was certainly worth, for by such a help we might have exactly demonstrated the balance of this government. But, says Coke, it contained twelve plough-lands, and that was thought to be the most certain account. But this again is extremely uncertain; for one plough out of some land that was fruitful might work more than ten out of some other that was barren. Nevertheless, seeing it appears by Bracton, that of earldoms and baronies it was wont to be said that the whole kingdom was composed, as also that these, consisting of 60,000 knights' fees, furnished 60,000 men for the King's service, being the whole militia of this monarchy, it cannot be imagined that the vavasories or freeholds in the people amounted to any considerable proportion. Wherefore the balance and foundation of this government were in the 60,000 knights' fees, and these being possessed by the 250 lords, it was a government of the few, or of the nobility, wherein the people might also assemble, but could have no more than a mere name. And the clergy, holding a third of the whole nation, as is plain by the Parliament-roll, it is an absurdity (seeing the clergy of France came first through their riches to be a state of that kingdom) to acknowledge the people to have been a state of this realm, and not to allow it to the clergy, who were so much more weighty in the balance, which is that of all other whence a state or order in a government is denominated. Wherefore this monarchy consisted of the King, and of the three *ordines regni,* or estates, the lords spiritual and temporal, and the commons; it consisted of these, I say, as to the balance, though, during the reign of some of these kings, not as to the administration.

For the ambition of Turbo, and some of those that more immediately succeeded him, to be absolute princes, strove against the nature of their foundation, and, inasmuch as he had divided almost the whole realm among his Neustrians, with some encouragement for a while. But the Neustrians, while they were but foreign plants, having no security against the natives, but in growing up by their princes' sides, were no sooner well rooted in their vast dominions than they came up according to the infallible consequence of the balance domestic, and, contracting the national interest of the baronage, grew as fierce in the vindication of the ancient rights and liberties of the same, as if they

had been always natives: whence, the kings being as obstinate on the one side for their absolute power, as these on the other for their immunities, grew certain wars, which took their denomination from the barons.

This fire about the middle of the reign of Adoxus began to break out. And whereas the predecessors of this King had divers times been forced to summon councils resembling those of the Teutons, to which the lords only that were barons by dominion and tenure had hitherto repaired, Adoxus, seeing the effects of such dominion, began first not to call such as were barons by writ (for that was according to the practice of ancient times), but to call such by writs as were otherwise no barons; by which means, striving to avoid the consequence of the balance, in coming unwillingly to set the government straight, he was the first that set it awry. For the barons in his reign, and his successors, having vindicated their ancient authority, restored the Parliament with all the rights and privileges of the same, saving that from thenceforth the kings had found out a way whereby to help themselves against the mighty by creatures of their own, and such as had no other support but by their favor. By which means this government, being indeed the masterpiece of modern prudence, has been cried up to the skies, as the only invention whereby at once to maintain the sovereignty of a prince and the liberty of the people. Whereas, indeed, it has been no other than a wrestling-match, wherein the nobility, as they have been stronger, have thrown the King, or the King, if he has been stronger, has thrown the nobility; or the King, where he has had a nobility, and could bring them to his party, has thrown the people, as in France and Spain; or the people, where they have had no nobility, or could get them to be of their party, have thrown the King, as in Holland, and of later times in Oceana.

But they came not to this strength, but by such approaches and degrees as remain to be further opened. For whereas the barons by writ, as the sixty-four abbots and thirty-six priors that were so called, were but *pro tempore*, Dicotome, being the twelfth king from the Conquest, began to make barons by letters-patent, with the addition of honorary pensions for the maintenance of their dignities to them and their heirs; so that they were hands in the King's purse and had no shoulders for his throne. Of these, when the house of peers came once to be full, as will be seen hereafter, there was nothing more empty. But for the present, the throne having other supports, they did not hurt that so much as they did the King; for the old barons, taking Dicotome's prodigality to such creatures so ill that they deposed him, got the trick of it, and never gave over setting

up and pulling down their kings according to their various interests, and that faction of the White and Red, into which they have been thenceforth divided, till Panurgus, the eighteenth king from the Conquest, was more by their favor than his right advanced to the crown. This King, through his natural subtlety, reflecting at once upon the greatness of their power, and the inconstancy of their favor, began to find another flaw in this kind of government, which is also noted by Machiavel—namely, that a throne supported by a nobility is not so hard to be ascended as kept warm. Wherefore his secret jealousy, lest the dissension of the nobility, as it brought him in might throw him out, made him travel in ways undiscovered by them, to ends as little foreseen by himself, while to establish his own safety, he, by mixing water with their wine, first began to open those sluices that have since overwhelmed not the King only, but the throne. For whereas a nobility strikes not at the throne, without which they cannot subsist, but at some king that they do not like, popular power strikes through the King at the throne, as that which is incompatible with it. Now that Panurgus, in abating the power of the nobility, was the cause whence it came to fall into the hands of the people, appears by those several statutes that were made in his reign, as that for population, those against retainers, and that for alienations.

By the statute of population, all houses of husbandry that were used with twenty acres of ground and upward, were to be maintained and kept up forever with a competent proportion of land laid to them, and in no wise, as appears by a subsequent statute, to be severed. By which means the houses being kept up, did of necessity enforce dwellers; and the proportion of land to be tilled being kept up, did of necessity enforce the dweller not to be a beggar or cottager, but a man of some substance, that might keep hinds and servants and set the plough a-going. This did mightily concern, says the historian of that prince, the might and manhood of the kingdom, and in effect amortize a great part of the lands to the hold and possession of the yeomanry or middle people, who living not in a servile or indigent fashion, were much unlinked from dependence upon their lords, and living in a free and plentiful manner, became a more excellent infantry, but such a one upon which the lords had so little power, that from henceforth they may be computed to have been disarmed.

And as they had lost their infantry after this manner, so their cavalry and commanders were cut off by the statute of retainers; for whereas it was the custom of the nobility to have younger brothers of good houses, mettled fellows, and such as were knowing in the feats of arms about them, they who were

longer followed with so dangerous a train, escaped not such punishments as made them take up.

Henceforth the country lives and great tables of the nobility, which no longer nourished veins that would bleed for them, were fruitless and loathsome till they changed the air, and of princes became courtiers; where their revenues, never to have been exhausted by beef and mutton, were found narrow, whence followed racking of rents, and at length sale of lands, the riddance through the statute of alienations being rendered far more quick and facile than formerly it had been through the new invention of entails.

To this it happened that Coraunus, the successor of that King, dissolving the abbeys, brought, with the declining state of the nobility, so vast a prey to the industry of the people, that the balance of the commonwealth was too apparently in the popular party to be unseen by the wise Council of Queen Parthenia, who, converting her reign through the perpetual love tricks that passed between her and her people into a kind of romance, wholly neglected the nobility. And by these degrees came the House of Commons to raise that head, which since has been so high and formidable to their princes that they have looked pale upon those assemblies. Nor was there anything now wanting to the destruction of the throne, but that the people, not apt to see their own strength, should be put to feel it; when a prince, as stiff in disputes as the nerve of monarchy was grown slack, received that unhappy encouragement from his clergy which became his utter ruin, while trusting more to their logic than the rough philosophy of his Parliament, it came to an irreparable breach; for the house of peers, which alone had stood in this gap, now sinking down between the King and the commons, showed that Crassus was dead and the isthmus broken. But a monarchy, divested of its nobility, has no refuge under heaven but an army. Wherefore the dissolution of this government caused the war, not the war the dissolution of this government.

Of the King's success with his arms it is not necessary to give any further account, than that they proved as ineffectual as his nobility; but without a nobility or an army (as has been shown) there can be no monarchy. Wherefore what is there in nature that can arise out of these ashes but a popular government, or a new monarchy to be erected by the victorious army?

To erect a monarchy, be it never so new, unless like Leviathan you can hang it, as the country-fellow speaks, by geometry (for what else is it to say, that every other man must give up his will to the will of this one man without any other foun-

dation?), it must stand upon old principles—that is, upon a nobility or an army planted on a due balance of dominion. *Aut viam inveniam aut faciam,* was an adage of Cæsar; and there is no standing for a monarchy unless it finds this balance, or makes it. If it finds it, the work is done to its hand; for, where there is inequality of estates, there must be inequality of power; and where there is inequality of power, there can be no commonwealth. To make it, the sword must extirpate out of dominion all other roots of power, and plant an army upon that ground. An army may be planted nationally or provincially. To plant it nationally, it must be in one of the four ways mentioned, that is, either monarchically in part, as the Roman *beneficiarii;* or monarchically, in the whole, as the Turkish Timariots; aristocratically, that is, by earls and barons, as the Neustrians were planted by Turbo; or democratically, that is, by equal lots, as the Israelitish army in the land of Canaan by Joshua. In every one of these ways there must not only be confiscations, but confiscations to such a proportion as may answer to the work intended.

Confiscation of a people that never fought against you, but whose arms you have borne, and in which you have been victorious, and this upon premeditation and in cold blood, I should have thought to be against any example in human nature, but for those alleged by Machiavel of Agathocles, and Oliveretto di Fermo; the former whereof being captain-general of the Syracusans, upon a day assembled the Senate and the people, as if he had something to communicate with them, when at a sign given he cut the senators in pieces to a man, and all the richest of the people, by which means he came to be king. The proceedings of Oliveretto, in making himself Prince of Fermo, were somewhat different in circumstances, but of the same nature. Nevertheless Catiline, who had a spirit equal to any of these in his intended mischief, could never bring the like to pass in Rome. The head of a small commonwealth, such a one as was that of Syracuse or Fermo, is easily brought to the block; but that a populous nation, such as Rome, had not such a one, was the grief of Nero. If Sylvia or Cæsar attained to be princes, it was by civil war, and such civil war as yielded rich spoils, there being a vast nobility to be confiscated; which also was the case in Oceana, when it yielded earth by earldoms, and baronies to the Neustrian for the plantation of his new potentates. Where a conqueror finds the riches of a land in the hands of the few, the forfeitures are easy, and amount to vast advantage; but where the people have equal shares, the confiscation of many comes to little, and is not only dangerous but fruitless.

The Romans, in one of their defeats of the Volsci, found among the captives certain Tusculans, who, upon examination, confessed that the arms they bore were by command of their State; whereupon information being given to the Senate by the general Camillus, he was forthwith commanded to march against Tusculum; which doing accordingly, he found the Tusculan fields full of husbandmen, that stirred not otherwise from the plough than to furnish his army with all kinds of accommodations and victuals. Drawing near to the city, he saw the gates wide open, the magistrates coming out in their gowns to salute and bid him welcome; entering, the shops were all at work, and open, the streets sounded with the noise of schoolboys at their books; there was no face of war. Whereupon Camillus, causing the Senate to assemble, told them, that though the art was understood, yet had they at length found out the true arms whereby the Romans were most undoubtedly to be conquered, for which cause he would not anticipate the Senate, to which he desired them forthwith to send, which they did accordingly; and their dictator with the rest of their ambassadors being found by the Roman senators as they went into the house standing sadly at the door, were sent for in as friends, and not as enemies; where the dictator having said, "If we have offended, the fault was not so great as is our penitence and your virtue," the Senate gave them peace forthwith, and soon after made the Tusculans citizens of Rome.

But putting the case, of which the world is not able to show an example, that the forfeiture of a populous nation, not conquered, but friends, and in cool blood, might be taken, your army must be planted in one of the ways mentioned. To plant it in the way of absolute monarchy, that is, upon feuds for life, such as the Timars, a country as large and fruitful as that of Greece, would afford you but 16,000 Timariots, for that is the most the Turk (being the best husband that ever was of this kind) makes of it at this day: and if Oceana, which is less in fruitfulness by one-half, and in extent by three parts, should have no greater a force, whoever breaks her in one battle, may be sure she shall never rise; for such (as was noted by Machiavel) is the nature of the Turkish monarchy, if you break it in two battles, you have destroyed its whole militia, and the rest being all slaves, you hold it without any further resistance. Wherefore the erection of an absolute monarchy in Oceana, or in any other country that is no larger, without making it a certain prey to the first invader, is altogether impossible.

To plant by halves, as the Roman emperors did their beneficiaries, or military colonies, it must be either for life; and this an army of Oceaners in their own country, especially having

estates of inheritance, will never bear; because such an army so planted is as well confiscated as the people; nor had the Mamelukes been contented with such usage in Egypt, but that they were foreigners, and daring not to mix with the natives, it was of absolute necessity to their being.

Or planting them upon inheritance, whether aristocratically as the Neustrians, or democratically as the Israelites, they grow up by certain consequences into the national interest, and this, if they be planted popularly, comes to a commonwealth; if by way of nobility, to a mixed monarchy, which of all other will be found to be the only kind of monarchy whereof this nation, or any other that is of no greater extent, has been or can be capable; for if the Israelites, though their democratical balance, being fixed by their agrarian, stood firm, be yet found to have elected kings, it was because, their territory lying open, they were perpetually invaded, and being perpetually invaded, turned themselves to anything which, through the want of experience, they thought might be a remedy; whence their mistake in election of their kings, under whom they gained nothing, but, on the contrary, lost all they had acquired by their commonwealth, both estates and liberties, is not only apparent, but without parallel. And if there have been, as was shown, a kingdom of the Goths in Spain, and of the Vandals in Asia, consisting of a single person and a Parliament (taking a parliament to be a council of the people only, without a nobility), it is expressly said of those councils that they deposed their kings as often as they pleased; nor can there be any other consequence of such a government, seeing where there is a council of the people they do never receive laws, but give them; and a council giving laws to a single person, he has no means in the world whereby to be any more than a subordinate magistrate but force: in which case he is not a single person and a parliament, but a single person and an army, which army again must be planted as has been shown, or can be of no long continuance.

It is true, that the provincial balance being in nature quite contrary to the national, you are no way to plant a provincial army upon dominion. But then you must have a native territory in strength, situation, or government, able to overbalance the foreign, or you can never hold it. That an army should in any other case be long supported by a mere tax, is a mere fancy as void of all reason and experience as if a man should think to maintain such a one by robbing of orchards; for a mere tax is but pulling of plum-trees, the roots whereof are in other men's grounds, who, suffering perpetual violence, come to hate the author of it; and it is a maxim, that no prince that is hated by his people can be safe. Arms planted upon dominion extirpate

enemies and make friends; but maintained by a mere tax, have enemies that have roots, and friends that have none.

To conclude, Oceana, or any other nation of no greater extent, must have a competent nobility, or is altogether incapable of monarchy; for where there is equality of estates, there must be equality of power, and where there is equality of power, there can be no monarchy.

To come then to the generation of the commonwealth. It has been shown how, through the ways and means used by Panurgus to abase the nobility, and so to mend that flaw which we have asserted to be incurable in this kind of constitution, he suffered the balance to fall into the power of the people, and so broke the government; but the balance being in the people, the commonwealth (though they do not see it) is already in the nature of them. There wants nothing else but time, which is slow and dangerous, or art, which would be more quick and secure, for the bringing those native arms, wherewithal they are found already, to resist, they know not how, everything that opposes them, to such maturity as may fix them upon their own strength and bottom.

But whereas this art is prudence, and that part of prudence which regards the present work is nothing else but the skill of raising such superstructures of government as are natural to the known foundations, they never mind the foundation, but through certain animosities, wherewith by striving one against another they are infected, or through freaks, by which, not regarding the course of things, nor how they conduce to their purpose, they are given to building in the air, come to be divided and subdivided into endless parties and factions, both civil and ecclesiastical, which, briefly to open, I shall first speak of the people in general, and then of their divisions.

A people, says Machiavel, that is corrupt, is not capable of a commonwealth. But in showing what a corrupt people is, he has either involved himself, or me; nor can I otherwise come out of the labyrinth, than by saying, the balance altering a people, as to the foregoing government, must of necessity be corrupt; but corruption in this sense signifies no more than that the corruption of one government, as in natural bodies, is the generation of another. Wherefore if the balance alters from monarchy, the corruption of the people in this case is that which makes them capable of a commonwealth. But whereas I am not ignorant that the corruption which he means is in manners, this also is from the balance. For the balance leading from monarchical into popular abates the luxury of the nobility, and, enriching the people, brings the government from a more private to a more public interest; which coming nearer, as has

been shown, to justice and right reason, the people upon a like alteration is so far from such a corruption of manners as should render them incapable of a commonwealth, that of necessity they must thereby contract such a reformation of manners as will bear no other kind of government. On the other side, where the balance changes from popular to oligarchical or monarchical, the public interest, with the reason and justice included in the same, becomes more private; luxury is introduced in the room of temperance, and servitude in that of freedom, which causes such a corruption of manners both in the nobility and people, as, by the example of Rome in the time of the Triumvirs, is more at large discovered by the author to have been altogether incapable of a commonwealth.

But the balance of Oceana changing quite contrary to that of Rome, the manners of the people were not thereby corrupted, but, on the contrary, adapted to a commonwealth. For differences of opinion in a people not rightly informed of their balance, or a division into parties (while there is not any common ligament of power sufficient to reconcile or hold them) is no sufficient proof of corruption. Nevertheless, seeing this must needs be matter of scandal and danger, it will not be amiss, in showing what were the parties, to show what were their errors.

The parties into which this nation was divided, were temporal or spiritual; and the temporal parties were especially two, the one royalists, the other republicans, each of which asserted their different causes, either out of prudence or ignorance, out of interest or conscience.

For prudence, either that of the ancients is inferior to the modern, which we have hitherto been setting face to face, that anyone may judge, or that of the royalist must be inferior to that of the commonwealthsman. And for interest, taking the commonwealthsman to have really intended the public, for otherwise he is a hypocrite and the worst of men, that of the royalist must of necessity have been more private. Wherefore, the whole dispute will come upon matter of conscience, and this, whether it be urged by the right of kings, the obligation of former laws, or of the oath of allegiance, is absolved by the balance.

For if the right of kings were as immediately derived from the breath of God as the life of man, yet this excludes not death and dissolution. But, that the dissolution of the late monarchy was as natural as the death of man, has been already shown. Wherefore it remains with the royalists to discover by what reason or experience it is possible for a monarchy to stand upon a popular balance; or, the balance being popular, as well the oath of allegiance, as all other monarchical laws, imply an impossibility, and are therefore void.

To the commonwealthsman I have no more to say, but that if he excludes any party, he is not truly such, nor shall ever found a commonwealth upon the natural principle of the same, which is justice. And the royalist for having not opposed a commonwealth in Oceana, where the laws were so ambiguous that they might be eternally disputed and never reconciled, can neither be justly for that cause excluded from his full and equal share in the government; nor prudently for this reason, that a commonwealth consisting of a party will be in perpetual labor for her own destruction: whence it was that the Romans, having conquered the Albans, incorporated them with equal right into the commonwealth. And if the royalists be "flesh of your flesh," and nearer of blood than were the Albans to the Romans, you being also both Christians, the argument is the stronger. Nevertheless there is no reason that a commonwealth should any more favor a party remaining in fixed opposition against it, than Brutus did his own sons. But if it fixes them upon that opposition, it is its own fault, not theirs; and this is done by excluding them. Men that have equal possessions and the same security for their estates and their liberties that you have, have the same cause with you to defend both; but if you will be trampling, they fight for liberty, though for monarchy; and you for tyranny, though under the name of a commonwealth: the nature of orders in a government rightly instituted being void of all jealousy, because, let the parties which it embraces be what they will, its orders are such as they neither would resist if they could, nor could if they would, as has been partly already shown, and will appear more at large by the following model.

The parties that are spiritual are of more kinds than I need mention; some for a national religion, and others for liberty of conscience, with such animosity on both sides, as if these two could not consist together, and of which I have already sufficiently spoken, to show that indeed the one cannot well subsist without the other. But they of all the rest are the most dangerous, who, holding that the saints must govern, go about to reduce the commonwealth to a party, as well for the reasons already shown, as that their pretences are against Scripture, where the saints are commanded to submit to the higher powers, and to be subject to the ordinance of man. And that men, pretending under the notion of saints or religion to civil power, have hitherto never failed to dishonor that profession, the world is full of examples, whereof I shall confine myself at present only to a couple, the one of old, the other of new Rome.

In old Rome, the patricians or nobility pretending to be the godly party, were questioned by the people for engrossing all

the magistracies of that commonwealth, and had nothing to say why they did so, but that magistracy required a kind of holiness which was not in the people; at which the people were filled with such indignation as had come to cutting of throats, if the nobility had not immediately laid by the insolency of that plea; which nevertheless when they had done, the people for a long time after continued to elect no other but patrician magistrates.

The example of new Rome in the rise and practice of the hierarchy (too well known to require any further illustration) is far more immodest.

This has been the course of nature; and when it has pleased or shall please God to introduce anything that is above the course of nature, he will, as he has always done, confirm it by miracle; for so in his prophecy of the reign of Christ upon earth he expressly promises, seeing that "the souls of them that were beheaded for Jesus, shall be seen to live and reign with him;" which will be an object of sense, the rather, because the rest of the dead are not to live again till the thousand years be finished. And it is not lawful for men to persuade us that a thing already is, though there be no such object of our sense, which God has told us shall not be till it be an object of our sense.

The saintship of a people as to government, consists in the election of magistrates fearing God, and hating covetousness, and not in their confining themselves, or being confined, to men of this or that party or profession. It consists in making the most prudent and religious choice they can; yet not in trusting to men, but, next God, to their own orders. "Give us good men, and they will make us good laws," is the maxim of a demagogue, and is (through the alteration which is commonly perceivable in men, when they have power to work their own wills) exceeding fallible. But "give us good orders, and they will make us good men," is the maxim of a legislator, and the most infallible in the politics.

But these divisions (however there be some good men that look sadly on them) are trivial things; first as to the civil concern, because the government, whereof this nation is capable, being once seen, takes in all interests. And, secondly, as to the spiritual; because as the pretence of religion has always been turbulent in broken governments, so where the government has been sound and steady, religion has never shown itself with any other face than that of its natural sweetness and tranquillity; nor is there any reason why it should, wherefore the errors of the people are occasioned by their governors. If they be doubtful of the way, or wander from it, it is because their guides misled them; and the guides of the people are never so well qualified for leading by any virtue of their own, as by that of the government.

The government of Oceana (as it stood at the time whereof we discourse, consisting of one single Council of the people, exclusively of the King and the Lords) was called a Parliament: nevertheless the parliaments of the Teutons and of the Neustrians consisted, as has been shown, of the King, lords, and commons; wherefore this, under an old name, was a new thing—a parliament consisting of a single assembly elected by the people, and invested with the whole power of the government, without any covenants, conditions, or orders whatsoever. So new a thing, that neither ancient nor modern prudence can show any avowed example of the like. And there is scarce anything that seems to me so strange as that (whereas there was nothing more familiar with these councillors than to bring the Scripture to the house) there should not be a man of them that so much as offered to bring the house to the Scripture, wherein, as has been shown, is contained that original, whereof all the rest of the commonwealths seem to be copies. Certainly if Leviathan (who is surer of nothing than that a popular commonwealth consists but of one council) transcribed his doctrine out of this assembly, for him to except against Aristotle and Cicero for writing out of their own commonwealths was not so fair play; or if the Parliament transcribed out of him, it had been an honor better due to Moses. But where one of them should have an example but from the other, I cannot imagine, there being nothing of this kind that I can find in story, but the oligarchy of Athens, the Thirty Tyrants of the same, and the Roman Decemvirs.

For the oligarchy, Thucydides tells us, that it was a Senate or council of 400, pretending to a balancing council of the people consisting of 5,000, but not producing them; wherein you have the definition of an oligarchy, which is a single council both debating and resolving, dividing and choosing, and what that must come to was shown by the example of the girls, and is apparent by the experience of all times; wherefore the thirty set up by the Lacedæmonians (when they had conquered Athens) are called tyrants by all authors, Leviathan only excepted, who will have them against all the world to have been an aristocracy, but for what reason I cannot imagine; these also, as void of any balance, having been void of that which is essential to every commonwealth, whether aristocratical or popular; except he be pleased with them, because that, according to the testimony of Xenophon, they killed more men in eight months than the Lacedæmonians had done in ten years; " oppressing the people (to use Sir Walter Raleigh's words) with all base and intolerable slavery."

The usurped government of the Decemvirs in Rome was of

the same kind. Wherefore in the fear of God let Christian legislators (setting the pattern given in the Mount on the one side, and these execrable examples on the other) know the right hand from the left; and so much the rather, because those things which do not conduce to the good of the governed are fallacious, if they appear to be good for the governors. God, in chastising a people, is accustomed to burn his rod. The empire of these oligarchies was not so violent as short, nor did they fall upon the people, but in their own immediate ruin. A council without a balance is not a commonwealth, but an oligarchy; and every oligarchy, except it be put to the defence of its wickedness or power against some outward danger, is factious. Wherefore the errors of the people being from their governors (which maxim in the politics bearing a sufficient testimony to itself, is also proved by Machiavel), if the people of Oceana have been factious, the cause is apparent, but what remedy?

In answer to this question, I come now to the army, of which the most victorious captain and incomparable patriot, Olphaus Megaletor, was now general, who being a much greater master of that art whereof I have made a rough draught in these preliminaries, had such sad reflections upon the ways and proceedings of the Parliament as cast him upon books and all other means of diversion, among which he happened on this place of Machiavel: "Thrice happy is that people which chances to have a man able to give them such a government at once, as without alteration may secure them of their liberties; seeing it was certain that Lacedæmon, in observing the laws of Lycurgus, continued about 800 years without any dangerous tumult or corruption." My lord general (as it is said of Themistocles, that he could not sleep for the glory obtained by Miltiades at the battle of Marathon) took so new and deep an impression at these words of the much greater glory of Lycurgus, that, being on this side assaulted with the emulation of his illustrious object, and on the other with the misery of the nation, which seemed (as it were ruined by his victory) to cast itself at his feet, he was almost wholly deprived of his natural rest, till the debate he had within himself came to a firm resolution, that the greatest advantages of a commonwealth are, first, that the legislator should be one man; and, secondly, that the government should be made all together, or at once. For the first, it is certain, says Machiavel, that a commonwealth is seldom or never well turned or constituted, except it has been the work of one man; for which cause a wise legislator, and one whose mind is firmly set, not upon private but the public interest, not upon his posterity but upon his country, may justly endeavor to get the sovereign power into his own hands, nor shall any man that

is master of reason blame such extraordinary means as in that case will be necessary, the end proving no other than the constitution of a well-ordered commonwealth.

The reason of this is demonstrable; for the ordinary means not failing, the commonwealth has no need of a legislator, but the ordinary means failing, there is no recourse to be had but to such as are extraordinary. And, whereas a book or a building has not been known to attain to its perfection if it has not had a sole author or architect, a commonwealth, as to the fabric of it, is of the like nature. And thus it may be made at once; in which there be great advantages; for a commonwealth made at once, takes security at the same time it lends money; and trusts not itself to the faith of men, but launches immediately forth into the empire of laws, and, being set straight, brings the manners of its citizens to its rule, whence followed that uprightness which was in Lacedæmon. But manners that are rooted in men, bow the tenderness of a commonwealth coming up by twigs to their bent; whence followed the obliquity that was in Rome, and those perpetual repairs by the consuls' axes, and tribunes' hammers, which could never finish that commonwealth but in destruction.

My lord general being clear in these points, and of the necessity of some other course than would be thought upon by the Parliament, appointed a meeting of the army, where he spoke his sense agreeable to these preliminaries with such success to the soldiery, that the Parliament was soon after deposed; nad he himself, in the great hall of the Pantheon or palace of justice, situated in Emporium, the capital city, was created by the universal suffrage of the army, Lord Archon, or sole legislator of Oceana, upon which theatre you have, to conclude this piece, a person introduced, whose fame shall never draw its curtain.

The Lord Archon being created, fifty select persons to assist him, by laboring in the mines of ancient prudence, and bringing its hidden treasures to new light, were added, with the style also of legislators, and sat as a council, whereof he was the sole director and president.

PART II

THE COUNCIL OF LEGISLATORS

OF this piece, being the greater half of the whole work, I shall be able at this time to give no further account, than very briefly to show at what it aims.

My Lord Archon, in opening the Council of legislators, made it appear how unsafe a thing it is to follow fancy in the fabric of a commonwealth; and how necessary that the archives of ancient prudence should be ransacked before any councillor should presume to offer any other matter in order to the work in hand, or toward the consideration to be had by the Council upon a model of government. Wherefore he caused an urn to be brought, and every one of the councillors to draw a lot. By the lots as they were drawn,

The Commonwealth of	*Fell to*
Israel	Phosphorus de Auge
Athens	Navarchus de Paralo
Lacedæmon	Laco de Scytale
Carthage	Mago de Syrtibus
The Achæans, Ætolians, and Lycians	Aratus de Isthmo
The Switz	Alpester de Fulmine
Holland and the United Provinces	Glaucus de Ulna
Rome	Dolabella de Enyo
Venice	Lynceus de Stella

These contained in them all those excellencies whereof a commonwealth is capable; so that to have added more had been to no purpose. Upon time given to the councillors, by their own studies and those of their friends, to prepare themselves, they were opened in the order, and by the persons mentioned at the Council of legislators, and afterward by order of the same were repeated at the council of the prytans to the people; for in drawing of the lots, there were about a dozen of them inscribed with the letter P, whereby the councillors that drew them became prytans.

The prytans were a committee or council sitting in the great hall of Pantheon, to whom it was lawful for any man to offer anything in order to the fabric of the commonwealth; for which cause, that they might not be oppressed by the throng, there was a rail about the table where they sat, and on each side of

the same a pulpit; that on the right hand for any man that would propose anything, and that on the left for any other that would oppose him. And all parties (being indemnified by proclamation of the Archon) were invited to dispute their own interests, or propose whatever they thought fit (in order to the future government) to the council of the prytans, who, having a guard of about two or three hundred men, lest the heat of dispute might break the peace, had the right of moderators, and were to report from time to time such propositions or occurrences as they thought fit, to the Council of legislators sitting more privately in the palace called Alma.

This was that which made the people (who were neither safely to be admitted, nor conveniently to be excluded in the framing of the commonwealth) verily believe, when it came forth, that it was no other than that whereof they themselves had been the makers.

Moreover, this Council sat divers months after the publishing and during the promulgation of the model to the people; by which means there is scarce anything was said or written for or against the said model but you shall have it with the next impression of this work, by way of oration addressed to and moderated by the prytans.

By this means the Council of legislators had their necessary solitude and due aim in their greater work, as being acquainted from time to time with the pulse of the people, and yet without any manner of interruption or disturbance.

Wherefore every commonwealth in its place having been opened by due method—that is, first, by the people; secondly, by the Senate; and, thirdly, by the magistracy—the Council upon mature debate took such results or orders out of each, and out of every part of each of them, as upon opening the same they thought fit; which being put from time to time in writing by the clerk or secretary, there remained no more in the conclusion, than putting the orders so taken together, to view and examine them with a diligent eye, that it might be clearly discovered whether they did interfere, or could anywise come to interfere or jostle one with the other. For as such orders jostling or coming to jostle one another are the certain dissolution of the commonwealth, so, taken upon the proof of like experience, and neither jostling nor showing which way they can possibly come to jostle one another, they make a perfect and (for aught that in human prudence can be foreseen) an immortal commonwealth.

And such was the art whereby my Lord Archon (taking council of the Commonwealth of Israel, as of Moses; and of the rest of the commonwealths, as of Jethro) framed the model of the Commonwealth of Oceana.

PART III

THE MODEL OF THE COMMONWEALTH OF OCEANA

WHEREAS my Lord Archon, being from Moses and Lycurgus the first legislator that hitherto is found in history to have introduced or erected an entire commonwealth at once, happened, like them also, to be more intent upon putting the same into execution or action, than into writing; by which means the model came to be promulgated or published with more brevity and less illustration than are necessary for their understanding who have not been acquainted with the whole proceedings of the Council of legislators, and of the prytans, where it was asserted and cleared from all objections and doubts: to the end that I may supply what was wanting in the promulgated epitome to a more full and perfect narrative of the whole, I shall rather take the commonwealth practically; and as it has now given an account of itself in some years' revolutions (as Dicearchus is said to have done that of Lacedæmon, first transcribed by his hand some three or four hundred years after the institution), yet not omitting to add for proof to every order such debates and speeches of the legislators in their Council, or at least such parts of them as may best discover the reason of the government; nor such ways and means as were used in the institution or rise of the building, not to be so well conceived, without some knowledge given of the engines wherewithal the mighty weight was moved. But through the entire omission of the Council of legislators or workmen that squared every stone to this structure in the quarries of ancient prudence, the proof of the first part of this discourse will be lame, except I insert, as well for illustration as to avoid frequent repetition, three remarkable testimonies in this place.

The first is taken out of the Commonwealth of Israel: "So Moses hearkened to the voice of Jethro, his father-in-law, and did all that he had said. And Moses chose able men out of all Israel, and made them heads over the people;" tribunes, as it is in the vulgar Latin; or phylarchs, that is, princes of the tribes, sitting upon twelve thrones, and judging the twelve tribes of Israel; and next to these he chose rulers of thousands, rulers of hundreds, rulers of fifties, and rulers of tens, which were the steps and rise of this commonwealth from its foundation or root

to its proper elevation or accomplishment in the Sanhedrim, and the congregation, already opened in the preliminaries.

The second is taken out of Lacedæmon, as Lycurgus (for the greater impression of his institutions upon the minds of his citizens) pretended to have received the model of that commonwealth from the oracle of Apollo at Delphos, the words whereof are thus recorded by Plutarch in the life of that famous legislator: " When thou shalt have divided the people into tribes (which were six) and *obæ* (which were five in every tribe), thou shalt constitute the Senate, consisting, with the two Kings, of thirty councillors, who, according as occasion requires, shall cause the congregation to be assembled between the bridge and the river Gnacion, where the Senate shall propose to the people, and dismiss them without suffering them to debate." The *obæ* were lineages into which every tribe was divided, and in each tribe there was another division containing all those of the same that were of military age; which being called the *mora,* was subdivided into troops and companies that were kept in perpetual discipline under the command of a magistrate called the *polemarch.*

The third is taken out of the Commonwealth of Rome, or those parts of it which are comprised in the first and second books of Livy, where the people, according to the institution by Romulus, are first divided into thirty *curias* or parishes, whereof he elected, by three out of each *curia,* the Senate, which, from his reign to that of Servius Tullius, proposed to the parishes or parochial congregations; and these being called the *Comitia curiata,* had the election of the kings, the confirmation of their laws, and the last appeal in matters of judicature, as appears in the case of Horatius that killed his sister; till, in the reign of Servius (for the other kings kept not to the institution of Romulus), the people being grown somewhat, the power of the *Curiata* was for the greater part translated to the *Centuriata comitia* instituted by this King, which distributed the people, according to the sense of valuation of their estates, into six classes, every one containing about forty centuries, divided into youth and elders; the youth for field-service, the elders for the defence of their territory, all armed and under continual discipline, in which they assembled both upon military and civil occasions. But when the Senate proposed to the people, the horse only, whereof there were twelve centuries, consisting of the richest sort over and above those of the foot enumerated, were called with the first classes of the foot to the suffrage; or if these accorded not, then the second classes were called to them, but seldom or never any of the rest. Wherefore the people, after the expulsion of the kings, growing impatient

of this inequality, rested not till they had reduced the suffrage as it had been in the *Comitia curiata* to the whole people again; but in another way, that is to say, by the *Comitia tributa*, which thereupon were instituted, being a council where the people in exigencies made laws without the Senate, which laws were called *plebiscita*. This Council is that in regard whereof Cicero and other great wits so frequently inveigh against the people, and sometimes even Livy, as at the first institution of it. To say the truth, it was a kind of anarchy, whereof the people could not be excusable, if there had not, through the courses taken by the Senate, been otherwise a necessity that they must have seen the commonwealth run into oligarchy.

The manner how the *Comitia curiata, centuriata* or *tributa* were called, during the time of the commonwealth, to the suffrage, was by lot: the *curia*, century, or tribe, whereon the first lot fell, being styled *principium*, or the prerogative; and the other *curiæ*, centuries or tribes, whereon the second, third, and fourth lots, etc., fell, the *jure vocatæ*. From henceforth not the first classes, as in the times of Servius, but the prerogative, whether *curia*, century, or tribe, came first to the suffrage, whose vote was called *omen prærogativum*, and seldom failed to be leading to the rest of the tribes. The *jure vocatæ*, in the order of their lots, came next: the manner of giving suffrage was, by casting wooden tablets, marked for the affirmative or the negative, into certain urns standing upon a scaffold, as they marched over it in files, which for the resemblance it bore was called the bridge. The candidate, or competitor, who had most suffrages in a *curia*, century, or tribe, was said to have that *curia*, century, or tribe; and he who had most of the *curiæ*, centuries, or tribes, carried the magistracy.

These three places being premised, as such upon which there will be frequent reflection, I come to the narrative, divided into two parts, the first containing the institution, the second the constitution of the commonwealth, in each whereof I shall distinguish the orders, as those which contain the whole model, from the rest of the discourse, which tends only to the explanation or proof of them.

In the institution or building of a commonwealth, the first work, as that of builders, can be no other than fitting and distributing the materials.

The materials of a commonwealth are the people, and the people of Oceana were distributed by casting them into certain divisions, regarding their quality, their age, their wealth, and the places of their residence or habitation, which was done by the ensuing orders.

The first order " distributes the people into freemen or citi-

zens and servants, while such; for if they attain to liberty, that is, to live of themselves, they are freemen or citizens."

This order needs no proof, in regard of the nature of servitude, which is inconsistent with freedom, or participation of government in a commonwealth.

The second order " distributes citizens into youth and elders (such as are from eighteen years of age to thirty, being accounted youth; and such as are of thirty and upward, elders), and establishes that the youth shall be the marching armies, and the elders the standing garrisons of this nation."

A commonwealth, whose arms are in the hands of her servants, had need be situated, as is elegantly said of Venice by Contarini, out of the reach of their clutches; witness the danger run by that of Carthage in the rebellion of Spendius and Matho. But though a city, if one swallow makes a summer, may thus chance to be safe, yet shall it never be great; for if Carthage or Venice acquired any fame in their arms, it is known to have happened through the mere virtue of their captains, and not of their orders; wherefore Israel, Lacedæmon, and Rome entailed their arms upon the prime of their citizens, divided, at least in Lacedæmon and Rome, into youth and elders: the youth for the field, and the elders for defence of the territory.

The third order " distributes the citizens into horse and foot, by the sense or valuation of their estates; they who have above £100 a year in lands, goods, or moneys, being obliged to be of the horse, and they who have under that sum to be of the foot. But if a man has prodigally wasted and spent his patrimony, he is neither capable of magistracy, office, or suffrage in the commonwealth."

Citizens are not only to defend the commonwealth, but according to their abilities, as the Romans under Servius Tullius (regard had to their estates), were some enrolled in the horse centuries, and others of the foot, with arms enjoined accordingly; nor could it be otherwise in the rest of the commonwealths, though out of historical remains, that are so much darker, it be not so clearly probable. And the necessary prerogative to be given by a commonwealth to estates, is in some measure in the nature of industry, and the use of it to the public. " The Roman people," says Julius Exuperantius, " were divided into classes, and taxed according to the value of their estates. All that were worth the sums appointed were employed in the wars; for they most eagerly contend for the victory, who fight for liberty in defence of their country and possessions. But the poorer sort were polled only for their heads (which was all they had), and kept in garrison at home in time of war; for these might betray the armies for bread, by

reason of their poverty, which is the reason that Marius, to whom the care of the government ought not to have been committed, was the first that led them into the field;" and his success was accordingly. There is a mean in things; as exorbitant riches overthrow the balance of a commonwealth, so extreme poverty cannot hold it, nor is by any means to be trusted with it. The clause in the order concerning the prodigal is Athenian, and a very laudable one; for he that could not live upon his patrimony, if he comes to touch the public money, makes a commonwealth bankrupt.

The fourth order "distributes the people according to the places of their habitation, into parishes, hundreds, and tribes."

For except the people be methodically distributed, they cannot be methodically collected; but the being of a commonwealth consists in the methodical collection of the people: wherefore you have the Israelitish divisions into rulers of thousands, of hundreds, of fifties, and of tens; and of the whole commonwealth into tribes: the Laconic into *obæ, moras,* and tribes; the Roman into tribes, centuries, and classes; and something there must of necessity be in every government of the like nature, as that in the late monarchy—by counties. But this being the only institution in Oceana, except that of the agrarian, which required any charge or included any difficulty, engages me to a more particular description of the manner how it was performed, as follows:

A thousand surveyors, commissioned and instructed by the Lord Archon and the Council, being divided into two equal numbers, each under the inspection of two surveyors-general, were distributed into the northern and southern parts of the territory, divided by the river Hemisua, the whole whereof contains about 10,000 parishes, some ten of those being assigned to each surveyor; for as to this matter there needed no great exactness, it tending only, by showing whither everyone was to repair and whereabout to begin, to the more orderly carrying on of the work; the nature of their instructions otherwise regarding rather the number of the inhabitants than of the parishes. The surveyors, therefore, being every one furnished with a convenient proportion of urns, balls, and balloting-boxes —in the use whereof they had been formerly exercised—and now arriving each at his respective parish, being with the people by teaching them their first lesson, which was the ballot; and though they found them in the beginning somewhat froward, as at toys, with which, while they were in expectation of greater matters from a Council of legislators, they conceived themselves to be abused, they came within a little while to think them pretty sport, and at length such as might very soberly be

used in good earnest; whereupon the surveyors began the institution included in—

The first order, requiring " That upon the first Monday next ensuing the last of December the bigger bell in every parish throughout the nation be rung at eight of the clock in the morning, and continue ringing for the space of one hour; and that all the elders of the parish respectively repair to the church before the bell has done ringing, where, dividing themselves into two equal numbers, or as near equal as may be, they shall take their places according to their dignities, if they be of divers qualities, and according to their seniority, if they be of the same, the one half on the one side, and the other half on the other, in the body of the church, which done, they shall make oath to the overseers of the parish for the time being (instead of these the surveyors were to officiate at the institution, or first assembly) by holding up their hands, to make a fair election according to the laws of the ballot, as they are hereafter explained, of such persons, amounting to a fifth part of their whole number, to be their deputies, and to exercise their power in manner hereafter explained, as they shall think in their consciences to be fittest for that trust, and will acquit themselves of it to the best advantage of the commonwealth. And oath being thus made, they shall proceed to election, if the elders of the parish amount to 1,000 by the ballot of the tribe, as it is in due place explained, and if the elders of the parish amount to fifty or upward, but within the number of 1,000, by the ballot of the hundred, as it is in due place explained. But, if the elders amount not to fifty, then they shall proceed to the ballot of the parish, as it is in this place and after this manner explained.

" The two overseers for the time being shall seat themselves at the upper end of the middle alley, with a table before them, their faces being toward the congregation, and the constable for the time being shall set an urn before the table, into which he shall put so many balls as there be elders present, whereof there shall be one that is gilded, the rest being white; and when the constable has shaken the urn, sufficiently to mix the balls, the overseers shall call the elders to the urn, who from each side of the church shall come up the middle alley in two files, every man passing by the urn, and drawing out one ball; which, if it be silver, he shall cast into a bowl standing at the foot of the urn, and return by the outward alley on his side to his place. But he who draws the golden ball is the proposer, and shall be seated between the overseers, where he shall begin in what order he pleases, and name such as, upon his oath already taken, he conceives fittest to be chosen, one by one, to the elders; and the party named shall withdraw while the congregation is balloting

his name by the double box or boxes appointed and marked on the outward part, to show which side is affirmative and which negative, being carried by a boy or boys appointed by the overseers, to every one of the elders, who shall hold up a pellet made of linen rags between his finger and his thumb, and put it after such a manner into the box, as though no man can see into which side he puts it, yet any man may see that he puts in but one pellet or suffrage. And the suffrage of the congregation being thus given, shall be returned with the box or boxes to the overseers, who opening the same, shall pour the affirmative balls into a white bowl standing upon the table on the right hand, to be numbered by the first overseer; and the negative into a green bowl standing on the left hand, to be numbered by the second overseer; and the suffrages being numbered, he who has the major part in the affirmative is one of the deputies of the parish, and when so many deputies are chosen as amount to a full fifth part of the whole number of the elders, the ballot for that time shall cease. The deputies being chosen are to be listed by the overseers in order as they were chosen, except only that such as are horse must be listed in the first place with the rest, proportionable to the number of the congregation, after this manner:

Anno Domini

THE LIST OF THE FIRST MOVER

A. A., Equestrian Order, First Deputy, B. B., Second Deputy, C. C., Third Deputy, D. D., Fourth Deputy, E. E., Fifth Deputy,	Of the parish of ——— in the hundred of ——— and the tribe of ———, which parish at the present election contains twenty elders, whereof one is of the horse or equestrian order.

" The first and second in the list are overseers by consequence; the third is the constable, and the fourth and fifth are churchwardens; the persons so chosen are deputies of the parish for the space of one year from their election, and no longer, nor may they be elected two years together. This list, being the *primum mobile,* or first mover of the commonwealth, is to be registered in a book diligently kept and preserved by the overseers, who are responsible in their places, for these and other duties to be hereafter mentioned, to the censors of the tribe; and the congregation is to observe the present order, as they will answer the contrary to the phylarch, or prerogative troop of the tribe, which, in case of failure in the whole or any part of it, have power to fine them or any of them at discetion, but under an appeal to the Parliament."

For proof of this order, first, in reason, it is with all politicians past dispute that paternal power is in the right of nature; and this is no other than the derivation of power from fathers of families as the natural root of a commonwealth. And for experience, if it be otherwise in that of Holland, I know no other example of the like kind. In Israel, the sovereign power came clearly from the natural root, the elders of the whole people; and Rome was born, *Comitiis curiatis,* in her parochial congregations, out of which Romulus first raised her Senate, then all the rest of the orders of that commonwealth, which rose so high: for the depth of a commonwealth is the just height of it—

> "She raises up her head unto the skies,
> Near as her root unto the centre lies."

And if the Commonwealth of Rome was born of thirty parishes, this of Oceana was born of 10,000. But whereas mention in the birth of this is made of an equestrian order, it may startle such as know that the division of the people of Rome, at the institution of that commonwealth into orders, was the occasion of its ruin. The distinction of the patrician as a hereditary order from the very institution, engrossing all the magistracies, was indeed the destruction of Rome; but to a knight or one of the equestrian order, says Horace,

> "*Si quadringentis sex septem millia desunt,
> Plebs eris.*"

By which it should seem that this order was not otherwise hereditary than a man's estate, nor did it give any claim to magistracy; wherefore you shall never find that it disquieted the commonwealth, nor does the name denote any more in Oceana than the duty of such a man's estate to the public.

But the surveyors, both in this place and in others, forasmuch as they could not observe all the circumstances of this order, especially that of the time of election, did for the first as well as they could; and, the elections being made and registered, took each of them copies of those lists which were within their allotments, which done they produced—

The sixth order, directing "In case a parson or vicar of a parish comes to be removed by death or by the censors, that the congregation of the parish assemble and depute one or two elders by the ballot, who upon the charge of the parish shall repair to one of the universities of this nation with a certificate signed by the overseers, and addressed to the vice-chancellor, which certificate, giving notice of the death or removal of the parson or vicar, of the value of the parsonage or vicarage, and

of the desire of the congregation to receive a probationer from that university, the vice-chancellor, upon the receipt thereof, shall call a convocation, and having made choice of a fit person, shall return him in due time to the parish, where the person so returned shall return the full fruits of the benefice or vicarage, and do the duty of the parson or vicar, for the space of one year, as probationer; and that being expired, the congregation of the elders shall put their probationer to the ballot, and if he attains not to two parts in three of the suffrage affirmative, he shall take his leave of the parish, and they shall send in like manner as before for another probationer; but if their probationer obtains two parts in three of the suffrage affirmative, he is then pastor of that parish. And the pastor of the parish shall pray with the congregation, preach the Word, and administer the sacraments to the same, according to the directory to be hereafter appointed by the Parliament. Nevertheless such as are of gathered congregations, or from time to time shall join with any of them, are in no wise obliged to this way of electing their teachers, or to give their votes in this case, but wholly left to the liberty of their own consciences, and to that way of worship which they shall choose, being not popish, Jewish, or idolatrous. And to the end they may be the better protected by the State in the exercise of the same, they are desired to make choice, and such manner as they best like, of certain magistrates in every one of their congregations, which we could wish might be four in each of them, to be auditors in cases of differences or distaste, if any through variety of opinions, that may be grievous or injurious to them, shall fall out. And such auditors or magistrates shall have power to examine the matter, and inform themselves, to the end that if they think it of sufficient weight, they may acquaint the phylarch with it, or introduce it into the Council of Religion; where all such causes as those magistrates introduce shall from time to time be heard and determined according to such laws as are or shall hereafter be provided by the Parliament for the just defence of the liberty of conscience."

This order consists of three parts, the first restoring the power of ordination to the people, which, that it originally belongs to them, is clear, though not in English yet in Scripture, where the apostles ordained elders by the holding up of hands in every congregation, that is, by the suffrage of the people, which was also given in some of those cities by the ballot. And though it may be shown that the apostles ordained some by the laying on of hands, it will not be shown that they did so in every congregation.

Excommunication, as not clearly provable out of the Scripture, being omitted, the second part of the order implies and

establishes a national religion; for there be degrees of knowledge in divine things; true religion is not to be learned without searching the Scripture; the Scriptures cannot be searched by us unless we have them to search; and if we have nothing else, or (which is all one) understand nothing else but a translation, we may be (as in the place alleged we have been) beguiled or misled by the translation, while we should be searching the true sense of the Scripture, which cannot be attained in a natural way (and a commonwealth is not to presume upon that which is supernatural) but by the knowledge of the original and of antiquity, acquired by our own studies, or those of some others, for even faith comes by hearing. Wherefore a commonwealth not making provision of men from time to time, knowing in the original languages wherein the Scriptures were written, and versed in those antiquities to which they so frequently relate, that the true sense of them depends in great part upon that knowledge, can never be secure that she shall not lose the Scripture, and by consequence her religion; which to preserve she must institute some method of this knowledge, and some use of such as have acquired it, which amounts to a national religion.

The commonwealth having thus performed her duty toward God, as a rational creature, by the best application of her reason to Scripture, and for the preservation of religion in the purity of the same, yet pretends not to infallibility, but comes in the third part of the order, establishing liberty of conscience according to the instructions given to her Council of Religion, to raise up her hands to heaven for further light; in which proceeding she follows that (as was shown in the preliminaries) of Israel, who, though her national religion was always a part of her civil law, gave to her prophets the upper hand of all her orders.

But the surveyors having now done with the parishes, took their leave; so a parish is the first division of land occasioned by the first collection of the people of Oceana, whose function proper to that place is comprised in the six preceding orders.

The next step in the progress of the surveyors was to a meeting of the nearest of them, as their work lay, by twenties; where conferring their lists, and computing the deputies contained therein, as the number of them in parishes, being nearest neighbors, amounted to 100, or as even as might conveniently be brought with that account, they cast them and those parishes into the precinct which (be the deputies ever since more or fewer) is still called the hundred; and to every one of these precincts they appointed a certain place, being the most convenient town within the same, for the annual rendezvous; which

done, each surveyor, returning to his hundred, and summoning the deputies contained in his lists to the rendezvous, they appeared and received—

The seventh order, requiring, " That upon the first Monday next ensuing the last of January, the deputies of every parish annually assemble in arms at the rendezvous of the hundred, and there elect out of their number one justice of the peace, one juryman, one captain, one ensign of their troop or century, each of these out of the horse; and one juryman, one coroner, one high constable, out of the foot; the election to be made by the ballot in this manner. The jurymen for the time being are to be overseers of the ballot (instead of these, the surveyors are to officiate at the first assembly), and to look to the performance of the same according to what was directed in the ballot of the parishes, saving that the high constable setting forth the urn shall have five several suits of gold balls, and one dozen of every suit; whereof the first shall be marked with the letter A, the second with the letter B, the third with C, the fourth with D, and the fifth with E: and of each of these suits he shall cast one ball into his hat, or into a little urn, and shaking the balls together, present them to the first overseer, who shall draw one, and the suit which is so drawn by the overseer shall be of use for that day, and no other; for example, if the overseer drew an A, the high constable shall put seven gold balls marked with the letter A into the urn, with so many silver ones as shall bring them even with the number of the deputies, who being sworn, as before, at the ballot of the parish to make a fair election, shall be called to the urn; and every man coming in manner as was there shown, shall draw one ball, which, if it be silver, he shall cast it into a bowl standing at the foot of the urn, and return to his place: but the first that draws a gold ball (showing it to the overseers, who if it has not the letter of the present ballot, have power to apprehend and punish him) is the first elector, the second the second elector, and so to the seventh; which order they are to observe in their function.

" The electors as they are drawn shall be placed upon the bench by the overseers, till the whole number be complete, and then be conducted, with the list of the officers to be chosen, into a place apart, where, being private, the first elector shall name a person to the first office in the list; and if the person so named, being balloted by the rest of the electors, attains not to the better half of the suffrages in the affirmative, the first elector shall continue nominating others, till one of them so nominated by him attains to the plurality of the suffrages in the affirmative, and be written first competitor to the first office. This done, the second elector shall observe in his turn the like order; and

so the rest of the electors, naming competitors each to his respective office in the list, till one competitor be chosen to every office: and when one competitor is chosen to every office, the first elector shall begin, again to name a second competitor to the first office, and the rest successively shall name to the rest of the offices till two competitors be chosen to every office; the like shall be repeated till three competitors be chosen to every office. And when three competitors are chosen to every office, the list shall be returned to the overseers, or such as the overseers, in case they or either of them happened to be electors, have substituted in his or their place or places; and the overseers or substitutes having caused the list to be read to the congregation, shall put the competitors, in order as they are written, to the ballot of the congregation; and the rest of the proceedings being carried on in the manner directed in the fifth order, that competitor, of the three written to each office, who has most of the suffrages above half in the affirmative, is the officer. The list being after this manner completed, shall be entered into a register, to be kept at the rendezvous of the hundred, under inspection of the magistrates of the same, after the manner following:

Anno Domini

The List of the Nebulosa

A. A., Equestrian Order, Justice of the Peace,	
B. B., Equestrian Order, First Juryman,	Of the hundred of ———
C. C., Equestrian Order, Captain of the Hundred,	in the tribe of ———, which hundred consists
D. D., Equestrian Order, Ensign,	at this election of 105
E. E., Second Juryman,	deputies.
F. F., High Constable,	
G. G., Coroner,	

" The list being entered, the high constable shall take three copies of the same, whereof he shall presently return one to the lord high sheriff of the tribe, a second to the lord *custos rotulorum*, and a third to the censors; or these, through the want of such magistrates at the first muster, may be returned to the orator, to be appointed for that tribe. To the observation of all and every part of this order, the officers and deputies of the hundred are all and every of them obliged, as they will answer it to the phylarch, who has power, in case of failure in the whole or any part, to fine all or any of them so failing at discretion, or according to such laws as shall hereafter be provided in that case, but under an appeal to the Parliament."

There is little in this order worthy of any further account, but that it answers to the rulers of hundreds in Israel, to the *mora*

or military part of the tribe in Lacedæmon, and to the century in Rome. The jurymen, being two in a hundred, and so forty in a tribe, give the latitude allowed by the law for exceptions. And whereas the golden balls at this ballot begin to be marked with letters, whereof one is to be drawn immediately before it begins, this is to the end that the letter being unknown, men may be frustrated of tricks or foul play, whereas otherwise a man may bring a golden ball with him, and make as if he had drawn it out of the urn. The surveyors, when they had taken copies of these lists, had accomplished their work in the hundreds.

So a hundred is the second division of land occasioned by the second collection of the people, whose civil and military functions proper to this place are comprised in the foregoing order.

Having stated the hundreds, they met once again by twenties, where there was nothing more easy than to cast every twenty hundreds, as they lay most conveniently together, into one tribe; so the whole territory of Oceana, consisting of about 10,000 parishes, came to be cast into 1,000 hundreds, and into fifty tribes. In every tribe at the place appointed for the annual rendezvous of the same, were then, or soon after, begun those buildings which are now called pavilions; each of them standing with one open side upon fair columns, like the porch of some ancient temple, and looking into a field capable of the muster of some 4,000 men; before each pavilion stand three pillars sustaining urns for the ballot, that on the right hand equal in height to the brow of a horseman, being called the horse urn, that on the left hand, with bridges on either side to bring it equal in height with the brow of a footman, being called the foot urn, and the middle urn, with a bridge on the side toward the foot urn, the other side, as left for the horse, being without one; and here ended the whole work of the surveyors, who returned to the Lord Archon with this—

ACCOUNT OF THE CHARGE

Imprimis: Urns, balls, and balloting-boxes for 10,000 parishes, the same being wooden-ware,	£20,000
Item: Provisions of the like kind for a thousand hundreds,	3,000
Item: Urns and balls of metal, with balloting-boxes for fifty tribes,	2,000
Item: For erecting of fifty pavilions,	60,000
Item: Wages for four surveyors-general at £1,000 a man,	4,000
Item: Wages for the rest of the surveyors, being 1,000, at £250 a man	250,000
Sum total,	£339,000

This is no great matter of charge for the building of a commonwealth, in regard that it has cost (which was pleaded by the surveyors) as much to rig a few ships. Nevertheless that proves not them to be honest, nor their account to be just; but they had their money for once, though their reckoning be plainly guilty of a crime, to cost him his neck that commits it another time, it being impossible for a commonwealth (without an exact provision that it be not abused in this kind) to subsist; for if no regard should be had of the charge (though that may go deep), yet the debauchery and corruption whereto, by negligence in accounts, it infallibly exposes its citizens, and thereby lessens the public faith, which is the nerve and ligament of government, ought to be prevented. But the surveyors being despatched, the Lord Archon was very curious in giving names to his tribes, which having caused to be written in scrolls cast into an urn, and presented to the councillors, each of them drew one, and was accordingly sent to the tribe in his lot, as orators of the same, a magistracy no otherwise instituted, than for once and *pro tempore*, to the end that the council upon so great an occasion might both congratulate with the tribes, and assist at the first muster in some things of necessity to be differently carried from the established administration and future course of the commonwealth.

The orators being arrived, every one as soon as might be, at the rendezvous of his tribe, gave notice to the hundreds, and summoned the muster, which appeared for the most part upon good horses, and already indifferently well armed; as to instance in one for all, the tribe of Nubia, where Hermes de Caduceo, lord orator of the same, after a short salutation and a hearty welcome, applied himself to his business, which began with—

The eighth order, requiring " That the lord high sheriff as commander-in-chief, and the lord *custos rotulorum* as muster-master of the tribe (or the orator for the first muster), upon reception of the lists of their hundreds, returned to them by the high constables of the same, presently cause them to be cast up, dividing the horse from the foot, and listing the horse by their names in troops, each troop containing about 100 in number, to be inscribed First, Second, or Third troop, etc., according to the order agreed upon by the said magistrates; which done, they shall list the foot in like manner, and inscribe the companies in like order. These lists upon the eve of the muster shall be delivered to certain trumpeters and drummers, whereof there shall be fifteen of each sort (as well for the present as otherwise to be hereafter mentioned) stipendiated by the tribe. And the trumpeters and drummers shall be in the field before the pavilion, upon the day of the muster, so soon as it is light, where they

shall stand every one with his list in his hand, at a due distance, placed according to the order of the list, the trumpeters with the lists of the horse on the right hand, and the drummers with the lists of the foot on the left hand; where having sounded awhile, each of them shall begin to call and continue calling the names of the deputies, as they come into the field, till both the horse and foot be gathered by that means into their due order. The horse and foot being in order, the lord lieutenant of the tribe shall cast so many gold balls marked with the figures 1, 2, 3, 4, etc., as there be troops of horse in the field, together with so many silver balls as there be companies, marked in the same manner, into a little urn, to which he shall call the captains; and the captains drawing the gold balls shall command the horse, and those that draw the silver the foot, each in the order of his lot. The like shall be done by the conductor at the same time for the ensigns at another urn; and they that draw the gold balls shall be cornets, the left ensigns."

This order may puzzle the reader, but tends to a wonderful speed of the muster, to which it would be a great matter to lose a day in ranging and marshalling, whereas by virtue of this the tribe is no sooner in the field than in *battalia*, nor sooner in *battalia* than called to the urns or the ballot by virtue of—

The ninth order, "Whereby the censors (or the orator for the first muster) upon reception of the lists of the hundreds from the high constables, according as is directed by the seventh order, are to make their notes for the urns beforehand, with regard had to the lists of the magistrates, to be elected by the ensuing orders, that is to say, by the first list called the prime magnitude, six; and by the second called the galaxy, nine. Wherefore the censors are to put into the middle urn for the election of the first list twenty-four gold balls, with twenty-six blanks or silver balls, in all sixty; and into the side urns sixty gold balls, divided into each according to the different number of the horse and foot; that is to say, if the horse and the foot be equal, equally; and if the horse and the foot be unequal, unequally, by an arithmetical proportion. The like shall be done the second day of the muster for the second list, except that the censors shall put into the middle urn thirty-six gold balls with twenty-four blanks, in all sixty; and sixty gold balls into the side urns, divided respectively into the number of the horse and the foot; and the gold balls in the side urns at either ballot are by the addition of blanks to be brought even with the number of the ballotants at either urn respectively. The censors having prepared their notes, as has been shown, and being come at the day appointed into the field, shall present a little urn to the lord high sheriff, who is to draw twice for the letters to be used that

day, the one at the side urns, and the other at the middle. And the censors having fitted the urns accordingly, shall place themselves in certain movable seats or pulpits (to be kept for that use in the pavilion), the first censor before the horse urn, the second before the foot urn, the lord lieutenant doing the office of censor *pro tempore* at the middle urn; where all and every one of them shall cause the laws of the ballot to be diligently observed, taking a special care that no man be suffered to come above once to the urn (whereof it more particularly concerns the sub-censors, that is to say, the overseers of every parish, to be careful, they being each in this regard responsible for their respective parishes) or to draw above one ball, which if it be gold, he is to present to the censor, who shall look upon the letter; and if it be not that of the day, and of the respective urn, apprehend the party, who for this or any other like disorder is obnoxious to the phylarch."

This order being observed by the censors, it is not possible for the people, if they can but draw the balls, though they understand nothing at all of the ballot, to be out. To philosophize further upon this art, though there be nothing more rational, were not worth the while, because in writing it will be perplexed, and the first practice of it gives the demonstration; whence it came to pass that the orator, after some needless pains in the explanation of the two foregoing orders, betaking himself to exemplify the same, found the work done to his hand, for the tribe, as eager upon a business of this nature, had retained one of the surveyors, out of whom (before the orator arrived) they had got the whole mystery by a stolen muster, at which in order to the ballot they had made certain magistrates *pro tempore*. Wherefore he found not only the pavilion (for this time a tent) erected with three posts, supplying the place of pillars to the urns, but the urns being prepared with a just number of balls for the first ballot, to become the field, and the occasion very gallantly with their covers made in the manner of helmets, open at either ear to give passage to the hands of the ballotants, and slanting with noble plumes to direct the march of the people. Wherefore he proceeded to—

The tenth order, " Requiring of the deputies of the parishes, that upon every Monday next ensuing the last of February, they make their personal appearance, horse and foot in arms accordingly, at the rendezvous of the tribe, where, being in discipline, the horse upon the right, and the foot upon the left, before the pavilion, and having made oath by holding up their hands, upon the tender of it by the lord high sheriff, to make election without favor, and of such only as they shall judge fittest for the commonwealth, the conductor shall take three balls, the one in-

scribed with these words (outward files), another with these words (inward files), and the third with these (middle files), which balls he shall cast into a little urn, and present it to the lord high sheriff, who, drawing one, shall give the words of command, as they are thereupon inscribed, and the ballot shall begin accordingly. For example, if the ball be inscribed 'Middle files,' the ballot shall begin by the middle; that is, the two files that are middle to the horse shall draw out first to the horse urn, and the two files that are middle to the foot shall draw out first to the foot urn, and be followed by all the rest of the files as they are next to them in order. The like shall be done by the inward, or by the outward files in case they be first called. And the files, as every man has drawn his ball, if it be silver, shall begin at the urn to countermarch to their places, but he that has drawn a gold ball at a side urn shall proceed to the middle urn, where if the balls he draws be silver he shall also countermarch, but if it be gold he shall take his place upon a form set across the pavilion, with his face toward the lord high sheriff, who shall be seated in the middle of the pavilion, with certain clerks by him, one of which shall write down the names of every elector, that is, of every one that drew a gold ball at the middle urn, and in the order his ball was drawn, till the electors amount to six in number. And the first six electors, horse and foot promiscuously, are the first order of electors; the second six (still accounting them as they are drawn) the second order, the third six the third order, and the fourth six the fourth order of electors; every elector having place in his order, according to the order wherein he was drawn. But so soon as the first order of electors is complete, the lord high sheriff shall send them with a copy of the following list, and a clerk that understands the ballot, immediately to a little tent standing before the pavilion in his eye, to which no other person but themselves, during the election, shall approach. The list shall be written in this manner:

Anno Domini

THE LIST OF THE PRIME MAGNITUDE, OR FIRST DAY'S ELECTION OF MAGISTRATES

1. The Lord High Sheriff, Commander-in-Chief,
2. Lord Lieutenant,
3. Lord *Custos Rotulorum*, Muster-Master-General,
4. The Conductor, being Quartermaster General,
5. The First Censor,
6. The Second Censor,

Of the tribe of Nubia, containing at this present muster 700 horse and 1,500 foot, in all 22,000 deputies.

"And the electors of the first band or order, being six, shall each of them name to his respective magistracy in the left such as are not already elected in the hundreds, till one competitor be chosen to every magistracy in the list by the ballot of the electors of the first order, which done, the list with the competitors thereunto annexed shall be returned to the lord high sheriff by the clerk attending that order, but the electors shall keep their places; for they have already given their suffrage, and may not enter into the ballot of the tribe. If there arises any dispute in an order of electors, one of the censors or sub-censors appointed by them in case they be electors, shall enter into the tent of that order, and that order shall stand to his judgment in the decision of the controversy. The like shall be done exactly by each other order of electors, being sent as they are drawn, each with another copy of the same list, into a distinct tent, till there be returned to the lord high sheriff four competitors to every magistracy in the list; that is to say, one competitor elected to every office in every one of the four orders, which competitors the lord high sheriff shall cause to be pronounced or read by a crier to the congregation, and the congregation having heard the whole lists repeated, the names shall be put by the lord high sheriff to the tribe, one by one, beginning with the first competitor in the first order, thence proceeding to the first competitor in the second order, and so to the first in the third and fourth orders. And the suffrages being taken in boxes by boys (as has been already shown) shall be poured into the bowls standing before the censors, who shall be seated at each end of the table in the pavilion, the one numbering the affirmatives and the other the negatives, and he of the four competitors to the first magistracy that has most above half the suffrages of the tribe in the affirmative, is the first magistrate. The like is to be done successively by the rest of the competitors in their order. But because soon after the boxes are sent out for the first name, there be others sent out for the second, and so for the third, etc., by which means divers names are successively at one and the same time in balloting; the boy that carries a box shall sing or repeat continually the name of the competitor for whom that box is carrying, with that also of the magistracy to which he is proposed. A magistrate of the tribe happening to be an elector, may substitute any one of his own order to execute his other function. The magistrates of the prime magnitude being thus elected, shall receive the present charge of the tribe."

If it be objected against this order that the magistrates to be elected by it will be men of more inferior rank than those of the hundreds, in regard that those are chosen first, it may be remembered that so were the burgesses in the former government,

nevertheless the knights of the shire were men of greater quality; and the election at the hundred is made by a council of electors, of whom less cannot be expected than the discretion of naming persons fittest for those capacities, with an eye upon these to be elected at the tribe. As for what may be objected in point of difficulty, it is demonstrable by the foregoing orders, that a man might bring 10,000 men, if there were occasion, with as much ease, and as suddenly to perform the ballot, as he can make 5,000 men, drawing them out by double files, to march a quarter of a mile. But because at this ballot, to go up and down the field, distributing the linen pellets to every man, with which he is to ballot or give suffrage, would lose a great deal of time, therefore a man's wife, his daughters, or others, make him his provision of pellets before the ballot, and he comes into the field with a matter of a score of them in his pocket. And now I have as good as done with the sport. The next is—

The eleventh order, " Explaining the duties and functions of the magistrates contained in the list of the prime magnitude, and those of the hundreds, beginning with the lord high sheriff, who, over and above his more ancient offices, and those added by the former order, is the first magistrate of the phylarch, or prerogative troop. The lord lieutenant, over and above his duty mentioned, is commander-in-chief of the musters of the youth, and second magistrate of the phylarch. The *custos rotulorum* is to return the yearly muster-rolls of the tribe, as well that of the youth as of the elders, to the rolls in emporium, and is the third magistrate of the phylarch. The censors by themselves and their sub-censors, that is, the overseers of the parishes, are to see that the respective laws of the ballot be observed in all the popular assemblies of the tribe. They have power also to put such national ministers, as in preaching shall intermeddle with matters of government, out of their livings, except the party appeals to the phylarch, or to the Council of Religion, where in that case the censors shall prosecute. All and every one of these magistrates, together with the justices of peace, and the jurymen of the hundreds, amounting in the whole number to threescore and six, are the prerogative troop or phylarch of the tribe.

" The function of the phylarch or prerogative troop is fivefold:

" First, they are the council of the tribe, and as such to govern the musters of the same according to the foregoing orders, having cognizance of what has passed in the congregation or elections made in the parishes or the hundreds, with power to punish any undue practices, or variation from their respective rules and orders, under an appeal to the Parliament. A marriage

legitimately is to be pronounced by the parochial congregation, the muster of the hundred, or the phylarch. And if a tribe have a desire (which they are to express at the muster by their captains, every troop by his own) to petition the Parliament the phylarch, as the council, shall frame the petition in the pavilion, and propose it by clauses to the ballot of the whole tribe; and the clauses that shall be affirmed by the ballot of the tribe, and signed by the hands of the six magistrates of the prime magnitude, shall be received and esteemed by the Parliament as the petition of the tribe, and no other.

"Secondly, the phylarch has power to call to their assistance what other troops of the tribe they please (be they elders or youth, whose discipline will be hereafter directed), and with these to receive the judges itinerant in their circuits, whom the magistrates of the phylarch shall assist upon the bench, and the juries elsewhere in their proper functions according to the more ancient laws and customs of this nation.

"Thirdly, the phylarch shall hold the court called the quarter-sessions according to the ancient custom, and therein shall also hear causes in order to the protection of liberty of conscience, by such rules as are or shall hereafter be appointed by the Parliament.

"Fourthly, all commissions issued into the tribes by the Parliament, or by the chancery, are to be directed to the phylarch, or some of that troop, and executed by the same respectively.

"Fifthly, in the case of levies of money the Parliament shall tax the phylarchs, the phylarchs shall tax the hundreds, the hundreds the parishes, and the parishes shall levy it upon themselves. The parishes having levied the tax-money accordingly, shall return it to the officers of the hundreds, the hundred to the phylarchs, and the phylarchs to the Exchequer. But if a man has ten children living, he shall pay no taxes; if he has five living, he shall pay but half taxes; if he has been married three years, or be above twenty-five years of age, and has no child or children lawfully begotten, he shall pay double taxes. And if there happen to grow any dispute upon these or such other orders as shall or may hereto be added hereafter, the phylarchs shall judge the tribes, and the Parliament shall judge the phylarchs. For the rest, if any man shall go about to introduce the right or power of debate into any popular council or congregation of this nation, the phylarch or any magistrate of the hundred, or of the tribe, shall cause him presently to be sent in custody to the Council of War.

The part of the order relating to the rolls in Emporium being of singular use, is not unworthy to be somewhat better opened. In what manner the lists of the parishes, hundreds, and tribes

are made, has been shown in their respective orders, where, after the parties are elected, they give an account of the whole number of the elders or deputies in their respective assemblies or musters; the like for this part exactly is done by the youth in their discipline (to be hereafter shown) wherefore the lists of the parishes, youth and elders, being summed up, give the whole number of the people able to bear arms, and the lists of the tribes, youth and elders, being summed up, give the whole number of the people bearing arms. This account, being annually recorded by the master of the rolls, is called the "Pillar of Nilus," because the people, being the riches of the commonwealth, as they are found to rise or fall by the degrees of this pillar, like that river, give an account of the public harvest.

Thus much for the description of the first day's work at the muster, which happened (as has been shown) to be done as soon as said; for as in practice it is of small difficulty, so requires it not much time, seeing the great Council of Venice, consisting of a like number, begins at twelve of the clock, and elects nine magistrates in one afternoon. But the tribe being dismissed for this night, repaired to their quarters, under the conduct of their new magistrates. The next morning returning to the field very early, the orator proceeded to—

The twelfth order, "Directing the muster of the tribe in the second day's election, being that of the list called the galaxy; in which the censors shall prepare the urns according to the directions given in the ninth order for the second ballot; that is to say, with thirty-six gold balls in the middle urn, making four orders, and nine electors in every order, according to the number of the magistrates in the list of the galaxy, which is as follows:

1. Knight } To be chosen out of the horse.
2. Knight
3. Deputy }
4. Deputy } To be chosen out of the horse.
5. Deputy
6. Deputy }
7. Deputy }
8. Deputy } To be chosen out of the foot.
9. Deputy

"The rest of the ballot shall proceed exactly according to that of the first day. But, forasmuch as the commonwealth demands as well the fruits of a man's body as of his mind, he that has not been married shall not be capable of these magistracies till he be married. If a deputy, already chosen to be an officer in the parish, in the hundred, or in the tribe, be afterward chosen of the galaxy, it shall be lawful for

him to delegate his office in the parish, in the hundred, or in the tribe, to any one of his own order being not already chosen into office. The knights and deputies being chosen, shall be brought to the head of the tribe by the lord high sheriff, who shall administer to them this oath: 'Ye shall well and truly observe and keep the orders and customs of this commonwealth which the people have chosen.' And if any of them shall refuse the oath, he shall be rejected, and that competitor which had the most voices next shall be called in his place, who, if he takes the oath, shall be entered in the list; but if he also refuses the oath, he who had most voices next shall be called, and so till the number of nine out of those competitors which had most voices be sworn knights and deputies of the galaxy. (This clause, in regard to the late divisions, and to the end that no violence be offered to any man's conscience, to be of force but for the first three years only.) The knights of the galaxy being elected and sworn, are to repair, by the Monday next ensuing to the last of March, to the Pantheon or palace of justice, situated in the metropolis of this commonwealth (except the Parliament, by reason of a contagious sickness, or some other occasion, has adjourned to another part of the nation), where they are to take their places in the Senate, and continue in full power and commission as senators for the full term of three years next ensuing the date of their election. The deputies of the galaxy are to repair by the same day (except as before excepted) to the halo situated in Emporium, where they are to be listed of the prerogative tribe, or equal representative of the people; and to continue in full power and commission as their deputies for the full term of three years next ensuing their election. But, forasmuch as the term of every magistracy or office in this commonwealth requires an equal vacation, a knight or deputy of the galaxy, having fulfilled his term of three years, shall not be re-elected into the same galaxy, or any other, till he has also fulfilled his three years' vacation."

Whoever shall rightly consider the foregoing orders, will be as little able to find how it is possible that a worshipful knight should declare himself in ale and beef worthy to serve his country, as how my lord high sheriff's honor, in case he were protected from the law, could play the knave. But though the foregoing orders, so far as they regard the constitution of the Senate and the people, requiring no more as to an ordinary election than is therein explained, that is but one-third part of their knights and deputies, are perfect; yet must we in this place, and as to the institution, of necessity erect a scaffold. For the commonwealth to the first creation of her

councils in full number, required thrice as many as are eligible by the foregoing orders. Wherefore the orator, whose aid in this place was most necessary, rightly informing the people of the reason, stayed them two days longer at the muster, and took this course. One list, containing two knights and seven deputies, he caused to be chosen upon the second day; which list being called the first galaxy, qualified the parties elected of it with power for the term of one year, and no longer: another list, containing two knights and seven deputies more, he caused to be chosen the third day, which list being called the second galaxy, qualified the parties elected of it with power for the term of two years, and no longer. And upon the fourth day he chose the third galaxy, according as it is directed by the order, empowered for three years; which lists successively falling (like the signs or constellations of one hemisphere, which setting, cause those of the other to rise) cast the great orbs of this commonwealth into an annual, triennial, and perpetual revolution.

The business of the muster being thus happily finished, Hermes de Caduceo, lord orator of the tribe of Nubia, being now put into her first rapture, caused one of the censor's pulpits to be planted in front of the squadron, and ascending into the same, spake after this manner:

"MY LORDS, THE MAGISTRATES AND THE PEOPLE OF THE TRIBE OF NUBIA:

"We have this day solemnized the happy nuptials of the two greatest princes that are upon the earth or in nature, arms and councils, in the mutual embraces whereof consists your whole commonwealth; whose councils upon their perpetual wheelings, marches, and countermarches, create her armies, and whose armies with the golden volleys of the ballot at once create and salute her councils. There be those (such is the world at present) that think it ridiculous to see a nation exercising its civil functions in military discipline; while they, committing their buff to their servants, come themselves to hold trenchards. For what avails it such as are unarmed, or (which is all one) whose education acquaints them not with the proper use of their swords, to be called citizens? What were 2,000 or 3,000 of you, though never so well affected to your country, but naked, to one troop of mercenary soldiers? If they should come upon the field and say, 'Gentlemen, it is thought fit that such and such men should be chosen by you,' where were your liberty? or, 'Gentlemen, parliaments are exceeding good, but you are to have a little patience; these times are not so fit for them,' where were

your commonwealth? What causes the monarchy of the Turks but servants in arms? What was it that begot the glorious Commonwealth of Rome but the sword in the hands of her citizens? Wherefore my glad eyes salute the serenity and brightness of this day with a shower that shall not cloud it.

"Behold the army of Israel become a commonwealth, and the Commonwealth of Israel remaining an army, with her rulers of tens and of fifties, her rulers of hundreds and thousands, drawing near (as this day throughout our happy fields) to the lot by her tribes, increased above threefold, and led up by her phylarchs or princes, to sit upon fifty thrones, judging the fifty tribes of Oceana! Or, is it Athens, breaking from her iron sepulchre, where she has been so long trampled by hosts of Janizaries? For certainly that is the voice of Theseus, having gathered his scattered Athenians into one city. This freeborn nation lives not upon the dole or bounty of one man, but distributing her annual magistracies and honors with her own hand, is herself King People— (At which the orator was awhile interrupted with shouts, but at length proceeded.) Is it grave Lacedæmon in her armed tribe, divided by her *obæ* and her *mora,* which appears to chide me that I teach the people to talk, or conceive such language as is dressed like a woman, to be a fit usher of the joys of liberty into the hearts of men? Is it Rome in her victorious arms (for so she held her *concio* or congregation) that congratulates with us, for finding out that which she could not hit on, and binding up her *Comitia curiata, centuriata,* and *tributa,* in one inviolable league of union? Or is it the great council of incomparable Venice, bowling forth by the selfsame ballot her immortal commonwealth? For, neither by reason nor by experience is it impossible that a commonwealth should be immortal; seeing the people being the materials, never die; and the form, which is motion, must, without opposition, be endless. The bowl which is thrown from your hand, if there be no rub, no impediment, shall never cease: for which cause the glorious luminaries that are the bowls of God, were once thrown forever; and next these, those of Venice. But certainly, my lords, whatever these great examples may have shown us, we are the first that have shown to the world a commonwealth established in her rise upon fifty such towers, and so garrisoned as are the tribes of Oceana, containing 100,000 elders upon the annual list, and yet but an outguard; besides her marching armies to be equal in the discipline, and in the number of her youth.

"And forasmuch as sovereign power is a necessary but a formidable creature, not unlike the powder which (as you are

soldiers) is at once your safety and your danger, being subject to take fire against you as well as for you, how well and securely is she by your galaxies so collected as to be in full force and vigor, and yet so distributed that it is impossible you should be blown up by your own magazine? Let them who will have it, that power if it be confined cannot be sovereign, tell us, whether our rivers do not enjoy a more secure and fruitful reign within their proper banks, than if it were lawful for them, in ravaging our harvests, to spill themselves? whether souls, not confined to their peculiar bodies, do govern them any more than those of witches in their trances? whether power, not confined to the bounds of reason and virtue, has any other bounds than those of vice and passion? or if vice and passion be boundless, and reason and virtue have certain limits, on which of these thrones holy men should anoint their sovereign? But to blow away this dust, the sovereign power of a commonwealth is no more bounded, that is to say straitened, than that of a monarch; but is balanced. The eagle mounts not to her proper pitch, if she be bounded, nor is free if she be not balanced. And lest a monarch should think he can reach further with his sceptre, the Roman eagle upon such a balance spread her wings from the ocean to Euphrates. Receive the sovereign power; you have received it, hold it fast, embrace it forever in your shining arms. The virtue of the loadstone is not impaired or limited, but receives strength and nourishment, by being bound in iron. And so giving your lordships much joy, I take my leave of this tribe."

The orator descending, had the period of his speech made with a vast applause and exultation of the whole tribe, attending him for that night to his quarter, as the phylarch with some commanded troops did the next day to the frontiers of the tribe, where leave was taken on both sides with more tears than grief.

So a tribe is the third division of land occasioned by the third collection of the people, whose functions proper to that place are contained in the five foregoing orders.

The institution of the commonwealth was such as needed those props and scaffolds which may have troubled the reader; but I shall here take them away, and come to the constitution which stands by itself, and yields a clearer prospect.

The motions, by what has been already shown, are spherical; and spherical motions have their proper centre, for which cause (ere I proceed further) it will be necessary, for the better understanding of the whole, that I discover the centre whereupon the motions of this commonwealth are formed.

The centre, or basis of every government, is no other than the fundamental laws of the same.

Fundamental laws are such as state what it is that a man may call his own, that is to say, property; and what the means be whereby a man may enjoy his own, that is to say, protection. The first is also called dominion, and the second empire or sovereign power, whereof this (as has been shown) is the natural product of the former: for such as is the balance of dominion in a nation, such is the nature of its empire.

Wherefore the fundamental laws of Oceana, or the centre of this commonwealth, are the agrarian and the ballot: the agrarian by the balance of dominion preserving equality in the root; and the ballot by an equal rotation conveying it into the branch, or exercise of sovereign power, as, to begin with the former, appears by—

The thirteenth order, "Constituting the agrarian laws of Oceana, Marpesia, and Panopea, whereby it is ordained, first, for all such lands as are lying and being within the proper territories of Oceana, that every man who is at present possessed, or shall hereafter be possessed, of an estate in land exceeding the revenue of £2,000 a year, and having more than one son, shall leave his lands either equally divided among them, in case the lands amount to above £2,000 a year to each, or so near equally, in case they come under, that the greater part or portion of the same remaining to the eldest exceed not the value of £2,000 revenue. And no man, not in present possession of lands above the value of £2,000 by the year, shall receive, enjoy (except by lawful inheritance), acquire, or purchase to himself lands within the said territories, amounting, with those already in his possession, above the said revenue. And if a man has a daughter or daughters, except she be an heiress or they be heiresses, he shall not leave or give to any one of them in marriage, or otherwise, for her portion, above the value of £1,500 in lands, goods, and moneys. Nor shall any friend, kinsman, or kinswoman add to her or their portion or portions that are so provided for, to make any one of them greater. Nor shall any man demand or have more in marriage with any woman. Nevertheless an heiress shall enjoy her lawful inheritance, and a widow, whatsoever the bounty or affection of her husband shall bequeath to her, to be divided in the first generation, wherein it is divisible according as has been shown.

"Secondly, for lands lying and being within the territories of Marpesia, the agrarian shall hold in all parts as it is established in Oceana, except only in the standard or proportion of estates in land, which shall be set for Marpesia, at £500. And,

"Thirdly, for Panopea, the agrarian shall hold in all parts, as in Oceana. And whosoever possessing above the proportion allowed by these laws, shall be lawfully convicted of the same, shall forfeit the overplus to the use of the State."

Agrarian laws of all others have ever been the greatest bugbears, and so in the institution were these, at which time it was ridiculous to see how strange a fear appeared in everybody of that which, being good for all, could hurt nobody. But instead of the proof of this order, I shall out of those many debates that happened ere it could be passed, insert two speeches that were made at the Council of legislators, the first by the Right Honorable Philautus de Garbo, a young man, being heir-apparent to a very noble family, and one of the councillors, who expressed himself as follows:

"*May it please your Highness, my Lord Archon of Oceana.*

"If I did not, to my capacity, know from how profound a councillor I dissent, it would certainly be no hard task to make it as light as the day: First, that an agrarian is altogether unnecessary; secondly, that it is dangerous to a commonwealth; thirdly, that it is insufficient to keep out monarchy; fourthly, that it ruins families; fifthly, that it destroys industry; and last of all, that though it were indeed of any good use, it will be a matter of such difficulty to introduce in this nation, and so to settle that it may be lasting, as is altogether invincible.

"First, that an agrarian is unnecessary to a commonwealth, what clearer testimony can there be than that the commonwealths which are our contemporaries (Venice, to which your Highness gives the upper hand of all antiquity, being one) have no such thing? And there can be no reason why they have it not, seeing it is in the sovereign power at any time to establish such an order, but that they need it not; wherefore no wonder if Aristotle, who pretends to be a good commonwealthsman, has long since derided Phaleas, to whom it was attributed by the Greeks, for his invention.

"Secondly, that an agrarian is dangerous to a commonwealth is affirmed upon no slight authority, seeing Machiavel is positive that it was the dissension which happened about the agrarian that caused the destruction of Rome; nor do I think that it did much better in Lacedæmon, as I shall show anon.

"Thirdly, that it is insufficient to keep out monarchy cannot without impiety be denied, the holy Scriptures bearing witness that the Commonwealth of Israel, notwithstanding her agrarian, submitted her neck to the arbitrary yoke of her princes.

"Fourthly, therefore, to come to my next assertion, that it is destructive to families: this also is so apparent, that it needs pity rather than proof. Why, alas, do you bind a nobility (which no generation shall deny to have been the first that freely sacrificed their blood to the ancient liberties of this people) on an unholy altar? Why are the people taught that their liberty, which, except our noble ancestors had been born, must have long since been buried, cannot now be born except we be buried? A commonwealth should have the innocence of the dove. Let us leave this purchase of her birth to the serpent, which eats itself out of the womb of its mother.

"Fifthly, but it may be said, perhaps, that we are fallen from our first love, become proud and idle. It is certain, my lords, that the hand of God is not upon us for nothing. But take heed how you admit of such assaults and sallies upon men's estates, as may slacken the nerve of labor, and give others also reason to believe that their sweat is vain; or else, whatsoever be pretended, your agrarian (which is my fifth assertion) must indeed destroy industry. For, that so it did in Lacedæmon is most apparent, as also that it could do no otherwise, where every man having his forty quarters of barley, with wine proportionable, supplied him out of his own lot by his laborer or helot; and being confined in that to the scantling above which he might not live, there was not any such thing as a trade, or other art, except that of war, in exercise. Wherefore a Spartan, if he were not in arms, must sit and play with his fingers, whence ensued perpetual war, and, the estate of the city being as little capable of increase as that of the citizens, her inevitable ruin. Now what better ends you can propose to yourselves in the like ways, I do not so well see as I perceive that there may be worse; for Lacedæmon yet was free from civil war: but if you employ your citizens no better than she did, I cannot promise you that you shall fare so well, because they are still desirous of war that hope that it may be profitable to them; and the strongest security you can give of peace, is to make it gainful. Otherwise men will rather choose that whereby they may break your laws, than that whereby your laws may break them. Which I speak not so much in relation to the nobility or such as would be holding, as to the people or them that would be getting; the passion in these being so much the stronger, as a man's felicity is weaker in the fruition of things, than in their prosecution and increase.

"Truly, my lords, it is my fear, that by taking of more hands, and the best from industry, you will farther endamage it, than can be repaired by laying on a few, and the worst;

while the nobility must be forced to send their sons to the plough, and, as if this were not enough, to marry their daughters also to farmers.

"Sixthly, but I do not see (to come to the last point) how it is possible that this thing should be brought about, to your good I mean, though it may to the destruction of many. For that the agrarian of Israel, or that of Lacedæmon, might stand, is no such miracle; the lands, without any consideration of the former proprietor, being surveyed and cast into equal lots, which could neither be bought, nor sold, nor multiplied: so that they knew whereabout to have a man. But in this nation no such division can be introduced, the lands being already in the hands of proprietors, and such whose estates lie very rarely together, but mixed one with another; being also of tenures in nature so different, that as there is no experience that an agrarian was ever introduced in such a case, so there is no appearance how or reason why it should: but that which is against reason and experience is impossible."

The case of my Lord Philautus was the most concerned in the whole nation; for he had four younger brothers, his father being yet living, to whom he was heir of £10,000 a year. Wherefore being a man both of good parts and esteem, his words wrought both upon men's reason and passions, and had borne a stroke at the head of the business, if my Lord Archon had not interposed the buckler in this oration:

"My Lords, the Legislators of Oceana:

"My Lord Philautus has made a thing which is easy to seem hard; if the thanks were due to his eloquence, it would be worthy of less praise than that he owes it to his merit, and the love he has most deservedly purchased of all men: nor is it rationally to be feared that he who is so much beforehand in his private, should be in arrear in his public, capacity. Wherefore, my lord's tenderness throughout his speech arising from no other principle than his solicitude lest the agrarian should be hurtful to his country, it is no less than my duty to give the best satisfaction I am able to so good a patriot, taking every one of his doubts in the order proposed. And,

"First, whereas my lord, upon observation of the modern commonwealths, is of opinion that an agrarian is not necessary: it must be confessed that at the first sight of them there is some appearance favoring his assertion, but upon accidents of no precedent to us. For the commonwealths of Switzerland and Holland, I mean of those leagues, being situated in

countries not alluring the inhabitants to wantonness, but obliging them to universal industry, have an implicit agrarian in the nature of them: and being not obnoxious to a growing nobility (which, as long as their former monarchies had spread the wing over them, could either not at all be hatched, or was soon broken) are of no example to us, whose experience in this point has been to the contrary. But what if even in these governments there be indeed an explicit agrarian? For when the law commands an equal or near equal distribution of a man's estate in land among his children, as it is done in those countries, a nobility cannot grow; and so there needs no agrarian, or rather there is one. And for the growth of the nobility in Venice (if so it be, for Machiavel observes in that republic, as a cause of it, a great mediocrity of estates) it is not a point that she is to fear, but might study, seeing she consists of nothing else but nobility; by which, whatever their estates suck from the people, especially if it comes equally, is digested into the better blood of that commonwealth, which is all, or the greatest, benefit they can have by accumulation. For how unequal soever you will have them to be in their incomes, they have officers of the pomp, to bring them equal in expenses, or at least in the ostentation or show of them. And so unless the advantage of an estate consists more in the measure than in the use of it, the authority of Venice does but enforce our agrarian; nor shall a man evade or elude the prudence of it, by the authority of any other commonwealth.

" For if a commonwealth has been introduced at once, as those of Israel and Lacedæmon, you are certain to find her underlaid with this as the main foundation; nor, if she is obliged more to fortune than prudence, has she raised her head without musing upon this matter, as appears by that of Athens, which through her defect in this point, says Aristotle, introduced her ostracism, as most of the democracies of Greece. But, not to restrain a fundamental of such latitude to any one kind of government, do we not yet see that if there be a sole landlord of a vast territory, he is the Turk? that if a few landlords overbalance a populous country, they have store of servants? that if a people be in an equal balance, they can have no lords? that no government can otherwise be erected, than upon some one of these foundations? that no one of these foundations (each being else apt to change into some other) can give any security to the government, unless it be fixed? that through the want of this fixation, potent monarchy and commonwealths have fallen upon the heads of the people, and accompanied their own sad ruins with vast effusions of innocent blood? Let the fame, as was the merit of the ancient

nobility of this nation, be equal to or above what has been already said, or can be spoken, yet have we seen not only their glory, but that of a throne, the most indulgent to and least invasive for so many ages upon the liberty of a people that the world has known, through the mere want of fixing her foot by a proportionable agrarian upon her proper foundation, to have fallen with such horror as has been a spectacle of astonishment to the whole earth. And were it well argued from one calamity, that we ought not to prevent another? Nor is Aristotle so good a commonwealthsman for deriding the invention of Phaleas as in recollecting himself, where he says that democracies, when a less part of their citizens overtop the rest in wealth, degenerate into oligarchies and principalities; and, which comes nearer to the present purpose, that the greater part of the nobility of Tarentum coming accidentally to be ruined, the government of the few came by consequence to be changed into that of the many.

"These things considered, I cannot see how an agrarian, as to the fixation or security of a government, can be less than necessary. And if a cure be necessary, it excuses not the patient, his disease being otherwise desperate, that it is dangerous; which was the case of Rome, not so stated by Machiavel, where he says, that the strife about the agrarian caused the destruction of that commonwealth. As if when a senator was not rich (as Crassus held) except he could pay an army, that commonwealth could expect nothing but ruin whether in strife about the agrarian, or without it. 'Of late,' says Livy, 'riches have introduced avarice, and voluptuous pleasures abounding have through lust and luxury begot a desire of lasting and destroying all good orders.' If the greatest security of a commonwealth consists in being provided with the proper antidote against this poison, her greatest danger must be from the absence of an agrarian, which is the whole truth of the Roman example. For the Laconic, I shall reserve the further explication of it, as my lord also did, to another place; and first see whether an agrarian proportioned to a popular government be sufficient to keep out monarchy. My lord is for the negative, and fortified by the people of Israel electing a king. To which I say that the action of the people therein expressed is a full answer to the objection of that example; for the monarchy neither grew upon them, nor could, by reason of the agrarian, possibly have invaded them, if they had not pulled it upon themselves by the election of a king. Which being an accident, the like whereof is not to be found in any other people so planted, nor in this till, as it is manifest, they were given up by God to infatuation (for says he

to Samuel, 'They have not rejected thee, but they have rejected me, that I should not reign over them'), has something in it which is apparent, by what went before, to have been besides the course of nature, and by what followed.

"For the King having no other foundation than the calamities of the people, so often beaten by their enemies, that despairing of themselves they were contented with any change, if he had peace as in the days of Solomon, left but a slippery throne to his successor, as appeared by Rehoboam. And the agrarian, notwithstanding the monarchy thus introduced, so faithfully preserved the root of that commonwealth, that it shot forth oftener and by intervals continued longer than any other government, as may be computed from the institutoin of the same by Joshua, 1,465 years before Christ, to the total dissolution of it, which happened in the reign of the emperor Adrian, 135 years after the Incarnation. A people planted upon an equal agrarian, and holding to it, if they part with their liberty, must do it upon good-will, and make but a bad title of their bounty. As to instance yet further in that which is proposed by the present order to this nation, the standard whereof is at £2,000 a year; the whole territory of Oceana being divided by this proportion, amounts to 5,000 lots. So the lands of Oceana being thus distributed, and bound to this distribution, can never fall to fewer than 5,000 proprietors. But 5,000 proprietors so seized will not agree to break the agrarian, for that were to agree to rob one another; nor to bring in a king, because they must maintain him, and can have no benefit by him; nor to exclude the people, because they can have as little by that, and must spoil their militia. So the commonwealth continuing upon the balance proposed, though it should come into 5,000 hands, can never alter, and that it should ever come into 5,000 hands is as improbable as anything in the world that is not altogether impossible.

"My lord's other considerations are more private; as that this order destroys families; which is as if one should lay the ruin of some ancient castle to the herbs which usually grow out of them, the destruction of those families being that indeed which naturally produced this order. For we do not now argue for that which we would have, but for that which we are already possessed of, as would appear if a note were but taken of all such as have at this day above £2,000 a year in Oceana. If my lord should grant (and I will put it with the most) that they who are proprietors in land, exceeding this proportion, exceed not 300, with what brow can the interest of so few be balanced with that of the whole nation? or rather, what interest have they to put in such a balance? they would

live as they had been accustomed to do; who hinders them? they would enjoy their estates; who touches them? they would dispose of what they have according to the interest of their families; it is that which we desire. A man has one son, let him be called; would he enjoy his father's estate? it is his, his son's, and his son's son's after him. A man has five sons, let them be called; would they enjoy their father's estate? It is divided among them; for we have four votes for one in the same family, and therefore this must be the interest of the family, or the family knows not its own interest. If a man shall dispute otherwise, he must draw his arguments from custom and from greatness, which was the interest of the monarchy, not of the family; and we are now a commonwealth. If the monarchy could not bear with such divisions because they tendered to a commonwealth, neither can a commonwealth connive at such accumulations because they tend to a monarchy. If the monarchy might make bold with so many for the good of one, we may make bold with one for the good of so many, nay, for the good of all.

"My lords, it comes into my mind, that which upon occasion of the variety of parties enumerated in our late civil wars, was said by a friend of mine coming home from his travels, about the latter end of these troubles; that he admired how it came to pass, that younger brothers, especially being so many more in number than their elder, did not unite as one man against a tyranny, the like whereof has not been exercised in any other nation. And truly, when I consider that our countrymen are none of the worst-natured, I must confess I marvel much how it comes to pass that we should use our children as we do our puppies—take one, lay it in the lap, feed it with every good bit, and drown five; nay, yet worse, forasmuch as the puppies are once drowned, whereas the children are left perpetually drowning. Really, my lords, it is a flinty custom! and all this for his cruel ambition, that would raise himself a pillar, a golden pillar for his monument, though he has children, his own reviving flesh, and a kind of immortality. And this is that interest of a family, for which we are to think ill of a government that will not endure it. But quiet ourselves; the land through which the river Nilus wanders in one stream, is barren; but where it parts into seven, it multiplies its fertile shores by distributing, yet keeping and improving, such a propriety and nutrition, as is a prudent agrarian to a well-ordered commonwealth.

"Nor (to come to the fifth assertion) is a political body rendered any fitter for industry by having one gouty and another withered leg, than a natural. It tends not to the improve-

ment of merchandise that there be some who have no need of their trading, and others that are not able to follow it. If confinement discourages industry, an estate in money is not confined, and lest industry should want whereupon to work, land is not engrossed or entailed upon any man, but remains at its devotion. I wonder whence the computation can arise, that this should discourage industry. Two thousand pounds a year a man may enjoy in Oceana, as much in Panopea, £500 in Marpesia; there be other plantations, and the commonwealth will have more. Who knows how far the arms of our agrarian may extend themselves? and whether he that might have left a pillar, may not leave a temple of many pillars to his more pious memory? Where there is some measure in riches, a man may be rich, but if you will have them to be infinite, there will be no end of starving himself, and wanting what he has: and what pains does such a one take to be poor! Furthermore, if a man shall think that there may be an industry less greasy or more noble, and so cast his thoughts upon the commonwealth, he will have leisure for her, and she riches and honors for him; his sweat shall smell like Alexander's. My Lord Philautus is a young man who, enjoying his £10,000 a year, may keep a noble house in the old way, and have homely guests; and having but two, by the means proposed, may take the upper hand of his great ancestors; with reverence to whom, I may say, there has not been one of them would have disputed his place with a Roman consul.

"My lord, do not break my heart; the nobility shall go to no other ploughs than those which we call our consuls. But, says he, it having been so with Lacedæmon, that neither the city nor the citizens were capable of increase, a blow was given by that agrarian, which ruined both. And what are we concerned with that agrarian, or that blow, while our citizens and our city (and that by our agrarian) are both capable of increase? The Spartan, if he made a conquest, had no citizens to hold it; the Oceaner will have enow. The Spartan could have no trade; the Oceaner may have all. The agrarian in Laconia, that it might bind on knapsacks, forbidding all other arts but that of war, could not make an army of above 30,000 citizens. The agrarian in Oceana, without interruption of traffic, provides us in the fifth part of the youth an annual source or fresh spring of 100,000, besides our provincial auxiliaries, out of which to draw marching armies; and as many elders, not feeble, but men most of them in the flower of their age, and in arms for the defence of our territories. The agrarian in Laconia banished money, this multiplies it; that allowed a matter of twenty or thirty acres to a man, this 2,000 or 3,000;

there is no comparison between them. And yet I differ so much from my lord, or his opinion that the agrarian was the ruin of Lacedæmon, that I hold it no less than demonstrable to have been her main support. For if, banishing all other diversions, it could not make an army of above 30,000, then, letting in all other diversions, it must have broken that army. Wherefore Lysander, bringing in the golden spoils of Athens, irrevocably ruined that commonwealth; and is a warning to us, that in giving encouragement to industry, we also remember that covetousness is the root of all evil. And our agrarian can never be the cause of those seditions threatened by my lord, but is the proper cure of them, as Lucan notes well in the state of Rome before the civil wars, which happened through the want of such an antidote.

" Why then are we mistaken, as if we intended not equal advantages in our commonwealth to either sex, because we would not have women's fortunes consist in that metal which exposes them to cutpurses? If a man cuts my purse I may have him by the heels or by the neck for it; whereas a man may cut a woman's purse, and have her for his pains in fetters. How brutish, and much more than brutish, is that commonwealth which prefers the earth before the fruits of the womb? If the people be her treasure, the staff by which she is sustained and comforted, with what justice can she suffer them, by whom she is most enriched, to be for that cause the most impoverished? And yet we see the gifts of God, and the bounties of heaven in fruitful families, through this wretched custom of marrying for money, become their insupportable grief and poverty. Nor falls this so heavy upon the lower sort, being better able to shift for themselves, as upon the nobility or gentry. For what avails it in this case, from whence their veins have derived their blood; while they shall see the tallow of a chandler sooner converted into that beauty which is required in a bride? I appeal, whether my Lord Philautus or myself be the advocate of nobility; against which, in the case proposed by me, there would be nothing to hold the balance. And why is a woman, if she may have but £1,500, undone? If she be unmarried, what nobleman allows his daughter in that case a greater revenue than so much money may command? And if she marry, no nobleman can give his daughter a greater portion than she has. Who is hurt in this case?—nay, who is not benefited? If the agrarian gives us the sweat of our brows without diminution; if it prepares our table; if it makes our cup to overflow; and above all this, in providing for our children, anoints our heads with that oil which takes away the greatest of worldly cares; what man, that is not besotted with a covetousness as vain as endless, can im-

agine such a constitution to be his poverty? Seeing where no woman can be considerable for her portion, no portion will be considerable with a woman; and so his children will not only find better preferments without his brokage, but more freedom of their own affections.

"We are wonderful severe in laws, that they shall not marry without our consent, as if it were care and tenderness over them; but is it not lest we should not have the other £1,000 with this son, or the other £100 a year more in jointure for that daughter? These, when we are crossed in them, are the sins for which we water our couch with tears, but not of penitence. Seeing whereas it is a mischief beyond any that we can do to our enemies, we persist to make nothing of breaking the affection of our children. But there is in this agrarian a homage to pure and spotless love, the consequence whereof I will not give for all your romances. An alderman makes not his daughter a countess till he has given her £20,000, nor a romance a considerable mistress till she be a princess; these are characters of bastard love. But if our agrarian excludes ambition and covetousness, we shall at length have the care of our own breed, in which we have been curious as to our dogs and horses. The marriage-bed will be truly legitimate, and the race of the commonwealth not spurious.

"But (*impar magnanimis ausis, imparque dolori*) I am hurled from all my hopes by my lord's last assertion of impossibility, that the root from whence we imagine these fruits should be planted or thrive in this soil. And why? Because of the mixture of estates and variety of tenures. Nevertheless, there is yet extant in the Exchequer an old survey of the whole nation; wherefore such a thing is not impossible. Now if a new survey were taken at the present rates, and the law made that no man should hold hereafter above so much land as is valued therein at £2,000 a year, it would amount to a good and sufficient agrarian. It is true that there would remain some difficulty in the different kind of rents, and that it is a matter requiring not only more leisure than we have, but an authority which may be better able to bow men to a more general consent than is to be wrought out of them by such as are in our capacity. Wherefore as to the manner, it is necessary that we refer it to the Parliament; but as to the matter, they cannot otherwise fix their government upon the right balance.

"I shall conclude with a few words to some parts of the order, which my lord has omitted. As first to the consequences of the agrarian to be settled in Marpesia, which irreparably breaks the aristocracy of that nation; being of such a nature, as standing, it is not possible that you should govern. For while the people

of that country are little better than the cattle of the nobility, you must not wonder if, according as these can make their markets with foreign princes, you find those to be driven upon your grounds. And if you be so tender, now you have it in your power, as not to hold a hand upon them that may prevent the slaughter which must otherwise ensue in like cases, the blood will lie at your door. But in holding such a hand upon them, you may settle the agrarian; and in settling the agrarian, you give that people not only liberty, but lands; which makes your protection necessary to their security; and their contribution due to your protection, as to their own safety.

"For the agrarian of Panopea, it allowing such proportions of so good land, men that conceive themselves straitened by this in Oceana, will begin there to let themselves forth, where every citizen will in time have his villa. And there is no question, but the improvement of that country by this means must be far greater than it has been in the best of former times.

"I have no more to say, but that in those ancient and heroic ages (when men thought that to be necessary which was virtuous) the nobility of Athens, having the people so much engaged in their debt that there remained no other question among these than which of those should be king, no sooner heard Solon speak than they quitted their debts, and restored the commonwealth; which ever after held a solemn and annual feast called the Sisacthia, or Recision, in memory of that action. Nor is this example the phœnix; for at the institution by Lycurgus, the nobility having estates (as ours here) in the lands of Laconia, upon no other valuable consideration than the commonwealth proposed by him, threw them up to be parcelled by his agrarian. But now when no man is desired to throw up a farthing of his money, or a shovelful of his earth, and that all we can do is but to make a virtue of necessity, we are disputing whether we should have peace or war: for peace you cannot have without some government, nor any government without the proper balance. Wherefore if you will not fix this which you have, the rest is blood, for without blood you can bring in no other."

By these speeches made at the institution of the agrarian you may perceive what were the grounds of it. The next is—

The fourteenth order, "Constituting the ballot of Venice, as it is fitted by several alterations, and appointed to every assembly, to be the constant and only way of giving suffrage in this commonwealth, according to the following scheme."

I shall endeavor by the following figure to demonstrate the manner of the Venetian ballot (a thing as difficult in discourse or writing, as facile in practice) according to the use of it in

Oceana. The whole figure represents the Senate, containing, as to the house or form of sitting, a square and a half; the tribunal at the upper end being ascended by four steps. On the upper-

THE MANNER AND USE OF THE BALLOT

most of these sit the magistrates that constitute the signory of the commonwealth, that is to say, A the strategus; B the orator; C the three commissioners of the great seal; D the three com-

missioners of the Treasury, whereof one, E, exercises for the present the office of a censor at the middle urn, F.

To the two upper steps of the tribunal answer G, G—G, G, the two long benches next the wall on each side of the house; the outwardmost of which are equal in height to the uppermost step, and the innermost equal in height to the next. Of these four benches consists the first seat; as the second seat consists in like manner of those four benches H, H—H, H, which being next the floor, are equal in height to the two nethermost steps of the throne. So the whole house is distributed into two seats, each consisting of four benches.

This distribution causes not only the greater conveniency, as will be shown, to the senators in the exercise of their function at the ballot, but a greater grace to the aspect of the Senate. In the middle of the outward benches stand I, I, the chairs of the censors, those being their ordinary places, though upon occasion of the ballot they descend, and sit where they are shown by K, K at each of the outward urns L, L. Those M, M that sit with their tables, and the bowls N, N before them, upon the half-space or second step of the tribunal from the floor, are the clerks or secretaries of the house. Upon the short seats O, O on the floor (which should have been represented by woolsacks) sit: P, the two tribunes of the horse; Q, the two tribunes of the foot; and R, R—R, R the judges, all which magistrates are assistants, but have no suffrage. This posture of the Senate considered, the ballot is performed as follows:

First, whereas the gold balls are of several suits, and accordingly marked with several letters of the alphabet, a secretary presents a little urn (wherein there is one ball of every suit or mark) to the strategus and the orator; and look what letter the strategus draws, the same and no other is to be used for that time in the middle urn F; the like for the letter drawn by the orator is to be observed for the side urns L, L, that is to say, if the strategus drew a ball with an A, all the gold balls in the middle urn for that day are marked with the letter A; and if the orator drew a B, all the gold balls in the side urn for that day are marked with the letter B, which done immediately before the ballot, and so the letter unknown to the ballotants, they can use no fraud or juggling; otherwise a man might carry a gold ball in his hand, and seem to have drawn it out of an urn. He that draws a gold ball at any urn, delivers it to the censor or assessor of that urn, who views the character, and allows accordingly of his lot.

The strategus and the orator having drawn for the letters, the urns are prepared accordingly by one of the commissioners and the two censors. The preparation of the urns is after this man-

ner. If the Senate be to elect, for example, the list called the tropic of magistrates, which is this:

1. The Lord Strategus;
2. The Lord Orator;
3. The Third Commissioner of the Great Seal;
4. The Third Commissioner of the Treasury;
5. The First Censor;
6. The Second Censor;

this list or schedule consists of six magistracies, and to every magistracy there are to be four competitors; that is, in all four-and-twenty competitors proposed to the house. They that are to propose the competitors are called electors, and no elector can propose above one competitor: wherefore for the proposing of four-and-twenty competitors you must have four-and-twenty electors; and whereas the ballot consists of a lot and of a suffrage, the lot is for no other use than for the designation of electors; and he that draws a gold ball at the middle urn is an elector. Now, as to have four-and-twenty competitors proposed, you must have four-and-twenty electors made, so to have four-and-twenty electors made by lot, you must have four-and-twenty gold balls in the middle urn; and these (because otherwise it would be no lot) mixed with a competent number of blanks, or silver balls. Wherefore to the four-and-twenty gold balls cast six-and-twenty silver ones, and those (reckoning the blanks with the prizes) make fifty balls in the middle urn. This done (because no man can come to the middle urn that has not first drawn a gold ball at one of the side urns) and to be sure that the prizes or gold balls in this urn be all drawn, there must come to it fifty persons; therefore there must be in each of the side urns five-and-twenty gold balls, which in both come to fifty; and to the end that every senator may have his lot, the gold balls in the side urns are to be made up with blanks equal to the number of the ballotants at either urn; for example, the house consisting of 300 senators, there must be in each of the side urns 125 blanks and twenty-five prizes, which come in both the side urns to 300 balls. This is the whole mystery of preparing the urns, which the censors having skill to do accordingly, the rest of the ballot, whether the parties balloting understand it or not must of necessary consequence come right; and they can neither be out, nor fall into any confusion in the exercise of this art.

But the ballot, as I said, is of two parts, lot and suffrage, or the proposition and result. The lot determines who shall propose the competitors; and the result of the Senate, which of the

competitors shall be the magistrates. The whole, to begin with the lot, proceeds in this manner:

The first secretary with an audible voice reads first the list of the magistrates to be chosen for the day, then the oath for fair election, at which the senators hold up their hands; which done, another secretary presents a little urn to the strategus, in which are four balls, each of them having one of these four inscriptions: "First seat at the upper end," "First seat at the lower end," "Second seat at the upper end," "Second seat at the lower end." And look which of them the strategus draws, the secretary pronouncing the inscription with a loud voice, the seat so called comes accordingly to the urns: this in the figure is the second seat at the upper end. The manner of their coming to the side urns is in double files, that being two holes in the cover of each side urn, by which means two may draw at once. The senators therefore S, S—S, S are coming from the upper end of their seats H, H—H, H to the side urns L, L. The senators T, T—T are drawing. The senator V has drawn a gold ball at his side urn, and is going to the middle urn F, where the senator W, having done the like at the other side urn, is already drawing. But the senators X, X—X, X having drawn blanks at their side urns, and thrown them into the bowls Y, Y standing at the feet of the urns, are marching by the lower end into their seats again; the senator *a* having done the like at the middle urn, is also throwing his blank into the bowl *b,* and marching to his seat again: for a man by a prize at a side urn gains no more than right to come to the middle urn, where, if he draws a blank, his fortune at the side urn comes to nothing at all; wherefore he also returns to his place. But the senator *c* has had a prize at the middle urn, where the commissioner, having viewed his ball, and found the mark to be right, he marches up the steps to the seat of the electors, which is the form *d* set across the tribunal, where he places himself, according as he was drawn, with the other electors *e, e, e* drawn before him. These are not to look back, but sit with their faces toward the signory or state, till their number amount to that of the magistrates to be that day chosen, which for the present, as was shown, are six: wherefore six electors being made, they are reckoned according as they were drawn: first, second, third, fourth, fifth, sixth, in their order; and the first six that are chosen are the first order of electors.

The first order of electors being made, are conducted by a secretary, with a copy of the list to be chosen, out of the Senate, and into a committee or council-chamber, being neither suffered by the way, nor in their room (till the ballot be ended), to have conference with any but themselves; wherefore the secretary,

having given them their oath that they shall make election according to the law and their conscience, delivers them the list, and seats himself at the lower end of the table with his pen and paper, while another secretary keeps the door.

By such time as the first order of electors are thus seated, the second order of electors is drawn, who, with a second copy of the same list, are conducted into another committee-chamber, by other secretaries performing the same office with the former.

The like exactly is done by the third and by the fourth orders (or hands, as the Venetians call them) of electors, by which means you have the four-and-twenty electors divided according to the four copies of the same list, by six, into four hands or orders; and every one of these orders names one competitor to every magistracy in the list; that is to say, the first elector names to the first magistracy, the second elector to the second magistracy, and so forth. But though the electors, as has been shown, are chosen by mere lot, yet the competitors by them named are not chosen by any lot, but by the suffrage of the whole order—for example, the first elector in the first order proposes a name to be strategus, which name is balloted by himself and the other five electors; and if the name so balloted attain not to above half the suffrages, it is laid aside, and the first elector names another to the same magistracy; and so in case this also fails, another, till one he has named, whether it be himself, or some other, has attained to above half the suffrages in the affirmative; and the name so attaining to above half the suffrages in the affirmative is written to the first magistracy in the list by the secretary; which being done, the second elector of the first order, names to the second magistracy till one of his nomination be chosen to the same. The like is done by the rest of the electors of the first order, till one competitor be chosen, and written to every magistracy in their list. Now the second, third, and fourth orders of electors doing exactly after the same manner, it comes to pass that one competitor to every magistracy being chosen in each order, there be in all four competitors chosen to every magistracy.

If any controversy arises in an order of electors, one of the censors (these being at this game the groom-porters) is advertised by the secretary, who brings him in, and the electors disputing are bound to acquiesce in his sentence. For which cause it is that the censors do not ballot at the urns; the signory also abstains, lest it should deform the house: wherefore the blanks in the side urns are by so many the fewer. And so much for the lot, which is of the greater art but less consequence, because it concerns proposition only: but all (except the tribunes and the judges, which being but assistants have no suffrage) are to ballot at the result, to which I now come.

The four orders of electors having perfected their lists, the face of the house is changed: for the urns are taken away, and every senator and magistrate is seated in his proper place, saving the electors, who, having given their suffrages already, may not stir out of their chambers till the house have given theirs, and the rest of the ballot be performed; which follows in this manner:

The four lists being presented by the secretaries of each council of electors to the signory, are first read, according to their order, to the house, with an audible voice; and then the competitors are put to the ballot or suffrage of the whole Senate in this manner: A, A named to be strategus in the first order; whereupon eight ballotins, or pages, such as are expressed by the figures f, f, take eight of the boxes represented, though rudely, by the figures g, g, and go four on the one and four on the other side of the house, that is, one to every bench, signifying " A, A named to be the strategus in the first order: " and every magistrate or senator (beginning by the strategus and the orator first) holds up a little pellet of linen, as the box passes, between his finger and his thumb, that men may see he has but one, and then puts it into the same. The box consisting in the inner part of two boxes, being painted on the outside white and green, to distinguish the affirmative from the negative side, is so made that when your hand is in it, no man can see to which of the sides you put the suffrage, nor hear to which it falls, because the pellet being linen, makes no noise. The strategus and the orator having begun, all the rest do the like.

The ballotins having thus gathered the suffrages, bring them before the signory, in whose presence the outward boxes being opened, they take out the inner boxes, whereof the affirmative is white, and the negative green, and pour the white in the bowl N on the right hand, which is white also, and the green into the bowl N on the left, which is also green. These bowls or basins (better represented at the lower end of the figure by h, i) being upon this occasion set before the tables of the secretaries at the upper end N, N, the white on the right hand, and the green on the left, the secretaries on each side number the balls, by which, if they find that the affirmatives amount not to above one-half, they write not the name that was balloted, but if they amount to above one-half, they write it, adding the number of above half the suffrages to which it attained. The first name being written, or laid aside, the next that is put is BB named to be strategus in the second order; the third CC, named to be strategus in the third order; the fourth DD, named to be strategus in the fourth order, and he of these four competitors that has most above half in the affirmative, is the magistrate; or if none of

them attain to above half, the nomination for that magistracy is to be repeated by such new electors as shall be chosen at the next ballot. And so, as is exemplified in the first magistracy, proceeds the ballot of the rest; first in the first, then in the second, and so in the third and fourth orders.

Now whereas it may happen that AA, for example, being named strategus in the first order, may also be named to the same or some one or more other magistracies in one or more of the other orders; his name is first balloted where it is first written, that is to the more worthy magistracy, whereof if he misses, he is balloted as it comes in course for the next, and so for the rest, if he misses of that, as often as he is named.

And because to be named twice, or oftener, whether to the same or some other magistracy, is the stronger recommendation, the note must not fail to be given upon the name, at the proposition in this manner: AA named to be strategus in the first, and in the second order, or AA named to be strategus in the first and the third, in the first and the fourth, etc. But if he be named to the same magistracy in the first, second, third, and fourth orders, he can have no competitor; wherefore attaining to above half the suffrages, he is the magistrate. Or thus: AA named to be strategus in the first, to be censor in the second, to be orator in the third, and to be commissioner of the seal in the fourth order, or the like in more or fewer orders, in which cases if he misses of the first magistracy, he is balloted to the second; if he misses of the second, to the third; and if he misses of the third, to the fourth.

The ballot not finished before sunset, though the election of the magistrates already chosen be good, voids the election of such competitors as being chosen are not yet furnished with magistracies, as if they had never been named (for this is no juggling-box, but an art that must see the sun), and the ballot for the remaining magistracies is to be repeated the next day by new orders of electors, and such competitors as by them shall be elected. And so in the like manner, if of all the names proposed to the same magistracy, no one of them attains to above half the suffrages in the affirmative.

The senatorian ballot of Oceana being thus described, those of the parish, of the hundred, and of the tribe, being so little different, that in this they are all contained, and by this may be easily understood, are yet fully described, and made plain enough before in the fifth, sixth, seventh, eighth, ninth, and tenth orders.

This, therefore, is the general order, whence those branches of the ballot, some whereof you have already seen, are derived; which, with those that follow, were all read and debated in this

place at the institution. When my Lord Epimonus de Garrula, being one of the councillors, and having no further patience (though the rulers were composed by the agent of this commonwealth, residing for that purpose at Venice) than to hear the direction for the parishes, stood up and made way for himself in this manner:

"MAY IT PLEASE YOUR HIGHNESS, MY LORD ARCHON:
"Under correction of Mr. Peregrin, Spy, our very learned agent and intelligencer, I have seen the world a little, Venice, and (as gentlemen are permitted to do) the great Council balloting. And truly I must needs say, that it is for a dumb show the goodliest that I ever beheld with my eyes. You should have some would take it ill, as if the noble Venetians thought themselves too good to speak to strangers, but they observed them not so narrowly. The truth is, they have nothing to say to their acquaintance; or men that are in council sure would have tongues: for a council, and not a word spoken in it, is a contradiction. But there is such a pudder with their marching and countermarching, as, though never a one of them draw a sword, you would think they were training; which till I found that they did it only to entertain strangers, I came from among them as wise as I went thither. But in the Parliament of Oceana you had no balls nor dancing, but sober conversation; a man might know and be known, show his parts, and improve them. And now if you take the advice of this same fellow, you will spoil all with his whimsies. Mr. Speaker—cry you mercy, my Lord Archon, I mean—set the wisest man of your house in the great Council of Venice, and you will not know him from a fool. Whereas nothing is more certain than that flat and dull fellows in the judgment of all such as used to keep company with them before, upon election into our house, have immediately chitted like barley in the vat, where it acquires a new spirit, and flowed forth into language, that I am as confident as I am here, if there were not such as delight to abuse us, is far better than Tully's; or, let anybody but translate one of his orations, and speak it in the house, and see if everybody do not laugh at him.

"This is a great matter, Mr. Speaker; they do not cant it with your book-learning, your orbs, your centres, your prime magnitudes, and your nebulones, things I profess that would make a sober man run stark mad to hear them; while we, who should be considering the honor of our country, and that it goes now or never upon our hand, whether it shall be ridiculous to all the world, are going to nine-holes or trow madam for our business, like your dumb Venetian, whom this same Sir Politic your resident, that never saw him do anything but make faces, would in-

sinuate to you, at this distance, to have the only knack of state. Whereas if you should take the pains, as I have done, to look a little nearer, you would find these same wonderful things to be nothing else but mere natural fopperies, or *capriccios* as they call them in Italian, even of the meanest, of that nation. For, put the case you be travelling in Italy, ask your *contadino*, that is, the next country-fellow you meet, some question, and presently he ballots you an answer with a nod, which is affirmative; or a shake with his head, which is the negative box; or a shrug with his shoulder, which is the *bossolo di non sinceri*. Good! You will admire Sandys for telling you, that *grotta di cane* is a miracle: and I shall be laughed at, for assuring you, that it is nothing else but such a damp (continued by the neighborhood of certain sulphur mines) as through accidental heat does sometimes happen in our coalpits. But ingratitude must not discourage an honest man from doing good. There is not, I say, such a tongue-tied generation under heaven as your Italian, that you should not wonder if he makes signs. But our people must have something in their diurnals; we must ever and anon be telling them our minds; or if we be at it when we raise taxes, like those gentlemen with the finger and the thumb, they will swear that we are cutpurses. Come, I know what I have heard them say, when some men had money that wrought hard enough for it; and do you conceive they will be better pleased when they shall be told that upon like occasions you are at mumchance or stool-ball?

"I do not speak for myself; for though I shall always acknowledge that I got more by one year's sitting in the house than by my three years' travels, it was not of that kind. But I hate that this same Spy, for pretending to have played at billiards with the most serene Commonwealth of Venice, should make such fools of us here, when I know that he must have had his intelligence from some corn-cutter upon the Rialto; for a noble Venetian would be hanged if he should keep such a fellow company. And yet if I do not think he has made you all dote, never trust me, my Lord Archon is sometimes in such strange raptures. Well, good my lord, let me be heard as well as your apple squire. Venice has fresh blood in her cheeks, I must confess, yet she is but an old lady. Nor has he picked her cabinet; these he sends you are none of her receipts, I can assure you; he bought them for a Julio at St. Mark's of a mountebank. She has no other wash, upon my knowledge, for that same envied complexion of hers but her marshes, being a little better scented, saving your presence, than a chamber-pot. My lords, I know what I say, but you will never have done with it, that neither the great Turk, nor any of those little Turks her neighbors, have

been able to spoil her! Why you may as well wonder that weasels do not suck eggs in swans' nests. Do you think that it has lain in the devotion of her beads; which you that have puked so much at popery, are now at length resolved shall consecrate M. Parson, and be dropped by every one of his congregation, while those same whimsical intelligences your surveyors (you will break my heart) give the turn to your *primum mobile!* And so I think they will; for you will find that money is the *primum mobile,* and they will turn you thus out of some £300,000 or £400,000: a pretty sum for urns and balls, for boxes and pills, which these same quacksalvers are to administer to the parishes; and for what disease I marvel! Or how does it work? Out comes a constable, an overseer, and a churchwarden! Mr. Speaker, I am amazed!"

Never was there goose so stuck with lard as my Lord Epimonus's speech with laughter, the Archon having much ado to recover himself in such a manner as might enable him to return these thanks:

"In your whole lives, my lords, were you never entertained with so much ingenuity, my Lord Epimonus having at once mended all the faults of travellers. For, first, whereas they are abominable liars, he has not told you (except some malicious body has misinformed him concerning poor Spy) one syllable of falsehood. And, secondly, whereas they never fail to give the upper hand in all their discourses to foreign nations, still jostling their own into the kennel, he bears an honor to his country that will not dissolve in Cephalonia, nor be corrupted with figs and melons, which I can assure you is an ordinary obligation; and therefore hold it a matter of public concern that we be to no occasion of quenching my lord's affections, nor is there any such great matter between us, but, in my opinion, might be easily reconciled, for though that which my lord gained by sitting in the house, I steadfastly believe, as he can affirm, was got fairly, yet dare I not, nor do I think, that upon consideration he will promise for other gamesters, especially when they were at it so high, as he intimates not only to have been in use, but to be like enough to come about again. Wherefore say I, let them throw with boxes, for unless we will be below the politics of an ordinary, there is no such bar to cogging. It is known to his lordship that our game is most at a throw, and that every cast of our dice is in our suffrages, nor will he deny that partiality in a suffrage is downright cogging.

"Now if the Venetian boxes be the most sovereign of all remedies against this same cogging, is it not a strange thing that

they should be thrown first into the fire by a fair gamester? Men are naturally subject to all kinds of passions; some you have that are not able to withstand the brow of an enemy, and others that make nothing of this, are less proof against that of a friend. So that if your suffrage be barefaced, I dare say you shall not have one fair cast in twenty. But whatever a man's fortune be at the box, he neither knows whom to thank, nor whom to challenge. Wherefore (that my lord may have a charitable opinion of the choice affection which I confess to have, above all other beauties, for that of incomparable Venice) there is in this way of suffrage no less than a demonstration that it is the most pure, and the purity of the suffrage in a popular government is the health, if not the life of it, seeing the soul is not otherwise breathed into the sovereign power than by the suffrage of the people. Wherefore no wonder if Postellus be of opinion that this use of the ball is the very same with that of the bean in Athens, or that others, by the text concerning Eldad and Medad, derive it from the Commonwealth of Israel. There is another thing, though not so material to us, that my lord will excuse me if I be not willing to yield, which is, that Venice subsists only by her situation. It is true that a man in time of war may be more secure from his enemies by being in a citadel, but not from his diseases; wherefore the first cause, if he lives long, is his good constitution, without which his citadel were to little purpose, and it is not otherwise with Venice."

With this speech of the Archon I conclude the proof of the agrarian and the ballot, being the fundamental laws of this commonwealth, and come now from the centre to the circumferences or orbs, whereof some have been already shown; as how the parishes annually pour themselves into the hundreds, the hundreds into the tribes, and the tribes into the galaxies; the annual galaxy of every tribe consisting of two knights and seven deputies, whereof the knights constitute the Senate; the deputies, the prerogative tribe, commonly called the people; and the Senate and people constitute the sovereign power or Parliament of Oceana. Whereof to show what the Parliament is, I must first open the Senate, and then the prerogative tribe.

To begin with the Senate, of which (as a man is differently represented by a picture drawer and by an anatomist) I shall first discover the face or aspect, and then the parts, with the use of them. Every Monday morning in the summer at seven, and in the winter at eight, the great bell in the clock-house at the Pantheon begins, and continues ringing for the space of one hour; in which time the magistrates of the Senate, being attended according to their quality, with a respective number of the

ballotins, doorkeepers, and messengers, and having the ensigns of their magistracies borne before them, as the sword before the strategus, the mace before the orator, a mace with the seal before the commissioners of the chancery, the like with the purse before the commissioners of the treasury, and a silver wand, like those in use with the universities, before each of the censors, being chancellors of the same. These, with the knights, in all 300, assemble in the house or hall of the Senate.

The house or hall of the Senate being situated in the Pantheon or palace of justice, is a room consisting of a square and a half. In the middle of the lower end is the door, at the upper end hangs a rich state overshadowing the greater part of a large throne, or half-pace of two stages; the first ascended by two steps from the floor, and the second about the middle rising two steps higher. Upon this stand two chairs, in that on the right hand sits the strategus, in the other the orator, adorned with scarlet robes, after the fashion that was used by the dukes in the aristocracy. At the right end of the upper stage stand three chairs, in which the three commissioners of the seal are placed; and at the other end sit the three commissioners of the treasury, every one in a robe or habit like that of the earls. Of these magistrates of this upper stage consists the signory. At either end of the lower stage stands a little table, to which the secretaries of the Senate are set with their tufted sleeves in the habit of civil lawyers. To the four steps, whereby the two stages of the throne are ascended, answer four long benches, which successively deriving from every one of the steps, continue their respective height, and extend themselves by the side walls toward the lower end of the house, every bench being divided by numeral characters into the thirty-seven parts or places. Upon the upper benches sit the censors in the robes of barons; the first in the middle of the right hand bench, and the second directly opposite to him on the other side. Upon the rest of the benches sit the knights, who, if they be called to the urns, distributing themselves by the figures, come in equal files, either by the first seat, which consists of the two upper benches on either side; or by the second seat, consisting of the two lower benches on either side, beginning also at the upper or at the lower ends of the same, according to the lot whereby they are called; for which end the benches are open, and ascended at either end with easy stairs and large passages.

The rest of the ballot is conformable to that of the tribe; the censors of the house sitting at the side urn, and the youngest magistrate of the signory at the middle, the urns being placed before the throne, and prepared according to the number of the magistrates to be at that time chosen by the rules already given

to the censors of the tribes. But before the benches of the knights on either side stands one being shorter, and at the upper end of this sit the two tribunes of the horse. At the upper end of the other, the two tribunes of the foot in their arms, the rest of the benches being covered by the judges of the land in their robes. But these magistrates have no suffrage, nor the tribunes, though they derive their presence in the Senate from the Romans, nor the judges, though they derive theirs from the ancient Senate of Oceana. Every Monday this assembly sits of course; at other times, if there be occasion, any magistrate of the house, by giving order for the bell, or by his lictor or ensign-bearer, calls a senate. And every magistrate or knight during his session has the title, place, and honor of a duke, earl, baron, or knight respectively. And every one that has borne the same magistracy by his third session, has his respective place and title during the term of his life, which is all the honor conferred by this commonwealth, except upon the master of the ceremonies, the master of the horse, and the king of the heralds, who are knights by their places. And thus you have the face of the Senate, in which there is scarce any feature that is not Roman or Venetian; nor do the horns of the crescent extend themselves much unlike those of the Sanhedrim, on either hand of the prince, and of the father of that Senate. But upon beauty, in which every man has his fancy, we will not otherwise philosophize than to remember that there is something more than decency in the robe of a judge, that would not be well spared from the bench; and that the gravest magistrate to whom you can commit the sword of justice, will find a quickness in the spurs of honor, which, if they be not laid to virtue, will lay themselves to that which may rout a commonwealth.

To come from the face of the Senate to the constitution and use of the parts: it is contained in the peculiar orders. And the orders which are peculiar to the Senate, are either of election or instruction.

Elections in the Senate are of three sorts: annual, biennial, and extraordinary.

Annual elections are performed by the schedule called the tropic; and the tropic consists of two parts: the one containing the magistrates, and the other the councils to be yearly elected. The schedule or tropic of the magistrates is as follows in—

The fifteenth order, requiring, " That upon every Monday next ensuing the last of March, the knights of the annual galaxies taking their places in the Senate, be called the third region of the same; and that the house having dismissed the first region, and received the third, proceed to election of the magistrates contained in the first part of the tropic, by the ensuing schedule:

The lord strategus, The lord orator, The first censor, The second censor,	Annual magistrates.
The third commissioner of the seal, The third commissioner of the Treasury,	Triennal magistrates.

" The annual magistrates (provided that no one man bears above one of those honors during the term of one session) may be elected out of any region. But the triennial magistrates may not be elected out of any other than the third region only, lest the term of their session expire before that of their honor; and (it being unlawful for a man to bear magistracy any longer than he is thereto qualified by the election of the people) cause a fraction in the rotation of this commonwealth.

" The strategus is first president of the Senate, and general of the army, if it be commanded to march; in which case there shall be a second strategus elected to be first president of the Senate, and general of the second army; and if this also be commanded to march, a third strategus shall be chosen, and so on, as long as the commonwealth sends forth armies.

" The lord orator is the second and more peculiar president of the Senate to whom it appertains to keep the house to orders.

" The censors, whereof the first, by consequence of his election, is chancellor of the University of Clio, and the second of that of Calliope, are presidents of the Council for Religion and magistrates, to whom it belongs to keep the house to the order of the ballot. They are also inquisitors into the ways and means of acquiring magistracy, and have power to punish indirect proceedings in the same, by removing a knight or magistrate out of the house, under appeal to the Senate.

" The commissioners of the seal being three, whereof the third is annually chosen out of the third region, are judges in chancery.

" The commissioners of the Treasury being three, whereof the third is annually chosen out of the third region, are judges in the Exchequer; and every magistrate of this schedule has right to propose to the Senate.

" But the strategus with the six commissioners is the signory of this commonwealth, having right of session and suffrage in every council of the Senate, and power either jointly or severally to propose in all or any of them."

I have little in this order to observe and prove but that the strategus is the same honor both in name and thing that was borne, among others, by Philopemen and Aratus in the Com-

monwealth of the Achæans; the like having been in use also with the Ætolians. The orator, called otherwise the speaker, is, with small alteration, the same that had been of former use in this nation. These two, if you will, may be compared to the consuls in Rome, or the suffetes in Carthage, for their magistracy is scarce different.

The censors derive their power of removing a senator from those of Rome, the government of the ballot from those of Venice, and that of animadversion upon the *ambitus,* or canvass for magistracy, from both.

The signory, with the whole right and use of that magistracy to be hereafter more fully explained, is almost purely Venetian.

The second part of the tropic is directed by—

The sixteenth order, " Whereby the constitution of the councils being four; that is to say, the Council of State, the Council of War, the Council of Religion, and the Council of Trade, is rendered conformable in their revolutions to that of the Senate. As: First, by the annual election of five knights out of the first region of the Senate into the Council of State, consisting of fifteen knights, five in every region. Secondly, by the annual election of three knights out of the third region of the Council of State, to be proposed by the provosts, and elected by that council, into the Council of War, consisting of nine knights, three in every region, not excluded by this election from remaining members also of the Council of State; the four tribunes of the people have right of session and suffrage in the Council of War. Thirdly, by the annual election of four knights out of the third region of the Senate into the Council of Religion, consisting of twelve knights, four in every region; of this council the censors are presidents. Fourthly, by the annual election of four knights out of the third region of the Senate into the Council of Trade, consisting of twelve knights, four in every region. And each region, in every one of these councils thus constituted, shall weekly and interchangeably elect one provost whose magistracy shall continue for one week; nor shall he be re-elected into the same till every knight of that region in the same council has once borne the same magistracy. And the provosts being one in every region, three in every council, and twelve in all, beside their other capacities, shall assemble and be a council, or rather an Academy apart, to certain ends and purposes to be hereafter further explained with those of the rest of the councils."

This order is of no other use than the frame and turn of the councils, and yet of no small one; for in motion consists life, and the motion of a commonwealth will never be current unless it be circular. Men that, like my Lord Epimonus, not enduring the resemblance of this kind of government to orbs and spheres,

fall on physicking and purging it, do no more than is necessary; for if it be not in rotation both as to persons and things, it will be very sick. The people of Rome, as to persons, if they had not been taken up by the wheel of magistracy, had overturned the chariot of the Senate. And those of Lacedæmon, as to things, had not been so quiet when the Senate trashed their business, by encroaching upon the result, if by the institution of the ephors they had not brought it about again. So that if you allow not a commonwealth her rotation, in which consists her equality, you reduce her to a party, and then it is necessary that you be physicians indeed, or rather farriers; for you will have strong patients, and such as must be haltered and cast, or yourselves may need bone-setters. Wherefore the councils of this commonwealth, both in regard of their elections, and, as will be shown, of their affairs, are uniform with the Senate in their revolutions; not as whirlpits to swallow, but to bite, and with the screws of their rotation to hold and turn a business (like the vice of a smith) to the hand of the workman. Without engines of which nature it is not possible for the Senate, much less for the people, to be perfect artificers in a political capacity. But I shall not hold you longer from—

The seventeenth order, " Directing biennial elections, or the constitution of the orb of ambassador-in-ordinary, consisting of four residences, the revolution whereof is performed in eight years, and preserved through the election of one ambassador in two years by the ballot of the Senate to repair to the Court of France, and reside there for the term of two years; and the term of two years being expired, to remove from thence to the Court of Spain, there to continue for the space of two years, and thence to remove to the State of Venice, and after two years' residence in that city to conclude with his residence at Constantinople for a like term of time, and so to return. A knight of the Senate, or a deputy of the prerogative, may not be elected ambassador-in-ordinary, because a knight or deputy so chosen must either lose his session, which would cause an unevenness in the motion of this commonwealth, or accumulate magistracy, which agrees not with equality of the same. Nor may any man be elected into this capacity that is above five-and-thirty years of age, lest the commonwealth lose the charge of his education, by being deprived at his return of the fruit of it, or else enjoy it not long through the defects of nature."

This order is the perspective of the commonwealth, whereby she foresees danger; or the traffic, whereby she receives every two years the return of a statesman enriched with eight years' experience from the prime marts of negotiation in Europe. And so much for the elections in the Senate that are ordinary; such as are extraordinary follow in—

The eighteenth order, "Appointing all elections upon emergent occasions, except that of the dictator, to be made by the scrutiny, or that kind of election whereby a council comes to be a fifth order of 'electors. For example, if there be occasion of an ambassador-extraordinary, the provosts of the Council of State, or any two of them, shall propose to the same, till one competitor be chosen by that council; and the council having chosen a competitor, shall bring his name into the Senate, which in the usual way shall choose four more competitors to the same magistracy; and put them, with the competitor of the council, to the ballot of the house, by which he of the five that is chosen is said to be elected by the scrutiny of the Council of State. A vice-admiral, a polemarch, or field officer, shall be elected after the same manner, by the scrutiny of the Council of War. A judge or sergeant-at-law, by the scrutiny of the commissioners of the seal. A baron, or considerable officer of the Exchequer, by the scrutiny of the commissioners of the Treasury. Men in magistracy, or out of it, are equally capable of election by the scrutiny; but a magistrate or officer elected by the scrutiny to a military employment, if he be neither a knight of the Senate nor a deputy of the prerogative, ought to have his office confirmed by the prerogative, because the militia in a commonwealth, where the people are sovereign, is not lawful to be touched *injussu populi*.

The Romans were so curious that, though their consuls were elected in the centuriate assemblies, they might not touch the militia, except they were confirmed in the parochial assemblies; for a magistrate not receiving his power from the people, takes it from them, and to take away their power is to take away their liberty. As to the election by the scrutiny, it is easily perceived to be Venetian, there being no such way to take in the knowledge, which in all reason must be best in every council of such men as are most fit for their turns, and yet to keep them from the bias of particular affection or interest under that pretence; for the cause why the great Council in Venice scarce ever elects any other than the name that is brought in by the scrutiny, is very probable to be, that they may. . . . This election is the last of those appertaining to the Senate. The councils being chosen by the orders already shown, it remains that we come to those whereby they are instructed; and the orders of instruction to the councils are two: the first for the matter whereupon they are to proceed, and the second for the manner of their proceeding. The matter of the councils is distributed to them by—

The nineteenth order, "Distributing to every council such businesses as are properly to belong to their cognizance, whereof some they shall receive and determine, and others they shall receive, prepare, and introduce into the house: as, first,

"The Council of State is to receive all addresses, intelligences, and letters of negotiation; to give audience to ambassadors sent to, and to draw up instructions for such as shall be sent by, this commonwealth; to receive propositions from, and hold intelligence with, the provincial councils; to consider upon all laws to be enacted, amended, or repealed, and upon all levies of men or money, war or peace, leagues or associations to be made by this commonwealth, so far forth as is conducible to the orderly preparation of the same to be introduced by them into the Senate; provided, that all such affairs, as otherwise appertaining to the Council of State, are, for the good of the commonwealth, to be carried with greater secrecy, be managed by the Council of War, with power to receive and send forth agents, spies, emissaries, intelligencers, frigots, and to manage affairs of that nature, if it be necessary, without communication to the Senate, till such time as it may be had without detriment to the business. But they shall have no power to engage the commonwealth in a war without the consent of the Senate and the people. It appertains also to this council to take charge of the fleet as admiral, and of all storehouses, armories, arsenals, and magazines appertaining to this commonwealth. They shall keep a diligent record of the military expeditions from time to time reported by him that was strategus or general, or one of the polemarchs in that action; or at least so far as the experience of such commanders may tend to the improvement of the military discipline, which they shall digest and introduce into the Senate; and if the Senate shall thereupon frame any article, they shall see that it be observed, in the musters or education of the youth. And whereas the Council of War is the sentinel or scout of this commonwealth, if any person or persons shall go about to introduce debate into any popular assembly of the same, or otherwise to alter the present government, or strike at the root of it, they shall apprehend, or cause to be apprehended, seized, imprisoned, and examine, arraign, acquit, or condemn, and cause to be executed any such person or persons, by their proper power and authority, and without appeal.

The Council of Religion, as the arbiter of this commonwealth in cases of conscience more peculiarly appertaining to religion, Christian charity, and a pious life, shall have the care of the national religion, and the protection of the liberty of conscience with the cognizance of all causes relating to either of them. And first as to the national religion: they shall cause all places or preferments of the best revenue in either of the universities to be conferred upon no other than such of the most learned and pious men as have dedicated themselves to the study of theology. They shall also take a special care that, by such augmen-

tations as be or shall hereafter be appointed by the Senate, every benefice in this nation be improved at least to the value of £100 a year. And to the end that there be no interest at all, whereby the divines or teachers of the national religion may be corrupted, or corrupt religion, they shall be capable of no other kind of employment or preferment in this commonwealth. And whereas a directory for the administration of the national religion is to be prepared by this council, they shall in this and other debates of this nature proceed in manner following: a question arising in matter of religion shall be put and stated by the council in writing, which writing the censors shall send by their beadles (being proctors chosen to attend them) each to the university whereof he is chancellor, and the vice-chancellor of the same receiving the writing, shall call a convocation of all the divines of that university being above forty years of age. And the universities, upon a point so proposed, shall have no manner of intelligence or correspondence one with another, till their debates be ended, and they have made return of their answers to the Council of Religion by two or three of their own members, that they may clear their sense, if any doubt should arise, to the council, which done, they shall return, and the council, having received such information, shall proceed according to their own judgments, in the preparation of the whole matter for the Senate: that so the interest of the learned being removed, there may be a right application of reason to Scripture, which is the foundation of the national religion.

" Secondly, this council, as to the protection of the liberty of conscience, shall suffer no coercive power in the matter of religion to be exercised in this nation; the teachers of the natural religion being no other than such as voluntarily undertake that calling, and their auditors or hearers no other than are also voluntary. Nor shall any gathered congregation be molested or interrupted in their way of worship (being neither Jewish nor idolatrous), but vigilantly and vigorously protected and defended in the enjoyment, practice, and profession of the same. And if there be officers or auditors appointed by any such congregation for the introduction of causes into the Council of Religion, all such causes so introduced shall be received, heard, and determined by the same, with recourse had, if need be, to the Senate.

" Thirdly, every petition addressed to the Senate, except that of a tribe, shall be received, examined, and debated by this council; and such only as they, upon such examination and debate had, shall think fit, may be introduced into the Senate.

" The Council of Trade being the *vena porta* of this nation, shall hereafter receive instructions more at large. For the pres-

ent, their experience, attaining to a right understanding of those trades and mysteries that feed the veins of this commonwealth, and a true distinction of them from those that suck or exhaust the same, they shall acquaint the Senate with the conveniences and inconveniences, to the end that encouragement may be applied to the one, and remedy to the other.

"The Academy of the provosts, being the affability of the commonwealth, shall assemble every day toward the evening in a fair room, having certain withdrawing-rooms thereto belonging; and all sorts of company that will repair thither for conversation or discourse, so it be upon matters of government, news, or intelligence, or to propose anything to the councils, shall be freely and affably received in the outer chamber, and heard in the way of civil conversation, which is to be managed without any other awe or ceremony than is thereto usually appertaining, to the end that every man may be free, and that what is proposed by one, may be argued or discoursed by the rest, except the matter be of secrecy; in which case the provosts, or some of them, shall take such as desire audience into one of the withdrawing-rooms. And the provosts are to give their minds that this academy be so governed, adorned, and preserved, as may be most attractive to men of parts and good affections to the commonwealth, for the excellency of the conversation.

"Furthermore, if any man, not being able or willing to come in person, has any advice to give which he judges may be for the good of the commonwealth, he may write his mind to the Academy of the provosts, in a letter signed or not signed, which letter shall be left with the doorkeeper of the Academy. Nor shall any person delivering such a letter be seized, molested, or detained, though it should prove to be a libel. But the letters so delivered shall be presented to the provosts; and in case they be so many that they cannot well be perused by the provosts themselves, they shall distribute them as they please to be read by the gentlemen of the Academy, who, finding anything in them material, will find matter of discourse; or if they happen upon a business that requires privacy, return it with a note upon it to a provost. And the provosts by the secretaries attending shall cause such notes out of discourses or letters to be taken as they please, to the end that they may propose, as occasion serves, what any two of them shall think fit out of their notes so taken to their respective councils; to the end that not only the ear of the commonwealth be open to all, but that men of such education being in her eye, she may upon emergent elections or occasions be always provided of her choice of fit persons.

"Every council being adorned with a state for the signory, shall be attended by two secretaries, two doorkeepers, and two

messengers-in-ordinary, and have power to command more upon emergencies, as occasion requires. And the Academy shall be attended with two secretaries, two messengers, and two doorkeepers; this with ,the other councils being provided with their further conveniences at the charge of the State.

" But whereas it is incident to commonwealths, upon emergencies requiring extraordinary speed or secrecy, either through their natural delays or unnatural haste, to incur equal danger, while holding to the slow pace of their orders, they come not in time to defend themselves from some sudden blow; or breaking them for the greater speed, they but haste to their own destruction; if the Senate shall at any time make election of nine knights-extraordinary, to be added to the Council of War, as a *juncta* for the term of three months, the Council of War, with the *juncta* so added, is for the term of the same Dictator of Oceana, having power to levy men and money, to make war and peace, as also to enact laws, which shall be good for the space of one year (if they be not sooner repealed by the Senate and the people) and for no longer time, except they be confirmed by the Senate and the people. And the whole administration of the commonwealth for the term of the said three months shall be in the Dictator, provided that the Dictator shall have no power to do anything that tends not to his proper end and institution, but all to the preservation of the commonwealth as it is established, and for the sudden restitution of the same to the natural channel and common course of government. And all acts, orders, decrees, or laws of the Council of War with the *junota* being thus created, shall be signed,

" DICTATOR OCEANÆ."

This order of instructions to the councils being (as in a matter of that nature is requisite) very large, I have used my best skill to abbreviate it in such manner as might show no more of it than is necessary to the understanding of the whole, though as to the parts, or further duties of the councils, I have omitted many things of singular use in a commonwealth. But it was discoursed at the council by the Archon in this manner:

" MY LORDS, THE LEGISLATORS:

" Your councils, except the Dictator only, are proper and native springs and sources, you see, which (hanging a few sticks and straws, that, as less considerable, would otherwise be more troublesome, upon the banks of their peculiar channels) derive the full stream of business into the Senate, so pure, and so far from the possibility of being troubled or stained (as will undeniably appear by the course contained in the ensuing order)

with any kind of private interest or partiality, that it shall never be possible for any assembly hearkening to the advice or information of this or that worthy member (either instructed upon his pillow, or while he was making himself ready, or by the petition or ticket which he received at the door) to have half the security in his faith, or advantage by his wisdom; such a Senate or council being, through the uncertainty of the winds, like a wave of the sea. Nor shall it otherwise mend the matter by flowing up into dry ditches, or referring businesses to be better examined by committees, than to go further about with it to less purpose; if it does not ebb back again with the more mud in it. For in a case referred to an occasional committee, of which any member that is desirous may get himself named, and to which nobody will come but either for the sake of his friend or his own interest; it fares little better as to the information of the Senate, than if it had been referred to the parties. Wherefore the Athenians being distributed into four tribes, out of which by equal numbers they annually chose 400 men, called the Senate of the Bean, because the ballot at their election was performed by the use of beans, divided them by fifties into eight parts. And every fifty in their turn, for one-eighth part of the year, was a council apart called the Prytans.

"The Prytans in their distinct council receiving all comers, and giving ear to every man that had anything to propose concerning the commonwealth, had power to debate and prepare all the businesses that were to be introduced into the Senate. The Achæans had ten selected magistrates called the *demiurgs,* constituting a council apart called the *synarchy,* which, with the strategus, prepared all the business that was introduced into their Senate. But both the Senate of the Athenians, and that of the Achæans, would have wondered if a man had told them that they were to receive all comers and discourses, to the end that they might refer them afterward to the Prytans or the synarchy, much less to an occasional committee, exposed to the catch that catch may of the parties interested. And yet Venice in this, as in most of her orders, excels them all by the constitution of her councils, that of the College, and the other of the *Dieci,* or Council of Ten. The course of the College is exactly described in the ensuing order: and for that of the *Dieci,* it so little differs from what it has bestowed upon our Dictator, that I need not make any particular description of it. But to dictatorian power in general, and the use of it (because it must needs be of difficult digestion to such as, puking still at ancient prudence, show themselves to be in the nursery of mother-wit), it is no less than necessary to say something. And, first, in a common-

wealth that is not wrought up, or perfected, this power will be of very frequent, if not continual, use; wherefore it is said more than once, upon defects of the government, in the book of Judges, 'that in those days there was no king in Israel.' Nor has the translator, though for 'no king' he should have said 'no judge,' abused you so much; seeing that the Dictator (and such was the Judge of Israel) or the dictatorian power being in a single person, so little differs from monarchy, which followed in that, that from the same cause there has been no other effect in any commonwealth: as in Rome was manifest by Sylla and Cæsar, who to make themselves absolute or sovereign, had no more to do than to prolong their magistracy; for the dictatorian power was reputed divine, and therefore irresistible.

"Nevertheless, so it is, that without this power, which is so dangerous, and subject to introduce monarchy, a commonwealth cannot be safe from falling into the like dissolution; unless you have an expedient in this case of your own, and bound up by your providence from recoiling. Expedients in some cases you must not only have, but be beholden for them to such whom you must trust at a pinch, when you have not leisure to stand with them for security; which will be a thousand times more dangerous. And there can never be a commonwealth otherwise than by the order in debate wrought up to that perfection; but this necessity must sometimes happen in regard of her natural slowness and openness, and the suddenness of assaults that may be made upon her, as also the secrecy which in some cases may be of absolute necessity to her affairs. Whence Machiavel concludes it positively, that a commonwealth unprovided of such a refuge, must fall to ruin; for her course is either broken by the blow in one of those cases, or by herself, while it startles her out of her orders. And indeed a commonwealth is like a greyhound, which, having once coasted, will never after run fair, but grow slothful; and when it comes to make a common practice of taking nearer ways than its orders, it is dissolved: for the being of a commonwealth consists in its orders. Wherefore at this list you will be exposed to danger, if you have not provided beforehand for the safety of your resort in the like cases: nor is it sufficient that your resort be safe, unless it be as secret and quick; for if it be slow or open, your former inconveniences are not remedied.

"Now for our imitation in this part, there is nothing in experience like that of the Council of Ten in Venice; the benefit whereof would be too long to be shown in the whole piece, and therefore I shall take but a pattern out of Janotti.

In the war, says he, which the Venetians had with Florence in Casentin, the Florentines, finding a necessity in their affairs far from any other inclination in themselves to ask their peace, sent ambassadors about it to Venice, where they were no sooner heard, than the bargain was struck up by the Council of Ten: and everybody admiring (seeing this commonwealth stood upon the higher ground) what should be the reason of such haste, the council upon the return of the ambassadors imparted letters to the Senate, whereby it appeared that the Turks had newly launched a formidable fleet against their State, which, had it been understood by the Florentines, it was well enough known they would have made no peace. Wherefore the service of the Ten was highly applauded by the Senate, and celebrated by the Venetians. Whereby may appear not only in part what use there is of dictatorian power in that government, but that it is assumed at the discretion of that Council; whereas in this of Oceana it is not otherwise intrusted than when the Senate, in the election of nine knights-extraordinary, gives at once the commission, and takes security in a balance, added to the Council of War, though securer before by the tribunes of the people than that of Venice, which yet never incurred jealousy; for if the younger nobility have been often girding at it, that happened not so much through the apprehension of danger in it to the commonwealth, as through the awe of it upon themselves. Wherefore the graver have doubtlessly shown their prudence in the law; whereby the magistracy of these councillors being to last till their successors be created, the council is established."

The instructions of the councils for their matter being shown, it remains that I show the instructions for the manner of their proceeding, as they follow in—

The twentieth order, " Containing the method of debates to be observed by the magistrates and the councils successively in order to a decree of the Senate.

" The magistrates of the signory, as councillors of this commonwealth, shall take into their consideration all matters of state or of government; and, having right to propose in any council, may, any one or more of them, propose what business he or they please in that council to which it most properly belongs. And, that the councils may be held to their duty, the said magistrates are superintendents and inspectors of the same, with right to propose to the Senate.

" The censors have equal power with these magistrates, but in relation to the Council of Religion only.

" Any two of the three provosts in every council may pro-

pose to, and are the more peculiar proposers of, the same council; to the end that there be not only an inspection and superintendency of business in general, but that every work be also committed to a peculiar hand.

"Any one or more of the magistrates, or any two of the provosts respectively having proposed, the council shall debate the business so proposed, to which they of the third region that are willing shall speak first in their order; they of the second, next; and they of the first, last; and the opinions of those that proposed or spoke, as they shall be thought the most considerable by the council, shall be taken by the secretary of the same in writing, and each of them signed with the name of the author.

"The opinions being thus prepared, any magistrate of the signory, the censors, or any two of the provosts of that council, upon this occasion may assemble the Senate.

"The Senate being assembled, the opinions (for example, if they be four) shall be read in their order, that is, according to the order or dignity of the magistrates or councillors by which they were signed. And being read, if any of the council introducing them will speak, they, as best acquainted with the business, shall have precedence; and after them the senators shall speak according to their regions, beginning by the third first, and so continuing till every man that will has spoken; and when the opinions have been sufficiently debated, they shall be put all together to the ballot after this manner:

"Four secretaries, carrying each of them one of the opinions in one hand, with a white box in the other, and each following the other, according to the order of the opinions, shall present his box, naming the author of his opinion to every senator; and one secretary or ballotin with a green box shall follow the four white ones; and one secretary or ballotin with a red box shall follow the green one; and every senator shall put one ball into some one of these six boxes. The suffrage being gathered and opened before the signory, if the red box or non-sincere had above half the suffrages, the opinions shall be all cast out, for the major part of the house is not clear in the business. If no one of the four opinions had above half the suffrages in the affirmative, that which had fewest shall be cast out, and the other three shall be balloted again. If no one of the three had above half, that which had fewest shall be cast out, and the other two shall ballot again. If neither of the two had above half, that which had fewest shall be cast out, and the remaining opinion shall be balloted again. And if the remaining opinion has not above half, it shall also be cast out. But the first of the opinions

that arrives at most above half in the affirmative, is the decree of the Senate. The opinions being all of them cast out by the non-sincere, may be reviewed, if occasion permits, by the council, and brought in again. If they be cast out by the negative, the case being of advice only, the house approves not, and there is an end of it: the case being necessary, and admitting delay, the council is to think again upon the business, and to bring in new opinions; but the case being necessary, and not admitting delay, the Senate immediately electing the *juncta* shall create the Dictator. 'And let the Dictator,' as the Roman saying is, 'take care that the commonwealth receives no harm.'

"This is in case the debate concludes not in a decree. But if a decree be passed, it is either in matter of state or government according to law enacted already, and then it is good without going any further: or it is in matter of law to be enacted, repealed, or amended; and then the decree of the Senate, especially if it be for a war, or for a levy of men or money, is invalid, without the result of the commonwealth, which is in the prerogative tribe, or representative of the people.

"The Senate having prepared a decree to be proposed to the people, shall appoint their proposers; and no other may propose for the Senate to the people but the magistrates of the house; that is to say, the three commissioners of the seal, or any two of them; the three of the Treasury, or any two of them; or the two censors.

"The Senate having appointed their proposers, shall require of the tribunes a muster of the people at a set time and place: and the tribunes or any two of them having mustered the people accordingly, the proposers shall propose the sense or decree of the Senate by clauses to the people. And that which is proposed by the authority of the Senate, and resolved by the command of the people, is the law of Oceana."

To this order, implicitly containing the sum very near of the whole civil part of the commonwealth, my Lord Archon spoke thus in council:

"MY DEAR LORDS:

"There is a saying, that a man must cut his coat according to his cloth. When I consider what God has allowed or furnished to our present work, I am amazed. You would have a popular government; he has weighed it to you in the present balance, as I may say, to a drachm; you have no more to do but to fix it. For the superstructures of such a government they require a good aristocracy: and you have,

or have had a nobility or gentry the best studied, and the best writers, at least next that of Italy, in the whole world; nor have they been inferior, when so exercised, in the leading of armies. But the people are the main body of a commonwealth; show me from the treasuries of the snow (as it is in Job) to the burning zone a people whose shoulder so universally and so exactly fits the corselet. Nevertheless, it were convenient to be well provided with auxiliaries. There is Marpesia, through her fruitfulness, inexhaustible of men, and men through her barrenness not only enured to hardship, but in your arms. It may be said that Venice, excepting only that she takes not in the people, is the most incomparable situation of a commonwealth. You are Venice, taking in your people and your auxiliaries too. My lords, the children of Israel were makers of brick before they were builders of a commonwealth; but our brick is made, our mortar tempered, the cedars of Lebanon are hewed and squared to our hands. Has this been the work of man? Or is it in man to withstand this work? 'Shall he that contends with the Almighty instruct him? He that reproves God, let him answer it.' For our parts, everything is so laid that when we come to have use of it, it is the next at hand; and unless we can conceive that God and nature do anything in vain, there is no more for us to do but to despatch. The piece which we have reached to us in the foregoing orders, is the aristocracy. Athens, as has been shown, was plainly lost through the want of a good aristocracy.

"But the sufficiency of an aristocracy goes demonstrably upon the hand of the nobility or gentry; for that the politics can be mastered without study, or that the people can have leisure to study, is a vain imagination; and what kind of aristocracy divines and lawyers would make, let their incurable running upon their own narrow bias and their perpetual invectives against Machiavel (though in some places justly reprovable, yet the only politician, and incomparable patron of the people) serve for instruction. I will stand no more to the judgment of lawyers and divines in this work, than to that of so many other tradesmen; but if this model chances to wander abroad, I recommend it to the Roman *speculativi* (the most complete gentlemen of this age) for their censure; or with my Lord Epimonus his leave, send 300 or 400 copies to your agent at Venice to be presented to the magistrates there; and when they have considered them, to be proposed to the debate of the Senate, the most competent judges under heaven, who, though they have great affairs, will not refuse to return you the oracle of their ballot. The councillors of

princes I will not trust; they are but journeymen. The wisdom of these later times in princes' affairs (says Verulamius) is rather fine deliveries and shiftings of dangers when they be near, than solid and grounded courses to keep them off. Their councillors do not derive their proceedings from any sound root of government that may contain the demonstration, and assure the success of them, but are expedient-mongers, givers of themselves to help a lame dog over a stile; else how comes it to pass that the fame of Cardinal Richelieu has been like thunder, whereof we hear the noise, but can make no demonstration of the reason? But to return: if neither the people, nor divines and lawyers, can be the aristocracy of a nation, there remains only the nobility; in which style, to avoid further repetition, I shall understand the gentry also, as the French do by the word *noblesse*.

"Now to treat of the nobility in such sort as may be less obnoxious to mistake, it will be convenient, and answerable to the present occasion, that I divide my discourse into four parts:

"The first treating of nobility, and the kinds of it;

"The second, of their capacity of the Senate;

"The third, of the divers kinds of senates:

"The fourth, of the Senate, according to the foregoing orders.

"Nobility may be defined divers ways; for it is either ancient riches, or ancient virtue, or a title conferred by a prince or a commonwealth.

"Nobility of the first kind may be subdivided into two others, such as hold an overbalance in dominion or property to the whole people, or such as hold not an overbalance. In the former case, a nobility (such was the Gothic, of which sufficient has been spoken) is incompatible with popular government; for to popular government it is essential that power should be in the people, but the overbalance of a nobility in dominion draws the power to themselves. Wherefore in this sense it is that Machiavel is to be understood, where he says, that these are pernicious in a commonwealth; and of France, Spain, and Italy, that they are nations which for this cause are the corruption of the world: for otherwise nobility may, according to his definition (which is, 'that they are such as live upon their own revenues in plenty, without engagement either to the tilling of their lands, or other work for their livelihood'), hold an underbalance to the people; in which case they are not only safe, but necessary to the natural mixture of a well-ordered commonwealth.

"For how else can you have a commonwealth that is not

altogether mechanic? or what comparison is there of such commonwealths as are, or come nearest to mechanic—for example, Athens, Switzerland, Holland, to Lacedæmon, Rome, and Venice, plumed with their aristocracies? Your mechanics, till they have first feathered their nests, like the fowls of the air, whose whole employment is to seek their food, are so busied in their private concernments that they have neither leisure to study the public, nor are safely to be trusted with it, because a man is not faithfully embarked in this kind of ship, if he has no share in the freight. But if his share be such as gives him leisure by his private advantage to reflect upon that of the public, what other name is there for this sort of men, being *à leur aise,* but (as Machiavel you see calls them) nobility? Especially when their families come to be su h as are noted for their services done to the commonwealth, and so take into their ancient riches ancient virtue, which is the second definition of nobility, but such a one as is scarce possible in nature without the former. 'For as the baggage,' says Verulamius, 'is to an army, so are riches to virtue; they cannot be spared nor left behind, though they be impediments, such as not only hinder the march, but sometimes through the care of them lose or disturb the victory.' Of this latter sort is the nobility of Oceana; the best of all others because they, having no stamp whence to derive their price, can have it no otherwise than by their intrinsic value. The third definition of nobility, is a title, honor, or distinction from the people, conferred or allowed by the prince or the commonwealth. And this may be two ways, either without any stamp or privilege, as in Oceana; or with such privileges as are inconsiderable, as in Athens after the battle of Platæa, whence the nobility had no right, as such, but to religious offices, or inspection of the public games, to which they were also to be elected by the people; or with privileges, and those considerable ones, as the nobility in Athens before the battle of Platæa, and the patricians in Rome each of which had right, or claimed it, to the Senate and all the magistracies; wherein for some time they only by their stamp were current.

" But to begin higher, and to speak more at large of nobility in their several capacities of the Senate. The phylarchs, or princes of the tribes of Israel, were the most renowned, or, as the Latin, the most noble of the congregation, whereof by hereditary right they had the leading and judging. The patriarchs, or princes of families, according as they declared their pedigrees, had the like right as to their families; but neither in these nor the former was there any hereditary right to the Sanhedrim: though there be little question but the wise

men and understanding, and known among their tribes, which the people took or elected into those or other magistracies, and whom Moses made rulers over them, must have been of these, seeing they could not choose but be the most known among the tribes, and were likeliest by the advantages of education to be the most wise and understanding.

"Solon having found the Athenians neither locally nor genealogically, but by their different ways of life, divided into four tribes—that is, into the soldiery, the tradesmen, the husbandmen, and the goatherds—instituted a new distribution of them, according to the sense or valuation of their estates, into four classes: the first, second, and third consisting of such as were proprietors in land, distinguished by the rate of their freeholds, with that stamp upon them, which making them capable of adding honor to their riches, that is to say, of the Senate, and all the magistracies, excluded the fourth, being the body of the people, and far greater in number than the former three, from all other right, as to those capacities, except the election of these, who by this means became an hereditary aristocracy or senatorian order of nobility. This was that course which came afterward to be the destruction of Rome, and had now ruined Athens. The nobility, according to the inevitable nature of such a one, having laid the plot how to divest the people of the result, and so to draw the whole power of the commonwealth to themselves; which in all likelihood they had done, if the people, coming by mere chance to be victorious in the battle of Platæa, and famous for defending Greece against the Persians, had not returned with such courage as irresistibly broke the classes, to which of old they had borne a white tooth, brought the nobility to equal terms, and the Senate with the magistracies to be common to both; the magistracies by suffrage, and the Senate (which was the mischief of it, as I shall show anon in that constitution) by lot only.

"The Lacedæmonians were in the manner, and for the same cause with the Venetians at this day, no other than a nobility, even according to the definition given of nobility by Machiavel; for they neither exercised any trade, nor labored their lands or lots, which was done by their helots: wherefore some nobility may be far from pernicious in a commonwealth by Machiavel's own testimony, who is an admirer of this, though the servants thereof were more in number than the citizens. To these servants I hold the answer of Lycurgus —when he bade him who asked why he did not admit the people to the government of his commonwealth, to go home and admit his servants to the government of his family—to

relate: for neither were the Lacedæmonians servants, nor, further, capable of the government, unless, whereas the congregation had the result, he should have given them the debate also; every one of these that attained to sixty years of age, and the major vote of the congregation, being equally capable of the Senate.

"The nobility of Rome, and their capacity of the Senate, I have already described by that of Athens before the battle of Platæa, saving only that the Athenian was never eligible into the Senate without the suffrage of the people till the introduction of the lot, but the Roman nobility ever: for the patricians were elected into the Senate by the kings, by the consuls, or the censors, or if a plebeian happened to be conscribed, he and his posterity became patricians. Nor, though the people had many disputes with the nobility, did this ever come in controversy, which, if there had been nothing else, might in my judgment have been enough to overturn that commonwealth.

"The Venetian nobility, but that they are richer, and not military, resemble at all other points the Lacedæmonian, as I have already shown. These Machiavel excepts from his rule, by saying that their estates are rather personal than real, or of any great revenue in land, which comes to our account, and shows that a nobility or party of the nobility, not overbalancing in dominion, is not dangerous, but of necessary use in every commonwealth, provided it be rightly ordered; for if it be so ordered as was that of Rome, though they do not overbalance at the beginning, as they did not there, it will not be long ere they do, as is clear both in reason and experience toward the latter end. That the nobility only be capable of the Senate is there only not dangerous, where there be no other citizens, as in this government and that of Lacedæmon.

"The nobility of Holland and Switzerland, though but few, have privileges not only distinct from the people, but so great that in some sovereignties they have a negative voice; an example which I am far from commending, being such as (if those governments were not cantonized, divided, and subdivided into many petty sovereignties that balance one another, and in which the nobility, except they had a prince at the head of them, can never join to make work) would be the most dangerous that ever was, but the Gothic, of which it favors. For in ancient commonwealths you shall never find a nobility to have had a negative but by the poll, which, the people being far more in number, came to nothing; whereas these have it, be they never so few, by their stamp or order.

"Ours of Oceana have nothing else but their education and

their leisure for the public, furnished by their ease and competent riches: and their intrinsic value, which, according as it comes to hold weight in the judgment or suffrage of the people, is their only way to honor and preferment. Wherefore I would have your lordships to look upon your children as such, who, if they come to shake off some part of their baggage, shall make the more quick and glorious march; for it was nothing else but the baggage, sordidly plundered by the nobility of Rome, that lost the victory of the whole world in the midst of her triumph. · ·

"Having followed the nobility thus close, they bring us, according to their natural course and divers kinds, to the divers constitutions of the Senate.

"That of Israel (as was shown by my right noble Lord Phosphorus de Auge, in the opening of the commonwealth) consisted of seventy elders, elected at first by the people. But whereas they were for life, they ever after (though without any divine precept for it) substituted their successors by ordination, which ceremony was most usually performed by imposition of hands; and by this means a commonwealth of as popular institution as can be found became, as it is accounted by Josephus, aristocratical. From this ordination derives that which was introduced by the Apostles into the Christian Church; for which cause I think it is that the Presbyterians would have the government of the Church to be aristocratical, though the Apostles, to the end, as I conceive, that they might give no occasion to such a mistake, but show that they intended the government of the Church to be popular, ordained elders, as has been shown, by the holding up of hands (or free suffrage of the people) in every congregation or *ecclesia:* for that is the word in the original, being borrowed from the civil congregations of the people in Athens and Lacedæmon, which were so called; and the word for holding up of hands in the text is also the very same, which signified the suffrage of the people in Athens, χειροτονήσαντες ; for the suffrage of the Athenians was given *per chirotonian,* says Emmius.

"The Council of the Bean (as was shown by my Lord Navarchus de Paralo in his full discourse), being the proposing Senate of Athens (for that of the Areopagites was a judicatory), consisted of 400, some say 500 senators, elected annually, all at once, and by a mere lot without suffrage. Wherefore though the Senate, to correct the temerity of the lot, had power to cast out such as they should judge unworthy of that honor, this related to manners only, and was not sufficient to repair the commonwealth, which by such means became impotent; and forasmuch as her Senate con-

sisted not of the natural aristocracy, which in a commonwealth is the only spur and rein of the people, it was cast headlong by the rashness of her demagogues or grandees into ruin; while her Senate, like the Roman tribunes (who almost always, instead of governing, were rather governed by the multitude), proposed not to the result only, but to the debate also of the people, who were therefore called to the pulpits, where some vomited, and others drank, poison.

"The Senate of Lacedæmon, most truly discovered by my Lord Laco de Scytale, consisted but of thirty for life, whereof the two kings, having but single votes, were hereditary, the rest elected by the free suffrage of the people, but out of such as were sixty years of age. These had the whole debate of the commonwealth in themselves, and proposed to the result only of the people. And now the riddle which I have heretofore found troublesome to unfold, is out; that is to say, why Athens and Lacedæmon, consisting each of the Senate and the people, the one should be held a democracy, and the other an aristocracy, or laudable oligarchy, as it is termed by Isocrates; for that word is not, wherever you meet it, to be branded, seeing it is used also by Aristotle, Plutarch, and others, sometimes in a good sense. The main difference was that the people in this had the result only, and in that the debate and result, too. But for my part, where the people have the election of the Senate, not bound to a distinct order, and the result, which is the sovereign power, I hold them to have that share in the government (the Senate being not for life) whereof, with the safety of the commonwealth, they are capable in nature, and such a government, for that cause, to be democracy; though I do not deny but in Lacedæmon, the paucity of the senators considered, it might be called oligarchy, in comparison of Athens; or, if we look on their continuance for life, though they had been more, aristocracy.

"The Senate of Rome (whose fame has been heard to thunder in the eloquence of my Lord Dolabella d'Enyo) consisting of 300, was, in regard of the number, less oligarchical than that of Lacedæmon; but more in regard of the patricians, who, having an hereditary capacity of the same, were not elected to that honor by the people; but, being conscribed by the censors, enjoyed it for life. Wherefore these, if they had their wills, would have resolved as well as debated; which set the people at such variance with them as dissolved the commonwealth; whereas if the people had enjoyed the result, that about the agrarian, as well as all other strife, must of necessity have ceased.

"The Senates of Switzerland and Holland (as I have learnt

of my Lords Alpester and Glaucus), being bound up (like the sheaf of arrows which the latter gives) by leagues, lie like those in their quivers; but arrows, when they come to be drawn, fly from this way and from that; and I am contented that these concerned us not.

"That of Venice (by the faithful testimony of my most excellent Lord Linceus de Stella) has obliged a world, sufficiently punished by its own blindness and ingratitude, to repent and be wiser: for whereas a commonwealth in which there is no senate, or where the senate is corrupt, cannot stand, the great Council of Venice, like the statue of Nilus, leans upon an urn or waterpot, which pours forth the Senate in so pure and perpetual a stream, as being unable to stagnate, is forever incapable of corruption. The fuller description of this Senate is contained in that of Oceana; and that of Oceana in the foregoing orders. To every one of which, because something has been already said, I shall not speak in particular. But in general, your Senate, and the other assembly, or the prerogative, as I shall show in due place, are perpetual, not as lakes or puddles, but as the rivers of Eden; and are beds made, as you have seen, to receive the whole people, by a due and faithful vicissitude, into their current. They are not, as in the late way, alternate. Alternate life in government is the alternate death of it.

"This was the Gothic work, whereby the former government (which was not only a ship, but a gust, too) could never open her sails, but in danger to overset herself, neither could make any voyage nor lie safe in her own harbor. The wars of later ages, says Verulamius, seem to be made in the dark, in respect of the glory and honor which reflected on men from the wars in ancient times. Their shipping of this sort was for voyages; ours dare not launch, nor lies it safe at home. Your Gothic politicians seem to me rather to have invented some new ammunition or gunpowder, in their King and Parliament, than government. For what is become of the princes (a kind of people) in Germany?—blown up. Where are the estates, or the power of the people in France?—blown up. Where is that of the people in Arragon, and the rest of the Spanish kingdoms?—blown up. On the other side, where is the King of Spain's power in Holland?—blown up. Where is that of the Austrian princes in Switzerland?—blown up. This perpetual peevishness and jealousy, under the alternate empire of the prince and of the people, are obnoxious to every spark. Nor shall any man show a reason that will be holding in prudence, why the people of Oceana have blown up their King, but that their kings did not first blow up them. The rest is

discourse for ladies. Wherefore your parliaments are not henceforth to come out of the bag of Æolus, but by your galaxies, to be the perpetual food of the fire of Vesta.

" Your galaxies, which divide the house into so many regions, are three; one of which constituting the third region is annually chosen, but for the term of three years; which causes the house (having at once blossoms, fruit half ripe, and others dropping off in full maturity) to resemble an orange-tree, such as is at the same time an education or spring, and a harvest, too; for the people have made a very ill-choice in the man, who is not easily capable of the perfect knowledge in one year of the senatorian orders; which knowledge, allowing him for the first to have been a novice, brings him the second year to practise, and time enough. For at this rate you must always have 200 knowing men in the government. And thus the vicissitude of your senators is not perceivable in the steadiness and perpetuity of your Senate; which, like that of Venice, being always changing, is forever the same. And though other politicians have not so well imitated their pattern, there is nothing more obvious in nature, seeing a man who wears the same flesh but a short time, is nevertheless the same man, and of the same genius; and whence is this but from the constancy of nature, in holding a man to her orders? Wherefore keep also to your orders. But this is a mean request; your orders will be worth little if they do not hold you to them, wherefore embark. They are like a ship, if you be once aboard, you do not carry them, but they you; and see how Venice stands to her tackling: you will no more forsake them than you will leap into the sea.

" But they are very many and difficult. O my Lords, what seaman casts away his card because it has four-and-twenty points of the compass? and yet those are very near as many and as difficult as the orders in the whole circumference of your commonwealth. Consider, how have we been tossed with every wind of doctrine, lost by the glib tongues of your demagogues and grandees in our own havens? A company of fiddlers that have disturbed your rest for your groat; £2,000 to one, £3,000 a year to another, has been nothing. And for what? Is there one of them that yet knows what a commonwealth is? And are you yet afraid of such a government in which these shall not dare to scrape for fear of the statute? Themistocles could not fiddle, but could make of a small city a great commonwealth: these have fiddled, and for your money, till they have brought a great commonwealth to a small city.

" It grieves me, while I consider how, and from what causes, imaginary difficulties will be aggravated, that the foregoing

orders are not capable of any greater clearness in discourse or writing; but if a man should make a book, describing every trick and passage, it would fare no otherwise with a game at cards; and this is no more, if a man plays upon the square. 'There is a great difference,' says Verulamius, 'between a cunning man and a wise man (between a demagogue and a legislator), not only in point of honesty, but in point of ability, as there be that can pack the cards, and yet cannot play well; so there be some that are good in canvasses and fractions, that are otherwise weak men.' Allow me but these orders, and let them come with their cards in their sleeves, or pack if they can. 'Again,' says he, 'it is one thing to understand persons, and another to understand matters; for many are perfect in men's humors that are not greatly capable of the real part of business, which is the constitution of one that has studied men more than books. But there is nothing more hurtful in a State than that cunning men should pass for wise.' His words are an oracle. As Dionysius, when he could no longer exercise his tyranny among men, turned schoolmaster, that he might exercise it among boys. Allow me but these orders, and your grandees, so well skilled in the baits and palates of men, shall turn rat-catchers.

"And whereas 'councils (as is discreetly observed by the same author in his time) are at this day, in most places, but familiar meetings (somewhat like the Academy of our provosts), where matters are rather talked on than debated, and run too swift to order an act of council,' give me my orders, and see if I have not puzzled your demagogues.

"It is not so much my desire to return upon haunts, as theirs that will not be satisfied; wherefore if, notwithstanding what was said of dividing and choosing in our preliminary discourses, men will yet be returning to the question, Why the Senate must be a council apart (though even in Athens, where it was of no other constitution than the popular assembly, the distinction of it from the other was never held less than necessary) this may be added to the former reasons, that if the aristocracy be not for the debate, it is for nothing; but if it be for debate, it must have convenience for it; and what convenience is there for debate in a crowd, where there is nothing but jostling, treading upon one another, and stirring of blood, than which in this case there is nothing more dangerous? Truly, it was not ill said of my Lord Epimonus, that Venice plays her game, as it were, at billiards or nine-holes; and so may your lordships, unless your ribs be so strong that you think better of football: for such sport is debate in a popular assembly, as, notwithstanding the distinction of the Senate, was the destruction of Athens."

This speech concluded the debate which happened at the institution of the Senate. The next assembly is that of the people or prerogative tribe

The face, or mien, of the prerogative tribe for the arms, the horses, and thè discipline, but more especially for the select men, is that of a very noble regiment, or rather of two; the one of horse, divided into three troops (besides that of the provinces, which will be shown hereafter), with their captains, cornets, and two tribunes of the horse at the head of them; the other of foot in three companies (beside that of the provinces), with their captains, ensigns, and two tribunes of the foot at the head of them. (The first troop is called the Phœnix, the second the Pelican, and the third the Swallow. The first company the Cypress, the second the Myrtle, and the third the Spray. Of these again (not without a near resemblance of the Roman division of a tribe) the Phœnix and the Cypress constitute the first class, the Pelican and the Myrtle the second, and the Swallow with the Spray the third, renewed every spring by—

The one-and-twentieth order, "Directing, that upon every Monday next ensuing the last of March, the deputies of the annual galaxy arriving at the pavilion in the halo, and electing one captain and one cornet of the Swallow (triennial officers) by and out of the cavalry at the horse urn, according to the rules contained in the ballot of the hundred; and one captain with one ensign of the Spray (triennial officers) by and out of the infantry at the foot urn, after the same way of balloting, constitute and become the third classes of the prerogative tribe."

Seven deputies are annually returned by every tribe, whereof three are horse and four are foot; and there be fifty tribes: so the Swallow must consist of 150 horse, the Spray of 200 foot. And the rest of the classes being two, each of them in number equal, the whole prerogative (beside the provinces, that is, the knights and deputies of Marpesia and Panopea) must consist of 1,050 deputies. And these troops and companies may as well be called centuries as those of the Romans; for the Romans related not, in so naming theirs, to the number. And whereas they were distributed according to the valuation of their estates, so are these; which, by virtue of the last order, are now accommodated with their triennial officers. But there be others appertaining to this tribe whose election, being of far greater importance, is annual, as follows in

The twenty-second order, "Whereby the first class having elected their triennial officers, and made oath to the old tribunes,

that they will neither introduce, cause, nor to their power suffer debate to be introduced into any popular assembly of this government, but to their utmost be aiding and assisting to seize and deliver any person or persons in that way offending, and striking at the root of this commonwealth, to the Council of War, are to proceed with the other two classes of the prerogative tribe to election of the new tribunes, being four annual magistrates, whereof two are to be elected out of the cavalry at the horse urn, and two out of the infantry at the foot urn, according to the common ballot of the tribes. And they may be promiscuously chosen out of any classes, provided that the same person shall not be capable of bearing the tribunitian honor twice in the term of one galaxy. The tribunes thus chosen shall receive the tribe (in reference to the power of mustering and disciplining the same) as commanders-in-chief, and for the rest as magistrates, whose proper function is prescribed by the next order. The tribunes may give leave to any number of the prerogative, not exceeding 100 at a time, to be absent, so they be not magistrates nor officers, and return within three months. If a magistrate or officer has a necessary occasion, he may also be absent for the space of one month, provided that there be not above three cornets or ensigns, two captains, or one tribune so absent at one time."

To this the Archon spoke at the institution after this manner:

"MY LORDS:
"It is affirmed by Cicero, in his oration for Flaccus, that the commonwealths of Greece were all shaken or ruined by the intemperance of their *Comitia,* or assemblies of the people. The truth is, if good heed in this point be not taken, a commonwealth will have bad legs. But all the world knows he should have excepted Lacedæmon, where the people, as has been shown by the oracle, had no power at all of debate, nor (till after Lysander, whose avarice opened a gulf that was not long ere it swallowed up his country) came it ever to be exercised by them. Whence that commonwealth stood longest and firmest of any other but this, in our days, of Venice; which, having underlaid herself with the like institution, owes a great, if not the greater, part of her steadiness to the same principle; the great Council, which is with her the people, by the authority of my Lord Epimonus, never speaking a word. Nor shall any commonwealth, where the people in their political capacity is talkative, ever see half the days of one of these, but, being carried away by vainglorious men

(that, as Overbury says, void more than they drink), swim down the stream, as did Athens, the most prating of these dames, when that same ranting fellow Alcibiades fell a-demagoguing for the Silician War.

"But whereas debate, by the authority and experience of Lacedæmon and Venice, is not to be committed to the people in a well-ordered government, it may be said that the order specified is but a slight bar in a matter of like danger; for so much as an oath, if there be no recourse upon the breach of it, is a weak tie for such hands as have the sword in them, wherefore what should hinder the people of Oceana, if they happen not to regard an oath from assuming debate, and making themselves as much an anarchy as those of Athens? To which I answer, Take the common sort in a private capacity, and, except they be injured, you shall find them to have a bashfulness in the presence of the better sort, or wiser men, acknowledging their abilities by attention, and accounting it no mean honor to receive respect from them; but if they be injured by them, they hate them, and the more for being wise or great, because that makes it the greater injury. Nor refrain they in this case from any kind of intemperance of speech, if of action. It is no otherwise with a people in their political capacity; you shall never find that they have assumed debate for itself, but for something else. Wherefore in Lacedæmon where there was, and in Venice where there is, nothing else for which they should assume it, they have never shown so much as an inclination to it.

"Nor was there any appearance of such a desire in the people of Rome (who from the time of Romulus had been very well contented with the power of result either in the parochial assemblies, as it was settled upon them by him, or in the meetings of the hundreds, as it was altered in their regard for the worse by Servius Tullius) till news was brought, some fifteen years after the exile of Tarquin, their late King (during which time the Senate had governed pretty well), that he was dead at the Court of Aristodemus the tyrant of Cumæ. Whereupon the patricians, or nobility, began to let out the hitherto dissembled venom which is inherent in the root of oligarchy, and fell immediately upon injuring the people beyond all moderation. For whereas the people had served both gallantly and contentedly in arms upon their own charges, and, though joint purchasers by their swords of the conquered lands, had not participated in the same to above two acres a man (the rest being secretly usurped by the patricians), they, through the meanness of their support and the greatness of their expense, being generally indebted, no sooner returned home with vic-

tory to lay down their arms, than they were snatched up by their creditors, the nobility, to cram jails. Whereupon, but with the greatest modesty that was ever known in the like case, they first fell upon debate, affirming 'That they were oppressed and captivated at home, while abroad they fought for liberty and empire, and that the freedom of the common people was safer in time of war than peace, among their enemies than their fellow-citizens.' It is true that when they could not get the Senate, through fear, as was pretended by the patricians, to assemble and take their grievances into consideration, they grew so much the warmer, that it was glad to meet; where Appius Claudius, a fierce spirit, was of opinion that recourse should be had to consular power, whereby some of the brands of sedition being taken off, the flame might be extinguished. Servilius, being of another temper, thought it better and safer to try if the people might be bowed than broken.

"But this debate was interrupted by tumultuous news of the near approach of the Volsci, a case in which the Senate had no recourse but to the people, who, contrary to their former custom upon the like occasions, would not stir a foot, but fell a-laughing, and saying, 'Let them fight that have something to fight for.' The Senate that had purses, and could not sing so well before the thief, being in a great perplexity, found no possible way out of it but to beseech Servilius, one of a genius well known to be popular, that he would accept of the consulship, and make some such use of it as might be helpful to the patrician interest. Servilius, accepting of the offer, and making use of his interest with the people, persuaded them to hope well of the good intention of the fathers, whom it would little beseem to be forced to those things which would lose their grace, and that in view of the enemy, if they came not freely; and withal published an edict, that no man should withhold a citizen of Rome by imprisonment from giving his name (for that was the way, as I shall have opportunity hereafter to show more at large, whereby they drew out their armies), nor to seize or sell any man's goods or children that were in the camp. Whereupon the people with a mighty concourse immediately took arms, marched forth, and (which to them was as easy as to be put into the humor, and that, as appears in this place, was not hard) totally defeated the Volsci first, then the Sabines (for the neighboring nations, hoping to have had a good bargain of the discord in Rome, were up in arms on all sides), and after the Sabines the Aurunci. Whence returning, victorious in three battles they expected no less than that the Senate would have made

good their words, when Appius Claudius, the other Consul, of his innate pride, and that he might frustrate the faith of his colleague, caused the soldiers (who being set at liberty, had behaved themselves with such valor) to be restored at their return to their creditors and their jails.

"Great resort upon this was made by the people to Servilius, showing him their wounds, calling him to witness how they had behaved themselves, and minding him of his promise. Poor Servilius was sorry, but so overawed with the headiness of his colleague, and the obstinacy of the whole faction of the nobility, that, not daring to do anything either way, he lost both parties, the fathers conceiving that he was ambitious, and the people that he was false; while the Consul Claudius, continuing to countenance such as daily seized and imprisoned some of the indebted people, had still new and dangerous controversies with them, insomuch that the commonwealth was torn with horrid division, and the people (because they found it not so safe or so effectual in public) minded nothing but laying their heads together in private conventicles. For this Aulus Virginius and Titus Vetusius, the new Consuls, were reproved by the Senate as slothful, and upbraided with the virtue of Appius Claudius. Whereupon the Consuls having desired the Senate that they might know their pleasure, showed afterward their readiness to obey it, by summoning the people according to command, and requiring names whereby to draw forth an army for diversion, but no man would answer. Report hereof being made to the Senate, the younger sort of the fathers grew so hot with the Consuls that they desired them to abdicate the magistracy, which they had not the courage to defend.

"The Consuls, though they conceived themselves to be roughly handled, made this soft answer: 'Fathers conscript, that you may please to take notice it was foretold some horrid sedition is at hand, we shall only desire that they whose valor in this place is so great, may stand by us to see how we behave ourselves, and then be as resolute in your commands as you will; your fatherhoods may know if we be wanting in the performance.'

"At this some of the hot young noblemen returned with the Consuls to the tribunal, before which the people were yet standing; and the Consuls having generally required names in vain, to put it to something, required the name of one that was in their eye particularly; on whom, when he moved not, they commanded a lictor to lay hands; but the people, thronging about the party summoned, forbade the lictor, who durst not touch him; at which the hotspurs that came with the con-

suls, enraged by the affront, descended from the throne to the aid of the lictor; from whom in so doing they turned the indignation of the people upon themselves with such heat that the Consuls interposing, thought fit, by remitting the assembly, to appease the tumult; in which, nevertheless, there had been nothing but noise. Nor was there less in the Senate, being suddenly rallied upon this occasion, where they that received the repulse, with others whose heads were as addled as their own, fell upon the business as if it had been to be determined by clamor, till the Consuls, upbraiding the Senate that it differed not from the market-place, reduced the house to orders.

"And the fathers, having been consulted accordingly, there were three opinions: Publius Virginius conceived that the consideration to be had upon the matter in question, or aid of the indebted and imprisoned people, was not to be further extended than to such as had engaged upon the promise made by Servilius; Titus Largius, that it was no time to think it enough, if men's merits were acknowledged, while the whole people, sunk under the weight of their debts, could not emerge without some common aid, which to restrain, by putting some into a better condition than others, would rather more inflame the discord than extinguish it; Appius Claudius (still upon the old haunt) would have it that the people were rather wanton than fierce; it was not oppression that necessitated, but their power that invited them to these freaks; the empire of the Consuls since the appeal to the people (whereby a plebeian might ask his fellows if he were a thief) being but a mere scarecrow. 'Go to,' says he, 'let us create the dictator, from whom there is no appeal, and then let me see more of this work, or him that shall forbid my lictor.'

"The advice of Appius was abhorred by many; and to introduce a general recision of debts with Largius, was to violate all faith; that of Virginius, as the most moderate, would have passed best, but that there were private interests, that constant bane of the public, which withstood it. So they concluded with Appius, who also had been dictator, if the Consuls and some of the graver sort had not thought it altogether unseasonable, at a time when the Volsci and the Sabines were up again, to venture so far upon alienation of the people: for which cause Valerius, being descended from the Publicolas, the most popular family, as also in his own person of a mild nature, was rather trusted with so rigid a magistracy. Whence it happened that the people, though they knew well enough against whom the Dictator was created, feared nothing from Valerius; but upon a new promise made to the same effect with that of Servilius, hoped better another time, and throw-

ing away all disputes, gave their names roundly, went out, and, to be brief, came home again as victorious as in the former action, the Dictator entering the city in triumph. Nevertheless, when he came to press the Senate to make good his promise, and do something for the ease of the people, they regarded him no more as to that point than they had done Servilius. Whereupon the Dictator, in disdain to be made a stale, abdicated his magistracy, and went home. Here, then, was a victorious army without a captain, and a Senate pulling it by the beard in their gowns. What is it (if you have read the story, for there is not such another) that must follow? Can any man imagine that such only should be the opportunity upon which this people could run away?

"Alas, poor men, the Æqui and the Volsci and the Sabines were nothing, but the fathers invincible! There they sat, some 300 of them armed all in robes, and thundering with their tongues, without any hopes in the earth to reduce them to any tolerable conditions. Wherefore, not thinking it convenient to abide long so near them, away marches the army, and encamps in the fields. This retreat of the people is called the secession of Mount Aventin, where they lodged, very sad at their condition, but not letting fall so much as a word of murmur against the fathers. The Senate by this time were great lords, had the whole city to themselves; but certain neighbors were upon the way that might come to speak with them, not asking leave of the porter. Wherefore their minds became troubled, and an orator was posted to the people to make as good conditions with them as he could; but, whatever the terms were, to bring them home, and with all speed. And here it was covenanted between the Senate and the people, that these should have magistrates of their own election, called the tribunes, upon which they returned.

"To hold you no longer, the Senate having done this upon necessity, made frequent attempts to retract it again, while the tribunes, on the other side, to defend what they had got, instituted their *Tributa Comitia,* or council of the people; where they came in time, and, as disputes increased, to make laws without the authority of the Senate, called *plebiscita.* Now to conclude in the point at which I drive: such were the steps whereby the people of Rome came to assume debate, nor is it in art or nature to debar a people of the like effect, where there is the like cause. For Romulus, having in the election of his Senate squared out a nobility for the support of a throne, by making that of the patricians a distinct and hereditary order, planted the commonwealth upon two contrary interests or roots, which, shooting forth, in time produced two

commonwealths, the one oligarchical in the nobility, the other a mere anarchy of the people, and ever after caused a perpetual feud and enmity between the Senate and the people, even to death.

"There is not a more noble or useful question in the politics than that which is started by Machiavel, whether means were to be found whereby the enmity that was between the Senate and the people of Rome could have been removed? Nor is there any other in which we, on the present occasion, are so much concerned, particularly in relation to this author; forasmuch as his judgment in the determination of the question standing, our commonwealth falls. And he that will erect a commonwealth against the judgment of Machiavel, is obliged to give such reasons for his enterprise as must not go a-begging. Wherefore to repeat the politician very honestly, but somewhat more briefly, he disputes thus:

"'There be two sorts of commonwealths, the one for preservation, as Lacedæmon and Venice; the other for increase, as Rome.

"'Lacedæmon, being governed by a King and a small Senate, could maintain itself a long time in that condition, because the inhabitants, being few, having put a bar upon the reception of strangers, and living in a strict observation of the laws of Lycurgus, which now had got reputation, and taken away all occasion of tumults, might well continue long in tranquillity. For the laws of Lycurgus introduced a greater equality in estates, and a less equality in honors, whence there was equal poverty; and the plebeians were less ambitious, because the honors or magistracies of the city could extend but to a few and were not communicable to the people, nor did the nobility by using them ill ever give them a desire to participate of the same. This proceeded from the kings, whose principality, being placed in the midst of the nobility, had no greater means whereby to support itself than to shield the people from all injury; whence the people, not fearing empire, desired it not; and so all occasion of enmity between the Senate and the people was taken away. But this union happened especially from two causes: the one that the inhabitants of Lacedæmon being few, could be governed by the few; the other, that, not receiving strangers into their commonwealth, they did not corrupt it, nor increase it to such a proportion as was not governable by the few.

"'Venice has not divided with her plebeians, but all are called gentlemen that be in administration of the government; for which government she is more beholden to chance than the wisdom of her law-makers; for many retiring to those

islands, where that city is now built, from the inundations of barbarians that overwhelmed the Roman Empire, when they were increased to such a number that to live together it was necessary to have laws, they ordained a form of government, whereby assembling often in council upon affairs, and finding their number sufficient for government, they put a bar upon all such as repairing afterward to their city should become inhabitants, excluding them from participation of power. Whence they that were included in the administration had right, and they that were excluded, coming afterward, and being received upon no other conditions to be inhabitants, had no wrong, and therefore had no occasion, nor (being never trusted with arms) any means to be tumultuous. Wherefore this commonwealth might very well maintain itself in tranquillity.

"'These things considered, it is plain that the Roman legislators, to have introduced a quiet state, must have done one of these two things: either shut out strangers, as the Lacedemonians; or, as the Venetians, not allowed the people to bear arms. But they did neither. By which means the people, having power and increase, were in perpetual tumult. Nor is this to be helped in a commonwealth for increase, seeing if Rome had cut off the occasion of her tumults, she must have cut off the means of her increase, and by consequence of her greatness.

"'Wherefore let a legislator consider with himself whether he would make his commonwealth for preservation, in which case she may be free from tumults; or for increase, in which case she must be infested with them.

"'If he makes her for preservation, she may be quiet at home, but will be in danger abroad. First, because her foundation must be narrow, and therefore weak, as that of Lacedæmon, which lay but upon 30,000 citizens; or that of Venice, which lies but upon 3,000. Secondly, such a commonwealth must either be in peace, or war; if she be in peace, the few are soonest effeminated and corrupted and so obnoxious also to faction. If in war, succeeding ill, she is an easy prey; or succeeding well, ruined by increase: a weight which her foundation is not able to bear. For Lacedæmon, when she had made herself mistress upon the matter of all Greece, through a slight accident, the rebellion of Thebes, occasioned by the conspiracy of Pelopidas discovering this infirmity of her nature, the rest of her conquered cities immediately fell off, and in the turn as it were of a hand reduced her from the fullest tide to the lowest ebb of her fortune. And Venice having possessed herself of a great part of Italy by her purse, was no sooner in defence of it put to the trial of arms than she lost all in one battle.

"'Whence I conclude that in the ordination of a commonwealth a legislator is to think upon that which is most honorable, and, laying aside models for preservation, to follow the example of Rome conniving at, and temporizing with, the enmity between the Senate and the people, as a necessary step to the Roman greatness. For that any man should find out a balance that may take in the conveniences and shut out the inconveniences of both, I do not think it possible.' These are the words of the author, though the method be somewhat altered, to the end that I may the better turn them to my purpose.

"My lords, I do not know how you hearken to this sound; but to hear the greatest artist in the modern world giving sentence against our commonwealth is that with which I am nearly concerned. Wherefore, with all honor due to the prince of politicians, let us examine his reasoning with the same liberty which he has asserted to be the right of a free people. But we shall never come up to him, except by taking the business a little lower, we descend from effects to their causes. The causes of commotion in a commonwealth are either external or internal. External are from enemies, from subjects, or from servants. To dispute then what was the cause why Rome was infested by the Italian, or by the servile wars; why the slaves took the capitol; why the Lacedæmonians were near as frequently troubled with their helots as Rome with all those; or why Venice, whose situation is not trusted to the faith of men, has as good or better quarter with them whom she governs, than Rome had with the Latins; were to dispute upon external causes. The question put by Machiavel is of internal causes; whether the enmity that was between the Senate and the people of Rome might have been removed. And to determine otherwise of this question than he does, I must lay down other principles than he has done. To which end I affirm that a commonwealth, internally considered, is either equal or unequal. A commonwealth that is internally equal, has no internal cause of commotion, and therefore can have no such effect but from without. A commonwealth internally unequal has no internal cause of quiet, and therefore can have no such effect but by diversion.

"To prove my assertions, I shall at this time make use of no other than his examples. Lacedæmon was externally unquiet, because she was externally unequal, that is as to her helots; and she was internally at rest, because she was equal in herself, both in root and branch; in the root by her agrarian, and in branch by the Senate, inasmuch as no man was thereto qualified but by election of the people. Which institution of

Lycurgus is mentioned by Aristotle, where he says that rendering his citizens emulous (not careless) of that honor, he assigned to the people the election of the Senate. Wherefore Machiavel in this, as in other places, having his eye upon the division of patrician and plebeian families as they were in Rome, has quite mistaken the orders of this commonwealth, where there was no such thing. Nor did the quiet of it derive from the power of the kings, who were so far from shielding the people from the injury of the nobility, of which there was none in his sense but the Senate, that one declared end of the Senate at the institution was to shield the people from the kings, who from that time had but single votes. Neither did it proceed from the straitness of the Senate, or their keeping the people excluded from the government, that they were quiet, but from the equality of their administration, seeing the Senate (as is plain by the oracle, their fundamental law) had no more than the debate, and the result of the commonwealth belonged to the people.

"Wherefore when Theopompus and Polydorus, Kings of Lacedæmon, would have kept the people excluded from the government by adding to the ancient law this clause, 'If the determination of the people be faulty, it shall be lawful for the Senate to resume the debate,' the people immediately became unquiet, and resumed that debate, which ended not till they had set up their ephors, and caused that magistracy to be confirmed by their kings. 'For when Theopompus first ordained that the *ephori* or overseers should be created at Lacedæmon, to be such a restraint upon the kings there as the tribunes were upon the consuls at Rome, the Queen complained to him, that by this means he transmitted the royal authority greatly diminished to his children: "I leave indeed less," answered he, "but more lasting." And this was excellently said; for that power only is safe which is limited from doing hurt. Theopompus therefore, by confining the kingly power within the bounds of the laws, did recommend it by so much to the people's affection as he removed it from being arbitrary.' By which it may appear that a commonwealth for preservation, if she comes to be unequal, is as obnoxious to enmity between the Senate and the people as a commonwealth for increase; and that the tranquillity of Lacedæmon was derived from no other cause than her equality.

"For Venice, to say that she is quiet because she disarms her subjects, is to forget that Lacedæmon disarmed her helots, and yet could not in their regard be quiet; wherefore if Venice be defended from external causes of commotion, it is first through her situation, in which respect her subjects have no

hope (and this indeed may be attributed to her fortune) ; and, secondly, through her exquisite justice, whence they have no will to invade her. But this can be attributed to no other cause than her prudence, which will appear to be greater, as we look nearer; for the effects that proceed from fortune, if there be any such thing, are like their cause, inconstant. But there never happened to any other commonwealth so undisturbed and constant a tranquillity and peace in herself as are in that of Venice; wherefore this must proceed from some other cause than chance. And we see that as she is of all others the most quiet, so the most equal commonwealth. Her body consists of one order, and her Senate is like a rolling stone, as was said, which never did, nor, while it continues upon that rotation, never shall gather the moss of a divided or ambitious interest, much less such a one as that which grasped the people of Rome in the talons of their own eagles. And if Machiavel, averse from doing this commonwealth right, had considered her orders, as his reader shall easily perceive he never did, he must have been so far from attributing the prudence of them to chance, that he would have touched up his admirable work to that perfection which, as to the civil part, has no pattern in the universal world but this of Venice.

"Rome, secure by her potent and victorious arms from all external causes of commotion, was either beholden for her peace at home to her enemies abroad, or could never rest her head. My lords, you that are parents of a commonwealth, and so freer agents than such as are merely natural, have a care. For, as no man shall show me a commonwealth born straight that ever became crooked, so no man shall show me a commonwealth born crooked that ever became straight. Rome was crooked in her birth, or rather prodigious. Her twins, the patrician and plebeian orders, came, as was shown by the foregoing story, into the world, one body but two heads, or rather two bellies; for, notwithstanding the fable out of Æsop, whereby Menenius Agrippa, the orator that was sent from the Senate to the people at Mount Aventin, showed the fathers to be the belly, and the people to be the arms and the legs (which except that, how slothful soever it might seem, they were nourished, not these only, but the whole body must languish and be dissolved), it is plain that the fathers were a distinct belly; such a one as took the meat indeed out of the people's mouths, but abhorring the agrarian, returned it not in the due and necessary nutrition of a commonwealth. Nevertheless, as the people that live about the cataracts of Nilus are said not to hear the noise, so neither the Roman writers, nor Machiavel the most conversant with them, seem among so many of the tribunitian storms to hear their

natural voice; for though they could not miss of it so far as to attribute them to the strife of the people for participation in magistracy, or, in which Machiavel more particularly joins, to that about the agrarian, this was to take the business short, and the remedy for the disease.

"A people, when they are reduced to misery and despair, become their own politicians, as certain beasts, when they are sick, become their own physicians, and are carried by a natural instinct to the desire of such herbs as are their proper cure; but the people, for the greater part, are beneath the beasts in the use of them. Thus the people of Rome, though in their misery they had recourse by instinct, as it were, to the two main fundamentals of a commonwealth, participation of magistracy and the agrarian, did but taste and spit at them, not (which is necessary in physic) drink down the potion, and in that their healths. For when they had obtained participation of magistracy it was but lamely, not to a full and equal rotation in all elections; nor did they greatly regard it in what they had got. And when they had attained to the agrarian, they neglected it so far as to suffer the law to grow obsolete; but if you do not take the due dose of your medicines (as there be slight tastes which a man may have of philosophy that incline to atheism) it may chance to be poison, there being a like taste of the politics that inclines to confusion; as appears in the institution of the Roman tribunes, by which magistracy and no more the people were so far from attaining to peace, that they in getting but so much, got but heads for an eternal feud; whereas if they had attained in perfection either to the agrarian, they had introduced the equality and calm of Lacedæmon, or to rotation, and they had introduced that of Venice: and so there could have been no more enmity between the Senate and the people of Rome than there was between those orders in Lacedæmon, or is now in Venice. Wherefore Machiavel seems to me, in attributing the peace of Venice more to her luck than her prudence, of the whole stable to have saddled the wrong horse; for though Rome in her military part could beat it better, beyond all comparison, upon the sounding hoof, Venice for the civil part has plainly had the wings of Pegasus.

"The whole question then will come upon this point, whether the people of Rome could have obtained these orders? And first, to say that they could not have obtained them without altering the commonwealth, is no argument; seeing neither could they, without altering the commonwealth, have obtained their tribunes, which nevertheless were obtained. And if a man considers the posture that the people were in when they obtained their tribunes, they might as well, and with as great ease (forasmuch as the reason why the nobility yielded to the tribunes

was no other than that there was no remedy) have obtained anything else. And for experience, it was in the like case that the Lacedæmonians did set up their ephors, and the Athenians, after the battle of Platæa, bowed the Senate (so hard a thing it is for a commonwealth that was born crooked to become straight) as much the other way. Nor, if it be objected that this must have ruined the nobility (and in that deprived the commonwealth of the greatness which she acquired by them), is this opinion holding, but confuted by the sequel of the story, showing plainly that the nobility, through the defect of such orders (that is to say, of rotation and the agrarian), came to eat up the people; and battening themselves in luxury, to be, as Sallust speaks of them, 'a most sluggish and lazy nobility, in whom, besides the name, there was no more than in a statue;' and to bring so mighty a commonwealth, and of so huge a glory, to so deplorable an end. Wherefore means might have been found to remove the enmity that was between the Senate and the people of Rome.

"My lords, if I have argued well, I have given you the comfort and assurance that, notwithstanding the judgment of Machiavel, your commonwealth is both safe and sound; but if I have not argued well, then take the comfort and assurance which he gives you while he is firm, that a legislator is to lay aside all other examples, and follow that of Rome only, conniving and temporizing with the enmity between the Senate and the people as a necessary step to the Roman greatness. Whence it follows that your commonwealth, at the worst, is that which he has given you his word is the best.

"I have held your lordships long, but upon an account of no small importance, which I can now sum up in these few words: where there is a liquorishness in a popular assembly to debate, it proceeds not from the constitution of the people, but of the commonwealth. Now that your commonwealth is of such a constitution as is naturally free from this kind of intemperance, is that which, to make good, I must divide the remainder of my discourse into two parts:

"The first, showing the several constitutions of the assemblies of the people in other commonwealths;

"The second, comparing our assembly of the people with theirs; and showing how it excludes the inconveniences and embraces the conveniences of them all.

"In the beginning of the first part I must take notice, that among the popular errors of our days it is no small one that men imagine the ancient governments of this kind to have consisted for the most part of one city, that is, of one town; whereas by what we have learned of my lords that opened them, it appears that there was not any considerable one of such a constitution but Carthage, till this in our days of Venice.

"For to begin with Israel, it consisted of the twelve tribes, locally spread or quartered throughout the whole territory; and these being called together by trumpets, constituted the Church or assembly of the people. The vastness of this weight, as also the slowness thence unavoidable, became a great cause (as has been shown at large by my Lord Phosphorus) of the breaking that commonwealth; notwithstanding that the Temple, and those religious ceremonies for which the people were at least annually obliged to repair thither, were no small ligament of the tribes, otherwise but slightly tacked together.

"Athens consisted of four tribes, taking in the whole people, both of the city and of the territory; not so gathered by Theseus into one town, as to exclude the country, but to the end that there might be some capital of the commonwealth: though true it be, that the congregation, consisting of the inhabitants within the walls, was sufficient to all intents and purposes, without those of the country. These also being exceeding numerous, became burdensome to themselves and dangerous to the commonwealth; the more for their ill-education, as is observed by Xenophon and Polybius, who compare them to mariners that in a calm are perpetually disputing and swaggering one with another, and never lay their hands to the common tackling or safety till they be all endangered by some storm. Which caused Thucydides, when he saw this people through the purchase of their misery become so much wiser as to reduce their *Comitia* or assemblies to 5,000, to say in his eighth book: 'And now, at least in my time, the Athenians seem to have ordered their State aright, consisting of a moderate tempor both of the few (by which he means the Senate of the Bean) and of the many,' or the 5,000. And he does not only give you his judgment, but the best proof of it; for 'this,' says he, 'was the first thing that, after so many misfortunes past, made the city again to raise her head.' The place I would desire your lordships to note, as the first example that I find, or think is to be found, of a popular assembly by way of representative.

"Lacedæmon consisted of 30,000 citizens dispersed throughout Laconia, one of the greatest provinces in all Greece, and divided, as by some authors is probable, into six tribes. Of the whole body of these, being gathered, consisted the great Church or assembly, which had the legislative power; the little church, gathered sometimes for matters of concern within the city, consisted of the Spartans only. These happened, like that of Venice, to be good constitutions of a congregation, but from an ill-cause the infirmity of a commonwealth, which through her paucity was oligarchical.

" Wherefore, go which way you will, it should seem that

without a representative of the people, your commonwealth, consisting of a whole nation, can never avoid falling either into oligarchy or confusion.

"This was seen by the Romans, whose rustic tribes, extending themselves from the river Arno to the Vulturnus, that is, from Fesulæ or Florence to Capua, invented a way of representative by lots: the tribe upon which the first fell being the prerogative, and some two or three more that had the rest, the *jure vocatæ*. These gave the suffrage of the commonwealth in two meetings; the prerogative at the first assembly, and the *jure vocatæ* at a second.

"Now to make the parallel: all the inconveniences that you have observed in these assemblies are shut out, and all the conveniences taken into your prerogative. For first, it is that for which Athens, shaking off the blame of Xenophon and Polybius, came to deserve the praise of Thucydides, a representative. And, secondly, not, as I suspect in that of Athens, and is past suspicion in this of Rome, by lot, but by suffrage, as was also the late House of Commons, by which means in your prerogatives all the tribes of Oceana are *jure vocatæ*; and if a man shall except against the paucity of the standing number, it is a wheel, which in the revolution of a few years turns every hand that is fit, or fits every hand that it turns to the public work. Moreover, I am deceived if, upon due consideration, it does not fetch your tribes, with greater equality and ease to themselves and to the government, from the frontiers of Marpesia, than Rome ever brought any one of hers out of her *pomæria*, or the nearest parts of her adjoining territories. To this you may add, that whereas a commonwealth, which in regard of the people is not of facility in execution, were sure enough in this nation to be cast off through impatience; your musters and galaxies are given to the people, as milk to babes, whereby when they are brought up through four days' election in a whole year (one at the parish, one at the hundred, and two at the tribe) to their strongest meat, it is of no harder digestion than to give their negative or affirmative as they see cause. There be gallant men among us that laugh at such an appeal or umpire; but I refer it whether you be more inclining to pardon them or me, who I confess have been this day laughing at a sober man, but without meaning him any harm, and that is Petrus Cunæus, where speaking of the nature of the people, he says, 'that taking them apart, they are very simple, but yet in their assemblies they see and know something:' and so runs away without troubling himself with what that something is. Whereas the people, taken apart, are but so many private interests; but if you take them together, they are the public interest.

"The public interest of a commonwealth, as has been shown, is nearest that of mankind, and that of mankind is right reason; but with aristocracy (whose reason or interest, when they are all together, as appeared by the patricians, is but that of a party) it is quite contrary: for as, taken apart, they are far wiser than the people considered in that manner, so, being put together, they are such fools, who by deposing the people, as did those of Rome, will saw off the branch whereupon they sit, or rather destroy the root of their own greatness. Wherefore Machiavel, following Aristotle, and yet going before him, may well assert, 'that the people are wiser and more constant in their resolutions than a prince:' which is the prerogative of popular government for wisdom. And hence it is that the prerogative of your commonwealth, as for wisdom so for power, is in the people, which (though I am not ignorant that the Roman prerogative was so called *à prærogando,* because their suffrage was first asked) gives the denomination to your prerogative tribe."

The elections, whether annual or triennial, being shown by the twenty-second, that which comes in the next place to be considered is—

The twenty-third order, "Showing the power, function, and manner of proceeding of the prerogative tribe.

"The power or function of the prerogative is of two parts: the one of result, in which it is the legislative power; the other of judicature, in which regard it is the highest court, and the last appeal in this commonwealth.

"For the former part (the people by this constitution being not obliged by any law that is not of their own making or confirmation, by the result of the prerogative, their equal representative) it shall not be lawful for the Senate to require obedience from the people, nor for the people to give obedience to the Senate in or by any law that has not been promulgated, or printed and published for the space of six weeks, and afterward proposed by the authority of the Senate to the prerogative tribe, and resolved by the major vote of the same in the affirmative. Nor shall the Senate have any power to levy war, men, or money, otherwise than by the consent of the people so given, or by a law so enacted, except in cases of exigence, in which it is agreed that the power, both of the Senate and the people, shall be in the dictator, so qualified, and for such a term of time, as is according to that constitution already prescribed. While a law is in promulgation, the censors shall animadvert upon the Senate, and the tribunes upon the people, that there be no laying of heads together, no conventicles or canvassing to carry on or oppose anything; but that all may be done in a free and open way.

"For the latter part of the power of the prerogative, or that whereby they are the supreme judicatory of this nation, and of the provinces of the same, the cognizances of crimes against the majesty of the people, such as high treason, as also of peculation, that is, robbery of the treasury, or defraudation of the commonwealth, appertains to this tribe. And if any person or persons, provincials or citizens, shall appeal to the people, it belongs to the prerogative to judge and determine the case; provided that if the appeal be from any court of justice in this nation or the provinces, the appellant shall first deposit £100 in the court from which he appeals, to be forfeited to the same if he be cast in his suit by the people. But the power of the Council of War being the expedition of this commonwealth, and the martial law of the strategus in the field, are those only from which there shall lie no appeal to the people.

"The proceeding of the prerogative in case of a proposition is to be thus ordered: The magistrates, proposing by authority of the Senate, shall rehearse the whole matter, and expound it to the people; which done, they shall put the whole together to the suffrage, with three boxes, the negative, the affirmative, and the non-sincere; and the suffrage being returned to the tribunes, and numbered in the presence of the proposers. If the major vote be in the non-sincere, the proposer shall desist, and the Senate shall resume the debate. If the major vote be in the negative, the proposers shall desist, and the Senate, too. But if the major vote be in the affirmative, then the tribe is clear, and the proposers shall begin and put the whole matter, with the negative and the affirmative (leaving out the non-sincere) by clauses; and the suffrages being taken and numbered by the tribunes in the presence of the proposers, shall be written and reported by the tribunes of the Senate. And that which is proposed by the authority of the Senate, and confirmed by the command of the people, is the law of Oceana.

"The proceeding of the prerogative in a case of judicature is to be thus ordered: The tribunes being auditors of all causes appertaining to the cognizance of the people, shall have notice of the suit or trial, whether of appeal or otherwise, that is to be commenced; and if any one of them shall accept of the same, it appertains to him to introduce it. A cause being introduced, and the people mustered or assembled for the decision of the same, the tribunes are presidents of the court, having power to keep it to orders, and shall be seated upon a scaffold erected in the middle of the tribe. Upon the right hand shall stand a seat or large pulpit assigned to the plaintiff or the accuser; and, upon the left, another for the defendant, each if they please with his counsel. And the tribunes (being attended upon such occasions

with so many ballotins, secretaries, doorkeepers, and messengers of the Senate as shall be requisite) one of them shall turn up a glass of the nature of an hour-glass, but such a one as is to be of an hour and a half's running; which being turned up, the party or counsel on the right hand may begin to speak to the people. If there be papers to be read, or witnesses to be examined, the officer shall lay the glass sideways till the papers be read and the witnesses examined, and then turn it up again; and so long as the glass is running, the party on the right hand has liberty to speak, and no longer. The party on the right hand having had his time, the like shall be done in every respect for the party on the left. And the cause being thus heard, the tribunes shall put the question to the tribe with a white, a black, and a red box (or non-sincere), whether guilty or not guilty. And if the suffrage being taken, the major vote be in the non-sincere, the cause shall be reheard upon the next juridicial day following, and put to the question in the same manner. If the major vote comes the second time in the non-sincere, the cause shall be heard again upon the third day; but at the third hearing the question shall be put without the non-sincere. Upon the first of the three days in which the major vote comes in the white box, the party accused is absolved; and upon the first of them in which it comes in the black box, the party accused is condemned. The party accused being condemned, the tribunes (if the case be criminal) shall put with the white and the black box these questions, or such of them as, regard had to the case, they shall conceive most proper:

1. Whether he shall have a writ of ease;
2. Whether he shall be fined so much or so much;
3. Whether he shall be confiscated;
4. Whether he shall be rendered incapable of magistracy;
5. Whether he shall be banished;
6. Whether he shall be put to death.

"These, or any three of these questions, whether simple or such as shall be thought fitly mixed, being put by the tribunes, that which has most above half the votes in the black box is the sentence of the people, which the troop of the third class is to see executed accordingly.

"But whereas by the constitution of this commonwealth it may appear that neither the propositions of the Senate nor the judicature of the people will be so frequent as to hold the prerogative in continual employment, the Senate, a main part of whose office it is to teach and instruct the people, shall duly (if they have no greater affairs to divert them) cause an oration

to be made to the prerogative by some knight or magistrate of the Senate, to be chosen out of the ablest men, and from time to time appointed by the orator of the house, in the great hall of the Pantheon, while the Parliament resides in the town, or in some grove or sweet place in the field, while the Parliament for the heat of the year shall reside in the country, upon every Tuesday, morning or afternoon.

" And the orator appointed for the time to this office shall first repeat the orders of the commonwealth with all possible brevity; and then, making choice of one or some part of it, discourse thereof to the people. An oration or discourse of this nature, being afterward perused by the Council of State, may as they see cause be printed and published."

The Archon's comment upon the order I find to have been of this sense:

" MY LORDS:

" To crave pardon for a word or two in further explanation of what was read, I shall briefly show how the constitution of this tribe or assembly answers to their function; and how their function, which is of two parts, the former in the result or legislative power, the latter in the supreme judicature of the commonwealth, answers to their constitution. Machiavel has a discourse, where he puts the question, ' Whether the guard of liberty may with more security be committed to the nobility or to the people?' Which doubt of his arises through the want of explaining his terms; for the guard of liberty can signify nothing else but the result of the commonwealth: so that to say that the guard of liberty may be committed to the nobility, is to say that the result may be committed to the Senate, in which case the people signify nothing.

" Now to show it was a mistake to affirm it to have been thus in Lacedæmon, sufficient has been spoken; and whereas he will have it to be so in Venice also: 'They,' says Contarini, 'in whom resides the supreme power of the whole commonwealth, and of the laws, and upon whose orders depends the authority as well of the Senate as of all the other magistrates, is the Great Council.' It is institutively in the Great Council, by the judgment of all that know that commonwealth; though, for the reasons shown, it be sometimes exercised by the Senate. Nor need I run over the commonwealths in this place for the proof of a thing so doubtless, and such as has been already made so apparent, as that the result of each was in the popular part of it. The popular part of yours, or the prerogative tribe, consists of seven deputies (whereof three are of the horse) annually elected

out of every tribe of Oceana; which being fifty, amounts to 150 horse and 200 foot. And the prerogative consisting of three of these lists, consists of 450 horse and 600 foot, besides those of the provinces to be hereafter mentioned; by which means the overbalance in the suffrage remaining to the foot by 150 votes, you have to the support of a true and natural aristocracy the deepest root of a democracy that has been ever planted.

" Wherefore there is nothing in art or nature better qualified for the result than this assembly. It is noted out of Cicero by Machiavel, ' That the people, though they are not so prone to find out truth of themselves as to follow custom or run into error, yet if they be shown truth, they not only acknowledge and embrace it very suddenly, but are the most constant and faithful guardians and conservators of it.' It is your duty and office, whereto you are also qualified by the orders of this commonwealth, to have the people as you have your hawks and greyhounds, in leashes and slips, to range the fields and beat the bushes for them; for they are of a nature that is never good at this sport, but when you spring or start their proper quarry. Think not that they will stand to ask you what it is, or less know it than your hawks and greyhounds do theirs; but presently make such a flight or course, that a huntsman may as well undertake to run with his dogs, or a falconer to fly with his hawk, as an aristocracy at this game to compare with the people. The people of Rome were possesssed of no less a prey than the empire of the world, when the nobility turned tails, and perched among daws upon the tower of monarchy. For though they did not all of them intend the thing, they would none of them endure the remedy, which was the agrarian.

" But the prerogative tribe has not only the result, but is the supreme judicature, and the ultimate appeal in this commonwealth. For the popular government that makes account to be of any standing, must make sure in the first place of the appeal to the people. As an estate in trust becomes a man's own if he be not answerable for it, so the power of a magistracy not accountable to the people, from whom it was received, becoming of private use, the commonwealth loses her liberty. Wherefore the right of supreme judicature in the people (without which there can be no such thing as popular government) is confirmed by the constant practice of all commonwealths; as that of Israel in the cases of Achan, and of the tribe of Benjamin, adjudged by the congregation.

" The *dicasterian*, or court called the *heliaia* in Athens, which (the *comitia* of that commonwealth consisting of the whole people, and so being too numerous to be a judicatory) was constituted sometimes of 500, at others of 1,000, or, according to the

greatness of the cause, of 1,500, elected by the lot out of the whole body of the people, had, with the nine Archons that were presidents, the cognizance of such causes as were of highest importance in that State. The five ephors in Lacedæmon, which were popular magistrates, might question their kings, as appears by the cases of Pausanias, and of Agis, who being upon his trial in this court, was cried to by his mother to appeal to the people, as Plutarch has it in his life. The tribunes of the people of Rome (like, in the nature of their magistracy, and for some time in number, to the ephors, as being, according to Halicarnassus and Plutarch, instituted in imitation of them) had power to summon any man, his magistracy at least being expired (for from the Dictator there lay no appeal) to answer for himself to the people. As in the case of Coriolanus, who was going about to force the people, by withholding corn from them in a famine, to relinquish the magistracy of the tribunes, in that of Spurius Cassius for affecting tyranny, of Marcus Sergius for running away at Veii, of Caius Lucretius for spoiling his province, of Junius Silanus for making war without a command from the people against the Cimbri, with divers others. And the crimes of this nature were called *læsæ majestatis*, or high treason. Examples of such as were arraigned or tried for peculation, or defraudation of the commonwealth, were Marcus Curius for intercepting the money of the Samnites, Salinator for the unequal division of spoils to his soldiers, Marcus Posthumius for cheating the commonwealth by a feigned shipwreck. Causes of these two kinds were of a more public nature; but the like power upon appeals was also exercised by the people in private matters, even during the time of the kings, as in the case of Horatius. Nor is it otherwise with Venice, where the Doge Loredano was sentenced by the great Council, and Antonio Grimani, afterward doge, questioned, for that he, being admiral, had suffered the Turk to take Lepanto in view of his fleet.

" Nevertheless, there lay no appeal from the Roman dictator to the people; which, if there had, might have cost the commonwealth dear, when Spurius Melius, affecting empire, circumvented and debauched the tribunes: whereupon Titus Quintus Cincinnatus was created Dictator, who having chosen Servilius Ahala to be his lieutenant, or *magister equitum,* sent him to apprehend Melius, whom, while he disputed the commands of the Dictator and implored the aid of the people, Ahala cut off upon the place. By which example you may see in what cases the dictator may prevent the blow which is ready sometimes to fall ere the people be aware of the danger. Wherefore there lies no appeal from the *Dieci*, or the Council of Ten, in Venice, to the Great Council, nor from our Council of War to the people. For

the way of proceeding of this tribe, or the ballot, it is, as was once said for all, Venetian.

"This discourse of judicatories whereupon we are fallen, brings us rather naturally than of design from the two general orders of every commonwealth, that is to say, from the debating part, or the Senate, and the resolving part, or the people, to the third, which is the executive part or the magistracy, whereupon I shall have no need to dwell, for the executive magistrates of this commonwealth are the strategus in arms; the signory in their several courts, as the chancery, the exchequer; as also the councils in divers cases within their instructions; the censors as well in their proper magistracy, as in the Council of Religion; the tribunes in the government of the prerogative, and that judicatory; and the judges with their courts; of all which so much is already said or known as may suffice.

"The Tuesday lectures or orations to the people will be of great benefit to the Senate, the prerogative, and the whole nation. To the Senate, because they will not only teach your Senators elocution, but keep the system of the government in their memories. Elocution is of great use to your Senators, for if they do not understand rhetoric (giving it at this time for granted that the art were not otherwise good) and come to treat with, or vindicate the cause of the commonwealth against some other nation that is good at it, the advantage will be subject to remain upon the merit of the art, and not upon the merit of the cause. Furthermore, the genius or soul of this government being in the whole and in every part, they will never be of ability in determination upon any particular, unless at the same time they have an idea of the whole. That this therefore must be, in that regard, of equal benefit to the prerogative, is plain; though these have a greater concernment in it. For this commonwealth is the estate of the people; and a man, you know, though he be virtuous, yet if he does not understand his estate, may run out or be cheated of it. Last of all, the treasures of the politics will by this means be so opened, rifled, and dispersed, that this nation will as soon dote, like the Indians, upon glass beads, as disturb your government with whimsies and freaks of mother-wit, or suffer themselves to be stuttered out of their liberties. There is not any reason why your grandees, your wise men of this age, that laugh out and openly at a commonwealth as the most ridiculous thing, do not appear to be, as in this regard they are, mere idiots, but that the people have not eyes."

There remains no more relating to the Senate and the people than—

The twenty-fourth order, "Whereby it is lawful for the province of Marpesia to have thirty knights of their own election

continually present in the Senate of Oceana, together with sixty deputies of horse, and 120 of foot in the prerogative tribe, endued with equal power (respect had to their quality and number) in the debate and result of this commonwealth, provided that they observe the course or rotation of the same by the annual return of ten knights, twenty deputies of the horse, and forty of the foot. The like in all respects is lawful for Panopea; and the horse of both the provinces amounting to one troop, and the foot to one company, one captain and one cornet of the horse shall be annually chosen by Marpesia, and one captain and one ensign of the foot shall be annually chosen by Panopea."

The orb of the prerogative being thus complete, is not unnaturally compared to that of the moon, either in consideration of the light borrowed from the Senate, as from the sun; or of the ebbs and floods of the people, which are marked by the negative or affirmative of this tribe. And the constitution of the Senate and the people being shown, you have that of the Parliament of Oceana, consisting of the Senate proposing, and of the people resolving, which amounts to an act of Parliament. So the Parliament is the heart, which, consisting of two ventricles, the one greater and replenished with a grosser matter, the other less and full of a purer, sucks in and spouts forth the vital blood of Oceana by a perpetual circulation. Wherefore the life of this government is no more unnatural or obnoxious upon this score to dissolution than that of a man; nor to giddiness than the world; seeing the earth, whether it be itself or the heavens that are in rotation, is so far from being giddy, that it could not subsist without motion. But why should not this government be much rather capable of duration and steadiness by motion? Than which God has ordained no other to the universal commonwealth of mankind: seeing one generation comes and another goes, but the earth remains firm forever; that is, in her proper situation or place, whether she be moved or not moved upon her proper centre. The Senate, the people, and the magistracy, or the Parliament so constituted, as you have seen, is the guardian of this commonwealth, and the husband of such a wife as is elegantly described by Solomon: " She is like the merchant's ships; she brings her food from far. She considers a field, and buys it: with the fruit of her hands she plants a vineyard. She perceives that her merchandise is good. She stretches forth her hands to the poor. She is not afraid of the snow for her household; for all her household are clothed with scarlet. She makes herself coverings of tapestry; her clothing is silk and purple. Her husband is known (by his robes) in the gates, when he sits among the senators of the land." The gates, or inferior courts, were branches, as it were, of the Sanhedrim,

or Senate, of Israel. Nor is our commonwealth a worse housewife, nor has she less regard to her magistrates; as may pear by—

The twenty-fifth order, " That, whereas the public revenue is through the late civil wars dilapidated, the excise, being improved or improvable to the revenue of £1,000,000, be applied, for the space of eleven years to come, to the reparation of the same, and for the present maintenance of the magistrates, knights, deputies, and other officers, who, according to their several dignities and functions, shall annually receive toward the support of the same, as follows:

" The lord strategus marching, is, upon another account, to have field-pay as general.

	PER ANNUM
The lord strategus sitting	£2,000
The lord orator	2,000
The three commissioners of the seal	4,500
The three commissioners of the treasury	4,500
The two censors	3,000
The 290 knights, at £500 a man	145,000
The four ambassadors-in-ordinary	12,000
The Council of War for intelligence	3,000
The master of the ceremonies	500
The master of the horse	500
His substitute	150
The twelve ballotins for their winter liveries	240
For their summer liveries	120
For their board-wages	480
For the keeping of three coaches of state, twenty-four coach-horses, with coachmen and postillions	1,500
For the grooms, and keeping of sixteen great horses for the master of the horse, and for the ballotins whom he is to govern and instruct in the art of riding	480
The twenty secretaries of the Parliament	2,000
The twenty doorkeepers, who are to attend with pole-axes,	
For their coats	200
For their board-wages	1,000
The twenty messengers, which are trumpeters,	
For their coats	200
For their board-wages	1,000
For ornament of the musters of the youth	5,000
Sum	£189,370

" Out of the personal estates of every man, who at his death bequeaths not above forty shillings to the muster of that hundred wherein it lies, shall be levied one per cent. till the solid revenue of the muster of the hundred amounts to £50 per annum for the prizes of the youth.

" The twelve ballotins are to be divided into three regions, according to the course of the Senate; the four of the first region to be elected at the tropic out of such children as the knights

of the same shall offer, not being under eleven years of age, nor above thirteen. And their election shall be made by the lot at an urn set by the sergeant of the house for that purpose in the hall of the Pantheon. The livery of the commonwealth for the fashion or the color may be changed at the election of the strategus according to his fancy. But every knight during his session shall be bound to give to his footman, or some one of his footmen, the livery of the commonwealth.

"The prerogative tribe shall receive as follows:

	BY THE WEEK	
The two tribunes of the horse	£14	0
The two tribunes of the foot	12	0
The three captains of the horse	15	0
The three cornets	9	0
The three captains of the foot	12	0
The three ensigns	7	0
The 442 horse, at £2 a man	884	0
The 592 foot, at £1 10s. a man	888	0
The six trumpeters	7	10
The three drummers	2	5
Sum by the week	£1,850	15
Sum by the year	£96,239	0

The total of the Senate, the people, and the magistracy..£287,459 15

"The dignity of the commonwealth, and aids of the several magistracies and offices thereto belonging, being provided for as aforesaid, the overplus of the excise, with the product of the sum rising, shall be carefully managed by the Senate and the people through the diligence of the officers of the Exchequer, till it amount to £8,000,000, or to the purchase of about £400,000 solid revenue. At which time, the term of eleven years being expired, the excise, except it be otherwise ordered by the Senate and the people, shall be totally remitted and abolished forever."

At this institution the taxes, as will better appear in the Corollary, were abated about one-half, which made the order, when it came to be tasted, to be of good relish with the people in the very beginning; though the advantages then were no ways comparable to the consequences to be hereafter shown. Nevertheless, my Lord Epimonus, who with much ado had been held till now, found it midsummer moon, and broke out of bedlam in this manner:

"MY LORD ARCHON:

"I have a singing in my head like that of a cart-wheel, my brains are upon a rotation; and some are so merry, that a man cannot speak his griefs, but if your high-shod prerogative, and

those same slouching fellows your tribunes, do not take my lord strategus's and my lord orator's heads, and jolt them together under the canopy, then let me be ridiculous to all posterity. For here is a commonwealth, to which if a man should take that of the 'prentices in their ancient administration of justice at Shrovetide, it were an aristocracy. You have set the very rabble with truncheons in their hands, and the gentry of this nation, like cocks with scarlet gills, and the golden combs of their salaries to boot, lest they should not be thrown at.

"Not a night can I sleep for some horrid apparition or other; one while these myrmidons are measuring silks by their quarterstaves, another stuffiing their greasy pouches with my lord high treasurer's jacobuses. For they are above 1,000 in arms to 300, which, their gowns being pulled over their ears, are but in their doublets and hose. But what do I speak of 1,000? There be 2,000 in every tribe, that is, 100,000 in the whole nation, not only in the posture of an army, but in a civil capacity sufficient to give us what laws they please. Now everybody knows that the lower sort of people regard nothing but money; and you say it is the duty of a legislator to presume all men to be wicked: wherefore they must fall upon the richer, as they are an army; or, lest their minds should misgive them in such a villany, you have given them encouragement that they have a nearer way, seeing it may be done every whit as well as by the overbalancing power which they have in elections. There is a fair which is annually kept in the centre of these territories at Kiberton, a town famous for ale, and frequented by good fellows; where there is a solemnity of the pipers and fiddlers of this nation (I know not whether Lacedæmon, where the Senate kept account of the stops of the flutes and of the fiddle-strings of that commonwealth, had any such custom) called the bull-running; and he that catches and holds the bull, is the annual and supreme magistrate of that *comitia* or congregation, called king piper, without whose license it is not lawful for any of those citizens to enjoy the liberty of his calling.; nor is he otherwise legitimately qualified (or *civitate donatus*) to lead apes or bears in any perambulation of the same. Mine host of the Bear, in Kiberton, the father of ale, and patron of good football and cudgel players, has any time since I can remember been grand-chancellor of this order.

"Now, say I, seeing great things arise from small beginnings, what should hinder the people, prone to their own advantage and loving money, from having intelligence conveyed to them by this same king piper and his chancellor, with their loyal subjects the minstrels and bear-wards, masters of ceremonies, to which there is great recourse in their respective per-

ambulations, and which they will commission and instruct, with directions to all the tribes, willing and commanding them, that as they wish their own good, they choose no other into the next *primum mobile* but of the ablest cudgel and football players? Which done as soon as said, your *primum mobile*, consisting of no other stuff, must of necessity be drawn forth into your *nebulones* and your *galimofries;* and so the silken purses of your Senate and prerogative being made of sows' ears, most of them blacksmiths, they will strike while the iron is hot, and beat your estates into hob-nails, mine host of the Bear being strategus, and king piper lord orator. Well, my lords, it might have been otherwise expressed, but this is well enough a-conscience. In your way, the wit of man shall not prevent this or the like inconvenience; but if this (for I have conferred with artists) be a mathematical demonstration, I could kneel to you, that ere it be too late we might return to some kind of sobriety.

"If we empty our purses with these pomps, salaries, coaches, lackeys, and pages, what can the people say less than that we have dressed a Senate and a prerogative for nothing but to go to the park with the ladies?"

My Lord Archon, whose meekness resembled that of Moses, vouchsafed this answer:

"My Lords:

"For all this, I can see my Lord Epimonus every night in the park, and with ladies; nor do I blame this in a young man, or the respect which is and ought to be given to a sex that is one-half of the commonwealth of mankind, and without which the other would be none: but our magistrates, I doubt, may be somewhat of the oldest to perform this part with much acceptation; and, as the Italian proverb says, '*Servire e non gradire è cosa da far morire.*' Wherefore we will lay no certain obligation upon them in this point, but leave them, if it please you, to their own fate or discretion. But this (for I know my Lord Epimonus loves me, though I can never get his esteem) I will say, if he had a mistress should use him so, he would find it a sad life; or I appeal to your lordships, how I can resent it from such a friend, that he puts king piper's politics in the balance with mine. King piper, I deny not, may teach his bears to dance, but they have the worst ear of all creatures. Now how he should make them keep time in fifty several tribes, and that two years together, for else it will be to no purpose, may be a small matter with my lord to promise; but it seems to me of impossible performance. First, through the nature of the bean; and, secondly, through that of the ballot; or how what he has hitherto thought so hard, is now

come to be easy; but he may think that for expedition they will eat up these balls like apples.

" However, there is so much more in their way by the constitution of this, than is to be found in that of any other commonwealth, that I am reconciled, it now appearing plainly that the points of my lord's arrows are directed at no other white than to show the excellency of our government above others; which, as he proceeds further, is yet plainer; while he makes it appear that there can be no other elected by the people but smiths:

"'*Brontesque Steropesque et nudus membra Pyracmon:*'

Othoniel, Aod, Gideon, Jephtha, Samson, as in Israel; Miltiades, Aristides, Themistocles, Cimon, Pericles, as in Athens; Papyrius, Cincinnatus, Camillus, Fabius Scipio, as in Rome: smiths of the fortune of the commonwealth; not such as forged hob-nails, but thunderbolts. Popular elections are of that kind, that all of the rest of the world is not able, either in number or glory, to equal those of these three commonwealths. These indeed were the ablest cudgel and football players; bright arms were their cudgels, and the world was the ball that lay at their feet. Wherefore we are not so to understand the maxim of legislators, which holds all men to be wicked, as if it related to mankind or a commonwealth, the interests whereof are the only straight lines they have whereby to reform the crooked; but as it relates to every man or party, under what color soever he or they pretend to be trusted apart, with or by the whole. Hence then it is derived, which is made good in all experience, that the aristocracy is ravenous, and not the people. Your highwaymen are not such as have trades, or have been brought up to industry; but such commonly whose education has pretended to that of gentlemen. My lord is so honest, he does not know the maxims that are of absolute necessity to the arts of wickedness; for it is most certain, if there be not more purses than thieves, that the thieves themselves must be forced to turn honest, because they cannot thrive by their trade; but now if the people should turn thieves, who sees not that there would be more thieves than purses? wherefore that a whole people should turn robbers or levellers, is as impossible in the end as in the means.

" But that I do not think your artist which you mentioned, whether astronomer or arithmetician, can tell me how many barleycorns would reach to the sun, I could be content he were called to the account, with which I shall conclude this point: when by the way I have chid my lords the legislators, who, as if they doubted my tackling could not hold, would leave me to flag in a perpetual calm, but for my Lord Epimonus, who breathes now

and then into my sails and stirs the waters. A ship makes not her way so briskly as when she is handsomely brushed by the waves, and tumbles over those that seem to tumble against her; in which case I have perceived in the dark that light has been struck even out of the sea, as in this place, where my Lord Epimonus feigning to give us a demonstration of one thing, has given it of another, and of a better. For the people of this nation, if they amount in each tribe to 2,000 elders and 2,000 youths upon the annual roll, holding a fifth to the whole tribe, then the whole of a tribe, not accounting women and children, must amount to 20,000; and so the whole of all the tribes, being fifty, to 1,000,000.

"Now you have 10,000 parishes, and reckoning these one with another, each at £1,000 a year dry-rent, the rent or revenue of the nation, as it is or might be let to farm, amounts to £10,000,000; and £10,000,000 in revenue divided equally to 1,000,000 of men, comes but to £10 a year to each wherewith to maintain himself, his wife and children. But he that has a cow upon the common, and earns his shilling by the day at his labor, has twice as much already as this would come to for his share; because if the land were thus divided, there would be nobody to set him on work. So my Lord Epimonus's footman, who costs him thrice as much as one of these could thus get, would certainly lose by his bargain. What should we speak of those innumerable trades whereupon men live, not only better than others upon good shares of lands, but become also purchasers of greater estates? Is not this the demonstration which my lord meant, that the revenue of industry in a nation, at least in this, is three or four-fold greater than that of the mere rent? If the people then obstruct industry, they obstruct their own livelihood; but if they make a war, they obstruct industry. Take the bread out of the people's mouths, as did the Roman patricians, and you are sure enough of a war, in which case they may be levellers; but our agrarian causes their industry to flow with milk and honey. It will be owned that this is true, if the people were given to understand their own happiness; but where is it they do that? Let me reply with the like question, where do they not? They do not know their happiness it should seem in France, Spain, and Italy; but teach them what it is, and try whose sense is the truer.

"As to the late wars in Germany, it has been affirmed to me there, that the princes could never make the people to take arms while they had bread, and have therefore suffered countries now and then to be wasted that they might get soldiers. This you will find to be the certain pulse and temper of the people; and if they have been already proved to be the most wise and con-

stant order of a government, why should we think (when no man can produce one example of the common soldiery in an army mutinying because they had not captains' pay) that the prerogative should jolt the heads of the Senate together because these have the better salaries, when it must be as evident to the people in a nation, as to the soldiery in an army, that it is no more possible their emoluments of this kind should be afforded by any commonwealth in the world to be made equal with those of the Senate, than that the common soldiers should be equal with the captains? It is enough for the common soldier that his virtue may bring him to be a captain, and more to the prerogative, that each of them is nearer to be a senator.

"If my lord thinks our salaries too great, and that the commonwealth is not housewife enough, whether is it better housewifery that she should keep her family from the snow, or suffer them to burn her house that they may warm themselves? for one of these must be. Do you think that she came off at a cheaper rate when men had their rewards by £1,000 or £2,000 a year in land if inheritance? If you say that they will be more godly than they have been, it may be ill taken; and if you cannot promise that, it is time we find out some way of stinting at least, if not curing them of that same *sacra fames*. On the other side, if a poor man (as such a one may save a city) gives his sweat to the public, with what conscience can you suffer his family in the meantime to starve? but he that lays his hand to this plough shall not lose by taking it off from his own, and a commonwealth that will mend this shall be penny-wise. The Sanhedrim of Israel, being the supreme, and a constant court of judicature, could not choose but be exceeding gainful. The Senate of the Bean in Athens, because it was but annual, was moderately salaried; but that of the Areopagites, being for life, bountifully; and what advantages the senators of Lacedæmon had, where there was little money or use of it, were in honors for life. The patricians having no profit, took all. Venice being a situation where a man goes but to the door for his employment, the honor is great and the reward very little; but in Holland a councillor of state has £1,500 Flemish a year, besides other accommodations. The States-General have more. And that commonwealth looks nearer her penny than ours needs to do.

"For the revenue of this nation, besides that of her industry, it amounts, as has been shown, to £10,000,000; and the salaries in the whole come not to £300,000 a year. The beauty they will add to the commonwealth will be exceeding great, and the people will delight in this beauty of their commonwealth; the encouragement they will give to the study of the public being very profitable, the accommodation they will afford to your magistrates very

honorable and easy. And the sum, when it or twice as much was spent in hunting and housekeeping, was never any grievance to the people. I am ashamed to stand huckling upon this point; it is sordid. Your magistrates are rather to be provided with further accommodations. For what if there should be sickness? whither will you have them to remove? And this city in the soundest times, for the heat of the year, is no wholesome abode: have a care of their healths to whom you commit your own. I would have the Senate and the people, except they see cause to the contrary, every first of June to remove into the country air for the space of three months. You are better fitted with summer-houses for them than if you had built them to that purpose.

"There is some twelve miles distant the *convallium* upon the river Halcionia, for the tribunes and the prerogative, a palace capable of 1,000 men; and twenty miles distant you have Mount Celia, reverend as well for the antiquity as state of a castle completely capable of the Senate, the proposers having lodgings in the *convallium*, and the tribunes in Celia, it holds the correspondency between the Senate and the people exactly. And it is a small matter for the proposers, being attended with the coaches and officers of state, besides other conveniences of their own, to go a matter of five or ten miles (those seats are not much farther distant) to meet the people upon any heath or field that shall be appointed: where, having despatched their business, they may hunt their own venison (for I would have the great walled park upon the Halcionia to belong to the signory, and those about the *convallium* to the tribunes) and so go to supper. Pray, my lords, see that they do not pull down these houses to sell the lead of them; for when you have considered on it, they cannot be spared. The founders of the school in Hiera provided that the boys should have a summer seat. You should have as much care of these magistrates. But there is such a selling, such a Jewish humor in our republicans, that I cannot tell what to say to it; only this, any man that knows what belongs to a commonwealth, or how diligent every nation in that case has been to preserve her ornaments, and shall see the waste lately made (the woods adjoining to this city, which served for the delight and health of it, being cut down to be sold for threepence), will you tell that they who did such things would never have made a commonwealth. The like may be said of the ruin or damage done upon our cathedrals, ornaments in which this nation excels all others. Nor shall this ever be excused upon the score of religion; for though it be true that God dwells not in houses made with hands, yet you cannot hold your assemblies but in such houses, and these are of the best that have been

made with hands. Nor is it well argued that they are pompous, and therefore profane, or less proper for divine service, seeing the Christians in the primitive Church chose to meet with one accord in the Temple, so far were they from any inclination to pull it down."

The orders of this commonwealth, so far, or near so far as they concern the elders, together with the several speeches at the institution, which may serve for the better understanding of them as so many commentaries, being shown, I should now come from the elders to the youth, or from the civil constitution of this government to the military, but that I judge this the fittest place whereinto, by the way, to insert the government of the city, though for the present but perfunctorily:

"The metropolis or capital city of Oceana is commonly called Emporium, though it consists of two cities distinct, as well in name as in government, whereof the other is called Hiera, for which cause I shall treat of each apart, beginning with Emporium.

"Emporium, with the liberties, is under a twofold division, the one regarding the national, and the other the urban or city government. It is divided, in regard of the national government, into three tribes, and in respect of the urban into twenty-six, which for distinction's sake are called wards, being contained under three tribes but unequally; wherefore the first tribe containing ten wards is called *scazon,* the second containing eight *metoche,* and the third containing as many *telicouta,* the bearing of which names in mind concerns the better understanding of the government.

"Every ward has her wardmote, court, or inquest, consisting of all that are of the clothing or liveries of companies residing within the same.

"Such are of the livery or clothing as have attained to the dignity to wear gowns and parti-colored hoods or tippets, according to the rules and ancient customs of their respective companies.

"A company is a brotherhood of tradesmen professing the same art, governed according to their charter by a master and wardens. Of these there be about sixty, whereof twelve are of greater dignity than the rest, that is to say, the mercers, grocers, drapers, fishmongers, goldsmiths, skinners, merchant-tailors, haberdashers, salters, ironmongers, vintners, cloth-workers, which, with most of the rest, have common halls, divers of them being of ancient and magnificent structure, wherein they have frequent meetings, at the summons of their master or wardens, for the managing and regulation of their respective

trades and mysteries. These companies, as I shall show, are the roots of the whole government of the city. For the liveries that reside in the same ward, meeting at the wardmote inquest (to which it belongs to take cognizance of all sorts of nuisances and violations of the customs and orders of the city, and to present them to the court of aldermen), have also power to make election of two sorts of magistrates or officers; the first of elders or aldermen of the ward, the second of deputies of the same, otherwise called common councilmen.

" The wards in these elections, because they do not elect all at once, but some one year and some another, observe the distinction of the three tribes; for example, the *scazon,* consisting of ten wards, makes election the first year of ten aldermen, one in each ward, and of 150 deputies, fifteen in each ward, all which are triennial magistrates or officers, that is to say, are to bear their dignity for the space of three years.

" The second year the *metoche,* consisting of eight wards, elects eight aldermen, one in each ward, and 120 deputies, fifteen in each ward, being also triennial magistrates.

" The third year *telicouta,* consisting of a like number of wards, elects an equal number of like magistrates for a like term. So that the whole number of the aldermen, according to that of the wards, amounts to twenty-six; and the whole number of the deputies, to 390.

" The aldermen thus elected have divers capacities; for, first, they are justices of the peace for the term, and in consequence of their election. Secondly, they are presidents of the wardmote and governors each of that ward whereby he was elected. And last of all, these magistrates being assembled together, constitute the Senate of the city, otherwise called the court of aldermen; but no man is capable of this election that is not worth £10,000. This court upon every new election makes choice of nine censors out of their own number.

" The deputies in like manner being assembled together, constitute the prerogative tribe of the city, otherwise called the common council, by which means the Senate and the people of the city were comprehended, as it were, by the motion of the national government, into the same wheel of annual, triennial, and perpetual revolution.

" But the liveries, over and above the right of these elections by their divisions mentioned, being assembled all together at the guild of the city, constitute another assembly called the common hall.

" The common hall has the right of two other elections; the one of the lord mayor, and the other of the two sheriffs, being annual magistrates. The lord mayor can be elected out of no

other than one of the twelve companies of the first ranks; and the common hall agrees by the plurality of suffrages upon two names, which, being presented to the lord mayor for the time being, and the court of the aldermen, they elect one by their scrutiny; for so they call it, though it differs from that of the commonwealth. The orator or assistant to the lord mayor in holding of his courts, is some able lawyer elected by the court of aldermen, and called the recorder of Emporium.

"The lord mayor being thus elected, has two capacities: one regarding the nation, and the other the city. In that which regards the city, he is president of the court of aldermen, having power to assemble the same, or any other council of the city, as the common council or common hall, at his will and pleasure; and in that which regards the nation, he is commander-in-chief of the three tribes whereinto the city is divided; one of which he is to bring up in person at the national muster to the ballot, as his vice-comites, or high sheriffs, are to do by the other two, each at their distinct pavilion, where the nine aldermen, elected censors, are to officiate by three in each tribe, according to the rules and orders already given to the censors of the rustic tribes. And the tribes of the city have no other than one common phylarch, which is the court of aldermen and the common council, for which cause they elect not at their muster the first list called the prime magnitude.

"The conveniences of this alteration of the city government, besides the bent of it to a conformity with that of the nation, were many, whereof I shall mention but a few: as first, whereas men under the former administration, when the burden of some of these magistracies lay for life, were oftentimes chosen not for their fitness, but rather unfitness, or at least unwillingness to undergo such a weight, whereby they were put at great rates to fine for their ease; a man might now take his share in magistracy with that equity which is due to the public, and without any inconvenience to his private affairs. Secondly, whereas the city (inasmuch as the acts of the aristocracy, or court of aldermen, in their former way of proceeding, were rather impositions than propositions) was frequently disquieted with the inevitable consequence of disorder in the power of debate exercised by the popular part, or common council; the right of debate being henceforth established in the court of aldermen, and that of result in the common council, killed the branches of division in the root. Which for the present may suffice to have been said of the city of Emporium.

"That of Hiera consists as to the national government of two tribes, the first called *agoræa*, the second *propola;* but as to the peculiar policy of twelve *manipuls,* or wards divided into three

cohorts, each cohort containing four wards, whereof the wards of the first cohort elect for the first year four burgesses, one in each ward, the wards of the second cohort for the second year four burgesses, one in each ward, and the wards of the third cohort for the third year four burgesses, one in each ward, all triennial magistrates; by which the twelve burgesses, making one court for the government of this city, according to their instructions by act of Parliament, fall likewise into an annual, triennial, and perpetual revolution.

"This court being thus constituted, makes election of divers magistrates; as first, of a high steward, who is commonly some person of quality, and this magistracy is elected in the Senate by the scrutiny of this court; with him they choose some able lawyer to be his deputy, and to hold the court; and last of all they elect out of their own number six censors.

"The high steward is commander-in-chief of the two tribes, whereof he in person brings up the one at the national muster to the ballot, and his deputy the other at a distinct pavilion; the six censors chosen by the court officiating by three in each tribe at the urns; and these tribes have no other phylarch but this court.

"As for the manner of elections and suffrage, both in Emporium and Hiera, it may be said, once for all, that they are performed by ballot, and according to the respective rules already given.

"There be other cities and corporations throughout the territory, whose policy being much of this kind, would be tedious and not worth the labor to insert, nor dare I stay. *Juvenum manus emicat ardens.*"

I return, according to the method of the commonwealth, to the remaining parts of her orbs, which are military and provincial; the military, except the strategus, and the polemarchs or field-officers, consisting of the youth only, and the provincial consisting of a mixture both of elders and of the youth.

To begin with the youth, or the military orbs, they are circles to which the commonwealth must have a care to keep close. A man is a spirit raised by the magic of nature; if she does not stand safe, and so that she may set him to some good and useful work, he spits fire, and blows up castles; for where there is life, there must be motion or work; and the work of idleness is mischief, but the work of industry is health. To set men to this, the commonwealth must begin betimes with them, or it will be too late; and the means whereby she sets them to it is education, the plastic art of government. But it is as frequent as sad in experience (whether through negligence, or, which in the consequence is all one or worse, over-fondness in the domestic per-

formance of this duty) that innumerable children come to owe their utter perdition to their own parents, in each of which the commonwealth loses a citizen.

Wherefore the laws of a government, how wholesome soever in themselves, are such as, if men by a congruity in their education be not bred to find a relish in them, they will be sure to loathe and detest. The education therefore of a man's own children is not wholly to be committed or trusted to himself. You find in Livy the children of Brutus, having been bred under monarchy, and used to a court life, making faces at the Commonwealth of Rome: " A king (say they) is a man with whom you may prevail when you have need there should be law, or when you have need there should be no law; he has favors in the right, and he frowns not in the wrong place; he knows his friends from his enemies. But laws are deaf, inexorable things, such as make no difference between a gentleman and an ordinary fellow; a man can never be merry for them, for to trust altogether to his own innocence is a sad life." Unhappy wantons! Scipio, on the other side, when he was but a boy (about two or three and twenty), being informed that certain patricians of Roman gentlemen, through a qualm upon the defeat which Hannibal had given them at Cannæ, were laying their heads together and contriving their flight with the transportation of their goods out of Rome, drew his sword, and setting himself at the door of the chamber where they were at council, protested " that who did not immediately swear not to desert the commonwealth, he would make his soul to desert his body." Let men argue as they please for monarchy, or against a commonwealth, the world shall never see any man so sottish or wicked as in cool blood to prefer the education of the sons of Brutus before that of Scipio; and of this mould, except a Melius or a Manlius, was the whole youth of that commonwealth, though not ordinarily so well cast.

Now the health of a government and the education of the youth being of the same pulse, no wonder if it has been the constant practice of well-ordered commonwealths to commit the care and feeling of it to public magistrates. A duty that was performed in such a manner by the Areopagites, as is elegantly praised by Isocrates. "The Athenians (says he) write not their laws upon dead walls, nor content themselves with having ordained punishments for crimes, but provide in such a way, by the education of their youth, that there be no crimes for punishment." He speaks of those laws which regarded manners, not of those orders which concerned the administration of the commonwealth, lest you should think he contradicts Xenophon and Polybius. The children of Lacedæmon, at the seventh year of their age, were delivered to the *pædonomi*, or schoolmasters,

not mercenary, but magistrates of the commonwealth, to which they were accountable for their charge; and by these at the age of fourteen they were presented to other magistrates called the *beidiæi*, having the inspection of the games and exercises, among which that of the *platanista* was famous, a kind of fight in squadrons, but somewhat too fierce. When they came to be of military age they were listed of the *mora*, and so continued in readiness for public service under the discipline of the polemarchs. But the Roman education and discipline by the centuries and classes is that to which the Commonwealth of Oceana has had a more particular regard in her three essays, being certain degrees by which the youth commence as it were in arms for magistracy, as appears by—

The twenty-sixth order, instituting, " That if a parent has but one son, the education of that one son shall be wholly at the disposition of that parent. But whereas there be free schools erected and endowed, or to be erected and endowed in every tribe of this nation, to a sufficient proportion for the education of the children of the same (which schools, to the end there be no detriment or hindrance to the scholars upon case of removing from one to another, are every of them to be governed by the strict inspection of the censors of the tribes, both upon the schoolmaster's manner of life and teaching, and the proficiency of the children, after the rules and method of that in Hiera), if a parent has more sons than one, the censors of the tribes shall animadvert upon and punish him that sends not his sons within the ninth year of their age to some one of the schools of a tribe, there to be kept and taught, if he be able, at his own charges; and if he be not able, gratis, till they arrive at the age of fifteen years. And a parent may expect of his sons at the fifteenth year of their age, according to his choice or ability, whether it be to service in the way of apprentices to some trade or otherwise, or to further study, as by sending them to the inns of court, of chancery, or to one of the universities of this nation. But he that takes not upon him one of the professions proper to some of those places, shall not continue longer in any of them than till he has attained to the age of eighteen years; and every man having not at the age of eighteen years taken upon him, or addicted himself to the profession of the law, theology, or physic, and being no servant, shall be capable of the essays of the youth, and no other person whatsoever, except a man, having taken upon him such a profession, happens to lay it by ere he arrives at three or four and twenty years of age, and be admitted to this capacity by the respective phylarchs being satisfied that he kept not out so long with any design to evade the service of the commonwealth; but, that being no sooner at his own disposal, it was

no sooner in his choice to come in. And if any youth or other person of this nation have a desire to travel into foreign countries upon occasion of business, delight, or further improvement of his education, the same shall be lawful for him upon a pass obtained from the censors in Parliament, putting a convenient limit to the time, and recommending him to the ambassadors by whom he shall be assisted, and to whom he shall yield honor and obedience in their respective residences. Every youth at his return from his travel is to present the censors with a paper of his own writing, containing the interest of state or form of government of the countries, or some one of the countries, where he has been; and if it be good, the censors shall cause it to be printed and published, prefixing a line in commendation of the author.

" Every Wednesday next ensuing the last of December, the whole youth of every parish, that is to say, every man (not excepted by the foregoing part of the order), being from eighteen years of age to thirty, shall repair at the sound of the bell to their respective church, and being there assembled in presence of the overseers, who are to govern the ballot, and the constable who is to officiate at the urn, shall, after the manner of the elders, elect every fifth man of their whole number (provided that they choose not above one of two brothers at one election, nor above half if they be four or upward) to be a stratiot or deputy of the youth; and the list of the stratiots so elected being taken by the overseers, shall be entered in the parish book, and diligently preserved as a record, called the first essay. They whose estates by the law are able, or whose friends are willing, to mount them, shall be of the horse, the rest are of the foot. And he who has been one year of this list, is not capable of being re-elected till after another year's interval.

" Every Wednesday next ensuing the last of January, the stratiots being mustered at the rendezvous of their respective hundreds, shall, in the presence of the jurymen, who are overseers of that ballot, and of the high constable who is to officiate at the urn, elect out of the horse of their troop or company one captain, and one ensign or cornet, to the command of the same. And the jurymen having entered the list of the hundred into a record to be diligently kept at the rendezvous of the same, the first public game of this commonwealth shall begin and be performed in this manner. Whereas there is to be at every rendezvous of a hundred, one cannon, culverin, or saker, the prize arms being forged by sworn armorers of this commonwealth, and for their proof, besides their beauty, viewed and tried at the tower of Emporium, shall be exposed by the justice of peace appertaining to that hundred (the said justice with the jurymen

being judges of the game), and the judges shall deliver to the horseman that gains the prize at the career, one suit of arms being of the value £20, to the pikeman that gains the prize at throwing the bullet, one suit of arms of the value of £10, to the musketeer that gains the prize at the mark with his musket, one suit of arms of the value of £10, and to the cannoneer that gains the prize at the mark with the cannon, culverin, or saker, a chain of silver being the value of £10, provided that no one man at the same muster plays above one of the prizes. Whosoever gains a prize is bound to wear it (if it be his lot) upon service; and no man shall sell or give away any armor thus won, except he has lawfully attained to two or more of them at the games.

" The games being ended, and the muster dismissed, the captain of the troop or company shall repair with a copy of the list to the lord lieutenant of the tribe, and the high constable with a duplicate of the same to the *custos rotulorum,* or muster-master-general, to be also communicated to the censors; in each of which the jurymen, giving a note upon every name of an only son, shall certify the list is without subterfuge or evasion; or, if it be not, an account of those upon whom the evasion or subterfuge lies, to the end that the phylarch or the censors may animadvert accordingly.

"And every Wednesday next ensuing the last of February, the lord lieutenant, *custos rotulorum,* the censors, and the conductor, shall receive the whole muster of the youth of that tribe at the rendezvous of the same, distributing the horse and foot with their officers, according to the directions given in the like case for the distribution of the elders; and the whole squadron being put by that means in battalia, the second game of this commonwealth shall begin by the exercise of the youth in all the parts of their military discipline according to the orders of Parliament, or direction of the Council of War in that case. And the £100 allowed by the Parliament for the ornament of the muster in every tribe, shall be expended by the phylarch upon such artificial castles, citadels, or the like devices, as may make the best and most profitable sport for the youth and their spectators.

" Which being ended, the censors having prepared the urns by putting into the horse-urn 220 gold balls, whereof ten are to be marked with the letter M and other ten with the letter P; into the foot-urn 700 gold balls, whereof fifty are to be marked with the letter M and fifty with the letter P; and after they have made the gold balls in each urn, by the addition of silver balls to the same, in number equal with the horse and foot of the stratiots, the lord lieutenant shall call the stratiots to the urns, where they that draw the silver balls shall return to their places, and they

that draw the gold balls shall fall off to the pavilion, where, for the space of one hour, they may chop and change their balls according as one can agree with another, whose lot he likes better. But the hour being out, the conductor separating them whose gold balls have no letter from those whose balls are marked, shall cause the crier to call the alphabet, as first A; whereupon all they whose gold balls are not marked, and whose surnames begin with the letter A, shall repair to a clerk appertaining to the *custos rotulorum,* who shall first take the names of that letter; then those of B, and so on, till all the names be alphabetically enrolled. And the youth of this list being 600 foot in a tribe, that is, 30,000 foot in all the tribes; and 200 horse in a tribe, that is, 10,000 horse in all the tribes, are the second essay of the stratiots, and the standing army of this commonwealth to be always ready upon command to march. They whose balls are marked with M, amounting, by twenty horse and fifty foot in a tribe, to 2,500 foot and 500 horse in all the tribes, and they whose balls are marked with P, in every point correspondent, are parts of the third essay; they in M being straight to march for Marpesia, and they of P for Panopea, to the ends and according to the further directions following in the order for the provincial orbs.

" If the polemarchs or field officers be elected by the scrutiny of the Council of War, and the strategus commanded by the Parliament or the Dictator to march, the lord lieutenants (who have power to muster and discipline the youth so often as they receive orders for the same from the Council of War) are to deliver the second essay, or so many of them as shall be commanded, to the conductors, who shall present them to the lord strategus at the time and place appointed by his Excellency to be the general rendezvous of Oceana, where the Council of War shall have the accommodation of horses and arms for his men in readiness; and the lord strategus having armed, mounted, and distributed them, whether according to the recommendation of their prize arms, or otherwise, shall lead them away to his shipping, being also ready and provided with victuals, ammunition, artillery, and all other necessaries; commanding them, and disposing of the whole conduct of the war by his sole power and authority. And this is the third essay of the stratiots, which being shipped, or marched out of their tribes, the lord lieutenants shall re-elect the second essay out of the remaining part of the first, and the Senate another strategus.

" If any veteran or veterans of this nation, the term of whose youth or militia is expired, having a desire to be entertained in the further service of the commonwealth, shall present him or themselves at the rendezvous of Oceana to the strategus, it is in his power to take on such and so many of them as shall be agreed

by the polemarchs, and to send back an equal number of the stratiots.

"And for the better managing of the proper forces of this nation, the lord strategus, by appointment of the Council of War, and out of such levies as they shall have made in either or both of the provinces to that end, shall receive auxiliaries by sea or elsewhere at some certain place, not exceeding his proper arms in number.

"And whosoever shall refuse any one of his three essays, except upon cause shown, he be dispensed withal by the phylarch, or, if the phylarch be not assembled, by the censors of his tribe, shall be deemed a helot or public servant, shall pay a fifth part of his yearly revenue, besides all other taxes, to the commonwealth for his protection, and be incapable of bearing any magistracy except such as is proper to the law. Nevertheless if a man has but two sons, the lord lieutenant shall not suffer above one of them to come to the urn at one election of the second essay, and though he has above two sons, there shall not come above half the brothers at one election; and if a man has but one son, he shall not come to the urn at all without the consent of his parents, or his guardians, nor shall it be any reproach to him or impediment to his bearing of magistracy."

This order, with relation to foreign expeditions, will be proved and explained together with—

The twenty-seventh order, "Providing, in case of invasion apprehended, that the lords high sheriffs of the tribes, upon commands received from the Parliament or the Dictator, distribute the bands of the elders into divisions, after the nature of the essays of the youth; and that the second division or essay of the elders, being made and consisting of 30,000 foot and 10,000 horse, be ready to march with the second essay of the youth, and be brought also by the conductors to the strategus.

"The second essay of the elders and youth being marched out of their tribes, the lords high sheriffs and lieutenants shall have the remaining part of the annual bands both of elders and youth in readiness, which, if the beacons be fired, shall march to the rendezvous to be in that case appointed by the Parliament or the Dictator. And the beacons being fired, the *curiata comitia*, or parochial congregations, shall elect a fourth both of elders and youth to be immediately upon the guard of the tribes, and dividing themselves as aforesaid, to march also in their divisions according to orders, which method in case of extremity shall proceed to the election of a third, or the levy of a second, or of the last man in the nation, by the power of the lords high sheriffs, to the end that the commonwealth in her utmost pressure may show her trust that God in his justice will remember

mercy, by humbling herself, and yet preserving her courage, discipline, and constancy, even to the last drop of her blood and the utmost farthing.

"The services performed by the youth, or by the elders, in case of invasion, and according to this order, shall be at their proper cost and charges that are any ways able to endure it; but if there be such as are known in their parishes to be so indigent that they cannot march out of their tribes, nor undergo the burden in this case incumbent, then the congregations of their parishes shall furnish them with sufficient sums of money to be repaid upon the certificate of the same by the Parliament when the action shall be over. And of that which is respectively enjoined by this order, any tribe, parish, magistrate, or person that shall fail, is to answer for it, at the Council of War, as a deserter of his country."

The Archon, being the greatest captain of his own, if not of any age, added much to the glory of this commonwealth, by interweaving the militia with more art and lustre than any legislator from or before the time of Servius Tullius, who constituted the Roman militia. But as the bones or skeleton of a man, though the greatest part of his beauty be contained in their proportion or symmetry, yet shown without flesh are a spectacle that is rather horrid than entertaining, so without discourses are the orders of a commonwealth; which, if she goes forth in that manner, may complain of her friends that they stand mute and staring upon her. Wherefore this order was thus fleshed by the Lord Archon:

"MY LORDS:

"Diogenes seeing a young fellow drunk, told him that his father was drunk when he begot him. For this, in natural generation, I must confess I see no reason; but in the political it is right. The vices of the people are from their governors; those of their governors from their laws or orders; and those of their laws or orders from their legislators. Whatever was in the womb imperfect, as to her proper work, comes very rarely or never at all to perfection afterward; and the formation of a citizen in the womb of the commonwealth is his education.

"Education by the first of the foregoing orders is of six kinds: at the school, in the mechanics, at the universities, at the inns of court or chancery, in travels, and in military discipline, some of which I shall but touch, and some I shall handle more at large.

"That which is proposed for the erecting and endowing of schools throughout the tribes, capable of all the children of the

same, and able to give to the poor the education of theirs gratis, is only matter of direction in case of very great charity, as easing the needy of the charge of their children from the ninth to the fifteenth year of their age, during which time their work cannot be profitable; and restoring them when they may be of use, furnished with tools whereof there are advantages to be made in every work, seeing he that can read and use his pen has some convenience by it in the meanest vocation. And it cannot be conceived but that which comes, though in small parcels, to the advantage of every man in his vocation, must amount to the advantage of every vocation, and so to that of the whole commonwealth. Wherefore this is commended to the charity of every wise-hearted and well-minded man, to be done in time, and as God shall stir him up or enable him; there being such provision already in the case as may give us leave to proceed without obstruction.

"Parents, under animadversion of the censors, are to dispose of their children at the fifteenth year of their age to something; but what, is left, according to their abilities or inclination, at their own choice. This, with the multitude, must be to the mechanics, that is to say, to agriculture or husbandry, to manufactures, or to merchandise.

"Agriculture is the bread of the nation; we are hung upon it by the teeth; it is a mighty nursery of strength, the best army, and the most assured knapsack; it is managed with the least turbulent or ambitious, and the most innocent hands of all other arts. Wherefore I am of Aristotle's opinion, that a commonwealth of husbandmen—and such is ours—must be the best of all others. Certainly, my lords, you have no measure of what ought to be, but what can be, done for the encouragement of this profession. I could wish I were husband good enough to direct something to this end; but racking of rents is a vile thing in the richer sort, an uncharitable one to the poorer, a perfect mark of slavery, and nips your commonwealth in the fairest blossom. On the other side, if there should be too much ease given in this kind, it would occasion sloth, and so destroy industry, the principal nerve of a commonwealth. But if aught might be done to hold the balance even between these two, it would be a work in this nation equal to that for which Fabius was surnamed Maximus by the Romans.

"In manufactures and merchandise the Hollander has gotten the start of us; but at the long run it will be found that a people working upon a foreign commodity does but farm the manufacture, and that it is really entailed upon them only where the growth of it is native; as also that it is one thing to have the carriage of other men's goods, and another for a man to bring his

own to the best market. Wherefore (nature having provided encouragement for these arts in this nation above all others, where, the people growing, they of necessity must also increase) it cannot but establish them upon a far more sure and effectual foundation than that of the Hollanders. But these educations are in order to the first things or necessities of nature; as husbandry to the food, manufacture to the clothing, and merchandise to the purse of the commonwealth.

"There be other things in nature, which being second as to their order, for their dignity and value are first. and such to which the other are but accommodations; of this sort are especially these: religion, justice, courage, and wisdom.

"The education that answers to religion in our government is that of the universities. Moses, the divine legislator, was not only skilful in all the learning of the Egyptians, but took also into the fabric of his commonwealth the learning of the Midianites in the advice of Jethro; and his foundation of a university laid in the tabernacle, and finished in the Temple, became that pinnacle from whence (according to many Jewish and Christian authors) all the learning in the world has taken wing; as the philosophy of the Stoics from the Pharisees; that of the Epicureans from the Sadducees; and from the learning of the Jews, so often quoted by our Saviour, and fulfilled in him, the Christian religion. Athens was the most famous university in her days; and her senators, that is to say, the Areopagites, were all philosophers. Lacedæmon, to speak truth, though she could write and read, was not very bookish. But he that disputes hence against universities, disputes by the same argument against agriculture, manufacture, and merchandise; every one of these having been equally forbid by Lycurgus, not for itself (for if he had not been learned in all the learning of Crete, and well travelled in the knowledge of other governments, he had never made his commonwealth), but for the diversion which they must have given his citizens from their arms, who, being but few, if they had minded anything else, must have deserted the commonwealth. For Rome, she had *ingenium par ingenio,* was as learned as great, and held our College of Augurs in much reverence. Venice has taken her religion upon trust. Holland cannot attend it to be very studious. Nor does Switzerland mind it much; yet are they all addicted to their universities. We cut down trees to build houses; but I would have somebody show me, by what reason or experience the cutting down of a university should tend to the setting up of a commonwealth. Of this I am sure, that the perfection of a commonwealth is not to be attained without the knowledge of ancient prudence, nor the knowledge of ancient pru-

dence without learning, nor learning without schools of good literature, and these are such as we call universities.

"Now though mere university learning of itself be that which (to speak the words of Verulamius) 'crafty men contemn, and simple men only admire, yet is it such as wise men have use of; for studies do not teach their own use, but that is a wisdom without and above them, won by observation. Expert men may execute, and perhaps judge, of particulars one by one; but the general councils and the plots, and the marshalling of affairs, come best from those that are learned.' Wherefore if you would have your children to be statesmen, let them drink by all means of these fountains, where perhaps there were never any. But what though the water a man drinks be not nourishment, it is the vehicle without which he cannot be nourished. Nor is religion less concerned in this point than government: for take away your universities, and in a few years you lose it.

"The holy Scriptures are written in Hebrew and Greek; they that have neither of these languages may think light of both; but find me a man that has one in perfection, the study of whose whole life it has not been. Again, this is apparent to us in daily conversation, that if four or five persons that have lived together be talking, another speaking the same language may come in, and yet understand very little of their discourse, in that it relates to circumstances, persons, things, times and places which he knows not. It is no otherwise with a man, having no insight of the times in which they were written, and the circumstances to which they relate, in the reading of ancient books, whether they be divine or human. For example, when we fall upon the discourse about baptism and regeneration that was between our Saviour and Nicodemus, where Christ reproaches him with his ignorance in this matter: 'Art thou a doctor in Israel, and understandest not these things?' What shall we think of it? or wherefore should a doctor in Israel have understood these things more than another, but that both baptism and regeneration, as was showed at large by my Lord Phosphorus, were doctrines held in Israel? I instance in one place of a hundred, which he, that has not mastered the circumstances to which they relate, cannot understand. Wherefore to the understanding of the Scripture, it is necessary to have ancient languages, and the knowledge of ancient times, or the aid of them who have such knowledge; and to have such as may be always able and ready to give such aid (unless you would borrow it of another nation, which would not only be base, but deceitful) it is necessary to a commonwealth that she have schools of good literature, or universities of her own.

"We are commanded, as has been said more than once, to

search the Scriptures; and which of them search the Scriptures, they that take this pains in ancient languages and learning, or they that will not, but trust to translations only, and to words as they sound to present circumstances? than which nothing is more fallible, or certain to lose the true sense of Scriptures, pretended to be above human understanding, for no other cause than that they are below it. But in searching the Scriptures by the proper use of our universities, we have been heretofore blest with greater victories and trophies against the purple hosts and golden standards of the Romish hierarchy than any nation; and therefore why we should relinquish this upon the presumption of some, that because there is a greater light which they have, I do not know. There is a greater light than the sun, but it does not extinguish the sun, nor does any light of God's giving extinguish that of nature, but increase and sanctify it. Wherefore, neither the honor borne by the Israelitish, Roman, or any other commonwealth that I have shown, to their ecclesiastics, consisted in being governed by them, but in consulting them in matters of religion, upon whose responses or oracles they did afterward as they thought fit.

" Nor would I be here mistaken, as if, by affirming the universities to be, in order both to religion and government, of absolute necessity, I declared them or the ministry in any wise fit to be trusted, so far as to exercise any power not derived from the civil magistrate in the administration of either. If the Jewish religion were directed and established by Moses, it was directed and established by the civil magistrate; or if Moses exercised this administration as a prophet, the same prophet did invest with the same administration the Sanhedrim, and not the priests; and so does our commonwealth the Senate, and not the clergy. They who had the supreme administration or government of the national religion in Athens, were the first Archon, the *rex sacrificulus*, or high-priest, and a polemarch, which magistrates were ordained or elected by the holding up of hands in the church, congregation, or *comitia* of the people. The religion of Lacedæmon was governed by the kings, who were also high-priests, and officiated at the sacrifice; these had power to substitute their *pythii*, ambassadors, or *nuncios*, by which, not without concurrence of the Senate, they held intelligence with the oracle of Apollo at Delphos. And the ecclesiastical part of the Commonwealth of Rome was governed by the *pontifex maximus*, the *rex sacrificulus*, and the *Flamens*, all ordained or elected by the people, the *pontifex* by the tribes, the King by the centuries, and the *Flamens* by the parishes.

" I do not mind you of these things, as if, for the matter, there were any parallel to be drawn out of their superstitions to our

religion; but to show that for the manner, ancient prudence is as well a rule in divine as human things; nay, and such a one as the apostles themselves, ordaining elders by the holding up of hands in every congregation, have exactly followed; for some of the congregations where they thus ordained elders were those of Antioch, Iconium, Lystra, Derbe, the countries of Lycaonia, Pisidia, Pamphilia, Perga, with Attalia. Now that these cities and countries, when the Romans propagated their empire into Asia, were found most of them commonwealths, and that many of the rest were endued with like power, so that the people living under the protection of the Roman emperors continued to elect their own magistrates, is so known a thing, that I wonder whence it is that men, quite contrary to the universal proof of these examples, will have ecclesiastical government to be necessarily distinct from civil power, when the right of the elders ordained by the holding up of hands in every congregation to teach the people, was plainly derived from the same civil power by which they ordained the rest of their magistrates. And it is not otherwise in our commonwealth, where the parochial congregation elects or ordains its pastor. To object the Commonwealth of Venice in this place, were to show us that it has been no otherwise but where the civil power has lost the liberty of her conscience by embracing popery; as also that to take away the liberty of conscience in this administration from the civil power, were a proceeding which has no other precedent than such as is popish.

" Wherefore your religion is settled after the following manner: the universities are the seminaries of that part which is national, by which means others with all safety may be permitted to follow the liberty of their own consciences, in regard that, however they behave themselves, the ignorance of the unlearned in this case cannot lose your religion nor disturb your government, which otherwise it would most certainly do; and the universities with their emoluments, as also the benefices of the whole nation, are to be improved by such augmentations as may make a very decent and comfortable subsistence for the ministry, which is neither to be allowed synods nor assemblies, except upon the occasion shown in the universities, when they are consulted by the Council of State, and suffered to meddle with affairs of religion, nor to be capable of any other public preferment whatsoever; by which means the interest of the learned can never come to corrupt your religion, nor disturb your government, which otherwise it would most certainly do. Venice, though she does not see, or cannot help the corruption of her religion, is yet so circumspect to avoid disturbance of her government in this kind, that her Council proceeds not to election

of magistrates till it be proclaimed *fora papalini*, by which words such as have consanguinity with red hats, or relation to the Court of Rome, are warned to withdraw.

"If a minister in Holland meddles with matter of state, the magistrate sends him a pair of shoes; whereupon, if he does not go, he is driven away from his charge. I wonder why ministers, of all men, should be perpetually tampering with government; first because they, as well as others, have it in express charge to submit themselves to the ordinances of men; and secondly, because these ordinances of men must go upon such political principles as they of all others, by anything that can be found in their writings or actions, least understand: whence you have the suffrage of all nations to this sense, that an ounce of wisdom is worth a pound of clergy. Your greatest clerks are not your wisest men: and when some foul absurdity in state is committed, it is common with the French, and even the Italians, to call it '*pas de clerc*,' or '*governo de prete*.' They may bear with men that will be preaching without study, while they will be governing without prudence. My lords, if you know not how to rule your clergy, you will most certainly, like a man that cannot rule his wife, have neither quiet at home nor honor abroad. Their honest vocation is to teach your children at the schools and the universities, and the people in the parishes, and yours is concerned to see that they do not play the shrews, of which parts does consist the education of your commonwealth, so far as it regards religion.

"To justice, or that part of it which is commonly executive, answers the education of the inns of court and chancery. Upon which to philosophize, requires a public kind of learning that I have not. But they who take upon them any profession proper to the educations mentioned—that is, theology, physic, or law—are not at leisure for the essays. Wherefore the essays, being degrees whereby the youth commence for all magistracies, offices, and honors in the parish, hundred, tribe, Senate, or prerogative; divines, physicians, and lawyers not taking these degrees, exclude themselves from all such magistracies, offices, and honors. And whereas lawyers are likest to exact further reason for this, they (growing up from the most gainful art at the bar to those magistracies upon the bench which are continually appropriated to themselves, and not only endowed with the greatest revenues, but also held for life) have the least reason of all the rest to pretend to any other; especially in an equal commonwealth, where accumulation of magistracy, or to take a person engaged by his profit to the laws, as they stand, into the power, which is legislative, and which should keep them to what they were,

or ought to be, were a solecism in prudence. It is true that the legislative power may have need of advice and assistance from the executive magistracy, or such as are learned in the law; for which cause the judges are, as they have heretofore been, assistants in the Senate. Nor, however it came about, can I see any reason why a judge, being but an assistant or lawyer, should be member of a legislative council.

"I deny not that the Roman patricians were all patrons, and that the whole people were clients, some to one family and some to another, by which means they had their causes pleaded and defended in some appearance gratis; for the patron took no money, though if he had a daughter to marry, his clients were to pay her portion, nor was this so great a grievance. But if the client accused his patron, gave testimony or suffrage against him, it was a crime of such a nature that any man might lawfully kill him as a traitor; and this, as being the nerve of the optimacy, was a great cause of ruin to that commonwealth; for when the people would carry anything that pleased not the Senate, the senators were ill provided if they could not intercede—that is, oppose it by their clients; with whom, to vote otherwise than they pleased, was the highest crime. The observation of this bond till the time of the Gracchi—that is to say, till it was too late, or to no purpose to break it—was the cause why, in all the former heats and disputes that had happened between the Senate and the people, it never came to blows, which indeed was good; but withal, the people could have no remedy, which was certainly evil. Wherefore I am of opinion that a senator ought not to be a patron or advocate, nor a patron or advocate to be a senator; for if his practice be gratis it debauches the people, and if it be mercenary it debauches himself: take it which way you will, when he should be making of laws, he will be knitting of nets.

"Lycurgus, as I said, by being a traveller became a legislator, but in times when prudence was another thing. Nevertheless we may not shut out this part of education in a commonwealth, which will be herself a traveller; for those of this make have seen the world, especially because this is certain (though it be not regarded in our times, when things being left to take their chance, it fares with us accordingly) that no man can be a politician except he be first a historian or a traveller; for except he can see what must be, or what may be, he is no politician. Now if he has no knowledge in history, he cannot tell what has been, and if he has not been a traveller, he cannot tell what is; but he that neither knows what has been, nor what is, can never tell what must be, or

what may be. Furthermore, the embassies-in-ordinary by our constitution are the prizes of young men, more especially such as have been travellers. Wherefore they of these inclinations, having leave of the censors, owe them an account of their time, and cannot choose but lay it out with some ambition of praise or reward, where both are open, whence you will have eyes abroad, and better choice of public ministers, your gallants showing themselves not more to the ladies at their balls than to your commonwealth at her Academy when they return from their travels.

" But this commonwealth being constituted more especially of two elements, arms and councils, drives by a natural instinct at courage and wisdom; which he who has attained is arrived at the perfection of human nature. It is true that these virtues must have some natural root in him that is capable of them; but this amounts not to so great a matter as some will have it. For if poverty makes an industrious, a moderate estate a temperate, and a lavish fortune a wanton man, and this be the common course of things, wisdom then is rather of necessity than inclination. And that an army which was meditating upon flight, has been brought by despair to win the field, is so far from being strange, that like causes will evermore produce like effects. Wherefore this commonwealth drives her citizens like wedges; there is no way with them but thorough, nor end but that glory whereof man is capable by art or nature. That the genius of the Roman families commonly preserved itself throughout the line (as to instance in some, the Manlii were still severe, the Publicolæ lovers, and the Appii haters of the people) is attributed by Machiavel to their education; nor, if interest might add to the reason why the genius of a patrician was one thing, and that of a plebeian another, is the like so apparent between different nations, who, according to their different educations, have yet as different manners. It was anciently noted, and long confirmed by the actions of the French, that in their first assaults their courage was more than that of men, and for the rest less than that of women, which nevertheless, through the amendment of their discipline, we see now to be otherwise. I will not say but that some man or nation upon an equal improvement of this kind may be lighter than some other; but certainly education is the scale without which no man or nation can truly know his or her own weight or value. By our histories we can tell when one Marpesian would have beaten ten Oceaners, and when one Oceaner would have beaten ten Marpesians. Marc Antony was a Roman, but how did that appear in the embraces of Cleopatra? You must have some other education for your

youth, or they, like that passage, will show better in romance than true story.

"The custom of the Commonwealth of Rome in distributing her magistracies without respect of age, happened to do well in Corvinus and Scipio; for which cause Machiavel (with whom that which was done by Rome, and that which is well done, are for the most part all one) commends this course. Yet how much it did worse at other times, is obvious in Pompey and Cæsar; examples by which Boccalini illustrates the prudence of Venice in her contrary practice, affirming it to have been no small step to the ruin of the Roman liberty, that these (having tasted in their youth of the supreme honors) had no greater in their age to hope for, but by perpetuating of the same in themselves; which came to blood and ended in tyranny. The opinion of Verulamius is safe: 'The errors,' says he, 'of young men are the ruin of business; whereas the errors of old men amount but to this, that more might have been done, or sooner.' But though their wisdom be little, their courage is great; wherefore (to come to the main education of this commonwealth) the militia of Oceana is the province of youth.

"The distribution of this province by the essays is so fully described in the order, that I need repeat nothing; the order itself being but a repetition or copy of that original, which in ancient prudence is of all others the fairest, as that from whence the Commonwealth of Rome more particularly derived the empire of the world. And there is much more reason in this age, when governments are universally broken, or swerved from their foundations, and the people groan under tyranny, that the same causes (which could not be withstood when the world was full of popular governments) should have the like effects.

"The causes in the Commonwealth of Rome, whereof the empire of the world was not any miraculous, but a natural (nay, I may safely say a necessary) consequence, are contained in that part of her discipline which was domestic, and in that which she exercises in her provinces or conquest. Of the latter I shall have better occasion to speak when we come to our provincial orbs; the former divided the whole people by tribes, amounting, as Livy and Cicero show, at their full growth to thirty-five, and every tribe by the sense or valuation of estates into five classes: for the sixth being proletary, that is the nursery, or such as through their poverty contributed nothing to the commonwealth but children, was not reckoned nor used in arms. And this is the first point of the militia, in which modern prudence is quite contrary to the

ancient; for whereas we, excusing the rich and arming the poor, become the vassals of our servants, they, by excusing the poor and arming such as were rich enough to be freemen, became lords of the earth. The nobility and gentry of this nation, who understand so little what it is to be the lords of the earth that they have not been able to keep their own lands, will think it a strange education for their children to be common soldiers, and obliged to all the duties of arms; nevertheless it is not for four shillings a week, but to be capable of being the best man in the field or in the city, the latter part of which consideration makes the common soldier herein a better man than the general of any monarchical army.

" And whereas it may be thought that this would drink deep of noble blood, I dare boldly say, take the Roman nobility in the heat of their fiercest wars, and you shall not find such a shambles of them as has been made of ours by mere luxury and slothfulness; which, killing the body, kill the soul also: *Animasque in vulnere ponunt.* Whereas common right is that which he who stands in the vindication of, has used that sword of justice for which he receives the purple of magistracy. The glory of a man on earth can go no higher, and if he falls he rises again, and comes sooner to that reward which is so much higher as heaven is above the earth. To return to the Roman example: every class was divided, as has been more than once shown, into centuries, and every century was equally divided into youth and elders; the youth for foreign service, and the elders for the guard of the territory. In the first class were about eighteen centuries of horse, being those which, by the institution of Servius, were first called to the suffrage in the centurial assemblies. But the *delectus,* or levy of an army, which is the present business, proceeded, according to Polybius, in this manner:

" Upon a war decreed, the Consuls elected four-and-twenty military tribunes or colonels, whereof ten, being such as had merited their tenth stipend, were younger officers. The tribunes being chosen, the Consuls appointed a day to the tribes, when those in them of military age were to appear at the capitol. The day being come, and the youth assembled accordingly, the Consuls ascended their tribunal, and the younger tribunes were straight divided into four parts after this manner: four were assigned to the first legion (a legion at the most consisted of 6,000 foot and 300 horse), three to the second, four to the third, and three to the fourth. The younger tribunes being thus distributed, two of the elder were assigned to the first legion, three to the second, two to the third, and three to the fourth; and the officers of each legion

thus assigned, having drawn the tribes by lot, and being seated according to their divisions at a convenient distance from each other, the tribe of the first lot was called, whereupon they that were of it knowing the business, and being prepared, presently bolted out four of their number, in the choice whereof such care was taken that they offered none that was not a citizen, no citizen that was not of the youth, no youth that was not of some one of the five classes, nor any one of the five classes that was not expert at his exercises. Moreover, they used such diligence in matching them for age and stature, that the officers of the legion, except they happened to be acquainted with the youth so bolted, were forced to put themselves upon fortune, while they of the first legion chose one, they of the second the next, they of the third another, and the fourth youth fell to the last legion; and thus was the election (the legions and the tribes varying according to their lots) carried on till the foot were complete.

"The like course with little alteration was taken by the horse officers till the horse also were complete. This was called giving of names, which the children of Israel did also by lot; and if any man refused to give his name, he was sold for a slave, or his estate confiscated to the commonwealth. 'When Marcus Curius the Consul was forced to make a sudden levy, and none of the youth would give in their names, all the tribes being put to the lot, he commanded the first name drawn out of the urn of the Pollian tribe (which happened to come first) to be called; but the youth not answering, he ordered his goods to be sold:' which was conformable to the law in Israel, according to which Saul took a yoke of oxen, and hewed them in pieces, and sent them throughout the tribes, saying, 'Whosoever comes not forth to battle after Saul and Samuel, so shall it be done to his oxen.' By which you may observe also that they who had no cattle were not of the militia in Israel. But the age of the Roman youth by the Tullian law determined at thirty; and by the law (though it should seem by Machiavel and others that this was not well observed) a man could not stand for magistracy till he was *miles emeritus,* or had fulfilled the full term of his militia, which was complete in his tenth stipend or service, nor was he afterward obliged under any penalty to give his name, except the commonwealth were invaded, in which case the elders were as well obliged as the youth. The Consul might also levy *milites evocatos,* or soldiers, commanded men out of such as had served their turn, and this at his discretion. The legions being thus complete, were divided by two to each consul, and in these no man had right to serve but a Roman citizen; now

because two legions made but a small army, the Romans added to every one of their arms an equal number of foot, and a double number of horse levied among their Latin or Italian associates; so a consular army, with the legions and auxiliaries, amounted to about 30,000, and whereas they commonly levied two such armies together, these being joined made about 60,000.

"The steps whereby our militia follows the greatest captain, are the three essays; the first, elected by a fifth man in the parishes, and amounting in the whole to 100,000, choose their officers at the hundreds, where they fall also to their games or exercises, invited by handsome prizes, such as for themselves and the honor of them will be coveted, such as will render the hundred a place of sports, and exercise of arms all the year long, such as in the space of ten years will equip 30,000 men horse and foot, with such arms for their forge, proof, and beauty, as (notwithstanding the *argyraspides,* or silver shields of Alexander's guards) were never worn by so many, such as will present marks of virtue and direction to your general or strategus in the distribution of his army, which doubles the value of them to the proprietors, who are bound to wear them, and eases the commonwealth of so much charge, so many being armed already.

"But here will be the objection now. How shall such a revenue be compassed? Fifty pounds a year in every hundred is a great deal, not so easily raised; men will not part with their money, nor would the sum, as it is proposed by the order of Pompey, rise in many years. These are difficulties that fit our genius exactly, and yet £1,000 in each hundred, once levied, establishes the revenue forever. Now the hundreds one with another are worth £10,000 a year dry-rent, over and above personal estates, which bring it to twice the value, so that a twentieth part of one year's revenue of the hundred does it. If you cannot afford this while you pay taxes, though from henceforth they will be but small ones, do it when you pay none. If it be then too much for one year, do it in two; if it be too much for two years, do it in four. What husbands have we hitherto been? what is become of greater sums? My lords, if you should thus cast your bread upon the waters, after many days you shall find it; stand not huckling when you are offered corn and your money again in the mouth of the sack.

"But to proceed: the first essay being officered at the hundreds, and mustered at the tribes (where they are entertained with other sports, which will be very fine ones), proceeds to the election of the second essay, or standing army of this na-

tion, consisting of 30,000 foot and 10,000 horse; and these, upon a war decreed, being delivered at the rendezvous of Oceana to the strategus, are the third essay, which answers to the Roman legions. But you may observe, that whereas the consuls elected the military tribunes, and raised commanded men out of the veterans at their own discretion, our polemarchs, or field officers, are elected by the scrutiny of the Council of War, and our veterans not otherwise taken on than as volunteers, and with the consent of the polemarchs, which may serve for the removal of certain scruples which might otherwise be incident in this place, though without encouragement by the Roman way of proceeding, much less by that which is proposed. But whereas the Roman legions in all amounted not in one army to above 30,000 men, or little more, you have here 40,000; and whereas they added auxiliaries, it is in this regard that Marpesia will be a greater revenue to you than if you had the Indies; for whereas heretofore she has yielded you nothing but her native thistles, in ploughing out the rankness of her aristocracy by your agrarian, you will find her an inexhaustible magazine of men, and to her own advantage, who will make a far better account by the arms than by the pins of Poland. Wherefore as a consular army consisted of about an equal number of auxiliaries added to their legions by their Latin or Italian associates, you may add to a parliamentary army an equal number of Marpesians or Panopeans, as that colony shall hereafter be able to supply you, by which means the commonwealth will be able to go forth to battle with 80,000 men.

"To make wars with small forces is no husbandry, but a waste, a disease, a lingering and painful consumption of men and money, the Romans making theirs thick, made them short, and had little regard to money, as that which they who have men enough can command where it is fittest that it should be levied. All the ancient monarchies by this means got on wing, and attained to vast riches. Whereas your modern princes being dear purchasers of small parcels, have but empty pockets. But it may be some will accuse the order of rashness, in that it commits the sole conduct of the war to the general; and the custom of Venice by her *proveditori*, or checks upon her commanders-in-chief, may seem to be of greater prudence; but in this part of our government neither Venice nor any nation that makes use of mercenary forces is for our instruction. A mercenary army, with a standing general, is like the fatal sister that spins; but proper forces, with an annual magistrate, are like her that cuts the thread. Their interests are quite contrary, and yet you have a better

proveditor than the Venetian, another strategus sitting with an army standing by him; whereupon that which is marching, if there were any probability it should, would find as little possibility that it could recoil, as a foreign enemy to invade you. These things considered, a war will appear to be of a contrary nature to that of all other reckonings, inasmuch as of this you must never look to have a good account if you be strict in imposing checks. Let a council of huntsmen, assembled beforehand, tell you which way the stag shall run, where you shall cast about at the fault, and how you shall ride to be in at the chase all the day; but these may as well do that, as a council of war direct a general. The hours that have painted wings, and of different colors, are his council; he must be like the eye that makes not the scene, but has it so soon as it changes. That in many counsellors there is strength, is spoken of civil administrations; as to those that are military, there is nothing more certain than that in many counsellors there is weakness. Joint commissions in military affairs, are like hunting your hounds in their couples. In the Attic War Cleomenes and Demaratus, Kings of Lacedæmon, being thus coupled, tugged one against another; and while they should have joined against the Persian, were the cause of the common calamity, whereupon that commonwealth took better counsel, and made a law whereby from henceforth there went at once but one of her kings to battle.

"'The Fidenati being in rebellion, and having slain the colony of the Romans, four tribunes with consular power were created by the people of Rome, whereof one being left for the guard of the city, the other three were sent against the Fidenati, who, through the division that happened among them, brought nothing home but dishonor: whereupon the Romans created the Dictator, and Livy gives his judgment in these words: "The three tribunes with consular power were a lesson how useless in war is the joint command of several generals; for each following his own counsels, while they all differed in their opinions, gave by this opportunity an advantage to the enemy." When the consuls Quintus and Agrippa were sent against the Æqui, Agrippa for this reason refused to go with his colleague, saying: "That in the administration of great actions it was most safe that the chief command should be lodged in one person." And if the ruin of modern armies were well considered, most of it would be found to have fallen upon this point, it being in this case far safer to trust to any one man of common prudence, than to any two or more together of the greatest parts.' The consuls indeed, being equal in power, while one was present with the

Senate, and the other in the field with the army, made a good balance; and this with us is exactly followed by the election of a new strategus upon the march of the old one.

" The seven-and-twentieth order, whereby the elders in case of invasion are obliged to equal duty with the youth, and each upon their own charge, is suitable to reason (for every man defends his own estate) and to our copy, as in the war with the Samnites and Tuscans. 'The Senate ordered a vacation to be proclaimed, and a levy to be made of all sorts of persons, and not only the freemen and youths were listed, but cohorts of the old men were likewise formed.' This nation of all others is the least obnoxious to invasion. Oceana, says a French politician, is a beast that cannot be devoured but by herself; nevertheless, that government is not perfect which is not provided at all points; and in this (*ad triarios res rediit*) the elders being such as in a martial state must be veterans, the commonwealth invaded gathers strength like Antæus by her fall, while the whole number of the elders, consisting of 500,000, and the youth of as many, being brought up according to the order, give twelve successive battles, each battle consisting of 80,000 men, half elders and half youth. And the commonwealth, whose constitution can be no stranger to any of those virtues which are to be acquired in human life, grows familiar with death ere she dies. If the hand of God be upon her for her transgressions, she shall mourn for her sins, and lie in the dust for her iniquities, without losing her manhood.

"' *Si fractus illabatur orbis,*
Impavidam ferient ruinæ.'"

The remaining part, being the constitution of the provincial orb, is partly civil, or consisting of the elders; and partly military, or consisting of the youth. The civil part of the provincial orb is directed by—

The twenty-eighth order, " Whereby the council of a province being constituted of twelve knights, divided by four into three regions (for their term and revolution conformable to the Parliament), is perpetuated by the annual election at the tropic of four knights (being triennial magistrates) out of the region of the Senate whose term expires; and of one knight out of the same region to be strategus or general of the province, which magistracy is annual. The strategus or magistrate thus chosen shall be as well president of the provincial council with power to propose to the same, as general of the army. The council for the rest shall elect weekly provosts, having any two of them also right to propose after the

manner of the senatorian councils of Oceana. And whereas all provincial councils are members of the Council of State, they may and ought to keep diligent correspondence with the same, which is to be done after this manner: Any opinion or opinions legitimately proposed and debated at a provincial council, being thereupon signed by the strategus or any two of the provosts, may be transmitted to the Council of State in Oceana; and the Council of State proceeding upon the same in their natural course (whether by their own power, if it be a matter within their instructions; or by authority of the Senate thereupon consulted, if it be a matter of state which is not in their instructions; or by authority of the Senate and command of the people, if it be a matter of law, as for the levies of men or money upon common use and safety) shall return such answers, advice, or orders as in any of the ways mentioned shall be determined upon the case.

"The provincial councils of Marpesia and Panopea respectively shall take special care that the agrarian laws, as also all other laws that be or shall from time to time be enacted by the Parliament of Oceana, for either of them, be duly put in execution; they shall manage and receive the customs of either nation for the shipping of Oceana, being the common guard; they shall have a care that moderate and sufficient pay upon the respective province be duly raised for the support and maintenance of the officers and soldiers, or army of the same, in the most effectual, constant, and convenient way; they shall receive the regalia, or public revenues of those nations, out of which every councillor shall have for his term, and to his proper use, the sum of £500 per annum, and the strategus £500 as president, beside his pay as general, which shall be £1,000, the remainder to go to the use of the knights and deputies of the respective provinces, to be paid, if it will reach, according to the rates of Oceana; if not, by an equal distribution, respectively, or the overplus, if there be any, to be returned to the Treasury of Oceana. They shall manage the lands (if there be any such held in either of the provinces by the Commonwealth of Oceana, in dominion) and return the rents into the Exchequer. If the commonwealth comes to be possessed of richer provinces, the pay of the general or strategus, and of the councils, may be respectively increased. The people for the rest shall elect their own magistrates, and be governed by their own laws, having power also to appeal from their native or provincial magistrates, if they please, to the people of Oceana. And whereas there may be such as receiving injury, are not able to prosecute their appeals at so great a distance, eight sergeants-at-law, being sworn by the commission-

ers of the seal, shall be sent by four into each province once in two years; who, dividing the same by circuits, shall hear such causes, and having gathered and introduced them, shall return to the several appellants, gratis, the determinations and decrees of the people in their several cases.

"The term of a knight in a provincial orb, as to domestic magistracies, shall be esteemed a vacation, and no bar to present election to any other honor, his provincial magistracy being expired.

"The quorum of a provincial council, as also of every other council or assembly in Oceana, shall in time of health consist of two parts in three of the whole number proper to that council or assembly; and in a time of sickness, of one part in three; but of the Senate there can be no quorum without three of the signory, nor of a council without two of the provosts."

The civil part of the provincial orb being declared by the foregoing order, the military part of the same is constituted by—

The twenty-ninth order, "Whereby the stratiots of the third essay having drawn the gold balls marked with the letter M, and being ten horse and fifty foot in a tribe, that is to say, 500 horse and 2,500 foot in all, the tribes shall be delivered by the respective conductors to the provincial strategus or general, at such a time and place, or rendezvous, as he shall appoint by order and certificate of his election, and the strategus having received the horse and foot mentioned, which are the third classes of his provincial guard or army, shall forthwith lead them away to Marpesia, where the army consists of three classes, each class containing 3,000 men, whereof 500 are horse; and receiving the new strategus with the third class, the old strategus with the first class shall be dismissed by the provincial council. The same method with the stratiots of the letter P, is to be observed for the provincial orb of Panopea; and the commonwealth coming to acquire new provinces, the Senate and the people may erect new orbs in like manner, consisting of greater or less numbers, according as is required by the respective occasion. If a stratiot has once served his term in a provincial orb, and happens afterward to draw the letter of a province at the election of the second essay, he may refuse his lot; and if he refuses it, the censor of that urn shall cause the files balloting at the same to make a halt; and if the stratiot produces the certificate of his strategus or general, that he has served his time accordingly, the censor throwing the ball that he drew into the urn again, and taking out a blank, shall dismiss the youth, and cause the ballot to proceed."

To perfect the whole structure of this commonwealth, some directions are given to the third essay, or army marching, in—

The thirtieth order: "'When thou goest to battle against thy enemies, and seest horses and chariots, and a people more than thou, be not afraid of them, for the Lord thy God is he that goes with thee to fight for thee against thy enemies. And when thou dividest the spoil, it shall be as a statute and an ordinance to thee, that as his part is that goes down to the battle, so shall his part be that tarries by the stuff:' that is (as to the Commonwealth of Oceana) the spoil taken of the enemy (except clothes, arms, horses, ammunition, and victuals, to be divided to the soldiery by the strategus and the polemarchs upon the place according to their discretion) shall be delivered to four commissaries of the spoils elected and sworn by the Council of War; which commissaries shall be allowed shipping by the State, and convoys according as occasion shall require by the strategus, to the end that having a bill of lading signed by three or more of the polemarchs, they may ship and bring, or cause such spoils to be brought to the prize-office in Oceana, where they shall be sold; and the profit arising by such spoils shall be divided into three parts, whereof one shall go to the Treasury, another shall be paid to the soldiery of this nation, and a third to the auxiliaries at their return from their service, provided that the said auxiliaries be equal in number to the proper forces of this nation, otherwise their share shall be so much less as they themselves are fewer in number: the rest of the two-thirds to go to the officers and soldiers of the proper forces. And the spoils so divided to the proper forces, shall be subdivided into three equal parts, whereof one shall go to the officers, and two to the common soldiers, the like for the auxiliaries. And the share allotted to the officers shall be divided into four equal parts, whereof one shall go to the strategus, another to the polemarchs, a third to the colonels, and a fourth to the captains, cornets, ensigns, and under-officers, receiving their share of the spoil as common soldiers, the like for the auxiliaries. And this upon pain, in the case of failure, of what the people of Oceana (to whom the cognizance of peculation or crimes of this nature is properly appertaining) shall adjudge or decree."

Upon these three last orders the Archon seemed to be haranguing at the head of his army in this manner:

"MY DEAR LORDS AND EXCELLENT PATRIOTS:

"A government of this make is a commonwealth for increase. Of those for preservation, the inconveniences and

frailties have been shown: their roots are narrow, such as do not run, have no fibres; their tops weak and dangerously exposed to the weather, except you chance to find one, as Venice, planted in a flower-pot, and if she grows, she grows top-heavy, and falls, too. But you cannot plant an oak in a flower-pot; she must have earth for her root, and heaven for her branches.

"*Imperium Oceano, famam quæ terminet astris.*'

"Rome was said to be broken by her own weight, but poetically; for that weight by which she was pretended to be ruined was supported in her emperors by a far slighter foundation. And in the common experience of good architecture, there is nothing more known than that buildings stand the firmer and the longer for their own weight, nor ever swerve through any other internal cause than that their materials are corruptible; but the people never die, nor, as a political body, are subject to any other corruption than that which derives from their government. Unless a man will deny the chain of causes, in which he denies God, he must also acknowledge the chain of effects; wherefore there can be no effect in nature that is not from the first cause, and those successive links of the chain without which it could not have been. Now except a man can show the contrary in a commonwealth, if there be no cause of corruption in the first make of it, there can never be any such effect. Let no man's superstition impose profaneness upon this assertion; for as man is sinful, but yet the universe is perfect, so may the citizen be sinful, and yet the commonwealth be perfect. And as man, seeing the world is perfect, can never commit any such sin as shall render it imperfect, or bring it to a natural dissolution, so the citizen, where the commonwealth is perfect, can never commit any such crime as will render it imperfect, or bring it to a natural dissolution.

"To come to experience: Venice, notwithstanding we have found some flaws in it, is the only commonwealth in the make whereof no man can find a cause of dissolution; for which reason we behold her (though she consists of men that are not without sin) at this day with 1,000 years upon her back, yet for any internal cause, as young, as fresh, and free from decay, or any appearance of it, as she was born; but whatever in nature is not sensible of decay by the course of 1,000 years, is capable of the whole age of nature; by which calculation, for any check that I am able to give myself, a commonwealth, rightly ordered, may for any internal causes be as immortal or long-lived as the world. But if this be true, those com-

monwealths that are naturally fallen, must have derived their ruin from the rise of them. Israel and Athens died, not natural, but violent deaths, in which manner the world itself is to die. We are speaking of those causes of dissolution which are natural to government; and they are but two, either contradiction or inequality. If a commonwealth be a contradiction, she must needs destroy herself; and if she be unequal, it tends to strife, and strife to ruin. By the former of these fell Lacedæmon, by the latter Rome. Lacedæmon being made altogether for war, and yet not for increase, her natural progress became her natural dissolution, and the building of her own victorious hand too heavy for her foundation, so that she fell, indeed, by her own weight. But Rome perished through her native inequality, which how it inveterated the bosoms of the Senate and the people each against other, and even to death, has been shown at large.

"Look well to it, my lords, for if there be a contradiction or inequality in your commonwealth, it must fall; but if it has neither of these, it has no principle of mortality. Do not think me impudent; if this be truth, I shall commit a gross indiscretion in concealing it. Sure I am that Machiavel is for the immortality of a commonwealth upon far weaker principles. 'If a commonwealth,' says he, 'were so happy as to be provided often with men, that, when she is swerving from her principles, should reduce her to her institution, she would be immortal.' But a commonwealth, as we have demonstrated, swerves not from her principles, but by and through her institution; if she brought no bias into the world with her, her course for any internal cause must be straightforward, as we see is that of Venice. She cannot turn to the right hand nor to the left, but by some rub, which is not an internal, but external, cause: against such she can be no way fortified but through her situation, as is Venice, or through her militia, as was Rome, by which examples a commonwealth may be secure of those also. Think me not vain, for I cannot conceal my opinion here; a commonwealth that is rightly instituted can never swerve, nor one that is not rightly instituted be secured from swerving by reduction to her first principles; wherefore it is no less apparent in this place that Machiavel understood not a commonwealth as to the whole piece, than where having told you that a tribune, or any other citizen of Rome, might propose a law to the people, and debate it with them, he adds, 'this order was good while the people were good; but when the people became evil, it became most pernicious.' As if this order (through which, with the like, the people most apparently became evil) could ever have been good, or that the

people or the commonwealth could ever have become good, by being reduced to such principles as were the original of their evil.

"The disease of Rome was, as has been shown, from the native inequality of her balance, and no otherwise from the empire of the world, than as, this falling into one scale, that of the nobility (an evil in such a fabric inevitable) kicked out the people. Wherefore a man that could have made her to throw away the empire of the world, might in that have reduced her to her principles, and yet have been so far from rendering her immortal that, going no further, he should never have cured her. But your commonwealth is founded upon an equal agrarian; and if the earth be given to the sons of men, this balance is the balance of justice, such a one as in having due regard to the different industry of different men, yet faithfully judges the poor. 'And the king that faithfully judges the poor, his throne shall be established forever;' much more the commonwealth, seeing that equality, which is the necessary dissolution of monarchy, is the generation, the very life and soul, of a commonwealth. And now, if ever, I may be excusable, seeing my assertion, that the throne of a commonwealth may be established forever, is consonant to the holy Scriptures.

"The balance of a commonwealth that is equal is of such a nature that whatever falls into her empire must fall equally; and if the whole earth falls into your scales, it must fall equally, and so you may be a greater people and yet not swerve from your principles one hair. Nay, you will be so far from that that you must bring the world in such a case to your balance, even to the balance of justice. But hearken, my lords; are we on earth, do we see the sun, or are we visiting those shady places which are feigned by the poets?

"'*Continuò auditæ voces, vagitus et ingens.*'

These Gothic empires that are yet in the world, were at the first, though they had legs of their own, but a heavy and unwieldy burden; but their foundations being now broken, the iron of them enters even into the souls of the oppressed; and hear the voice of their comforters: 'My father hath chastised you with whips, but I will chastise you with scorpions.' Hearken, I say, if thy brother cries to thee in affliction, wilt thou not hear him? This is a commonwealth of the fabric that has an open ear and a public concern; she is not made for herself only, but given as a magistrate of God to mankind, for the vindication of common right and the law of nature.

Wherefore says Cicero of the like, that of the Romans, 'We have rather undertaken the patronage than the empire of the world.' If you, not regarding this example, like some other nations that are upon the point to smart for it, shall, having attained to your own liberty, bear the sword of your common magistracy in vain, sit still and fold your arms, or, which is worse, let out the blood of your people to tyrants, to be shed in the defence of their yokes like water, and so not only turn the grace of God into wantonness, but his justice into wormwood: I say if you do thus, you are not now making a commonwealth, but heaping coals of fire upon your own heads. A commonwealth of this make is a minister of God upon earth, to the end that the world may be governed with righteousness. For which cause (that I may come at length to our present business) the orders last rehearsed are buds of empire, such as with the blessing of God may spread the arms of your commonwealth, like a holy asylum, to the distressed world, and give the earth her sabbath of years, or rest from her labors, under the shadow of your wings. It is upon this point where the writings of Machiavel, having for the rest excelled all other authors, come as far to excel themselves.

"Commonwealths, says he, have had three ways of propagating themselves: One after the manner of monarchies, by imposing the yoke, which was the way of Athens, and, toward the latter times, of Lacedæmon; another by equal leagues, which is the way of Switzerland (I shall add of Holland, though since his time); a third by unequal leagues, which, to the shame of the world, was never practised, nay, nor so much as seen or minded, by any other commonwealth but that only of Rome. They will each of them, either for caution or imitation, be worthy to be well weighed, which is the proper work of this place. Athens and Lacedæmon have been the occasion of great scandal to the world, in two, or at least one of two regards: the first, their emulation, which involved Greece in perpetual wars; the second, their way of propagation, which by imposing yokes upon others, was plainly contradictory to their own principles.

"For the first: governments, be they of what kind soever, if they be planted too close, are like trees, that impatient in their growth to have it hindered, eat out one another. It was not unknown to these in speculation, or, if you read the story of Agesilaus, in action, that either of them with 30,000 men might have mastered the East; and certainly, if the one had not stood in the other's light, Alexander had come too late to that end, which was the means (and would be if they were to live again) of ruin, at least to one of them; wherefore with

any man that understands the nature of government this is excusable. So it was between Oceana and Marpesia; so it is between France and Spain, though less excusable; and so it ever will be in the like cases. But to come to the second occasion of scandal by them given, which was in the way of their propagation, it is not excusable; for they brought their confederates under bondage, by which means Athens gave occasion of the Peloponnesian War, the wound of which she died stinking, when Lacedæmon, taking the same infection from her carcass, soon followed.

"Wherefore, my lords, let these be warnings to you not to make that liberty which God has given you a snare to others in practising this kind of enlargement to yourselves.

"The second way of propagation or enlargement used by commonwealths is that of Switzerland and Holland, equal leagues; this, though it be not otherwise mischievous, is useless to the world, and dangerous to themselves: useless to the world, for as the former governments were storks, these are blocks, have no sense of honor, or concern in the sufferings of others. But as the Ætolians, a state of the like fabric, were reproached by Philip of Macedon to prostitute themselves, by letting out their arms to the lusts of others, while they leave their own liberty barren and without legitimate issue; so I do not defame these people; the Switzer for valor has no superior, the Hollander for industry no equal; but themselves in the meantime shall so much the less excuse their governments, seeing that to the Switz it is well enough known that the ensigns of his commonwealth have no other motto than *in te converte manus;* and that of the Hollander, though he sweats more gold than the Spaniard digs, lets him languish in debt; for she herself lives upon charity. These are dangerous to themselves, precarious governments, such as do not command, but beg their bread from province to province, in coats that being patched up of all colors are in effect of none. That their cantons and provinces are so many arrows, is good; but they are so many bows too, which is naught.

"Like to these was the commonwealth of the ancient Tuscans, hung together like bobbins, without a hand to weave with them; therefore easily overcome by the Romans, though at that time, for number, a far less considerable people. If your liberty be not a root that grows, it will be a branch that withers, which consideration brings me to the paragon, the Commonwealth of Rome.

"The ways and means whereby the Romans acquired the patronage, and in that the empire, of the world were different, according to the different condition of their commonwealth in

her rise and in her growth: in her rise she proceeded rather by colonies, in her growth by unequal leagues. Colonies without the bounds of Italy she planted none (such dispersion of the Roman citizen as to plant him in foreign parts, till the contrary interest of the emperors brought in that practice, was unlawful), nor did she ever demolish any city within that compass, or divest it of liberty; but whereas the most of them were commonwealths, stirred up by emulation of her great felicity to war against her, if she overcame any, she confiscated some part of their lands that were the greatest incendiaries, or causes of the trouble, upon which she planted colonies of her own people, preserving the rest of their lands and liberties for the natives or inhabitants. By this way of proceeding, that I may be as brief as possible, she did many and great things. For in confirming of liberty, she propagated her empire; in holding the inhabitants from rebellion, she put a curb upon the incursion of enemies; in exonerating herself of the poorer sort, she multiplied her citizens; in rewarding her veterans, she rendered the rest less seditious; and in acquiring to herself the reverence of a common parent, she from time to time became the mother of new-born cities.

" In her further growth the way of her propagation went more upon leagues, which for the first division were of two kinds, social and provincial.

" Again, social leagues, or leagues of society, were of two kinds:

" The first called Latinity or Latin, the second Italian right.

" The league between the Romans and the Latins, or Latin right, approached nearest to *jus quiritium*, or the right of a native Roman. The man or the city that was honored with this right, was *civitate donatus cum suffragio*, adopted a citizen of Rome, with the right of giving suffrage with the people in some cases, as those of conformation of law, or determination in judicature, if both the Consuls were agreed, not otherwise; wherefore that coming to little, the greatest and most peculiar part of this privilege was, that who had borne magistracy (at least that of *ædile* or *quæstor*) in any Latin city, was by consequence of the same a citizen of Rome at all points.

" Italian right was also a donation of the city, but without suffrage: they who were in either of these leagues, were governed by their own laws and magistrates, having all the rights, as to liberty, of citizens of Rome, yielding and praying to the commonwealth as head of the league, and having in the conduct of all affairs appertaining to the common cause, such aid of men and money as was particularly agreed to upon the merit of the cause, and specified in their respective leagues,

whence such leagues came to be called equal or unequal accordingly.

"Provincial leagues were of different extension, according to the merit and capacity of a conquered people; but they were all of one kind, for every province was governed by Roman magistrates, as a prætor or a proconsul, according to the dignity of the province, for the civil administration and conduct of the provincial army, and a quæstor for the gathering of the public revenue, from which magistrates a province might appeal to Rome.

"For the better understanding of these particulars, I shall exemplify in as many of them as is needful, and first in Macedon:

"The Macedonians were thrice conquered by the Romans, first under the conduct of Titus Quintus Flaminius; secondly, under that of Lucius Æmilius Paulus; and, thirdly, under that of Quintus Cæcilius Metellus, thence called Macedonicus.

"For the first time Philip of Macedon, who (possessed of Acrocorinthus) boasted no less than was true, that he had Greece in fetters, being overcome by Flaminius, had his kingdom restored to him, upon condition that he should immediately set all the cities which he held in Greece and in Asia at liberty; and that he should not make war out of Macedon but by leave of the Senate of Rome; which Philip (having no other way to save anything) agreed should be done accordingly.

"The Grecians being at this time assembled at the Isthmian games, where the concourse was mighty great, a crier, appointed to the office by Flaminius, was heard among them proclaiming all Greece to be free; to which the people being amazed at so hopeless a thing, gave little credit, till they received such testimony of the truth as put it past all doubt, whereupon they fell immediately on running to the proconsul with flowers and garlands, and such violent expressions of their admiration and joy, as, if Flaminius, a young man, about thirty-three, had not also been very strong, he must have died of no other death than their kindness, while everyone striving to touch his hand, they bore him up and down the field with an unruly throng, full of such ejaculations as these: How! Is there a people in the world, that at their own charge, at their own peril, will fight for the liberty of another? Did they live at the next door to the fire? Or what kind of men are these, whose business it is to pass the seas, that the world may be governed with righteousness? The cities of Greece and of Asia shake off their iron fetters at the voice of a crier! Was it madness to imagine such a thing, and is it done? O virtue! O felicity! O fame!

"In this example your lordships have a donation of liberty, or of Italian right to a people, by restitution to what they had formerly enjoyed; and some particular men, families or cities, according to their merit of the Romans, if not upon this, yet upon the like occasions, were gratified with Latinity.

"But Philip's share by this means did not please him, wherefore the league was broken by his son Perseus; and the Macedonians thereupon for the second time conquered by Æmilius Paulus, their King taken, and they some time after the victory summoned to the tribunal of the general; where, remembering how little hope they ought to have of pardon, they expected some dreadful sentence: when Æmilius, in the first place, declared the Macedonians to be free, in the full possession of their lands, goods, and laws, with right to elect annual magistrates, yielding and paying to the people of Rome one-half of the tribute which they were accustomed to pay to their own kings. This done he went on, making so skilful a division of the country in order to the methodizing of the people, and casting them into the form of popular government, that the Macedonians, being first surprised with the virtue of the Romans, began now to alter the scene of their admiration, that a stranger should do such things for them in their own country, and with such facility as they had never so much as once imagined to be possible. Nor was this all; for Æmilius, as if not dictating to conquered enemies, but to some well-deserving friends, gave them in the last place laws so suitable, and contrived with such care and prudence, that long use and experience (the only correctress of works of this nature) could never find a fault in them.

"In this example you have a donation of liberty, or of Italian right, to a people that had not tasted of it before, but were now taught how to use it.

"My lords, the royalists should compare what we are doing, and we what hitherto we have done for them, with this example. It is a shame that while we are boasting up ourselves above all others, we should yet be so far from imitating such examples as these, that we do not so much as understand that if government be the parent of manners, where there are no heroic virtues, there is no heroic government.

"But the Macedonians rebelling, at the name of a false Philip, the third time against the Romans, were by them judged incapable of liberty, and reduced by Metellus to a province.

"Now whereas it remains that I explain the nature of a province, I shall rather choose that of Sicily, because, having been the first which the Romans made, the descriptions of the rest relate to it.

"'We have so received the Sicilian cities into amity,' says Cicero, 'that they enjoy their ancient laws; and upon no other condition than of the same obedience to the people of Rome, which they formerly yielded to their own princes or superiors.' So the Sicilians, whereas they had been parcelled out to divers princes, and into divers states (the cause of perpetual wars, whereby, hewing one another down, they became sacrifices to the ambition of their neighbors, or of some invader), were now received at the old rate into a new protection which could hold them, and in which no enemy durst touch them; nor was it possible, as the case then stood, for the Sicilians to receive, or for the Romans to give more.

"A Roman province is defined by Sigonius as a region having provincial right. Provincial right in general was to be governed by a Roman prætor, or consul, in matters at least of state, and of the militia; and by a quæstor, whose office it was to receive the public revenue. Provincial right in particular was different, according to the different leagues or agreements between the commonwealth, and the people reduced into a province. '*Siculi hoc jure sunt, ut quod civis cum cive agat, domi certet suis legibus; quod siculus cum siculo non ejusdem civitatis, ut de eo prætor judices, ex P. Rupilii decreto, sortiatur. Quod privatus a populo petit, aut populus a privato, senatus ex aliqua civitate, qui judicet, datur, cui alterinæ civitates rejectæ sunt. Quod vivis Romanus a siculo petit, siculus judex datur; quod siculus a cive Romano, civis Romanus datur. Cæterarum rerum selecti judices ex civium Romanorum conventu proponi solent. Inter aratores et decumanos lege frumentaria, quam Hieronicam appellant, judicia fiunt.*' Because the rest would oblige me to a discourse too large for this place, it shall suffice that I have showed you how it was in Sicily.

"My lords, upon the fabric of your provincial orb I shall not hold you; because it is sufficiently described in the order, and I cannot believe that you think it inferior to the way of a prætor and a quæstor. But whereas the provincial way of the Roman Commonwealth was that whereby it held the empire of the world, and your orbs are intended to be capable at least of the like use, there may arise many controversies, as whether such a course be lawful, whether it be feasible; and, seeing that the Romans were ruined upon that point, whether it would not be to the destruction of the commonwealth.

"For the first: if the empire of a commonwealth be an occasion to ask whether it be lawful for a commonwealth to aspire to the empire of the world, it is to ask whether it be lawful for it to do its duty, or to put the world into a better condition than it was before.

"And to ask whether this be feasible, is to ask why the Oceaner, being under the like administration of government, may not do as much with 200 men as the Roman did with 100; for comparing their commonwealths in their rise, the difference is yet greater: now that Rome (*seris avaritia luxuriaque*), through the natural thirst of her constitution, came at length with the fulness of her provinces to burst herself, this is no otherwise to be understood than as when a man that from his own evil constitution had contracted the dropsy, dies with drinking, it being apparent that in case her agrarian had held, she could never have been thus ruined, and I have already demonstrated that your agrarian being once poised, can never break or swerve.

"Wherefore to draw toward some conclusion of this discourse, let me inculcate the use, by selecting a few considerations out of many. The regard had in this place to the empire of the world appertains to a well-ordered commonwealth, more especially for two reasons:

"1. The facility of this great enterprise, by a government of the model proposed;

"2. The danger that you would run in the omission of such a government.

"The facility of this enterprise, upon the grounds already laid, must needs be great, forasmuch as the empire of the world has been, both in reason and experience, the necessary consequence of a commonwealth of this nature only; for though it has been given to all kinds to drive at it, since that of Athens or Lacedæmon, if the one had not hung in the other's light, might have gained it, yet could neither of them have held it; not Athens, through the manner of her propagation, which, being by downright tyranny, could not preserve what she had, nor Lacedæmon, because she was overthrown by the weight of a less conquest. The facility then of this great enterprise being peculiar to popular government, I shall consider it, first, in gaining, and secondly, in holding.

"For the former, *volenti non fit injuria*. It is said of the people under Eumenes, that they would not have changed their subjection for liberty; wherefore the Romans gave them no disturbance. If a people be contented with their government, it is a certain sign that it is good, and much good do them with it. The sword of your magistracy is for a terror to them that do evil. Eumenes had the fear of God, or of the Romans, before his eyes; concerning such he has given you no commission.

"But till we can say, here are the Romans, where is Eumenes? do not think that the late appearances of God to

you have been altogether for yourselves; 'He has surely seen the affliction of your brethren, and heard their cry by reason of their task masters.' For to believe otherwise is not only to be mindless of his ways, but altogether deaf. If you have ears to hear, this is the way in which you will certainly be called upon; for if, while there is no stock of liberty, no sanctuary of the afflicted, it be a common object to behold a people casting themselves out of the pan of one prince into the fire of another; what can you think, but if the world should see the Roman eagle again, she would renew her age and her flight? Nor did ever she spread her wings with better omen than will be read in your ensigns; which if, called in by an oppressed people they interpose between them and their yoke, the people themselves must either do nothing in the meantime or have no more pains to take for their wished fruit than to gather it, if that be not likewise done for them. Wherefore this must needs be easy, and yet you have a greater facility than is in the arm of flesh; for if the cause of mankind be the cause of God, the Lord of Hosts will be your captain, and you shall be a praise to the whole earth.

"The facility of holding is in the way of your propagation; if you take that of Athens and Lacedemon, you shall rain snares, but either catch or hold nothing. Lying lips are an abomination to the Lord: if setting up for liberty you impose yokes, he will infallibly destroy you. On the other side, to go about a work of this nature by a league without a head, is to abdicate that magistracy wherewith he has not only endued you, but whereof he will require an account of you; for, 'cursed is he that does the work of the Lord negligently.' Wherefore you are to take the course of Rome: if you have subdued a nation that is capable of liberty, you shall make them a present of it, as did Flaminius to Greece, and Æmilius to Macedon, reserving to yourselves some part of that revenue which was legally paid to the former government, together with the right of being head of the league, which includes such levies of men and money as shall be necessary for the carrying on of the public work.

"For if a people have by your means attained to freedom, they owe both to the cause and you such aid as may propagate the like fruit to the rest of the world. But whereas every nation is not capable of her liberty to this degree, lest you be put to doing and undoing of things, as the Romans were in Macedon, you shall diligently observe what nation is fit for her liberty to this degree, and what not; which is to be done by two marks, the first if she be willing to 'help the Lord against the mighty;' for if she has no care of the liberty of

mankind she deserves not her own. But because in this you may be deceived by pretences, which, continuing for a while specious, may afterward vanish; the other is more certain, and that is if she be capable of an equal agrarian; which that it was not observed by excellent Æmilius in his donation of liberty, and introduction of a popular state among the Macedonians, I am more than moved to believe for two reasons; the first, because at the same time the agrarian was odious to the Roman patricians; the second, that the pseudo-Philip could afterward so easily recover Macedon, which could not have happened but by the nobility, and their impatience, having great estates, to be equalled with the people; for that the people should otherwise, at the mere sound of a name, have thrown away their liberty, is incredible. Wherefore be assured that the nation where you cannot establish an equal agrarian, is incapable of its liberty as to this kind of donation. For example, except the aristocracy in Marpesia be dissolved, neither can that people have their liberty there, nor you govern at home; for they continuing still liable to be sold by their lords to foreign princes, there will never (especially in a country of which there is no other profit to be made) be want of such merchants and drovers, while you must be the market where they are to receive their second payment.

"Nor can the aristocracy there be dissolved but by your means, in relation whereto you are provided with your provincial orb; which, being proportioned to the measure of the nation that you have vindicated or conquered, will easily hold it: for there is not a people in the world more difficult to be held than the Marpesians, which, though by themselves it be ascribed to their own nature, is truly to be attributed to that of their country. Nevertheless, you having 9,000 men upon the continual guard of it, that, threatened by any sudden insurrection, have places of retreat, and an army of 40,000 men upon a day's warning ready to march to their rescue, it is not to be rationally shown which way they can possibly slip out of your hands. And if a man should think that upon a province more remote and divided by the sea, you have not the like hold, he has not so well considered your wings as your talons, your shipping being of such a nature as makes the descent of your armies almost of equal facility in any country, so that what you take you hold, both because your militia, being already populous, will be of great growth in itself, and also through your confederates, by whom in taking and holding you are still more enabled to do both.

"Nor shall you easier hold than the people under your empire or patronage may be held. My lords, I would not go

to the door to see whether it be close shut; this is no underhand dealing, nor a game at which he shall have any advantage against you who sees your cards, but, on the contrary, the advantage shall be your own: for with 18,000 men (which number I put, because it circulates your orb by the annual change of 6,000), having established your matters in the order shown, you will be able to hold the greatest province; and 18,000 men, allowing them greater pay than any prince ever gave, will not stand the province in £1,000,000 revenue; in consideration whereof, they shall have their own estates free to themselves, and be governed by their own laws and magistrates; which, if the revenue of the province be in dry-rent (as there may be some that are four times as big as Oceana) £40,000,000, will bring it with that of industry, to speak with the least, to twice the value: so that the people there, who at this day are so oppressed that they have nothing at all whereon to live, shall for £1,000,000 paid to you, receive at least £79,000,000 to their proper use: in which place I appeal to any man, whether the empire described can be other than the patronage of the world.

"Now if you add to the propagation of civil liberty (so natural to this commonwealth that it cannot be omitted) the propagation of the liberty of conscience, this empire, this patronage of the world, is the kingdom of Christ: for as the kingdom of God the Father was a commonwealth, so shall the kingdom of God the Son; 'the people shall be willing in the day of his power.'

"Having showed you in this and other places some of those inestimable benefits of this kind of government, together with the natural and facile emanation of them from their fountain, I come (lest God who has appeared to you, for he is the God of nature, in the glorious constellation of these subordinate causes, whereof we have hitherto been taking the true elevation, should shake off the dust of his feet against you) to warn you of the dangers which you, not taking the opportunity, will incur by omission.

"Machiavel, speaking of the defect of Venice, through her want of proper arms, cries out, 'This cut her wings, and spoiled her mount to heaven.' If you lay your commonwealth upon any other foundation than the people, you frustrate yourself of proper arms, and so lose the empire of the world; nor is this all, but some other nation will have it.

"Columbus offered gold to one of your kings, through whose happy incredulity another prince has drunk the poison, even to the consumption of his people; but I do not offer you a nerve of war that is made of purse-strings, such a one as

has drawn the face of the earth into convulsions, but such as is natural to her health and beauty. Look you to it, where there is tumbling and tossing upon the bed of sickness, it must end in death or recovery. Though the people of the world, in the dregs of the Gothic empire, be yet tumbling and tossing upon the bed of sickness, they cannot die; nor is there any means of recovery for them but by ancient prudence, whence of necessity it must come to pass that this drug be better known. If France, Italy, and Spain were not all sick, all corrupted together, there would be none of them so; for the sick would not be able to withstand the sound, nor the sound to preserve their health, without curing of the sick. The first of these nations (which if you stay her leisure, will in my mind be France) that recovers the health of ancient prudence, shall certainly govern the world; for what did Italy when she had it? and as you were in that, so shall you in the like case be reduced to a province; I do not speak at random. Italy, in the consulship of Lucius Æmilius Papus and Caius Attilius Regulus, armed, upon the Gallic tumult that then happened of herself, and without the aid of foreign auxiliaries, 70,000 horse and 700,000 foot; but as Italy is the least of those three countries in extent, so is France now the most populous.

"' *I, decus, I, nostrum, melioribus utere fatis.*'

" My dear lords, Oceana is as the rose of Sharon, and the lily of the valley. As the lily among thorns, such is my love among the daughters. She is comely as the tents of Kedar, and terrible as an army with banners. Her neck is as the tower of David, builded for an armory, whereon there hang 1,000 bucklers and shields of mighty men. Let me hear thy voice in the morning, whom my soul loves. The south has dropped, and the west is breathing upon thy garden of spices. Arise, queen of the earth, arise, holy spouse of Jesus; for lo, the winter is past, the rain is over and gone; the flowers appear on the earth, the time for the singing of birds is come, and the voice of the turtle is heard in our land. Arise, I say, come forth, and do not tarry: ah! wherefore should my eyes behold thee by the rivers of Babylon, hanging thy harps upon the willows, thou fairest among women?

" Excellent patriots, if the people be sovereign, here is that which establishes their prerogative; if we be sincere, here is that which disburdens our souls, and makes good all our engagements; if we be charitable, here is that which embraces all parties; if we would be settled, here is that which will stand, and last forever.

"If our religion be anything else but a vain boast, scratching and defacing human nature or reason, which, being the image of God, makes it a kind of murder, here is that empire whence 'justice shall run down like a river, and judgment like a mighty stream.' Who is it then that calls us? or, what is in our way? A lion! Is it not the dragon, that old serpent? For what wretched shifts are these? Here is a great deal; might we not have some of this at one time, and some at another?

"My lords, permit me to give you the sum, or brief

Epitome of the Whole Commonwealth

"The centre or fundamental laws are, first, the agrarian, proportioned at £2,000 a year in land, lying and being within the proper territory of Oceana, and stating property in land at such a balance, that the power can never swerve out of the hands of the many.

"Secondly, the ballot conveying this equal sap from the root, by an equal election or rotation, into the branches of magistracy or sovereign power.

"The orbs of this commonwealth being civil, military, or provincial, are, as it were, cast upon this mould or centre by the divisions of the people; first, into citizens and servants; secondly, into youth and elders; thirdly, into such as have £100 a year in lands, goods, or moneys, who are of the horse; and such as have under, who are of the foot; fourthly, they are divided by their usual residence into parishes, hundreds, and tribes.

"The civil orbs consist of the elders, and are thus created: every Monday next ensuing the last of December, the elders in every parish elect the fifth man to be a deputy, which is but half a day's work; every Monday next ensuing the last of January, the deputies meet at their respective hundred, and elect out of their number one justice of the peace, one juryman, one coroner, and one high constable of the foot, one day's work.

"Every Monday next ensuing the last of February, the hundreds meet at their respective tribe, and there elect the lords high sheriff, lieutenant, *custos rotulorum*, the conductor, the two censors out of the horse, the magistrates of the tribe and of the hundreds, with the jurymen constituting the phylarch, and who assist in their respective offices at the assizes, hold the quarter-sessions, etc. The day following the tribe elects the annual galaxy, consisting of two knights and three deputies out of the horse, with four deputies out of the foot,

thereby endued with power, as magistrates of the whole nation, for the term of three years. An officer chosen at the hundred may not be elected a magistrate of the tribe; but a magistrate or officer either of the hundred or of the tribe, being elected into the galaxy, may substitute any one of his own order to his magistracy or office in the hundred or in the tribe. This of the muster is two days' work. So the body of the people is annually, at the charge of three days' work and a half, in their own tribes, for the perpetuation of their power, receiving over and above the magistracies so divided among them.

"Every Monday next ensuing the last of March, the knights, being 100 in all the tribes, take their places in the Senate. The knights, having taken their places in the Senate, make the third region of the same, and the house proceeds to the senatorian elections. Senatorian elections are annual, biennial, or emergent.

"The annual are performed by the tropic.

"The tropic is a schedule consisting of two parts; the first by which the senatorian magistrates are elected; and the second, by which the senatorian councils are perpetuated.

"The first part is of this tenor:

The lord strategus, The lord orator, The first censor, The second censor.	Annual magistrates, and therefore such as may be elected out of any region; the term of every region having at the tropic one year at the least unexpired.
The third commissioner of the seal, The third commissioner of the Treasury.	Triennial magistrates, and therefore such as can be chosen out of the third region only, as that alone which has the term of three years unexpired.

"The strategus and the orator sitting, are consuls, or presidents of the Senate.

"The strategus marching is general of the army, in which case a new strategus is to be elected in his room.

"The strategus sitting with six commissioners, being councillors of the nation, are the signory of the commonwealth.

"The censors are magistrates of the ballot, presidents of the Council for Religion, and chancellors of the universities.

"The second part of the tropic perpetuates the Council of State, by the election of five knights out of the first region of the Senate, to be the first region of that council consisting of fifteen knights, five in every region.

"The like is done by the election of four into the Council of

Religion, and four into the Council of Trade, out of the same region in the Senate; each of these councils consisting of twelve knights, four in every region.

"But the Council of War, consisting of nine knights, three in every region, is elected by and out of the Council of State, as the other councils are elected by and out of the Senate. And if the Senate add a *juncta* of nine knights more, elected out of their own number, for the term of three months, the Council of War, by virtue of that addition, is Dictator of Oceana for the said term.

"The signory jointly or severally has right of session and suffrage in every senatorial council, and to propose either to the Senate, or any of them. And every region in a council electing one weekly provost, any two of those provosts have power also to propose to their respective council, as the proper and peculiar proposers of the same, for which cause they hold an academy, where any man, either by word of mouth or writing, may propose to the proposers.

"Next to the elections of the tropic is the biennial election of one ambassador-in-ordinary, by the ballot of the house, to the residence of France; at which time the resident of France removes to Spain, he of Spain to Venice, he of Venice to Constantinople, and he of Constantinople returns. So the orb of the residents is wheeled about in eight years, by the biennial election of one ambassador-in-ordinary.

"The last kind of election is emergent. Emergent elections are made by the scrutiny. Election by scrutiny is when a competitor, being made by a council, and brought into the Senate, the Senate chooses four more competitors to him, and putting all five to the ballot, he who has most above half the suffrages is the magistrate. The polemarchs or field officers are chosen by the scrutiny of the Council of War; an ambassador-extraordinary by the scrutiny of the Council of State; the judges and sergeants-at-law by the scrutiny of the seal; and the barons and prime officers of the Exchequer, by the scrutiny of the Treasury.

"The opinion or opinions that are legitimately proposed to any council must be debated by the same, and so many as are resolved upon the debate are introduced into the Senate, where they are debated and resolved, or rejected by the whole house; that which is resolved by the Senate is a decree which is good in matters of state, but no law, except it be proposed to and resolved by the prerogative.

"The deputies of the galaxy being three horse and four foot in a tribe, amount in all the tribes to 150 horse and 200 foot; which, having entered the prerogative, and chosen their cap-

tains, cornet, and ensign (triennial officers), make the third class, consisting of one troop and one company; and so, joining with the whole prerogative, elect four annual magistrates, called tribunes, whereof two are of the horse and two of the foot. These have the command of the prerogative sessions, and suffrage in the Council of War, and sessions without suffrage in the Senate.

" The Senate having passed a decree which they would propose to the people, cause it to be printed and published, or promulgated for the space of six weeks, which, being ordered, they choose their proposers. The proposers must be magistrates, that is, the commissioners of the seal, those of the Treasury, or the censors. These being chosen, desire the muster of the tribunes, and appoint the day. The people being assembled at the day appointed, and the decree proposed, that which is proposed by authority of the Senate, and commanded by the people, is the law of Oceana, or an act of Parliament.

" So the Parliament of Oceana consists of the Senate proposing, and the people resolving.

" The people or prerogative are also the supreme judicatory of this nation, having power of hearing and determining all causes of appeal from all magistrates, or courts provincial or domestic, as also to question any magistrate, the term of his magistracy being expired, if the case be introduced by the tribunes, or any one of them.

" The military orbs consist of the youth, that is, such as are from eighteen to thirty years of age; and are created in the following manner:

" Every Wednesday next ensuing the last of December, the youth of every parish, assembling, elect the fifth of their number to be their deputies; the deputies of the youth are called stratiots, and this is the first essay.

" Every Wednesday next ensuing the last of January, the stratiots, assembling at the hundred, elect their captain and their ensign, and fall to their games and sports.

" Every Wednesday next ensuing the last of February, the stratiots are received by the lord lieutenant, their commander-in-chief, with the conductors and the censors; and, having been disciplined and entertained with other games, are called to the urns, where they elect the second essay, consisting of 200 horse and 600 foot in a tribe; that is, of 10,000 horse and 30,000 foot in all the tribes, which is the standing army of this nation, to march at any warning. They also elect at the same time a part of the third essay, by the mixture of balls marked with the letter M and the letter P, for Marpesia and Panopea; they of either mark being ten horse and fifty foot

in a tribe, that is, 500 horse and 2,500 foot in all the tribes, which are forthwith to march to their respective provinces.

"But the third essay of this nation more properly so called, is when the strategus with the polemarchs (the Senate and the people or the Dictator having decreed a war) receive in return of his warrants the second essay from the hands of the conductors at the rendezvous of Oceana; which army, marching with all accommodations provided by the Council of War, the Senate elects a new strategus, and the lords-lieutenant a new second essay.

"A youth, except he be an only son, refusing any one of his three essays, without sufficient cause shown to the phylarch or the censors, is incapable of magistracy, and is fined a fifth part of his yearly rent, or of his estate, for protection. In case of invasion the elders are obliged to like duty with the youth, and upon their own charge.

"The provincial orb consisting in part of the elders, and in part of the youth, is thus created:

"Four knights out of the first region falling, are elected in the Senate to be the first region of the provincial orb of Marpesia; these, being triennial magistrates, take their places in the provincial council, consisting of twelve knights, four in every region, each region choosing their weekly provosts of the council thus constituted. One knight more, chosen out of the same region in the Senate, being an annual magistrate, is president, with power to propose; and the opinions proposed by the president, or any two of the provosts, are debated by the council, and, if there be occasion of further power or instruction than they yet have, transmitted to the Council of State, with which the provincial is to hold intelligence.

"The president of this council is also strategus or general of the provincial army; wherefore the conductors, upon notice of his election, and appointment of his rendezvous, deliver to him the stratiots of his letter, which he takes with him into his province; and the provincial army having received the new strategus with the third class, the council dismisses the old strategus with the first class. The like is done for Panopea, or any other province.

"But whereas the term of every other magistracy or election in this commonwealth, whether annual or triennial, requires an equal vacation, the term of a provincial councillor or magistrate requires no vacation at all. The quorum of a provincial, as also that of every other council and assembly, requires two-thirds in a time of health, and one-third in a time of sickness.

"I think I have omitted nothing but the props and scaffolds, which are not of use but in building. And how much is here?

Show me another commonwealth in this compass? how many things? Show me another entire government consisting but of thirty orders. If you now go to law with anybody, there lie to some of our courts 200 original writs: if you stir your hand, there go more nerves and bones to that motion; if you play, you have more cards in the pack; nay, you could not sit with your ease in that chair, if it consisted not of more parts. Will you not then allow to your legislator, what you can afford your upholsterer; or to the throne, what is necessary to a chair?

" My lords, if you will have fewer orders in a commonwealth, you will have more; for where she is not perfect at first, every day, every hour will produce a new order, the end whereof is to have no order at all, but to grind with the clack of some demagogue. Is he providing already for his golden thumb? Lift up your heads; away with ambition, that fulsome complexion of a statesman, tempered, like Sylla's, with blood and muck. ' And the Lord give to his senators wisdom; and make our faces to shine, that we may be a light to them that sit in darkness and the shadow of death, to guide their feet in the way of peace.'—In the name of God, what's the matter?"

Philadelphus, the secretary of the council, having performed his task in reading the several orders as you have seen, upon the receipt of a packet from his correspondent Boccalini, secretary of Parnassus, in reading one of the letters, burst forth into such a violent passion of weeping and downright howling, that the legislators, being startled with the apprehension of some horrid news, one of them had no sooner snatched the letter out of his hand, than the rest crying, " Read, read," he obeyed in this manner:

" The 3d instant his Phœbean majesty having taken the nature of free states into his royal consideration, and being steadily persuaded that the laws in such governments are incomparably better and more surely directed to the good of mankind than in any other; that the courage of such a people is the aptest tinder to noble fire; that the genius of such a soil is that wherein the roots of good literature are least worm-eaten with pedantism, and where their fruits have ever come to the greatest maturity and highest relish, conceived such a loathing of their ambition and tyranny, who, usurping the liberty of their native countries, become slaves to themselves, inasmuch as (be it never so contrary to their own nature or consciences) they have taken the earnest of sin, and are engaged to persecute all men that are good with the same or greater rigor than is ordained by laws for the wicked, for none ever administered that power by good which he purchased by ill arts—Phœbus, I say, having consid-

ered this, assembled all the senators residing in the learned court at the theatre of Melpomene, where he caused Cæsar the Dictator to come upon the stage, and his sister Actia, his nephew Augustus, Julia his daughter, with the children which she had by Marcus Agrippa, Lucius and Caius Cæsars, Agrippa Posthumus, Julia, and Agrippina, with the numerous progeny which she bore to her renowned husband Germanicus, to enter. A miserable scene in any, but most deplorable in the eyes of Cæsar, thus beholding what havoc his prodigious ambition, not satisfied with his own bloody ghost, had made upon his more innocent remains, even to the total extinction of his family. For it is (seeing where there is any humanity, there must be some compassion) not to be spoken without tears, that of the full branches deriving from Octavia the eldest sister, and Julia the daughter of Augustus, there should not be one fruit or blossom that was not cut off or blasted by the sword, famine, or poison.

"Now might the great soul of Cæsar have been full; and yet that which poured in as much or more was to behold that execrable race of the Claudii, having hunted and sucked his blood, with the thirst of tigers, to be rewarded with the Roman Empire, and remain in full possession of that famous patrimony: a spectacle to pollute the light of heaven! Nevertheless, as if Cæsar had not yet enough, his Phœban majesty caused to be introduced on the other side of the theatre, the most illustrious and happy prince Andrea Doria, with his dear posterity, embraced by the soft and constant arms of the city of Genoa, into whose bosom, ever fruitful in her gratitude, he had dropped her fair liberty like the dew of heaven, which, when the Roman tyrant beheld, and how much more fresh that laurel was worn with a firm root in the hearts of the people than that which he had torn off, he fell into such a horrid distortion of limbs and countenance, that the senators, who had thought themselves steel and flint at such an object, having hitherto stood in their reverend snow-like thawing Alps, now covered their faces with their large sleeves."

"My lords," said the Archon, rising, " witty Philadelphus has given us grave admonition in dreadful tragedy. *Discite justitiam moniti, et non temnere divos.* Great and glorious Cæsar, the highest character of flesh, yet could not rule but by that part of man which is the beast; but a commonwealth is a monarchy; to her God is king, inasmuch as reason, his dictate, is her sovereign power."

Which said, he adjourned the Council. And the model was soon after promulgated. *Quod bonum, fœlix, faustumque sit huic reipublicæ. Agite quirites, censuere patres, jubeat populus.* (The sea roared, and the floods clapped their hands.)

Libertas

The Proclamation of his Highness the Lord Archon of Oceana upon Promulgation of the Model

"Whereas his Highness and the Council, in the framing of the model promulgated, have not had any private interest or ambition but the fear of God and the good of this people before their eyes; and it remains their desire that this great work may be carried on accordingly: This present greeting is to inform the good people of this land, that as the Council of Prytans sat during the framing of the model, to receive from time to time such propositions as should be offered by any wise-hearted or public-spirited man, toward the institution of a well-ordered commonwealth, so the said Council is to sit as formerly in the great hall of the Pantheon during promulgation (which is to continue for the space of three months) to receive, weigh, and, as there shall be occasion, transmit to the Council of Legislators, all such objections as shall be made against the said model, whether in the whole or in any part. Wherefore that nothing be done rashly or without the consent of the people, such, of what party soever, with whom there may remain any doubts or difficulties, are desired with all convenient speed to address themselves to the said prytans; where, if such objections, doubts, or difficulties receive solution to the satisfaction of the auditory, they shall have public thanks, but if the said objections, doubts, or difficulties receive no solution to the satisfaction of the auditory, then the model promulgated shall be reviewed, and the party that was the occasion of the review, shall receive public thanks, together with the best horse in his Highness's stable, and be one of the Council of Legislators. And so God have you in his keeping."

I should now write the same Council of the Prytans, but for two reasons: the one, that having had but a small time for that which is already done, I am overlabored; the other, that there may be new objections. Wherefore, if my reader has any such as to the model, I entreat him to address himself by way of oration, as it were, to the prytans, that when this rough draught comes to be a work, his speech being faithfully inserted in this place, may give or receive correction to amendment; for what is written will be weighed. But conversation, in these days, is a game at which they are best provided that have light gold; it is like the sport of women that make flowers of straws, which must be stuck up but may not be touched. Nor, which is worse, is this the fault of conversation only: but to the examiner I say

if to invent method and teach an art be all one, let him show that this method is not truly invented, or this art is faithfully taught.

I cannot conclude a circle (and such is this commonwealth) without turning the end into the beginning. The time of promulgation being expired, the surveyors were sent down, who having in due season made report that their work was perfect, the orators followed, under the administration of which officers and magistrates the commonwealth was ratified and established by the whole body of the people, in their parochial, hundred, and county assemblies. And the orators being, by virtue of their scrolls or lots, members of their respective tribes, were elected each the first knight of the third list, or galaxy; wherefore, having at their return assisted the Archon in putting the Senate and the people or prerogative into motion, they abdicated the magistracy both of orators and legislators.

PART IV

THE COROLLARY

FOR the rest (says Plutarch, closing up the story of Lycurgus) when he saw that his government had taken root, and was in the very plantation strong enough to stand by itself, he conceived such a delight within him, as God is described by Plato to have done when he had finished the creation of the world, and saw his own orbs move below him: for in the art of man (being the imitation of nature, which is the art of God) there is nothing so like the first call of beautiful order out of chaos and confusion, as the architecture of a well-ordered commonwealth. Wherefore Lycurgus, seeing in effect that his orders were good, fell into deep contemplation how he might render them, so far as could be effected by human providence, unalterable and immortal. To which end he assembled the people, and remonstrated to them: That for aught he could perceive, their policy was already such, and so well established, as was sufficient to entail upon them and theirs all that virtue and felicity whereof human life is capable: nevertheless that there being another thing of greater concern than all the rest, whereof he was not yet provided to give them a perfect account, nor could till he had consulted the oracle of Apollo, he desired that they would observe his laws without any change or alteration whatsoever till his return from Delphos; to which all the people cheerfully and unanimously engaged themselves by promise, desiring him that he would make as much haste as he could. But Lycurgus, before he went, began with the kings and the senators, and thence taking the whole people in order, made them all swear to that which they had promised, and then took his journey. Being arrived at Delphos, he sacrificed to Apollo, and afterward inquired if the policy which he had established was good and sufficient for a virtuous and happy life?

By the way, it has been a maxim with legislators not to give checks to the present superstition, but to make the best use of it, as that which is always the most powerful with the people; otherwise, though Plutarch, being a priest, was interested in the cause, there is nothing plainer than Cicero, in his book "*De Divinatione*" has made it, that there was never any such thing as an oracle, except in the cunning of the priests. But to be

civil to the author, the god answered to Lycurgus that his policy was exquisite, and that his city, holding to the strict observation of his form of government, should attain to the height of fame and glory. Which oracle Lycurgus causing to be written, failed not of transmitting to his Lacedæmon. This done, that his citizens might be forever inviolably bound by their oath, that they would alter nothing till his return, he took so firm a resolution to die in the place, that from thenceforward, receiving no manner of food, he soon after performed it accordingly. Nor was he deceived in the consequence; for his city became the first in glory and excellency of government in the whole world. And so much for Lycurgus, according to Plutarch.

My Lord Archon, when he beheld not only the rapture of motion, but of joy and harmony, into which his spheres (without any manner of obstruction or interfering, but as if it had been naturally) were cast, conceived not less of exultation in his spirit; but saw no more necessity or reason why he should administer an oath to the Senate and the people that they would observe his institutions, than to a man in perfect health and felicity of constitution that he would not kill himself. Nevertheless whereas Christianity, though it forbids violent hands, consists no less in self-denial than any other religion, he resolved that all unreasonable desires should die upon the spot; to which end that no manner of food might be left to ambition, he entered into the Senate with a unanimous applause, and having spoken of his government as Lycurgus did when he assembled the people, he abdicated the magistracy of Archon. The Senate, as struck with astonishment, continued silent, men upon so sudden an accident being altogether unprovided of what to say; till the Archon withdrawing, and being almost at the door, divers of the knights flew from their places, offering as it were to lay violent hands on him, while he escaping, left the Senate with the tears in their eyes, of children that had lost their father; and to rid himself of all further importunity, retired to a country house of his, being remote, and very private, insomuch that no man could tell for some time what was become of him.

Thus the law-maker happened to be the first object and reflection of the law made; for as liberty of all things is the most welcome to a people, so is there nothing more abhorrent from their nature than ingratitude. We, accusing the Roman people of this crime against some of their greatest benefactors, as Camillus, heap mistake upon mistake; for being not so competent judges of what belongs to liberty as they were, we take upon us to be more competent judges of virtue. And whereas virtue, for being a vulgar thing among them, was of no less rate than jewels are with such as wear the most, we are selling this prec-

ious stone, which we have ignorantly raked out of the Roman ruins, at such a rate as the Switzers did that which they took in the baggage of Charles of Burgundy. For that Camillus had stood more firm against the ruin of Rome than her capitol, was acknowledged; but on the other side, that he stood as firm for the patricians against the liberty of the people, was as plain; wherefore he never wanted those of the people that would die at his foot in the field, nor that would withstand him to his beard in the city. An example in which they that think Camillus had wrong, neither do themselves right, nor the people of Rome; who in this signify no less than that they had a scorn of slavery beyond the fear of ruin, which is the height of magnanimity.

The like might be shown by other examples objected against this and other popular governments, as in the banishment of Aristides the Just from Athens, by the ostracism, which, first, was no punishment, nor ever understood for so much as a disparagement; but tended only to the security of the commonwealth, through the removal of a citizen (whose riches or power with a party was suspected) out of harm's way for the space of ten years, neither to the diminution of his estate or honor. And next, though the virtue of Aristides might in itself be unquestioned, yet for him under the name of the Just to become universal umpire of the people in all cases, even to the neglect of the legal ways and orders of the commonwealth, approached so much to the prince, that the Athenians, doing Aristides no wrong, did their government no more than right in removing him; which therefore is not so probable to have come to pass, as Plutarch presumes, through the envy of Themistocles, seeing Aristides was far more popular than Themistocles, who soon after took the same walk upon a worse occasion. Wherefore as Machiavel, for anything since alleged, has irrefragably proved that popular governments are of all others the least ungrateful, so the obscurity, I say, into which my Lord Archon had now withdrawn himself caused a universal sadness and clouds in the minds of men upon the glory of his rising commonwealth.

Much had been ventilated in private discourse, and the people (for the nation was yet divided into parties that had not lost their animosities), being troubled, bent their eyes upon the Senate, when, after some time spent in devotion, and the solemn action of thanksgiving, his Excellency Navarchus de Paralo in the tribe of Dorean, lord strategus of Oceana (though in a new commonwealth a very prudent magistrate), proposed his part or opinion in such a manner to the Council of State, that, passing the ballot of the same with great unanimity and applause, it was introduced into the Senate, where it passed with greater.

Wherefore the decree being forthwith printed and published, copies were returned by the secretaries to the phylarchs (which is the manner of promulgation) and the commissioners of the seal, that is to say, the Right Honorable Phosphorus de Auge in the tribe of Eudia, Dolabella d'Enyo in the tribe of Turmæ, and Linceus de Stella in the tribe of Nubia, being elected proposers *pro tempore*, bespoke of the tribunes a muster of the people to be held that day six weeks, which was the time allowed for promulgation at the halo.

The satisfaction which the people throughout the tribes received upon promulgation of the decree, loaded the carriers with weekly letters between friend and friend, whether magistrates or private persons. But the day for proposition being come, and the prerogative upon the place appointed in discipline, Sanguine de Ringwood in the tribe of Saltum, captain of the Phœnix, marched by order of the tribunes with his troop to the piazza of the Pantheon, where his trumpets, entering into the great hall, by their blazon gave notice of his arrival; at which the sergeant of the house came down, and returning, informed the proposers, who descending, were received at the foot of the stairs by the captain, and attended to the coaches of state, with which Calcar de Gilvo in the tribe of Phalera, master of the horse, and the ballotins upon their great horses, stood waiting at the gate.

The proposers being in their coaches, the train for the pomp, the same that is used at the reception of ambassadors, proceeded in this order: In the front marched the troop with the cornet in the van and the captain in the rear; next the troop came the twenty messengers or trumpets, the ballotins upon the curvet with their usher in the van, and the master of the horse in the rear; next the ballotins, Bronchus de Rauco, in the tribe of Bestia, king of the heralds, with his fraternity in their coats-of-arms, and next to Sir Bronchus, Boristhenes de Holiwater in the tribe of Ave, master of the ceremonies; the mace and the seal of the chancery went immediately before the coaches, and on either side, the doorkeepers or guard of the Senate, with their pole-axes, accompanied with some 300 or 400 footmen belonging to the knights or senators, the trumpeters, ballotins, guards, postillions, coachmen and footmen, being very gallant in the liveries of the commonwealth, but all, except the ballotins, without hats, in lieu whereof they wore black velvet calots, being pointed with a little peak at the forehead. After the proposers came a long file of coaches full of such gentlemen as use to grace the commonwealth upon the like occasions. In this posture they moved slowly through the streets (affording, in the gravity of the pomp and the welcomeness of the end, a

most reverend and acceptable prospect to the people all the way from the Pantheon, being about half a mile) and arrived at the halo, where they found the prerogative in a close body environed with scaffolds that were covered with spectators. The tribunes received the proposers, and conducted them into a seat placed in the front of the tribe, like a pulpit, but that it was of some length, and well adorned by the heralds with all manner of birds and beasts, except that they were ill-painted, and never a one of his natural color. The tribunes were placed at a table that stood below the long seat, those of the horse in the middle, and those of the foot at either end, with each of them a bowl or basin before him, that on the right hand being white, and the other green: in the middle of the table stood a third, which was red. And the housekeepers of the pavilion, who had already delivered a proportion of linen balls or pellets to every one of the tribe, now presented boxes to the ballotins. But the proposers as they entered the gallery, or long seat, having put off their hats by way of salutation, were answered by the people with a shout; whereupon the younger commissioners seated themselves at either end; and the first, standing in the middle, spoke after this manner:

" MY LORDS, THE PEOPLE OF OCEANA:
" While I find in myself what a felicity it is to salute you by this name, and in every face, anointed as it were with the oil of gladness, a full and sufficient testimony of the like sense, to go about to feast you with words, who are already filled with that food of the mind which, being of pleasing and wholesome digestion, takes in the definition of true joy, were a needless enterprise. I shall rather put you in mind of that thankfulness which is due, than puff you up with anything that might seem vain. Is it from the arms of flesh that we derive these blessings? Behold the Commonwealth of Rome falling upon her own victorious sword. Or is it from our own wisdom, whose counsels had brought it even to that pass, that we began to repent ourselves of victory? Far be it from us, my lords, to sacrifice to our own nets, which we ourselves have so narrowly escaped! Let us rather lay our mouths in the dust, and look up (as was taught the other day when we were better instructed in this lesson) to the hills with our gratitude. Nevertheless, seeing we read how God upon the neglect of his prophets has been provoked to wrath, it must needs follow that he expects honor should be given to them by whom he has chosen to work as his instruments. For which cause, nothing doubting of my warrant, I shall proceed to that which more particularly concerns the present occasion, the discovery of my Lord Archon's virtues and merit, to be ever placed by this nation in their true meridian.

"My lords, I am not upon a subject which persuades me to balk, but necessitates me to seek out the greatest examples. To begin with Alexander, erecting trophies common to his sword and the pestilence: to what good of mankind did he infect the air with his heap of carcasses? The sword of war, if it be any otherwise used than as the sword of magistracy, for the fear and punishment of those that do evil, is as guilty in the sight of God as the sword of a murderer; nay more, for if the blood of Abel, of one innocent man, cried in the ears of the Lord for vengeance, what shall the blood of an innocent nation? Of this kind of empire, the throne of ambition, and the quarry of a mighty hunter, it has been truly said that it is but a great robbery. But if Alexander had restored the liberty of Greece, and propagated it to mankind, he had done like my Lord Archon, and might have been truly called the Great. Alexander cared not to steal a victory that would be given; but my Lord Archon has torn away a victory which had been stolen, while we went tamely yielding up obedience to a nation reaping in our fields, whose fields he has subjected to our empire, and nailed them with his victorious sword to their native Caucasus.

"Machiavel gives a handsome caution: 'Let no man,' says he, 'be circumvented with the glory of Cæsar, from the false reflection of their pens, who through the longer continuance of his empire in the name than in the family, changed their freedom for flattery. But if a man would know truly what the Romans thought of Cæsar, let them observe what they said of Catiline.'

"And yet by how much he who has perpetrated some heinous crime is more execrable than he who did but attempt it, by so much is Cæsar more execrable than Catiline. On the contrary, let him that would know what ancient and heroic times, what the Greeks and Romans would both have thought and said of my Lord Archon, observe what they thought and said of Solon, Lycurgus, Brutus, and Publicola. And yet by how much his virtue, that is crowned with the perfection of his work, is beyond theirs, who were either inferior in their aim, or in their performance; by so much is my Lord Archon to be preferred before Solon, Lycurgus, Brutus, and Publicola.

"Nor will we shun the most illustrious example of Scipio: this hero, though never so little less, yet was he not the founder of a commonwealth; and for the rest, allowing his virtue to have been of the most untainted ray, in what did it outshine this of my Lord Archon? But if dazzling the eyes of the magistrates it overawed liberty, Rome might be allowed some excuse that she did not like it, and I, if I admit not of this comparison: for where is my Lord Archon? Is there a genius, how free soever, which in his presence would not find itself to be under power?

He is shrunk into clouds, he seeks obscurity in a nation that sees by his light. He is impatient of his own glory, lest it should stand between you and your liberty.

" Liberty! What is even that, if we may not be grateful? And if we may, we have none: for who has anything that he does not owe? My lords, there be some hard conditions of virtue: if this debt were exacted, it were not due; whereas being cancelled, we are all entered into bonds. On the other side, if we make such a payment as will not stand with a free people, we do not enrich my Lord Archon, but rob him of his whole estate and his immense glory.

" These particulars had in due deliberation and mature debate, according to the order of this commonwealth, it is proposed by authority of the Senate, to you my lords the people of Oceana:

" I. That the dignity and office of Archon, or protector of the Commonwealth of Oceana, be and are hereby conferred, by the Senate and the people of Oceana, upon the most illustrious Prince and sole legislator of this commonwealth, Olphaus Megaletor, *pater patriæ*, whom God preserve, for the term of his natural life.

" II. That £350,000 per annum yet remaining of the ancient revenue, be estated upon the said illustrious Prince, or Lord Archon, for the said term, and to the proper and peculiar use of his Highness.

" III. That the Lord Archon have the reception of all foreign ambassadors, by and with the Council of State, according to the orders of this commonwealth.

" IV. That the Lord Archon have a standing army of 12,000 men, defrayed upon a monthly tax, during the term of three years, for the protection of this commonwealth against dissenting parties, to be governed, directed, and commanded by and with the advice of the Council of War, according to the orders of this commonwealth.

" V. That this commonwealth make no distinction of persons or parties, but every man being elected and sworn, according to the orders of the same, be equally capable of magistracy, or not elected, be equally capable of liberty, and the enjoyment of his estate free from all other than common taxes.

" VI. That a man putting a distinction upon himself, refusing the oath upon election, or declaring himself of a party not conformable to the civil government, may within any time of the three years' standing of the army, transport himself and his estate, without molestation or impediment, into any other nation.

" VII. That in case there remains any distinction of parties not conforming to the civil government of this commonwealth, after the three years of the standing army being expired, and

the commonwealth be thereby forced to prolong the term of the said army, the pay from henceforth of the said army be levied upon the estates of such parties so remaining unconformable to the civil government."

The proposer having ended his oration, the trumpets sounded; and the tribunes of the horse being mounted to view the ballot, caused the tribe (which thronging up to the speech, came almost round the gallery) to retreat about twenty paces, when Linceus de Stella, receiving the propositions, repaired with Bronchus de Rauco the herald, to a little scaffold erected in the middle of the tribe, where he seated himself, the herald standing bare upon his right hand. The ballotins, having their boxes ready, stood before the gallery, and at the command of the tribunes marched, one to every troop on horseback, and one to every company on foot, each of them being followed by other children that bore red boxes: now this is putting the question whether the question should be put. And the suffrage being very suddenly returned to the tribunes at the table, and numbered in the view of the proposers, the votes were all in the affirmative, whereupon the red or doubtful boxes were laid aside, it appearing that the tribe, whether for the negative or affirmative, was clear in the matter. Wherefore the herald began from the scaffold in the middle of the tribe, to pronounce the first proposition, and the ballotins marching with the negative or affirmative only, Bronchus, with his voice like thunder, continued to repeat the proposition over and over again, so long as it was in balloting. The like was done for every clause, till the ballot was finished, and the tribunes assembling, had signed the points, that is to say, the number of every suffrage, as it was taken by the secretary upon the tale of the tribunes, and in the sight of the proposers; for this may not be omitted: it is the pulse of the people. Now whereas it appertains to the tribunes to report the suffrage of the people to the Senate, they cast the lot for this office with three silver balls and one gold one; and it fell upon the Right Worshipful Argus de Crookhorn, in the tribe of Pascua, first tribune of the foot. Argus, being a good sufficient man in his own country, was yet of the mind that he should make but a bad spokesman, and therefore became something blank at his luck, till his colleagues persuaded him that it was no such great matter, if he could but read, having his paper before him. The proposers, taking coach, received a volley upon the field, and returned in the same order, save that, being accompanied with the tribunes, they were also attended by the whole prerogative to the piazza of the Pantheon, where, with another volley, they

took their leaves. Argus, who had not thought upon his wife and children all the way, went very gravely up: and everyone being seated, the Senate by their silence seemed to call for the report, which Argus, standing up, delivered in this wise:

"RIGHT HONORABLE LORDS AND FATHERS ASSEMBLED IN PARLIAMENT:

"So it is, that it has fallen to my lot to report to your excellencies in the votes of the people, taken upon the 3d instant, in the first year of this commonwealth, at the halo; the Right Honorable Phosphorus de Auge in the tribe of Eudia, Dolabella d'Enyo in the tribe of Turmæ, and Linceus de Stella in the tribe of Nubia, lords commissioners of the great seal of Oceana, and proposers *pro temporibus*, together with my brethren the tribunes, and myself being present. Wherefore these are to certify to your fatherhoods, that the said votes of the people were as follows, that is to say:

To the first proposition, *nemine contradicente;*
To the second, *nemine contradicente;*
To the third, the like;
To the fourth, 211, above half;
To the fifth, 201, above half;
To the sixth, 150, above half, in the affirmative;
To the seventh, *nemine contradicente* again, and so forth.

"My Lords, it is a language that is out of my prayers, and if I be out at it, no harm—

"But as concerning my Lord Archon (as I was saying) these are to signify to you the true-heartedness and goodwill which are in the people, seeing by joining with you, as one man, they confess that all they have to give is too little for his highness. For truly, fathers, if he who is able to do harm, and does none, may well be called honest; what shall we say to my Lord Archon's highness, who having had it in his power to have done us the greatest mischief that ever befell a poor nation, so willing to trust such as they thought well of, has done us so much good, as we should never have known how to do ourselves? Which was so sweetly delivered by my Lord Chancellor Phosphorus to the people, that I dare say there was never a one of them could forbear to do as I do—and, it please your fatherhoods, they be tears of joy. Aye, my Lord Archon shall walk the streets (if it be for his ease I mean) with a switch, while the people run after him and pray for him; he shall not wet his foot; they will strew flowers in his way; he shall sit higher in their hearts, and in the judgment of all good men,

than the kings that go upstairs to their seats; and one of these had as good pull two or three of his fellows out of their great chairs as wrong him or meddle with him; he has two or three hundred thousand men, that when you say the word, shall sell themselves to their shirts for him, and die at his foot. His pillow is of down, and his grave shall be as soft, over which they that are alive shall wring their hands. And to come to your fatherhoods, most truly so called, as being the loving parents of the people, truly you do not know what a feeling they have of your kindness, seeing you are so bound up, that if there comes any harm, they may thank themselves. And, alas! poor souls, they see that they are given to be of so many minds, that though they always mean well, yet if there comes any good, they may thank them that teach them better. Wherefore there was never such a thing as this invented, they do verily believe that it is no other than the same which they always had in their very heads, if they could have but told how to bring it out. As now for a sample: my lords the proposers had no sooner said your minds, than they found it to be that which heart could wish. And your fatherhoods may comfort yourselves, that there is not a people in the world more willing to learn what is for their own good, nor more apt to see it, when you have showed it them. Wherefore they do love you as they do their own selves; honor you as fathers; resolve to give you as it were obedience forever, and so thanking you for your most good and excellent laws, they do pray for you as the very worthies of the land, right honorable lords and fathers assembled in Parliament."

Argus came off beyond his own expectation; for thinking right, and speaking as he thought, it was apparent by the house and the thanks they gave him, that they esteemed him to be absolutely of the best sort of orators; upon which having a mind that till then misgave him, he became very crounse, and much delighted with that which might go down the next week in print to his wife and neighbors. Livy makes the Roman tribunes to speak in the same style with the consuls, which could not be, and therefore for aught in him to the contrary, Volero and Canuleius might have spoken in no better style than Argus. However, they were not created the first year of the commonwealth; and the tribunes of Oceana are since become better orators than were needful. But the laws being enacted, had the preamble annexed, and were delivered to Bronchus, who loved nothing in the earth so much as to go staring and bellowing up and down the town, like a stag in a forest, as he now did, with his fraternity in their coats-of-arms, and I know

not how many trumpets, proclaiming the act of parliament; when, meeting my Lord Archon, whom from a retreat that was without affectation, as being for devotion only, and to implore a blessing by prayer and fasting upon his labors, now newly arrived in town, the herald of the tribe of Bestia set up his throat, and having chanted out his lesson, passed as haughtily by him as if his own had been the better office, which in this place was very well taken, though Bronchus for his high mind happened afterward upon some disasters, too long to tell, that spoiled much of his embroidery.

My Lord Archon's arrival being known, the signory, accompanied by the tribunes, repaired to him, with the news he had already heard by the herald, to which my lord strategus added that his highness could not doubt upon the demonstrations given, but the minds of men were firm in the opinion that he could be no seeker of himself in the way of earthly pomp and glory, and that the gratitude of the Senate and the people could not therefore be understood to have any such reflection upon him. But so it was, that in regard of dangers abroad, and parties at home, they durst not trust themselves without a standing army, nor a standing army in any man's hands but those of his highness.

The Archon made answer, that he ever expected this would be the sense of the Senate and the people; and this being their sense, he should have been sorry they had made choice of any other than himself for a standing general; first, because it could not have been more to their own safety, and secondly, because so long as they should have need of a standing army, his work was not done; that he would not dispute against the judgment of the Senate and the people, nor ought that to be. Nevertheless, he made little doubt but experience would show every party their own interest in this government, and that better improved than they could expect from any other; that men's animosities should overbalance their interest for any time was impossible, that humor could never be lasting, nor through the constitution of the government of any effect at the first charge. For supposing the worst, and that the people had chosen no other into the Senate and the prerogative than royalists, a matter of 1,400 men must have taken their oaths at their election, with an intention to go quite contrary, not only to their oaths so taken, but to their own interest; for being estated in the sovereign power, they must have decreed it from themselves (such an example for which there was never any experience, nor can there be any reason), or holding it, it must have done in their hands as well every wit as in any other. Furthermore, they must have removed the government from a foundation

that apparently would hold, to set it upon another which apparently would not hold; which things if they could not come to pass, the Senate and the people consisting wholly of royalists, much less by a parcel of them elected. But if the fear of the Senate and of the people derived from a party without, such a one as would not be elected, nor engage themselves to the commonwealth by an oath; this again must be so large, as would go quite contrary to their own interest, they being as free and as fully estated in their liberty as any other, or so narrow that they could do no hurt, while the people being in arms, and at the beck of the strategus, every tribe would at any time make a better army than such a party; and there being no parties at home, fears from abroad would vanish. But seeing it was otherwise determined by the Senate and the people, the best course was to take that which they held the safest, in which, with his humble thanks for their great bounty, he was resolved to serve them with all duty and obedience.

A very short time after the royalists, now equal citizens, made good the Archon's judgment, there being no other that found anything near so great a sweet in the government. For he who has not been acquainted with affliction, says Seneca, knows but half the things of this world.

Moreover they saw plainly, that to restore the ancient government they must cast up their estates into the hands of 300 men; wherefore in case the Senate and the prerogative, consisting of 1,300 men, had been all royalists, there must of necessity have been, and be forever, 1,000 against this or any such vote. But the Senate, being informed by the signory that the Archon had accepted of his dignity and office, caused a third chair to be set for his Highness, between those of the strategus and the orator in the house, the like at every council; to which he repaired, not of necessity, but at his pleasure, being the best, and as Argus not vainly said, the greatest prince in the world; for in the pomp of his court he was not inferior to any, and in the field he was followed with a force that was formidable to all. Nor was there a cause in the nature of this constitution to put him to the charge of guards, to spoil his stomach or his sleep: insomuch, as being handsomely disputed by the wits of the academy, whether my Lord Archon, if he had been ambitious, could have made himself so great, it was carried clear in the negative; not only for the reasons drawn from the present balance, which was popular, but putting the case the balance had been monarchical. For there be some nations, whereof this is one, that will bear a prince in a commonwealth far higher than it is possible for them to bear a monarch. Spain looked upon the Prince of Orange as her

most formidable enemy; but if ever there be a monarch in Holland, he will be the Spaniard's best friend. For whereas a prince in a commonwealth derives his greatness from the root of the people, a monarch derives his from one of those balances which nip them in the root; by which means the Low Countries under a monarch were poor and inconsiderable, but in bearing a prince could grow to a miraculous height, and give the glory of his actions by far the upper hand of the greatest king in Christendom. There are kings in Europe, to whom a king of Oceana would be put a *petit companion*. But the Prince of this commonwealth is the terror and judge of them all.

That which my Lord Archon now minded most was the agrarian, upon which debate he incessantly thrust the Senate and the Council of State, to the end it might be planted upon some firm root, as the main point and basis of perpetuity to the commonwealth.

And these are some of the most remarkable passages that happened in the first year of this government. About the latter end of the second, the army was disbanded, but the taxes continued at £30,000 a month, for three years and a half. By which means a piece of artillery was planted, and a portion of land to the value of £50 a year purchased for the maintenance of the games, and of the prize arms forever, in each hundred.

With the eleventh year of the commonwealth, the term of the excise, allotted for the maintenance of the Senate and the people and for the raising of a public revenue, expired. By which time the Exchequer, over and above the annual salaries, amounting to £300,000 accumulating every year out of £1,000,000 income, £700,000 in banco, brought it with a product of the sum, rising to about £8,000,000 in the whole: whereby at several times they had purchased to the Senate and the people £400,000 per annum solid revenue; which, besides the lands held in Panopea, together with the perquisites of either province, was held sufficient for a public revenue. Nevertheless, taxes being now wholly taken off, the excise, of no great burden (and many specious advantages not vainly proposed in the heightening of the public revenue), was very cheerfully established by the Senate and the people, for the term of ten years longer; and the same course being taken, the public revenue was found in the one-and-twentieth year of the commonwealth to be worth £1,000,000 in good land. Whereupon the excise was so abolished for the present, as withal resolved to be the best, the most fruitful and easy way of raising taxes, according to future exigencies.

But the revenue being now such as was able to be a yearly

purchaser, gave a jealousy that by this means the balance of the commonwealth, consisting in private fortunes, might be eaten out; whence this year is famous for that law whereby the Senate and the people, forbidding any further purchase of lands to the public within the dominions of Oceana and the adjacent provinces, put the agrarian upon the commonwealth herself. These increases are things which men addicted to monarchy deride as impossible, whereby they unwarily urge a strong argument against that which they would defend. For having their eyes fixed upon the pomp and expense, by which not only every child of a king, being a prince, exhausts his father's coffers, but favorites and servile spirits, devoted to the flattery of those princes, grow insolent and profuse, returning a fit gratitude to their masters, whom, while they hold it honorable to deceive, they suck and keep eternally poor: it follows that they do not see how it should be possible for a commonwealth to clothe herself in purple, and thrive so strangely upon that which would make a prince's hair grow through his hood, and not afford him bread. As if it were a miracle that a careless and prodigal man should bring £10,000 a year to nothing, or that an industrious and frugal man brings a little to £10,000 a year. But the fruit of one man's industry and frugality can never be like that of a commonwealth; first, because the greatness of the increase follows the greatness of the stock or principal; and, secondly, because a frugal father is for the most part succeeded by a lavish son; whereas a commonwealth is her own heir.

This year a part was proposed by the Right Honorable Aureus de Woolsack in the tribe of Pecus, first commissioner of the Treasury, to the Council of State, which soon after passed the ballot of the Senate and the people, by which the lands of the public revenue, amounting to £1,000,000, were equally divided into £5,000 lots, entered by their names and parcels into a lot-book preserved in the Exchequer. And if any orphan, being a maid, should cast her estate into the Exchequer for £1,400, the Treasury was bound by the law to pay her quarterly £200 a year, free from taxes, for her life, and to assign her a lot for her security; if she married, her husband was neither to take out the principal without her consent (acknowledged by herself to one of the commissioners of the Treasury, who, according as he found it to be free, or forced, was to allow or disallow of it), nor any other way engage it than to her proper use. But if the principal were taken out, the Treasury was not bound to repay any more of it than £1,000, nor might that be repaid at any time, save within the first year of her marriage: the like was to be done by a half or quarter lot respectively.

This was found to be a great charity to the weaker sex, and as some say, who are more skilful in the like affairs than myself, of good profit to the commonwealth.

Now began the native spleen of Oceana to be much purged, and men not to affect sullenness and pedantism. The elders could remember that they had been youths. Wit and gallantry were so far from being thought crimes in themselves, that care was taken to preserve their innocence. For which cause it was proposed to the Council for Religion by the Right Honorable Cadiscus de Clero, in the tribe of Stamnum, first censor, that such women as, living in gallantry and view about the town, were of evil fame, and could not show that they were maintained by their own estates or industry; or such as, having estates of their own, were yet wasteful in their way of life, and of ill-example to others, should be obnoxious to the animadversion of the Council of Religion, or of the censors: in which the proceeding should be after this manner. Notice should be first given of the scandal to the party offending, in private: if there were no amendment within the space of six months, she should be summoned and rebuked before the said Council or censors; and, if after other six months it were found that neither this availed, she should be censored not to appear at any public meetings, games, or recreations, upon penalty of being taken up by the doorkeepers or guards of the Senate, and by them to be detained, till for every such offence £5 were duly paid for her enlargement.

Furthermore, if any common strumpet should be found or any scurrility or profaneness represented at either of the theatres, the prelates for every such offence should be fined £20 by the said Council, and the poet, for every such offence on his part, should be whipped. This law relates to another, which was also enacted the same year upon this occasion.

The youth and wits of the Academy having put the business so home in the defence of comedies that the provosts had nothing but the consequences provided against by the foregoing law to object, prevailed so far that two of the provosts of the Council of State joined in a proposition, which after much ado came to a law, whereby £100,000 was allotted for the building of two theatres on each side of the piazza of the halo: and two annual magistrates called prelates, chosen out of the knights, were added to the tropic, the one called the prelate of the buskin, for inspection of the tragic scene called Melpomene; and the other the prelate of the sock, for the comic called Thalia, which magistrates had each £500 a year allowed out of the profits of the theatres; the rest, except £800 a year to four poets, payable into the Exchequer. A poet laureate created in

one of these theatres by the strategus, receives a wreath of £500 in gold, paid out of the said profits. But no man is capable of this creation that had not two parts in three of the suffrages at the Academy, assembled after six weeks' warning and upon that occasion.

These things among us are sure enough to be censured, but by such only as do not know the nature of a commonwealth; for to tell men that they are free, and yet to curb the genius of a people in a lawful recreation to which they are naturally inclined, is to tell a tale of a tub. I have heard the Protestant ministers in France, by men that were wise and of their own profession, much blamed in that they forbade dancing, a recreation to which the genius of that air is so inclining that they lost many who would not lose that: nor do they less than blame the former determination of rashness, who now gently connive at that which they had so roughly forbidden. These sports in Oceana are so governed, that they are pleasing for private diversion, and profitable to the public: for the theatres soon defrayed their own charge, and now bring in a good revenue. All this is so far from the detriment of virtue, that it is to the improvement of it, seeing women that heretofore made havoc of their honor that they might have their pleasures, are now incapable of their pleasures if they lose their honor.

About the one-and-fortieth year of the commonwealth, the censors, according to their annual custom, reported the pillar of Nilus, by which it was found that the people were increased very near one-third. Whereupon the Council of War was appointed by the Senate to bring in a state of war, and the treasurers the state of the Treasury. The state of war, or the pay and charge of an army, was soon after exhibited by the Council in this account:

The Field Pay of a Parliamentary Army

	PER ANNUM
The lord strategus, marching	£10,000
Polemarchs—	
General of the horse	2,000
Lieutenant-general	2,000
General of the artillery	1,000
Commissary-general	1,000
Major-general	1,000
Quartermaster-general	1,000
Two adjutants to the major-general	1,000
Forty colonels	40,000
100 captains of horse, at £500 a man	50,000
300 captains of foot, at £300 a man	90,000
100 cornets, at £100 a man	10,000
300 ensigns, at £50 a man	15,000

800 { Quartermasters, Sergeants, Trumpeters, Drummers, }		20,000
10,000 horse, at 2s. 6d. per day each		470,000
30,000 foot, at 1s. per day each		500,000
Chirurgeons		400
40,000 auxiliaries, amounting to within a little as much		1,100,000
The charge of mounting 20,000 horse		300,000
The train of artillery, holding a 3d. to the whole		900,000
Sum total		£3,514,400

Arms and ammunition are not reckoned, as those which are furnished out of the store or arsenal of Emporium: nor wastage, as that which goes upon the account of the fleet, maintained by the customs; which customs, through the care of the Council for Trade and growth of traffic, were long since improved to about £1,000,000 revenue. The house being thus informed of a state of war, the commissioners brought in—

THE STATE OF THE TREASURY THIS PRESENT YEAR, BEING THE ONE-AND-FORTIETH OF THE COMMONWEALTH

Received from the one-and-twentieth of this commonwealth:

By £700,000 a year in bank, with the product of the sum rising	£16,000,000

Expended from the one-and-twentieth of this commonwealth:

Imprimis, for the addition of arms for 100,000 men to the arsenal, or tower of Emporium	£1,000,000
For the storing of the same with artillery	300,000
For the storing of the same with ammunition	200,000
For beautifying the cities, parks, gardens, public walks, and places for recreation of Emporium and Hiera, with public buildings, aqueducts, statues, and fountains, etc.	1,500,000
Extraordinary embassies	150,000
Sum	£3,150,000
Remaining in the Treasury, the salaries of the Exchequer being defalked	£12,000,000

By comparison of which accounts if a war with an army of 80,000 men were to be made by the penny, yet was the commonwealth able to maintain such a one above three years without levying a tax. But it is against all experience, sense, and reason that such an army should not be soon broken, or make a great progress; in either of which cases, the charge ceases; or rather if a right course be taken in the latter, profit comes in: for the Romans had no other considerable way but victory whereby to

fill their treasury, which nevertheless was seldom empty. Alexander did not consult his purse upon his design for Persia: it is observed by Machiavel, that Livy, arguing what the event in reason must have been had that King invaded Rome, and diligently measuring what on each side was necessary to such a war, never speaks a word of money. No man imagines that the Gauls, Goths, Vandals, Huns, Lombards, Saxons, Normans, made their inroads or conquests by the strength of the purse; and if it be thought enough, according to the dialect of our age, to say in answer to these things that those times are past and gone: what money did the late Gustavus, the most victorious of modern princes, bring out of Sweden with him into Germany? An army that goes upon a golden leg will be as lame as if it were a wooden one; but proper forces have nerves and muscles in them, such for which, having £4,000,000 or £5,000,000, a sum easy enough, with a revenue like this of Oceana, to be had at any time in readiness, you need never, or very rarely, charge the people with taxes. What influence the commonwealth by such arms has had upon the world, I leave to historians, whose custom it has been of old to be as diligent observers of foreign actions as careless of those domestic revolutions which (less pleasant it may be, as not partaking so much of the romance) are to statesmen of far greater profit; and this fault, if it be not mine, is so much more frequent with modern writers, as has caused me to undertake this work; on which to give my own judgment, it is performed as much above the time I have been about it, as below the dignity of the matter.

But I cannot depart out of this country till I have taken leave of my Lord Archon, a prince of immense felicity, who having built as high with his counsels as he digged deep with his sword, had now seen fifty years measured with his own unerring orbs.

Timoleon (such a hater of tyrants that, not able to persuade his brother Timophanes to relinquish the tyranny of Corinth, he slew him) was afterward elected by the people (the Sicilians groaning to them from under the like burden) to be sent to their relief: whereupon Teleclides, the man at that time of most authority in the Commonwealth of Corinth, stood up, and giving an exhortation to Timoleon, how he should behave himself in this expedition, told him that if he restored the Sicilians to liberty, it would be acknowledged that he destroyed a tyrant; if otherwise, he must expect to hear he had murdered a king. Timoleon, taking his leave with a very small provision for so great a design, pursued it with a courage not inferior to, and a felicity beyond, any that had been known to that day in mortal flesh, having in the space of eight years utterly rooted out of all Sicily those weeds of tyranny, through the detestation whereof

men fled in such abundance from their native country that whole cities were left desolate, and brought it to such a pass that others, through the fame of his virtues and the excellency of the soil, flocked as fast from all quarters to it as to the garden of the world: while he, being presented by the people of Syracuse with his town-house and his country retreat, the sweetest places in either, lived with his wife and children a most quiet, happy, and holy life; for he attributed no part of his success to himself, but all to the blessing and providence of the gods. As he passed his time in this manner, admired and honored by mankind, Laphistius, an envious demagogue, going to summon him upon some pretence or other to answer for himself before the assembly, the people fell into such a mutiny as could not be appeased but by Timoleon, who, understanding the matter, reproved them, by repeating the pains and travel which he had gone through, to no other end than that every man might have the free use of the laws. Wherefore when Dæmenetus, another demagogue, had brought the same design about again, and blamed him impertinently to the people for things which he did when he was general, Timoleon answered nothing, but raising up his hands, gave the gods thanks for their return to his frequent prayers, that he might but live to see the Syracusans so free, that they could question whom they pleased.

Not long after, being old, through some natural imperfection, he fell blind; but the Syracusans by their perpetual visits held him, though he could not see, their greatest object: if there arrived strangers, they brought him to see this sight. Whatever came in debate at the assembly, if it were of small consequence, they determined it themselves; but if of importance, they always sent for Timoleon, who, being brought by his servants in a chair, and set in the middle of the theatre, there ever followed a great shout, after which some time was allowed for the benedictions of the people; and then the matter proposed, when Timoleon had spoken to it, was put to the suffrage; which given, his servants bore him back in his chair, accompanied by the people clapping their hands, and making all expressions of joy and applause, till, leaving him at his house, they returned to the despatch of their business. And this was the life of Timoleon, till he died of age, and dropped like a mature fruit, while the eyes of the people were as the showers of autumn.

The life and death of my Lord Archon (but that he had his senses to the last, and that his character, as not the restorer, but the founder of a commonwealth, was greater) are so exactly the same, that (seeing by men wholly ignorant of antiquity I am accused of writing romance) I shall repeat nothing: but tell you that this year the whole nation of Oceana, even to the

women and children, were in mourning, where so great or sad a funeral pomp had never been seen or known. Some time after the performance of the obsequies a Colossus, mounted on a brazen horse of excellent fabric, was erected in the piazza of the Pantheon, engraved with this inscription-on the eastern side of the pedestal:

<div style="text-align:center">

HIS NAME

IS AS

PRECIOUS OINTMENT

</div>

And on the western with the following:

<div style="text-align:center">

GRATA PATRIA

Piæ et Perpetuæ Memoriæ

D.D.

OLPHAUS MEGALETOR

LORD ARCHON, AND SOLE LEGISLATOR

OF

OCEANA

PATER PATRIÆ

</div>

Invincible in the Field	The Greatest of Captains
Inviolable in his Faith	The Best of Princes
Unfeigned in his Zeal	The Happiest of Legislators
Immortal in his Fame	The Most Sincere of Christians

<div style="text-align:center">

Who setting the Kingdoms of Earth at Liberty,
Took the Kingdom of the Heavens by Violence.

</div>

Anno { *Ætat. suæ* 116
{ *Hujus Reipub.* 50

DESCRIPTION OF OCEANA

OCEANA is saluted by the panegyrist after this manner: " O the most blessed and fortunate of all countries, Oceana! how deservedly has nature with the bounties of heaven and earth endued thee! Thy ever fruitful womb not closed with ice nor dissolved by the raging star; where Ceres and Bacchus are perpetual twins: thy woods are not the harbor of devouring beasts, nor thy continual verdure the ambush of serpents, but the food of innumerable herds and flocks presenting thee, their shepherdess, with distended dugs or golden fleeces. The wings of thy night involve thee not in the horror of darkness, but have still some white feather; and thy day is (that for which we esteem life) the longest." But this ecstasy of Pliny, as is observed by Bertius, seems to allude as well to Marpesia and Panopea, now provinces of this commonwealth, as to Oceana itself.

To speak of the people in each of these countries. This of Oceana, for so soft a one, is the most martial in the whole world. " Let States that aim at greatness," says Verulamius, " take heed how their nobility and gentlemen multiply too fast, for that makes the common subject grow to be a peasant and base swain driven out of heart, and in effect but a gentleman's laborer; just as you may see in coppice woods, if you leave the staddels too thick, you shall never have clean underwood, but shrubs and bushes; so in countries, if the gentlemen be too many, the commons will be base; and you will bring it to that at last, that not the hundreth poll will be fit for a helmet, specially as to the infantry, which is the nerve of an army, and so there will be great population and little strength. This of which I speak has been nowhere better seen than by comparing of Oceana and France, whereof Oceana, though far less in territory and population, has been nevertheless an overmatch, in regard the middle people of Oceana make good solders, which the peasants in France do not." In which words Verulamius, as Machiavel has done before him, harps much upon a string which he has not perfectly tuned, and that is, the balance of dominion or property: as it follows

more plainly, in his praise "of the profound and admirable device of Panurgus, King of Oceana, in making farms and houses of husbandry of a standard; that is, maintained with such a proportion of land to them as may breed a subject to live in convenient plenty, and no servile condition, and to keep the plough in the hands of the owners, and not mere hirelings. And thus, indeed," says he, "you shall attain to Virgil's character which he gives of ancient Italy."

But the tillage, bringing up a good soldiery, brings up a good commonwealth; which the author in the praise of Panurgus did not mind, nor Panurgus in deserving that praise; for where the owner of the plough comes to have the sword, too, he will use it in defence of his own; whence it has happened that the people of Oceana, in proportion to their property, have been always free. And the genius of this nation has ever had some resemblance with that of ancient Italy, which was wholly addicted to commonwealths, and where Rome came to make the greatest account of her rustic tribes, and to call her consuls from the plough; for in the way of parliaments, which was the government of this realm, men of country lives have been still intrusted with the greatest affairs, and the people have constantly had an aversion to the ways of the court. Ambition, loving to be gay and to fawn, has been a gallantry looked upon as having something in it of the livery; and husbandry, or the country way of life, though of a grosser spinning, as the best stuff of a commonwealth, according to Aristotle, such a one being the most obstinate assertress of her liberty and the least subject to innovation or turbulency. Wherefore till the foundations, as will be hereafter shown, were removed, this people was observed to be the least subject to shakings and turbulency of any; whereas commonwealths, upon which the city life has had the stronger influence, as Athens, have seldom or never been quiet, but at the best are found to have injured their own business by overdoing it. Whence the urban tribes of Rome, consisting of the *Turba forensis*, and libertines that had received their freedom by manumission, were of no reputation in comparison of the rustics. It is true that with Venice it may seem to be otherwise, in regard the gentlemen (for so are all such called as have a right to that government) are wholly addicted to the city life; but then the *Turba forensis*, the secretaries, *Cittadini*, with the rest of the populace, are wholly excluded. Otherwise a commonwealth consisting but of one city would doubtless be stormy, in regard that ambition would be every man's trade; but where it consists of a country, the plough in the hands of the owner finds him a better calling, and produces

the most innocent and steady genius of a commonwealth, such as is that of Oceana.

Marpesia, being the northern part of the same island, is the dry-nurse of a populous and hardy nation, but where the staddels have been formerly too thick; whence their courage answered not their hardiness, except in the nobility, who governed that country much after the manner of Poland, but that the King was not elective till the people received their liberty; the yoke of the nobility being broken by the Commonwealth of Oceana, which in grateful return is thereby provided with an inexhaustible magazine of auxiliaries.

Panopea, the soft mother of a slothful and pusillanimous people, is a neighbor island, anciently subjected by the arms of Oceana; since almost depopulated for shaking the yoke, and at length replanted with a new race. But, through what virtues of the soil or vice of the air soever it be, they come still to degenerate. Wherefore seeing it is neither likely to yield men fit for arms, nor necessary it should, it had been the interest of Oceana so to have disposed of this province, being both rich in the nature of the soil, and full of commodious ports for trade, that it might have been ordered for the best in relation to her purse, which in my opinion, if it had been thought upon in time, might have been best done by planting it with Jews, allowing them their own rites and laws; for that would have brought them suddenly from all parts of the world, and in sufficient numbers. And though the Jews be now altogether for merchandise, yet in the land of Canaan (except since their exile from whence they have not been landlords) they were altogether for agriculture; and there is no cause why a man should doubt, but having a fruitful country and excellent ports, too, they would be good at both. Panopea, well peopled, would be worth a matter of £4,000,000 dry-rents; that is, besides the advantage of the agriculture and trade, which, with a nation of that industry, come at least to as much more. Wherefore Panopea, being farmed out to the Jews and their heirs forever, for the pay of a provincial army to protect them during the term of seven years, and for £2,000,000 annual revenue from that time forward, besides the customs, which would pay the provincial army, would have been a bargain of such advantage, both to them and this commonwealth, as is not to be found otherwise by either. To receive the Jews after any other manner into a commonwealth were to maim it; for they of all nations never incorporate, but taking up the room of a limb, are of no use or office to the body, while they suck the nourishment which would sustain a natural and useful member.

If Panopea had been so disposed of, that knapsack, with the Marpesian auxiliary, had been an inestimable treasure; the situation of these countries being islands (as appears by Venice how advantageous such a one is to the like government) seems to have been designed by God for a commonwealth. And yet that, through the straitness of the place and defect of proper arms, can be no more than a commonwealth for preservation; whereas this, reduced to the like government, is a commonwealth for increase, and upon the mightiest foundation that any has been laid from the beginning of the world to this day.

"*Illam arctâ capiens Neptunus compede stringit:
Hanc autem glaucis captus complectitur ulnis.*"

The sea gives law to the growth of Venice, but the growth of Oceana gives law to the sea.

These countries, having been anciently distinct and hostile kingdoms, came by Morpheus the Marpesian, who succeeded by hereditary right to the crown of Oceana, not only to be joined under one head, but to be cast, as it were by a charm, into that profound sleep, which, broken at length by the trumpet of civil war, has produced those effects that have given occasion to the preceding discourse, divided into four parts.

Dedalus European Classics

THE GOLEM — Gustav Meyrink

'The Cabala . . . found in the ghettos a suitable home for its strange speculations on the nature of God, the majestic power of letters and the possibility for initiates of creating a man in the same way God created Adam. This homunculus was called The Golem . . . Gustav Meyrink uses this legend . . . in a dream like setting on the Other Side of the Mirror and he has invested it with a horror so palpable that it has remained in my memory all these years.'
 –*Jorge Luis Borges*

"What holds us today is Meyrink's vision of Prague, as precise and fantastic at once as Dickens's London or Dostoevsky's St. Petersburg.'
 – *Times Literary Supplement (1970)*

When **The Golem** first appeared in book form in 1915, it was an immediate popular and critical success, selling hundreds of thousands of copies. It has inspired three film versions. Admirers of the book have included Carl Jung, Hermann Hesse, Alfred Kubin and Julio Cortazar.

LES DIABOLIQUES (The She Devils) — Barbey D'Aurevilly.

The publication of LES DIABOLIQUES in 1874 caused an uproar, with copies of the book being seized by order of the Minister of Justice as it was a danger to public morality. Scandal made the book an immediate success, a century later it is now firmly established as a classic and studied in French Schools.

"The book is a celebration of the seven deadly vices and shows no counterbalancing interest in the seven cardinal virtues. Even more, it is a celebration of pride, the pride of the ancient aristocracy of evil. Those who have the style to carry off their vices have also the right to do so."
 Robert Irwin

"Les Diaboliques is intended to be a collection of tales of horror and this horror is, in each case, well built up and sustained."
 Enid Starkie

LÀ-BAS (Lower Depths) — J.K. Huysmans

Là-Bas follows immediately on from "A Rebours" (Against Nature), and takes Huysmans' quest for the exotic and extreme

situations a stage further. The novel's hero Durtal, investigates the life and times of the fifteenth century sadist, necromancer and child-murderer Gilles de Rais. But these dabblings, and table talk of alchemy, astrology and spiritualism lead him on to direct experience of contemporary devil worship and sexual magic.

Bizarre and blasphemous, **Là-Bas** is even so a lightly fictionalised account of Huysmans' own experience in fin de siècle France. It is a classic work of fiction on nineteenth century Satanism and establishes Huysmans' reputation as one of the major novelists of his century.

BLANQUERNA — Ramon Lull

Blanquerna was the first novel to be written in any Romance language. It is a masterpiece of Catalan Literature by Ramon Lull, the thirteenth century mystic, philosopher, crusade propagandist and martyr.

"Lull was a universal genius, a bold anticipator of the thoughts and the problems of the future."

Friedrich Meer.

"His fictional works contain such startling and imaginative conceptions that they have become an imperishable part of early Spanish literature. Chief of these books is *Blanquerna* a kind of Catholic *"Pilgrim's Progress"*.

Martin Gardner

Written a century before *"The Canterbury Tales"* and a century and a half before *"Tirant Lo Blanc"*, Blanquerna embodies a medieval dream of mysticism and chivalry.

THE LATE MATTIA PASCAL — Luigi Pirandello

Nicoletta Simborowski's new translation of THE LATE MATTIA PASCAL, will help re-establish Pirandello's reputation as not only a great playwright, but one of the 20th century's greatest novelists.

Published in 1904 the novel marks the beginning of his preoccupation with the relativity of human personality, and his break with verism, and the style of Verga.

Impoverished and unhappily married Mattia runs away to Nice and wins a fortune at the Monte Carlo gaming tables, but despite his new found wealth still feels the need to return home. On the train home he reads in his local newspaper that the body of a drowned man has

been identified as the missing Mattia Pascal, and he is officially dead. He still returns home, where he finds his wife remarried, and takes up his old job in the library, living the life of the late Mattia Pascal.

LA MADRE (The Mother) — Grazia Deledda

Grazia Deledda is one of the most important women writers of the twentieth century. Her depiction of the primitive and isolated communities of northern Sardinia in a perceptive, intense and individual style gained her the Nobel Prize for Literature in 1927.

"The interest in 'La Madre' lies in the presentation of sheer instinctive life. The love of the priest for the woman is sheer instinctive passion, pure and undefiled by sentiment. The instinct of direct sex is so strong and so vivid, that only the blind instinct of mother obedience, the child instinct, can overcome it."
D.H. Lawrence

I MALAVOGLIA (The House by the Medlar Tree) — Giovanni Verga

I MALAVOGLIA is one of the great landmarks of Italian Literature. It is so rich in character, emotion and texture that it lives forever in the imagination of all those who read it.
What Verga called in his preface a 'sincere and dispassionate study of society' is an epic struggle against poverty and the elements by the fishermen of Aci Trezza, told in an expressive language based on their own dialect.
The lyrical and homeric qualities in Verga are superbly brought out in Judith Landry's new translation, which will enable a whole new generation of English readers to discover one of the great novels of the 19th Century.
"A great work" D.H. Lawrence.
"I Malavoglia obsessed me from the first moment I read it. And so when the chance came I made a film of it. 'La Terra Trema' " Luchino Visconti.

SHORT SICILIAN NOVELS — Giovanni Verga
(translated by D.H. Lawrence)

"Short Sicilian Novels have that sense of the wholeness of life, the spare exhuberance, the endless inflections and overtones, and the magnificent and thrilling vitality of major literature."
–New York Times

"In these stories the whole Sicily of the eighteen-sixties lives before us — poor gentry, priests, rich landowners, farmers, peasants, animals, seasons, and scenery; and whether his subject be the brutal bloodshed of an abortive revolution or the simple human comedy that can even attend deep mourning, Verga never loses his complete artistic mastery of his material. He throws the whole of his pity into the intensity of his art, and with the simplicity only attainable by genius lays bare beneath all the sweat and tears and clamour of day-to-day humanity those mysterious 'mortal things which touch the minds'."

–Times Literary Supplement

MASTRO-DON GESUALDO — Giovanni Verga
(translated by D.H. Lawrence)

On the face of things, Mastro-Don Gesualdo is a success. Born a peasant but a man 'with an eye for everything going', he becomes one of the richest men in Sicily, marrying an aristocrat with his daughter destined, in time, to wed a duke.

But Gesualdo falls fouls of the rigid class structure in mid-19th century Sicily. His title 'Mastro-Don', 'Worker-Gentleman', is ironic in itself. Peasants and gentry alike resent his extraordinary success. And when the pattern of society is threatened by revolt, Gesualdo is the rebels' first target . . .

Published in 1888, Verga's classic was first introduced to this country in 1925 by D.H. Lawrence in his own superb translation. Although broad in scope, with a large cast and covering over twenty years, *Mastro-Don Gesualdo* is exact and concentrated; it cuts from set-piece to set-piece — from feast-day to funeral to sun white stubble fields — anticipating the narrative techniques of the cinema.

CAVALLERIA RUSTICANA — Giovanni Verga (translated by D.H. Lawrence)
"these stories must be rated among the best produced in Europe in the last century."

Giovanni Cecchetti

"Cavalleria Rusticana has that sense of wholeness of life, the spare exhuberance, the endless inflections and overtones, and the magnificent and thrilling vitality of major literature."

New York Times

"complete artistic mastery".

Times Literary Supplement

The publication of Cavalleria Rusticana means that all Verga's major works are now available in English from Dedalus.